Fresh Watercolour

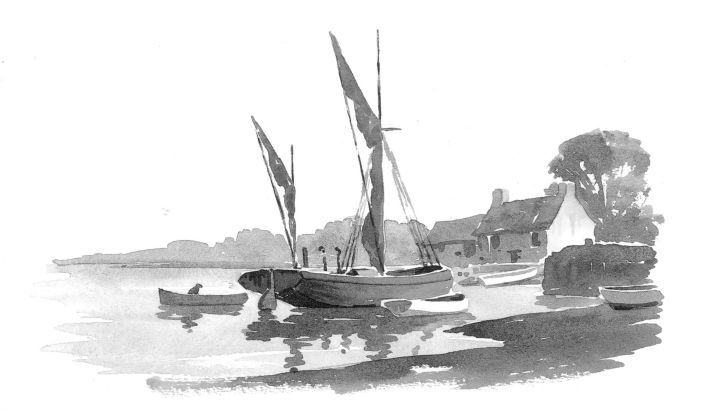

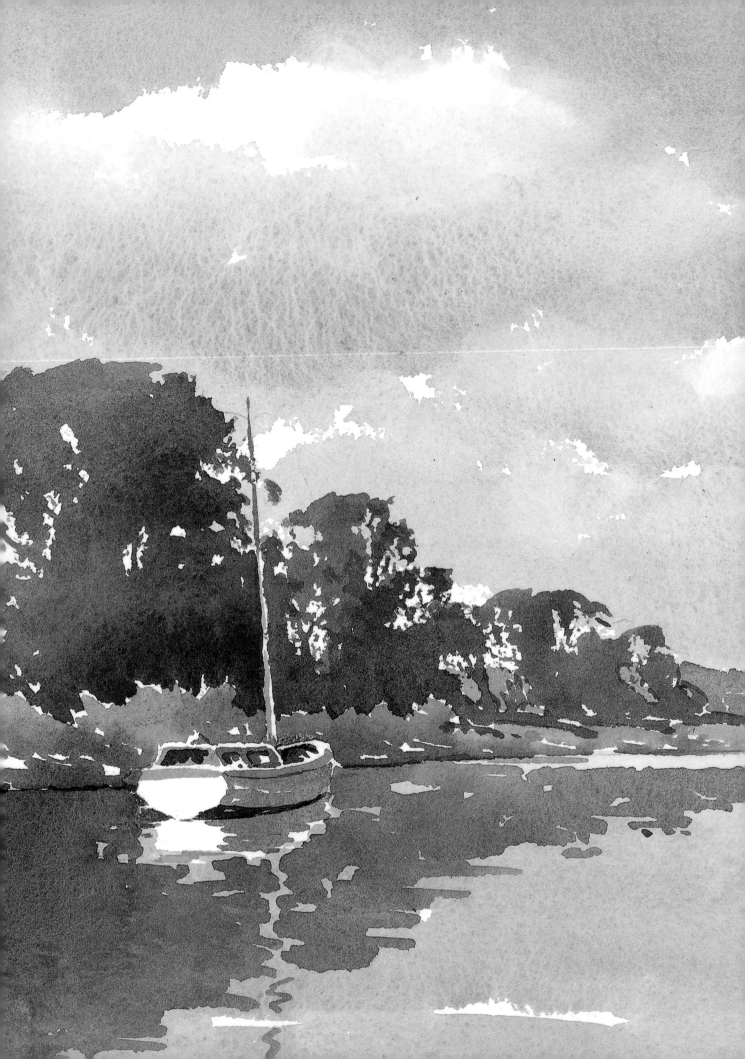

BRING LIGHT & LIFE TO YOUR PAINTING

Fresh Watercolour

RAY CAMPBELL SMITH

David & Charles

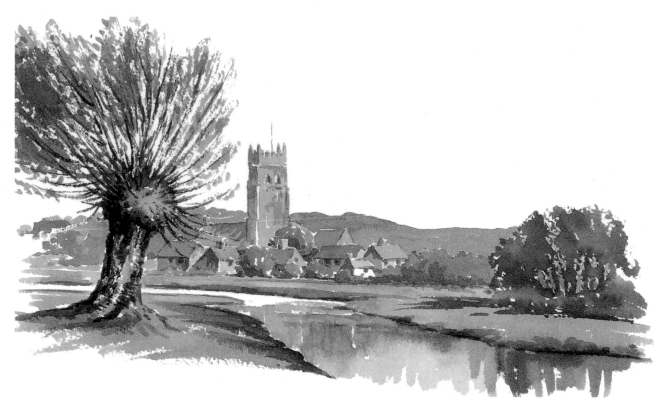

To my family, my friends and fellow painters, and all those who share my love of pure watercolour

Title page illustration: **The River Frome**
(10¾ × 15in)

British Library Cataloguing in Publication Data
Smith, Ray Campbell
 Fresh watercolour.
 1. Watercolour paintings
 I. Title
 751.422

 ISBN 0-7153-9791-5

First published 1991
Reprinted 1991, 1992

Book designed by Michael Head

Typeset by Typesetters (Birmingham) Ltd,
Smethwick, West Midlands
and printed in Hong Kong
by Wing King Tong Co Ltd
for David & Charles
Brunel House Newton Abbot Devon

Contents

Introduction

Watercolour, in skilled hands, can produce irresistible paintings! There is nothing like it for conveying, quickly and freshly, the essentials of an atmospheric landscape. Its transparent and translucent washes allow the paper to shine through to convey an impression of light flooding the countryside. Although watercolour adapts to a variety of styles, it is perhaps at its most effective and appealing when it is used boldly, quickly and impressionistically and indeed many of the watercolours we admire most look as though they were painted in a very few minutes. This appearance of spontaneity is deceptive and hides a great deal of careful thought and planning.

You probably have a good idea of the effects you are aiming for when you sit down to paint. But how many times have those loose and fluid visions, which inspired you to have a go, gradually faded as overworking and overcomplication take over? And how depressing to see the tired and muddy watercolours mount up! It is enough to make you give up in despair and yet you can learn a great deal from them if you can bring yourself to analyse them objectively. There are many reasons for such failures, but they can all be boiled down to lack of planning and lack of forethought. The beginner will often apply a wash without thinking ahead. If it does not produce the effect he wants – if, for example, he has not allowed for the fading that occurs as watercolour washes dry – he may modify it, perhaps several times, and before he realises what is happening, freshness and clarity will have been lost. What he should do is to analyse the effect he wants to create, plan carefully the manner in which to achieve it, perhaps testing for tone and colour on scrap paper, and then go ahead boldly and purposefully applying his washes. Once applied these washes should be left alone, for the more prodding and pushing about they receive, even while still wet, the more they will lose freshness. Even if the effect is not quite as intended, it will probably be far fresher and more effective than some much modified version. What it really amounts to is: 'Think first, paint later'.

Complicated and crowded landscapes are a fertile source of difficulty and cause the inexperienced painter to get bogged down in a morass of detail that would be all the better for a bit of drastic simplification. Here is an example of the simplifying process: In the painting, *Tranquil Harbour*, the far hillside was a mass of houses, roofs, chimneys, trees and so on. If all these buildings had been painted individually, the whole passage would have received far more attention than it warranted, and would have competed with the foreground boats and jetty. So a conscious decision had to be made to play it down and simplify it, with the help of an on-the-spot sketch. In the event all it received was a single greyish wash in which odd geometric shapes were left to stand for the houses, roofs, and other details. This broad suggestion of buildings leaves a lot to the imagination but watercolour is often at its most effective when it suggests and does not depict in minute detail. This piece of simplification has been described at some length because it typifies the sort of decision the watercolour painter is frequently called upon to make. You will paint with greater effect and authority if you constantly ask youself, 'how can I suggest that complicated passage with conviction and economy without committing myself to painting masses of fiddling detail?' This forward planning and bold execution will pay off every time. It is really a matter of reducing the landscape to simpler terms which watercolour can handle.

So far we have been considering very broadly watercolour technique – the most effective way of putting paint on paper – but this is only part of the story. Even more important is the problem of conveying to others the emotional response we felt when a particular scene first claimed our attention. This, of course, is vitally important for unless we can convey this feeling in our treatment of the subject, our painting, however expert the technique, will have little impact.

Occasionally we come across a scene that simply cries out to be painted and this is a real bonus; more frequently it is a particular aspect of

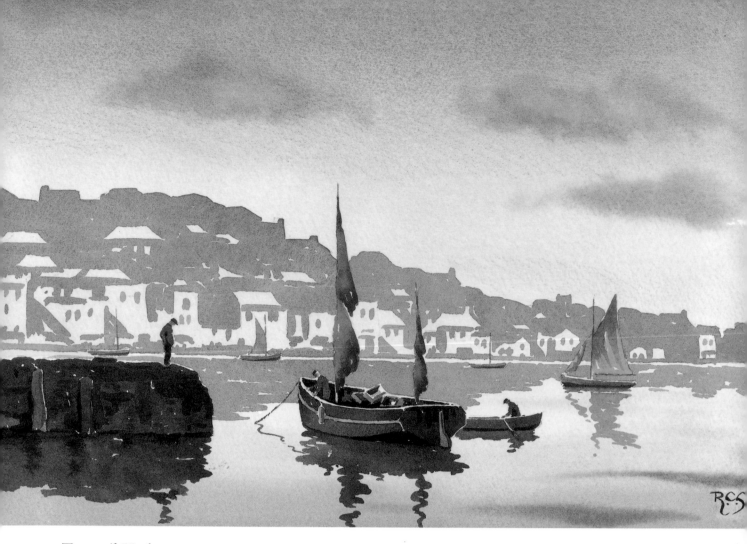

Tranquil Harbour (10¼in × 14¾in)

The attraction of this Cornish scene was the sense of peace it engendered together with the liquid shine of the calm water. These qualities are best conveyed by the use of broad, clear washes. Two pools of colour were prepared, the first of ultramarine with a little light red, the second of raw sienna, also with a touch of light red. The first wash was applied with horizontal sweeps of a 2in flat brush, starting at the top. About a quarter of the way down, the brush was dipped in the second wash, producing a gradual transition from grey/blue to the warmer colour of the lower sky. This sequence was reversed for the lower part of the water. While the paper was wet, but not too wet, the soft-edged clouds were put in with ultramarine and light red and their warm glow indicated with a touch of dilute raw sienna, care being taken to avoid the unwelcome phenomenon known as 'flowering' or 'fanning', a problem dealt with in Chapter 6. A couple of horizontal strokes with the same grey suggest the soft ripples of the right foreground, again wet into wet.

While all this was drying, the treatment of the far hillside was considered (see p7). The reflection of the hillside was then painted with an ultramarine and light red wash, care again being taken to preserve the highlights on top of the jetty and boat. This reflection actually extended lower than shown, but it was important to preserve the patch of shining water

between the jetty and the large boat. This is the sort of liberty the painter can sometimes take – a liberty the photographer may well envy. It only remained to paint in the foreground objects boldly and strongly, to bring them forward and make the background recede and, finally, to add their reflections with quick strokes of the brush.

a familiar scene that evokes a response, perhaps the way dappled shadows fall across a country lane, the way a group of sunlit buildings stand out against a dark shoulder of moorland, or any one of a hundred things that capture our imagination. Whatever the attraction we must be sure to give it due emphasis so that in our painting we proclaim: 'This is what grabbed me!' In this way we will share our experience with others and this sharing of emotion is surely what painting is all about. So the process should be observing, absorbing, feeling, mentally translating impressions into watercolour terms – and then planning a strategy.

One of the questions frequently asked is: 'How much drawing should I do before I start painting?' Unfortunately there is no straightforward and unequivocal answer to this question for it really all depends upon the degree of complexity

of the subject. If we are considering a simple landscape with just fields and a few trees, then we can go straight in with the brush. If, on the other hand, we are tackling a complicated scene with perhaps buildings at varying angles, then perspective and composition will need careful handling, and some considered drawing will be necessary. But do not use the pencil more than you have to for it is a mistake to draw so much detail that the painting process is simply a matter of colouring the areas between the lines, rather in the manner of a child's colouring book. It is much better to allow the brush freer rein, so that the rhythm of the brushstrokes lends character to the painting.

Progress in watercolour painting is not a regular or uniform process and there are times when every painter finds he is not breaking new ground and may even feel he is becoming stale. This is the time to try something new and experimental and watercolour is a medium that encourages this sort of break with tradition. One answer to the problem is doodling! Mix up several washes and simply paint or even pour them onto your paper, with no preconceived plan. Let these washes flow and blend and do what they will. Often the result will be a mess, but occasionally it will be interesting or even exciting and perhaps suggest something to you which a few deft strokes may bring to life. These happy accidents *do* occur in watercolour and the trick is to recognise them when they arise, preserve them and perhaps thereafter add them to your repertoire. In this way technique develops and imagination is stimulated.

We are frequently told that practice is the key to progress and although this is broadly true, painting is a creative process and our best work is done when we are really in the mood. An enquiring mind, a roving eye (in a strictly artistic sense) and an awareness of our surroundings will all help to stimulate our imagination and provide the inspiration that every painter needs.

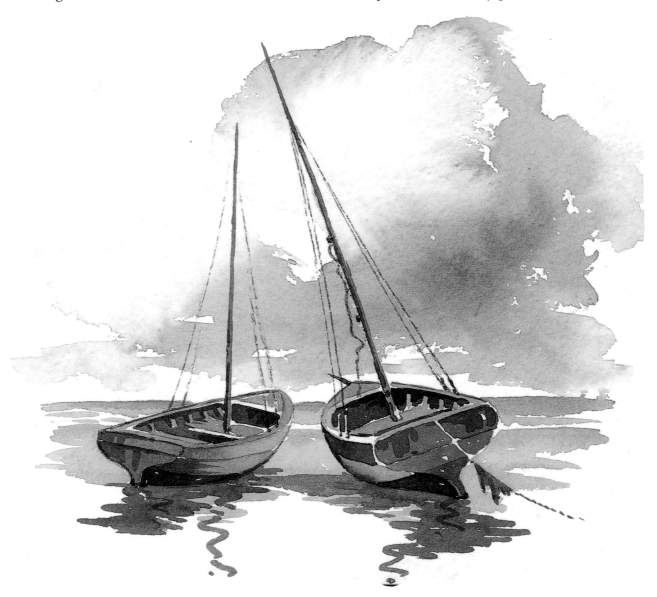

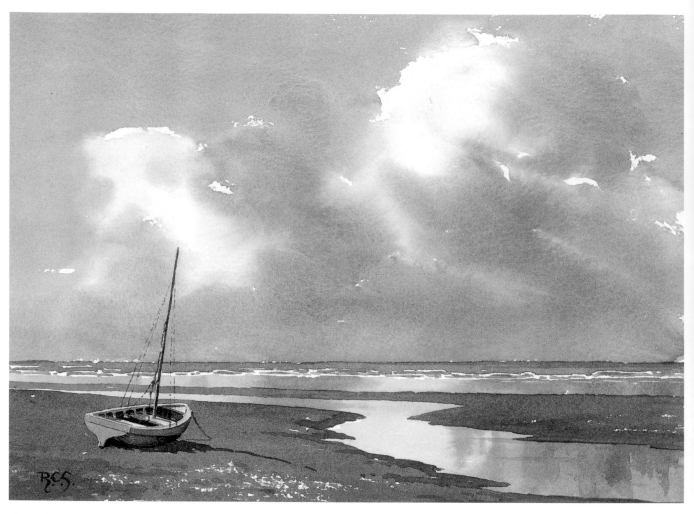

Foreshore (10½in × 14½in)
*This is a quick watercolour impression of an evening
scene dominated by a mass of shining cloud reflected
in the bands of wet sand and still water. The cloud
and its reflection caught the imagination as the
treatment makes apparent, with the deep tones of the
foreground emphasising the shine of the water.*

*Not a lot of drawing is necessary here, just an
indication of the horizon and the margins of the
stream, to make sure the water lies flat and does not
appear to flow uphill. The subtle lines of boats also
need careful handling for incorrectly drawn boats can
look remarkably unseaworthy. The boat helps to
balance the main cloud mass and its inward-leaning
mast directs the eye into the painting.*

Doodle no 1
*A start was made by splashing on a liquid mix of raw
and burnt sienna and another of ultramarine and light
red. A tree shape suggested itself, so that theme was
developed and with a brush loaded with Winsor blue
the first washes were blended and extra leaves, fence
posts, shadows and so on added.*

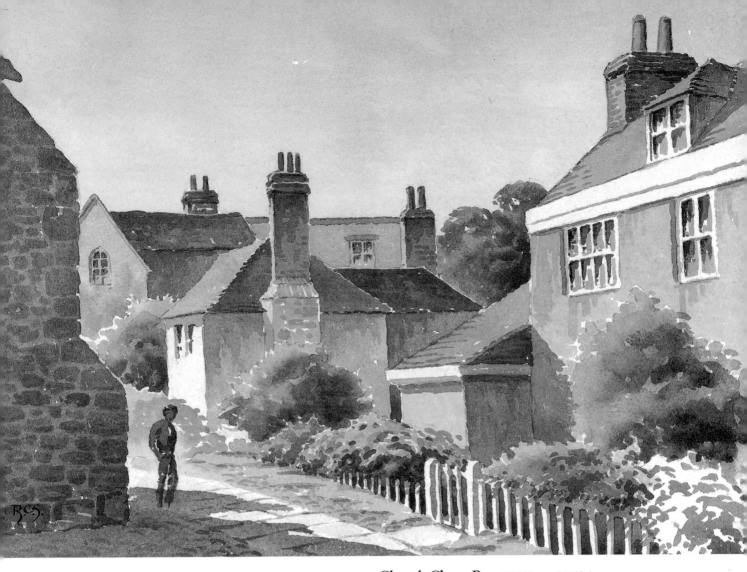

Doodle no 2

A series of wild, vertical brush strokes made with the side of a large brush, loaded with a wash of raw and burnt sienna, immediately suggested some long grass or cereal crop, so some shadows were put in with ultramarine and burnt sienna and an impression of poppy heads added with light red.

Church Close, Rye (10¾in × 14½in)

This is an example of a fairly complex scene where considerations of composition and perspective suggest some careful preliminary drawing. The important subjects of composition and perspective are both dealt with later in the book. For the present there are several points worth noting:

1 The treatment of the sky has been kept very simple so that it does not compete with the busy scene below.
2 The massive stone buttress on the left helps to balance the large house on the right and also prevents the eye following the pathway off the painting to the left.
3 The figure stands out against a patch of light and is walking into the painting rather than out of it.
4 Lights have been placed against darks wherever possible to provide contrast and create a three-dimensional effect.

1
The Challenge of Choosing Subjects

Painting good watercolours is a difficult business. It is beset by a number of problems which all have to be faced and overcome. That is no easy task and we should not make it harder by putting up with unnecessary difficulties. Using unsuitable or inferior materials – more of this later – makes good watercolour painting infinitely more difficult, and choosing unsuitable subjects is another way of adding to the problems. Beginners are understandably beguiled by magnificent but daunting panoramas and by spectacular sunsets that would give a Turner pause for thought. At least in the early stages they would do well to lower their sights a little and tackle subjects more comfortably within their range and within the scope of the medium. Watercolour is a delicate and subtle medium and is not at its best when pushed to the limit.

A breathtaking panorama does not usually make a good watercolour subject unless there is a considerable amount of simplification. Hill villages, for instance, are appealing subjects but it is all too easy to become embroiled in their mass of detail to the detriment of the overall impression. Faced with a magnificent sweep of country, it is usually better to select a small part of it as a subject and this is where a home-made viewfinder can be of assistance. This is simply a piece of stiff card, such as an off-cut of mounting board, with an aperture cut in it about the size and shape of a postcard. This simple device makes it possible to isolate a promising subject from a mass of surrounding detail. The lines which form the edge of the watercolour paper are an integral part of the composition and have to be considered in conjunction with the principal construction lines of that composition, so the edges of the aperture in the viewfinder, which frame the subject, will help in that respect as well.

Painters should cultivate open and receptive minds so that they immediately recognise good subject matter whenever and wherever they come across it. Beginners sometimes make up their minds in advance about the subjects they wish to paint and then waste fruitless and frustrating hours searching for that ideal but elusive subject, while ignoring the many other opportunities on offer. They sometimes find it difficult to free themselves from conventional notions of the picturesque and assume that the only good subjects are attractive ones. This is not to say they should seek out ugliness for its own sake or consider all beauty to be hackneyed. Nor should subjects be taboo simply because they have been painted many times before, provided the treatment is imaginative and says something new and original. It is always worth bearing in mind that form and tone and colour are what really matter and these can be found to advantage in a wide range of subjects, conventional or otherwise. It is

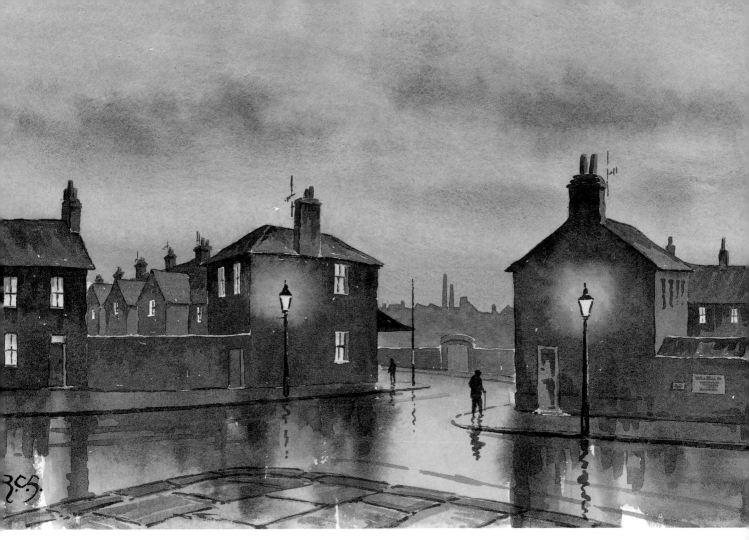

all a matter of using your eyes and imagination.

The typical art club programme lists painting trips to attractive rural locations and there is nothing wrong with that, for from the beginning art has held a mirror up to nature. But we are, perhaps, too inclined to turn automatically to the beauties of the countryside for our inspiration and ignore promising subjects in our towns. This is partly a form of escapism and partly an ingrained conviction that art and nature are inseparable. Whatever the reason the result is that the urban scene, often rich in character and atmosphere, is neglected. It is not only the Grand Canals and the Princes Streets that are worth painting; many of the older, run-down districts have an appeal of their own. A good time for painting such scenes is dusk when a warm light may suffuse the sky, an evening mist may soften the harsh outlines and lights begin to appear in windows and shop fronts. Metalled roads normally have little to offer the painter, but if they are wet with rain and reflect the lights and darks above, they can add greatly to the interest and appeal of a painting. *Street Corner* is an example of this type of subject. Here the soft evening light casts a warm glow over an undistinguished scene and is reflected in the wet road and pavement

Street Corner (10¼in × 14¾in)
Here the aim was to capture the softening effect of warm evening light upon a somewhat unpromising urban scene. The sky was a graded wash from cool to warmer colour approaching the horizon, with soft-edged clouds put in with a mixture of ultramarine and light red while the paper was still damp. Only three colours were used in this painting, the third being raw sienna (the advantages of a limited palette are described in Chapter 4). The main feature of this painting is the shining patch of wet road in the centre and this has been emphasised by the two dark figures placed against it. Notice how the lights in the windows appear to shine against their dark surroundings and how the street lamps shed their radiance against the dingy walls behind. Notice, too, how the lines of the pavements and walls direct the eye to the centre of interest, in this case the gap between the buildings.

below. The drab masonry is enlivened by glowing rectangles as lights are switched on and in the distance is the merest suggestion that this is an industrial area. Not a conventionally attractive scene, perhaps, but one that has atmosphere.

As you gain in experience and come to know your own strengths and weaknesses more intimately you will begin to see your subject matter in watercolour terms and will instinctively know how you will treat the constituent parts. This knowledge will assist you greatly in your search for subject matter and will help to shape your choice. Whatever you choose to paint, you should always remember that atmosphere and character and feeling are infinitely more important than mere topographical accuracy.

The Whelk Sheds (12¼in × 18in)
The unplanned jumble of fishermen's huts, with their variety of building materials, contrasts with the horizontal lines of sea and saltings on the left of the painting to make an interesting composition. The lively sky, with its billowing clouds, suggests a low horizon. The deep tones of the chimneys and roof register convincingly against the paler washes of the sky and the strongly painted shadows help to impart a three-dimensional quality to the buildings. The rough grass in the foreground has been painted in boldly and freely to contrast with the pale sandy track and the smooth expanse of water on the left.

Montmartre (13in × 9¾in)
Another example of how an undistinguished side street can make an interesting subject. The narrow road zigzags into the centre of interest where a figure is silhouetted against a pale background. Once again the road surface is wet from a recent shower and so reflects the lights and darks of the buildings above.

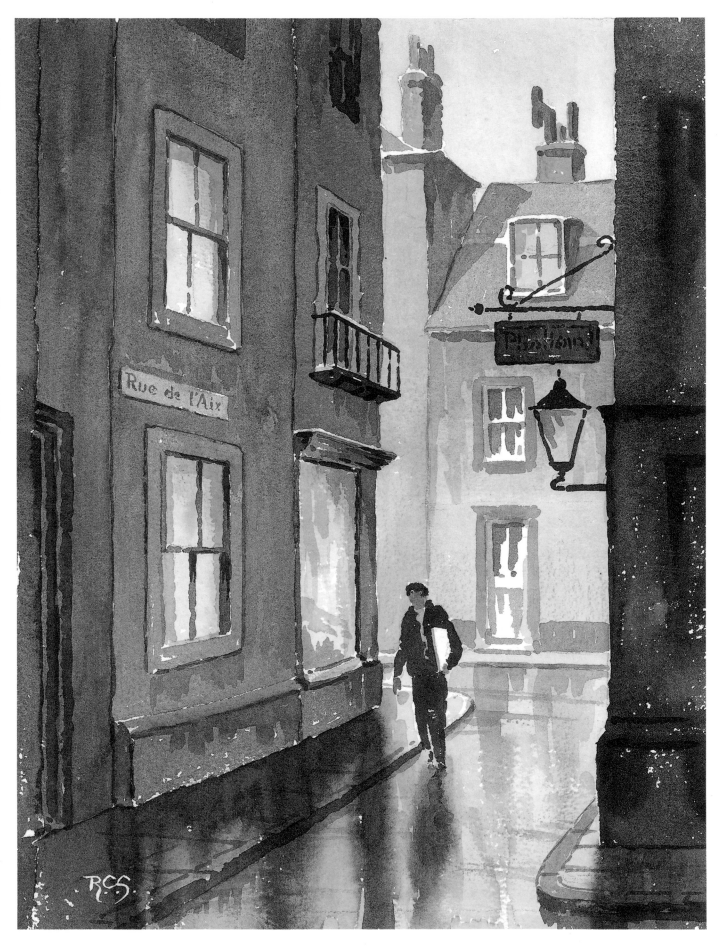

2 Related to this is the fault of placing a dominant vertical feature, such as a steeple, exactly halfway between the right- and left-hand margins of the paper.

Much better to move the object in question a bit to one side and then seek some way of achieving balance.

 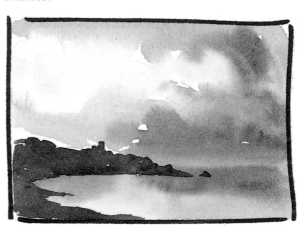

3 Failure to achieve tonal balance is the third fault in the list. Unless you have worked out your composition carefully, it is all too easy for most of the tonal weight of the painting to end up on one side or the other, imparting a lop-sided feeling to your work.

This imbalance may well be inherent in the chosen subject, but it is then up to you to do something about it. In the accompanying sketch balance has been restored by simply moving the heavy cloud mass to the right.

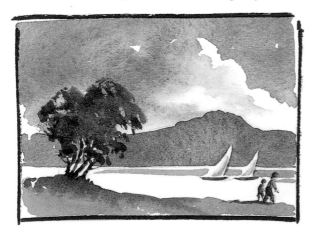 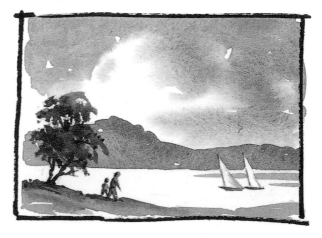

4 One of your aims should be to keep the viewer's eye firmly on your painting by doing all you can to prevent it moving off the edge. Most good paintings have a 'centre of interest', the significant part of the painting to which the artist wishes the eye to travel and come to rest. You therefore have to avoid anything that carries the eye away from this

important area. In the left-hand sketch the sailing boats are moving off the paper to the right, as are the figures; the trees are all leaning to the right and even the hills and clouds seem to be pointing in the same direction. By contrast, in the right-hand sketch, everything is carrying the eye into the heart of the painting.

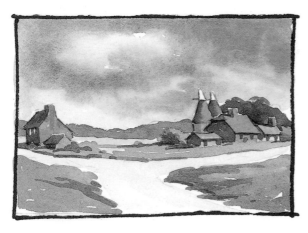

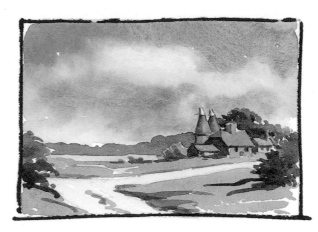

5 How, then, to keep the viewer's eye firmly on your painting and to direct it in such a way that it comes to rest at the centre of interest? In the left-hand sketch, the forking lane carries the eye first to the left, then to the right and provides no resting place. This is because there are two competing centres of interest.

In the solution to the problem, we have concentrated on one of these – the group of farm buildings to the right – and eliminated the other. By the use of carefully placed trees and bushes we have also blocked off both lanes so that they do not carry the eye off the edge.

6 While on the subject of lanes and roadways, it is worth noting that they can present problems of their own. For one thing we want to avoid the common fault of making them appear too dominant. For another we want to avoid our road margins

originating in the very corner of the paper. It is sometimes useful to break up their length by including lateral shadows, and these, if correctly painted, will help to describe the contours of the ground over which they fall.

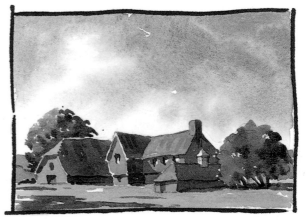

7 One of the ways to achieve good composition is through the careful grouping of the features of the chosen subject. It is clearly better to adopt a viewpoint from which there is some overlapping rather than one from which the objects appear to be

strung out in a straight line, without any connecting link. For much the same reason a building observed head on is usually a less interesting shape and of less artistic appeal than when viewed more obliquely.

19

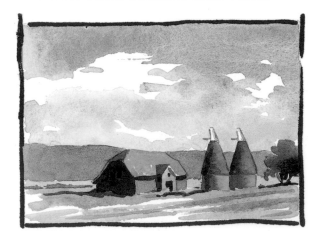

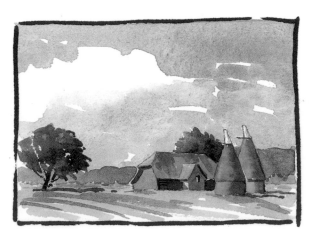

8 We have all seen paintings in which unrelated lines appear to coincide. In the left-hand sketch the line of distant hills continues the line of the cottage roof, while the two oasthouses appear to be touching instead of overlapping. These two basic faults are corrected in the right-hand sketch.

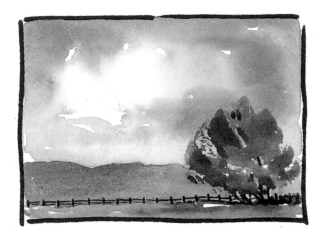

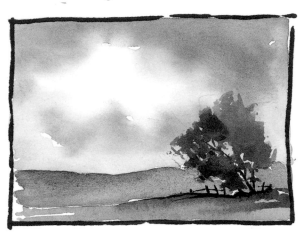

9 Problems arise when too much unnecessary detail is included. This makes for an over-busy painting for which a little simplification would work wonders. For example, the inclusion of a long line of regular fencing is usually fatal to good composition, and a shorter line, consisting of a few random posts, is infinitely preferable from the artistic if not from the utilitarian viewpoint.

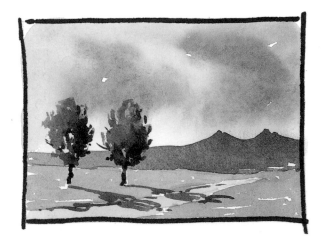

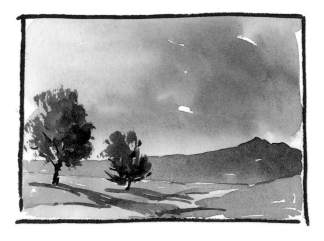

10 A mistake which often crops up is that of making objects in a painting appear too similar. This can arise when a painter studies the first object with some care but is then content to copy what he has already drawn for the second. If the objects in question are very similar in size, shape and tone, you should try hard to spot what differences there are and to make the most of them. Note how the repetitive forms in the left-hand sketch have been varied in the corrected version.

Not all subjects, however attractive, make good compositions. If shifting your position to find a better viewpoint does not do the trick, then as we have seen above it may be necessary to modify certain parts of the scene before you. Opinions differ on the ethics of adopting this rather drastic course, and much depends upon the object of the painting. If, to cite an extreme example, you have received a commission to make a painting of someone's house, then obviously you cannot play fast and loose with the local topography. If, on the other hand, the exact arrangement of the subject matter has no particular significance, there can be no real objection to a little judicious rearrangement if it enables you to achieve a better composition.

There is a lot to remember in this business of composition, but with growing experience, much of it becomes instinctive.

In the context of art, tone simply means lightness or darkness: light objects are said to have high tone, dark ones low tone. It is vitally important to get your tone values right. If, for example, you use your darkest colours for passages in your painting that are not at the bottom of the tonal scale, then you have nothing in reserve for still darker areas. If your judgement of tone is at all suspect, you would be well advised to work out your tone values in a preliminary black-and-white sketch, using conté or charcoal, and this would have the added advantage of helping you with your composition. When tone values are correct, a painting will stand up to being photographed in black and white and will still look convincing.

To some extent tone evaluation must be a compromise. We have nothing in our palette to match brilliant sunshine and any attempt to paint the deepest shadows as they really are would push the watercolour medium beyond the limit. In absolute terms, then, the tones we use are a compromise, but they should still be relatively correct.

Inexperienced painters often portray trees and green fields as though they were very similar in tone. Trees are, in fact, almost always darker, for their form is such that much of their foliage is in shadow whereas fields are flat and reflect far more light from the sky above. In addition, trees are often viewed against a bright sky and this makes them appear even darker than they are. Finally, tree foliage is normally deeper in tone than grass. So when you are painting in the field, be on the look-out for these tonal differences and do them full justice in your painting.

(overleaf)
The Church on the Marshes (10¾in × 15½in)
This lonely but much painted little church makes an appealing subject for the watercolourist. With no buildings or other prominent features nearby to provide balance, it poses certain compositional problems, so it was decided to place it left of centre and balance it with the stands of trees and heavy cloud shadow on the right. A very low horizon was adopted, a useful ploy with marshland subjects, for their very flatness seems to emphasise the immensity of the sky above. The weather was threatening and despite occasional gleams of pale sunlight, rain was never very far away, another good reason for working quickly! The foreground drainage ditch leads the eye conveniently to the church on its little green island and the lines of trees and hedges do much the same.

The light-toned sunlit elevation of the church made an interesting contrast with the slate-coloured clouds behind and its shadowed side with a paler patch of sky to the right, so this dramatic effect was emphasised. The sky was painted quickly and boldly, with deep shadows giving form and shape to the clouds. The foreshortening of the distant fields underlines the flatness of the terrain while the greying of the distant trees suggests recession and contrasts with the warmer colours of the nearer copse.

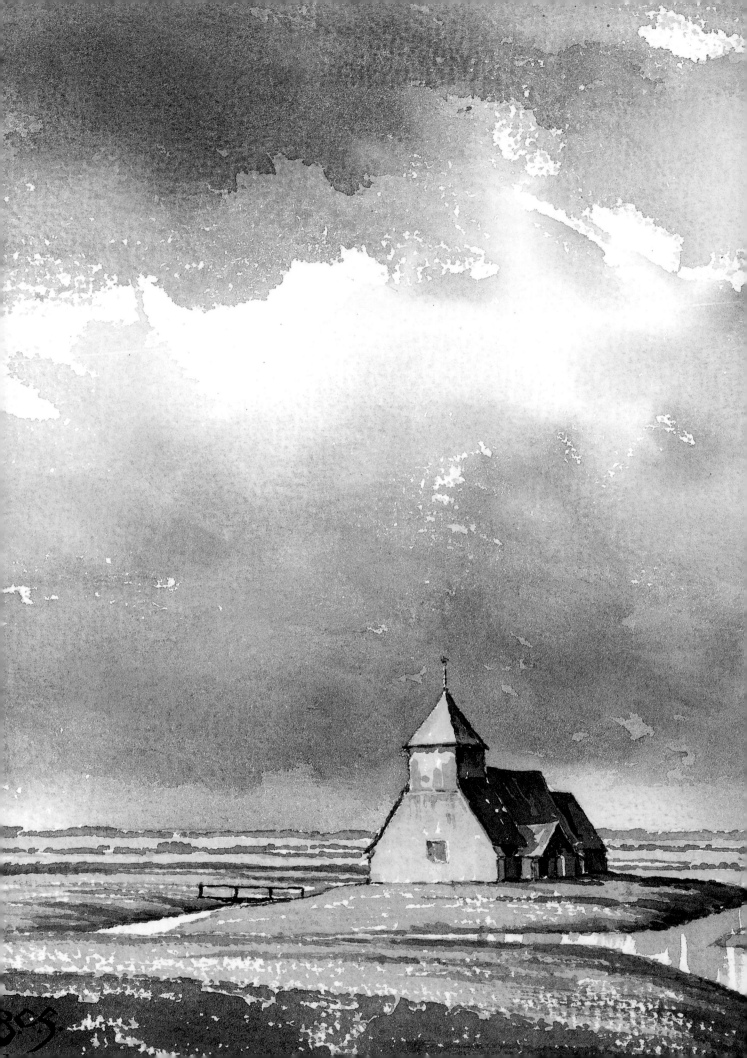

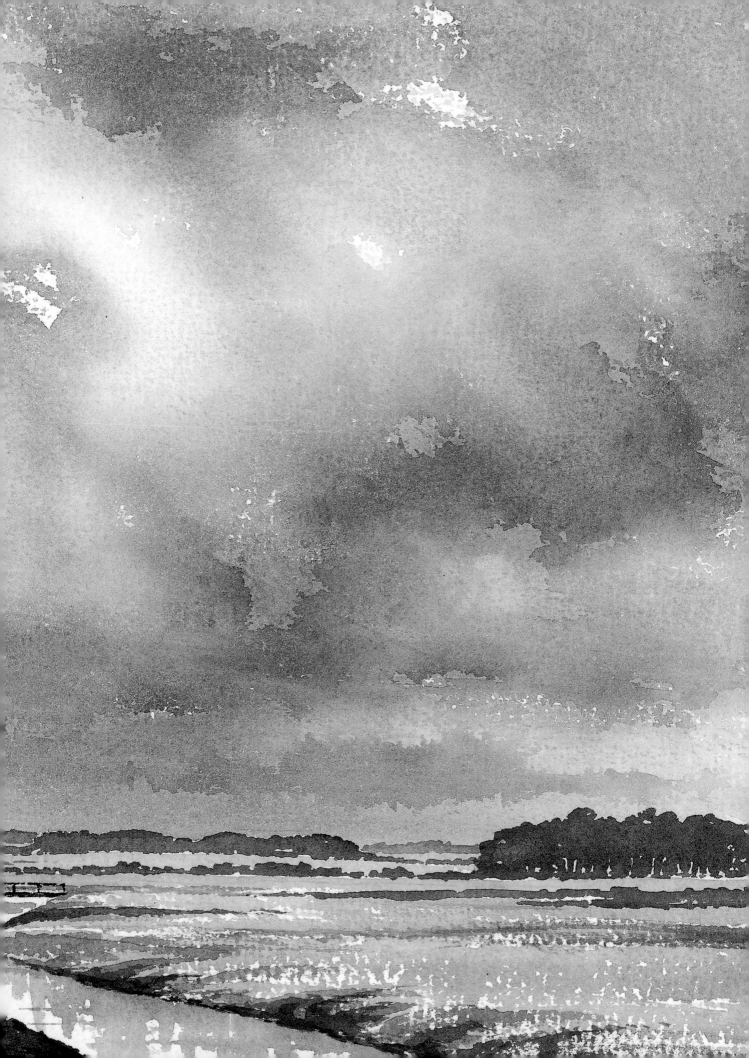

3

Perspective Made Easy

The title of this section may seem a little presumptuous to those who find perspective a real problem, but the truth is that once the comparatively simple rules are understood, everything falls into place and the problem really does disappear. So for the moment take this assurance on trust and read what follows believing that you, too, can master perspective. And once you have, it is like riding a bike, you will not forget it.

Perspective all depends upon the self-evident proposition that the further away an object is, the smaller it appears. That is not difficult to accept, is it? This obvious truth, then, can be represented diagrammatically by a straight line of telegraph poles of equal height stretching away on a flat plain to the far horizon (fig 1).

There are several points to note here. First, because we are postulating a dead-level plain, the horizon coincides with our eye-level line. In practice, this only happens with a sea horizon, for hills and trees and so on break the land horizon. Second, if we draw a line joining the top of the poles and another joining the base of the poles, these lines meet on our eye-level line, at a point where the poles are so distant we can no longer see them. This is called the vanishing point. Third, the line joining the points below eye level slopes up to the vanishing point while that joining the points above eye level slopes down to it. Nothing very hard so far! Let us now apply all this to a solid object, such as a flat-roofed house, viewed obliquely (fig 2).

If we extend the lines representing the tops and bottoms of the two side walls, they, too, will meet on our eye-level line, and this provides a simple way of checking up on the correctness of our perspective drawing. Two points to note here: first, the lines above eye level slope down to the horizon, those below eye level slope up to it. Just as before. Second, the lines of that side of the house turned towards us slope gently to the vanishing point, while those of the side turned away from us slope much more steeply.

You may feel all this is very simplified and that in the real world shapes are far more complex. True, but even complicated shapes can be broken down into simple ones and the principles hold good. Now let us consider a building all of which is above our eye level (fig 3).

Here the lines representing the tops of the walls and those representing the bottoms of the walls all slope down to the horizon, just as we would expect. Note also that the lines of the tops and the bottoms of doors and windows follow the same rules. Now let us take the example of a curved road, with houses built on that curve, and see what happens (fig 4).

Again, the lines representing the tops and bottoms of the house fronts meet on the eye-level line, but all at different vanishing points. Notice how the gradients of these lines vary, the steepest being those of the houses on the left which are more obliquely placed. Notice, too, how the lines of the right-hand house, which is directly facing us, are parallel and so do not meet at all.

Many people have difficulty with the perspective of buildings situated on hills, so let us imagine such a situation (fig 5).

The same principle still applies and the continuation of the lines representing the tops and bottoms of the houses still meet on the eye-level line, which here coincides with the observed horizon as we are looking out to sea. Because of the steepness of the hill down to the harbour, these houses have to be built up on the right to provide a level base. In the example I have taken, the houses are all parallel so there is only one vanishing point. If they had been set at different angles there would, of course, have been several vanishing points, just as there were with the houses built on a curving road, which we considered earlier.

Just one more point to consider: the closer a building is to you, the steeper will be the lines sloping to the vanishing points. The converse is also true: the further away a building is, the flatter those lines will be. It is all a matter of the *relative* distances from the eye to the nearer and further corners of the house.

The perspective of shadows is a rather more complex matter and the geometric construction correspondingly complicated. To avoid confu-

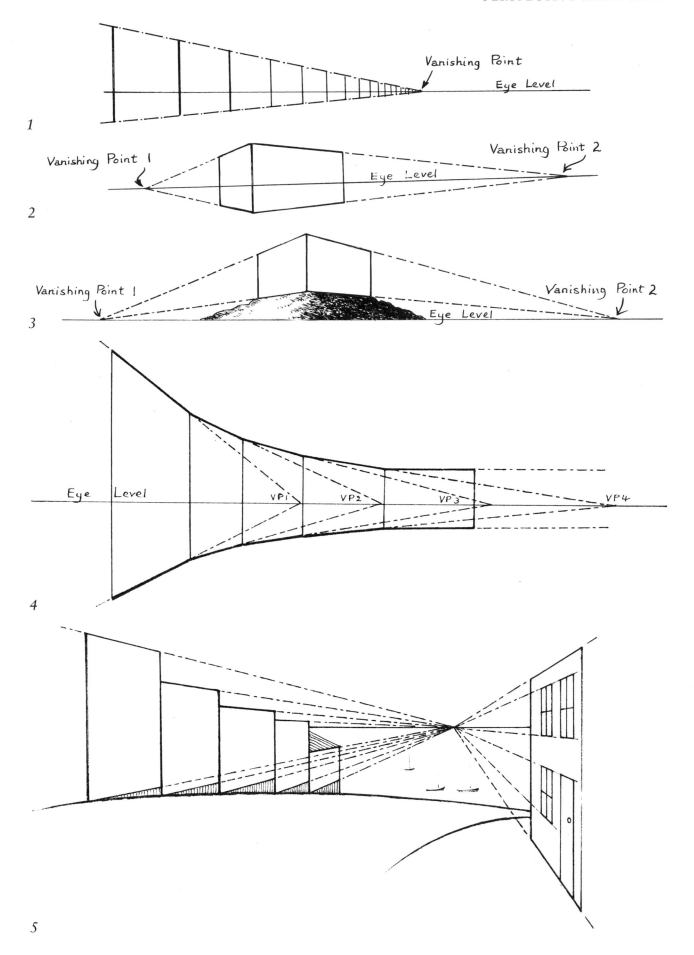

1

Vanishing Point

Eye Level

2

Vanishing Point 1

Eye Level

Vanishing Point 2

3

Vanishing Point 1

Eye Level

Vanishing Point 2

4

Eye Level

VP1 VP2 VP3 VP4

5

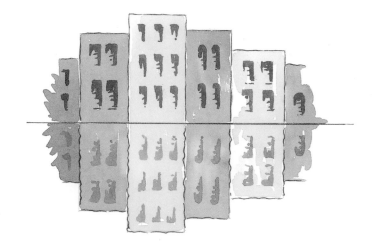

6

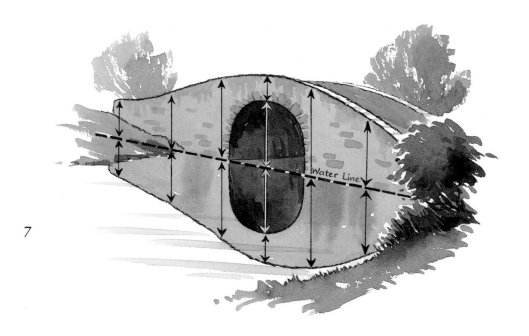

7

Water Line

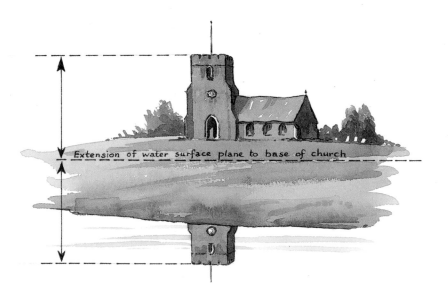

Extension of water surface plane to base of church

8

sion, therefore, I suggest that you rely on observation to construct reasonably accurate shadows. The perspective of reflections in water needs care for these can look very odd if not drawn accurately. To take a simple case first, a row of buildings rising from the water's edge presents no problems; they simply appear in their entirety, upside down (fig 6).

The same principle holds good with a more oblique arrangement, and all we have to do is to measure the height of key features above the water line and measure off an exactly equal distance below it. This construction will provide a framework upon which to base your drawing. The sketch of the old stone bridge shows how this is done (fig 7).

A building or other object set back from the water's edge is another matter and we need to understand the construction to be sure of showing just the right amount of reflection. Here is an example (fig 8).

In your imagination extend the plane of the water surface so that it cuts right through the riverbank to a point directly under the building, in this case a church. This imaginary extension of the water surface is represented by the dotted line AB. We now measure the distance from the top of the church tower to this line, and this distance, measured from the line AB down to the river, shows just how much of the tower will be reflected. Because the river bank is sloping back, it is not reflected; if it had been more vertical, there would have been some reflection.

Cretan Village (10in × 13¼in)
A simple little painting of an almost deserted village street in which the constructions described may be used to check the perspective. Notice how the lines above eye level slope down to the imaginary horizon, and those below slope up to it.

In the matter of composition, the buildings on the left prevent the curving road carrying the eye off the painting while the shadows they cast serve to break up what would otherwise have been an excessive area of road.

Not all perspective problems can be solved by geometric means, and with these we have to rely on careful observation. A winding river flowing through a broad valley is a case in point. Incorrectly drawn, the river may appear to be flowing uphill. Another very common fault is that of exaggerating the vertical depth of distant fields, which makes them look much closer than they are.

With experience perspective becomes second nature but until that happy day it is a good plan to check your drawing with one or other of the simple constructions described. At this point it is worth noting that perspective can be deliberately distorted to gain dramatic impact, but this is a ploy that should be used with discretion.

Another aspect of the subject is aerial perspective. This concept depends upon the observable fact that the further away an object is, the more the intervening atmosphere will modify its appearance. The mistier the conditions, the more noticeable this effect will be. Colours will become softer and tinged with blue and grey and there will be less tonal contrast between lights and darks. Both these effects will give the object in question a feeling of recession. Soft greys, blues and mauves are therefore recessionary colours while bright yellows, oranges and reds bring objects forward. I remember a student of mine once including a distant field of rape seed in his landscape painting. Even at a distance, the brilliant yellow of this crop was virtually undimmed, and this is how he painted it, thereby destroying any feeling of recession. We sometimes have to ignore what is there and make the landscape behave as we want it to!

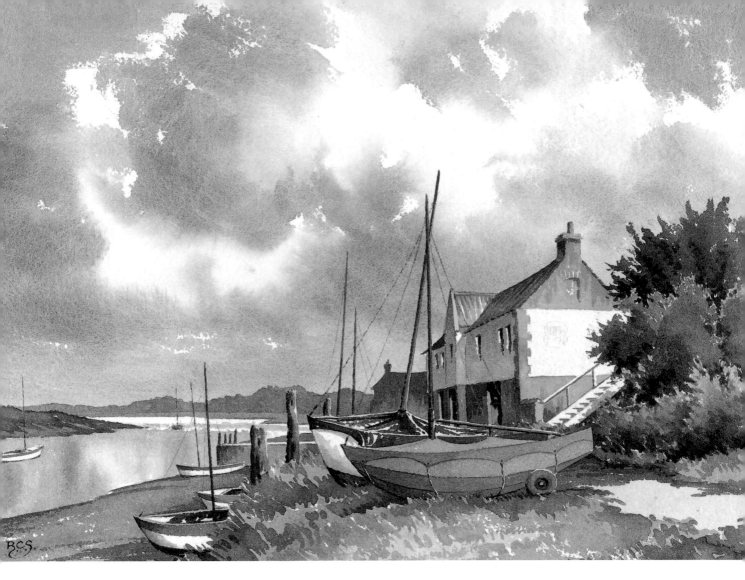

Burnham Overy Staithe (12¾in × 17½in)
*In this Norfolk scene, the lines of the main building –
a ship's chandlers – obey the rules of perspective and
also point to the bend in the river which here
constitutes the centre of interest. The lines of the river
are such that the water appears to 'lie flat' and the
dark bank prevents the river carrying the eye off the
painting to the left. The distant line of trees are blue/
grey in colour, to aid recession, and everywhere in the
painting there is counterchange – the setting of lights
against darks and darks against lights – to provide
strong tonal contrast.*

(overleaf)
Blakeney Marsh (10½in × 19in)
*Once again the perspective of the river ensures the
water lies flat and the greying of the long line of trees,
paling as it becomes more distant, strongly suggests
recession. The pale, grey-green area of marshland
beyond the river and its cloud shadows are
foreshortened in a vertical plane, to reinforce the
impression of flatness. The low horizon enables a
lively sky to be given due prominence.*

4

The Tools of the Trade

Bad workmen are said to blame their tools, but bad tools make good work more difficult, and this is particularly true in the field of art. Poor or badly chosen materials present almost insuperable, though quite unnecessary, problems. The enormous and ever-growing range and the extravagant claims advanced by some manufacturers make the task of selection a difficult one. The high cost of some materials makes it even more important to choose wisely and cut out inessentials, and here the watercolourist is fortunate in that his requirements are comparatively simple. In this chapter we shall consider these requirements in some detail and make recommendations which will help you select what you really need, for the least expense.

Paint-box and tubes of paint

Paints

The first purchase made by the aspiring watercolourist is usually a paintbox and the retailer has an interest in selling an expensive one, with a bewildering array of colours. The beginner may then feel he is not using this expensive purchase to the best advantage unless he uses the full range of colours in each painting. This is an expensive mistake and it is far better to choose a compact box with no more than a dozen colours. There are two advantages in adopting what is known as a limited palette: first, colours vary considerably in strength and in their handling properties; if you confine yourself to, say, half a dozen, you get to know these properties well and this is bound to benefit your technique. The second advantage is that by using a small number of colours, your paintings will 'hang together' more effectively, a theme that is covered more fully in Chapter 5.

There are two main grades of watercolour paint, students' quality and artists' quality. Artists' quality paints have greater strength and clarity, with more finely ground pigment and are naturally more expensive. Whether this additional cost is justified must be a matter of personal judgment, but it is worth bearing in mind that the difference in cost per painting must be small while the difference in brilliance and freshness may be appreciable.

Our next consideration concerns the relative merits of pan and tube colours. Pans are certainly more convenient to use, but as the paint is exposed to the air, it tends to dry and it is frustrating, as well as harmful to brushes, to try to coax reluctant pigment from dried-up pans. On the other hand, squeezing out large dobs of tube paint round the margin of the mixing palette can be very wasteful as perfectly good paint is washed off at the end of the day's work. The best answer to the problem is to squeeze out fresh paint from the tube into the appropriate pan at the beginning of each painting session, for in this way you will always have fresh, plastic paint at your disposal. What is more, the fresh paint will liven up what is already there in the pan, and nothing is wasted.

Brushes

We should think carefully about the brushes we buy for they are bound to influence our work for good or ill. Without doubt the best watercolour brushes are those made of kolinsky red sable and these are a joy to use, but the fact has to be faced that today they are extremely expensive. Fortunately there are alternatives and some of these are very good, particularly those with a mixture of sable and manmade fibre. The sable constituent enables them to hold good, full washes, while the manmade fibre gives them good spring and shape, and they are only a fraction of the cost of pure sable brushes.

The number and size of brushes required will depend to some extent upon the scale and style of your work. Generally speaking it is useful to have at least two large flat brushes, a 1in and a ½in, and a variety of smaller round brushes, perhaps a 12, a 10, an 8, a 4 and a rigger. It is good practice to use as large a brush as you can for this helps you to achieve broad, clear washes and eliminates fussy detail. Care of brushes is an important matter and will greatly prolong their useful life. After use they should be carefully washed in clear water until all trace of pigment has been removed and then laid flat and allowed to dry in the open. All too often, painters place wet brushes in jars immediately after washing, causing the remaining moisture to run down into the ferrule, to the detriment of the base of the hairs. Placing damp brushes in closed boxes is another bad habit for if they remain damp too long mildew and rot may well cause damage. A bristle brush can be a useful addition for removing unwanted paint from the watercolour paper, though it has to be said that only the more robust surfaces will take such treatment without serious damage.

Papers

There are many different kinds of watercolour paper on sale, varying enormously in quality, in weight and in type of surface and there is surely something to suit every style and taste. It is important for the success of your work to find one that really suits you and enhances your work, so it is well worth experimenting until you locate your ideal.

Papers vary in weight, usually from 90lb to 300lb to the ream (480 pages of Imperial size). The advantage of the heavier papers (200lb and above) is that they do not cockle seriously even when full washes are applied to them. When cockling occurs the liquid paint collects in the hollows, causing uneven washes, uneven drying and other horrors. Of course the heavier papers are more expensive, and if you prefer to use the

Brushes and mixing palette

Sitting at the easel

33

Standing at the easel

Drawing board on lap

lighter variety, you should stretch them. This is done by immersing the sheet for about half a minute in clean water and laying it flat on your drawing board. The excess liquid and any air bubbles are removed with a soft rag, care being taken not to damage the surface of the paper, which is very vulnerable when wet. The edge of the paper is then stuck down firmly all round with brown, gummed tape (*not* masking tape) and the board stood on its side to dry, slowly and without the application of heat. The following day the paper should be flat, taut and may be used without fear of cockling. There is one slight disadvantage, apart from the tedium of the process itself, and that is the removal of some of the surface dressing by soaking, for this sometimes makes it more difficult to achieve sparkle in the subsequent painting.

There are three principal types of surface in watercolour paper: 'smooth' (or HP for hot pressed); 'Not' (or CP for cold pressed) and 'rough'. The smooth surface contains very little 'tooth' and is not suitable for most styles of watercolour painting. At the other extreme, rough has a pronounced grain and is useful for obtaining textured effects and for dry brush work. It also gives rise to granulation, when the pigment collects in the little hollows of the surface to produce a somewhat speckled effect, which can sometimes be employed with advantage to represent texture. Between the two extremes is the Not surface, which is a good compromise and suitable for most purposes.

Other Equipment

For work in the field, robustness combined with lightness should be the aim. It is unlikely that your paintbox will provide sufficient space for all the washes required so you will need a mixing palette as well. There are a number of excellent designs on the market which provide ample space and enough divisions to keep washes from running together unintentionally. The lighter mixing palettes are of plastic and the better quality resist staining surprisingly well.

A drawing board large enough to take your normal paper size is, of course, a must. You will need a light folding stool if you prefer to sit while you work and a light, but sturdy, easel unless you paint, as I often do, with board on lap. If you employ full, liquid washes, it is sometimes useful to be able to tilt your board in various directions and enlist the aid of gravity to achieve the effects you want. A low folding table, conveniently placed, can be handy for taking paintbox, water jars, brushes, spare tubes and so on. Plenty of clean water is vital for a meagre supply that has

become muddy makes clear, fresh work an impossibility. It is a good plan to use two jars, one for washing brushes, one for mixing with paint. Do not forget to include clean rags or tissues.

If you like to make preliminary sketches to help you decide the best angle from which to view your subject, and perhaps work out your tone values in advance, you will also need a sketch block, pencils of varying blackness, perhaps a stick of charcoal and a rubber. With growing experience you may well wish to vary this list. There are all sorts of additional aids which you may care to consider. A putty rubber is well worth including for it will do less damage to the surface of your watercolour paper than the india-rubber variety. A sharp knife, or razor blade, used with restraint, can sometimes be useful for producing crisp light accents, masking fluid can preserve small areas of white paper and masking tape larger ones. Care should be taken to ensure these masking aids do not, on removal, take fibres of paper with them. Finally you will need something in which to carry all your equipment and tough army surplus haversacks are particularly suitable for this purpose.

Many beginners are reluctant to paint in the open for fear of someone looking over their shoulder; such reluctance is understandable but misplaced. To many members of the general public, even painting of modest standard is as magic. With growing experience, timidity disappears, particularly if you join an art club and paint with a group, finding safety in numbers. If you habitually paint indoors, you miss those little quirks of nature and tricks of the light which bring life and immediacy to your work and the more comfortable and controlled working conditions of the studio can never make up for this. So take your courage in both hands and accept gratefully what nature has to offer.

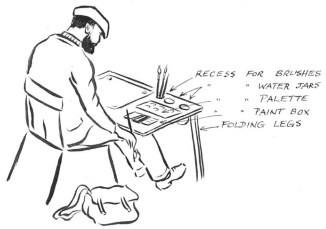

RECESS FOR BRUSHES
" " WATER JARS
" " PALETTE
" " PAINT BOX
FOLDING LEGS

A home-made solution

(overleaf)
Rye Mill (10½in × 14½in)
This is an example of a painting on a Not paper. The surface is sufficiently rough to respond to dragged-brush work, as you will see from the outlines of the trees and the foreground reeds.

The sky was painted first with two full washes, the first of raw sienna with a little light red, the second of ultramarine and light red. A 1in flat brush was used for each of these washes, which were allowed to blend at the margin. Too much work with the brush would have caused excessive mixing and blending to take place to the detriment of the area of radiance above the horizon.

This broad treatment of skies, with large, well-loaded brushes, makes it impossible to paint carefully round such features as the old mill, so masking fluid was used to pick out its sunlit sails, railings and other details. Remember to test masking fluid on an off-cut before using it on your watercolour paper to make sure it will not damage the surface.

Notice how the soft greys of the distance help it to recede while the warmer colours of the nearer features, with their stronger tonal contrast, bring them forward. Notice, too, how the soft treatment of the reflections in the water complement the detail above and do not compete with it.

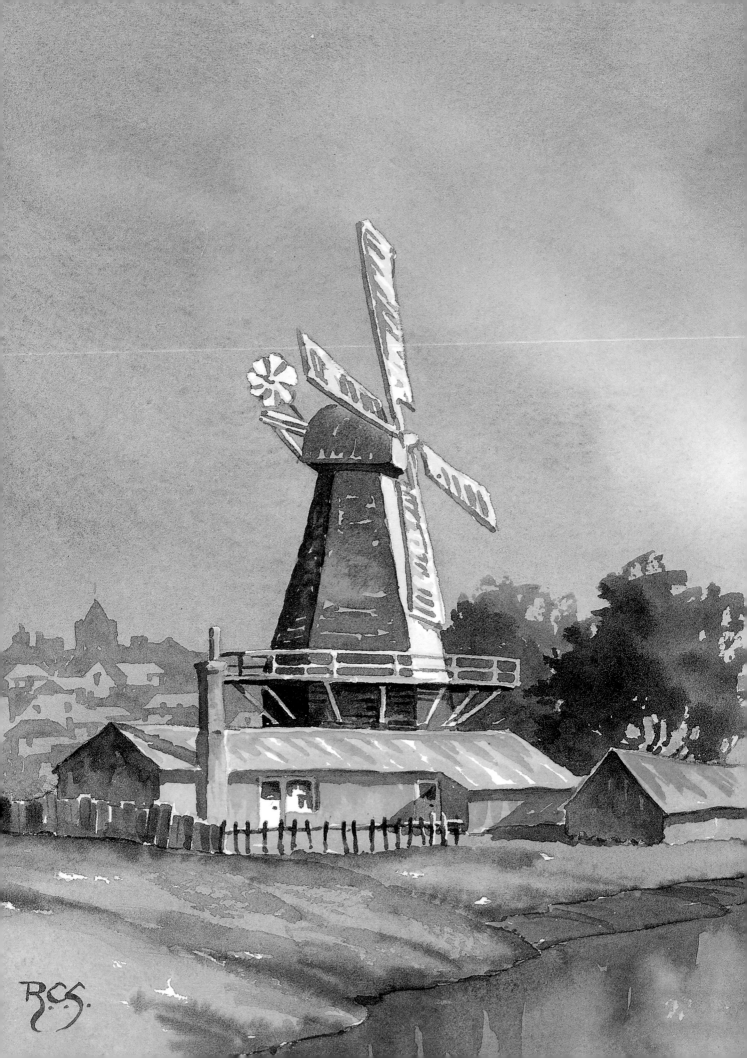

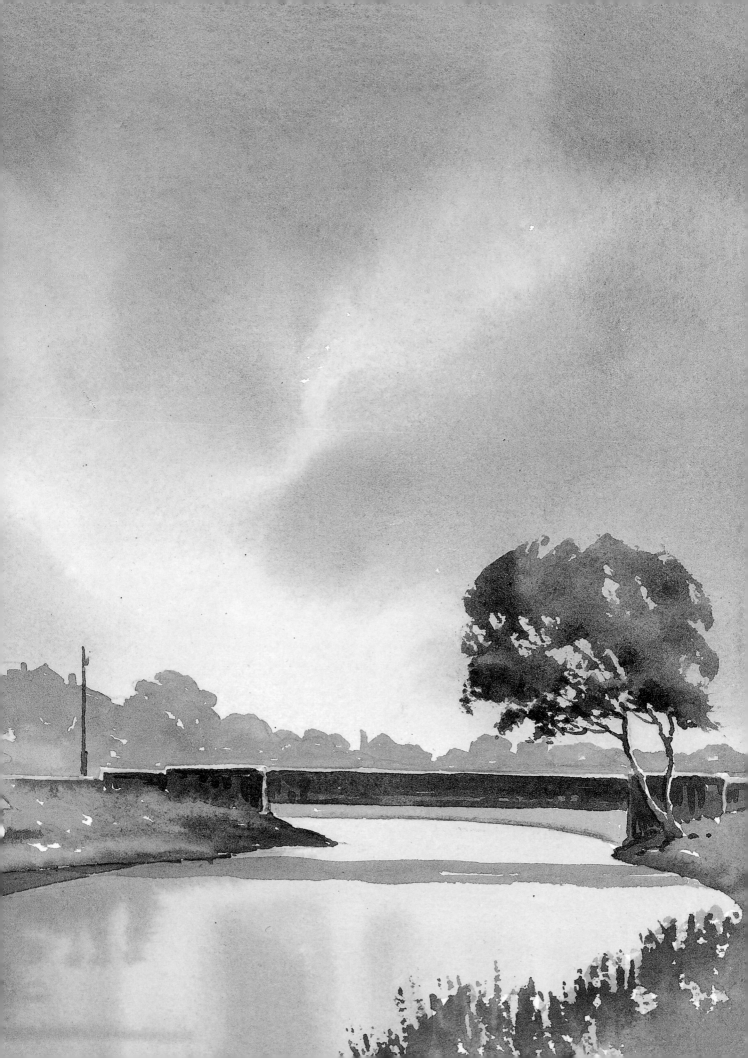

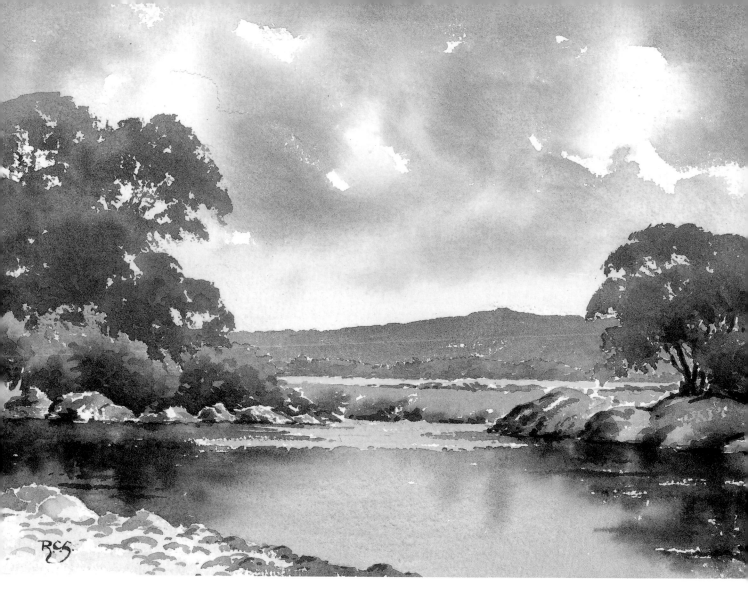

(above)

The River Dart (10¾in × 14½in)
*Here a rough-surfaced paper was used and its
roughness exploited to achieve a broken outline for
the trees and a suggestion of sparkle on the water.
Once again a soft grey was used for the distance, to
make the shoulder of moorland recede, and warmer
colour employed for the nearer features. There is
plenty of tonal contrast in the foreground, notably
between the bleached shingle in the lower left corner
of the painting and the rich browns of the tree
reflections above. The colours used were raw and
burnt sienna, ultramarine, Winsor blue and light red.*

5
Make Your Colours Glow

Pure watercolour is essentially a transparent medium, at its best when the paper is allowed to shine through to impart a beautiful freshness and clarity to the wash. This attractive freshness progressively decreases as additional washes are added and eventually dullness and muddiness make their unwelcome appearance. It is for this reason that watercolour students are always enjoined to say what they have to say in as few washes as possible – ideally in one! Another sound piece of advice is to apply colour in full, liquid washes, for colour applied with a sticky, rather dry brush never has the same clarity.

The expression 'dry brush' applied to a technique for obtaining a textured effect is something of a misnomer and is responsible for much dull work. For the best effects the brush should hold a limited amount of fairly liquid paint so that a quick stroke across the surface of a Not or rough paper will deposit colour on the little hills but leave the little depressions untouched, producing a speckled or textured effect. Because the colour is applied in fairly liquid form, it will be clear and transparent on drying, not dull and opaque as it would be if applied with too dry a brush. It takes forethought and planning to produce paintings of freshness and clarity but it is worth the effort.

As the beauty of watercolour lies in its transparency, the use of body colour should be avoided. True, there are many artists who produce splendid results with the help of opaque colour but there is a chalkiness about Chinese white highlights which cannot match the clarity of untouched paper.

In Chapter 4, the advantages of the limited palette were considered; the question now arises as to which colours to choose from the enormous number available. There are almost as many opinions on this subject as there are artists and their work is recognised not least by their characteristic palettes. To begin with, garish colours should be avoided for watercolour is at

its best when it understates. This means that the colours actually seen in nature sometimes have to be toned down to achieve a harmonious result. To cite an extreme example, if you were to try to match the brilliant blue of an overhead Mediterranean sky, pure, strong ultramarine would probably be used, and yet in practice this would look impossibly harsh. It would, therefore, be advisable to tone it down a little with, perhaps, a touch of light red and rather more water. Postcards from friends holidaying in overseas sunspots usually show skies of eye-aching blue and even though the colour may be true to life, it looks altogether too strong on such a small scale. Of course choice of colours must necessarily be influenced to some extent by subject matter. In flower painting, for example, the palette would have to contain colours capable of doing justice to the brilliant reds, purples, mauves, blues, pinks, oranges and yellows that abound in the florist's window.

My own basic palette consists of raw sienna, burnt sienna, light red, ultramarine, Winsor blue and Payne's grey, though I sometimes add to this for particular purposes. You will notice there is no green in my list. This is because, like many painters, I prefer to mix my own. Raw sienna, with a touch of Winsor blue, produces a splendid green for sunlit grass. If a still brighter green is required, perhaps for mown lawns or grazed fields, cadmium yellow may be substituted for, or added to, raw sienna. Raw sienna mixed with ultramarine produces a browner green, more akin to khaki, which is also useful for landscape work. Inexperienced painters often use made-up greens with far too much blue in them for foliage and this imparts an unreal look to their work. For those who prefer a made-up green, olive green is a good colour for foliage, though even that can usually benefit from an additional touch of yellow.

One of the painter's perennial problems is how to represent convincingly areas of glowing colour in the landscape. How can he, for example, paint a field of sunlit corn so that it really does appear to shine? There is only one solution to this problem and that is to place some darks alongside so that, by contrast, the passage in question appears luminous. If the corn is seen against a dark bank of trees or a cloud-shadowed hillside, this can create the illusion of sunlight. A similar tactic can be used to emphasise the colour of a particular passage, though in this case complementary colour rather than tonal contrast is employed. Complementary colours are, quite simply, opposites, for example red and green or blue and yellow. To emphasise the colour of a red pantiled roof, surround it with a mass of foliage, the green of which will heighten the impact of the red. The use of complementary colour to add emphasis is a technique widely employed by painters throughout the ages and is at its most effective when used with subtlety and restraint.

The most successful paintings are often those in which there is an imaginative use of colour and in which the artist has consciously sought, and found, colours above and beyond the obvious ones. A landscape in which the painter has simply reproduced uncritically the predominant greens of the countryside before him is unlikely to strike a chord or evoke much response. If, on the other hand, he has sought, and discovered, colours other than green, and has introduced and, perhaps, even exaggerated, the hints of red, orange, brown and purple that abound in the landscape, then his work will come to life. This has nothing to do with the approach of some painters who deliberately set out to distort colour by painting trees vermilion and grass ultramarine, to create a surrealist dream world of their own. So train yourself to look beyond the obvious and by studying your subject matter with imagination and insight, find colours that will breathe life into your work.

The sketches opposite show how a limited palette may be used to produce a range of colours suitable for landscape work.

Mix no 1
Here raw sienna and a little Winsor blue have been mixed to obtain a grass green. The darker green of the line of trees was put in to provide tonal contrast.

Mix no 2
The warm, dark green of the trees is a stronger blend of raw sienna, burnt sienna and Winsor blue, with a mixture of ultramarine and light red added for the shadowed areas.

Mix no 3
Light red with a little raw sienna makes a good terracotta colour for tiles. A touch of green was added to provide variety and suggest algae.

Mix no 4
Light red and ultramarine in varying proportions, produce a wide range of warm and cool greys, with a hint of purple. A strong wash, with a preponderance of light red, is used here for shadowed brickwork and tiles.

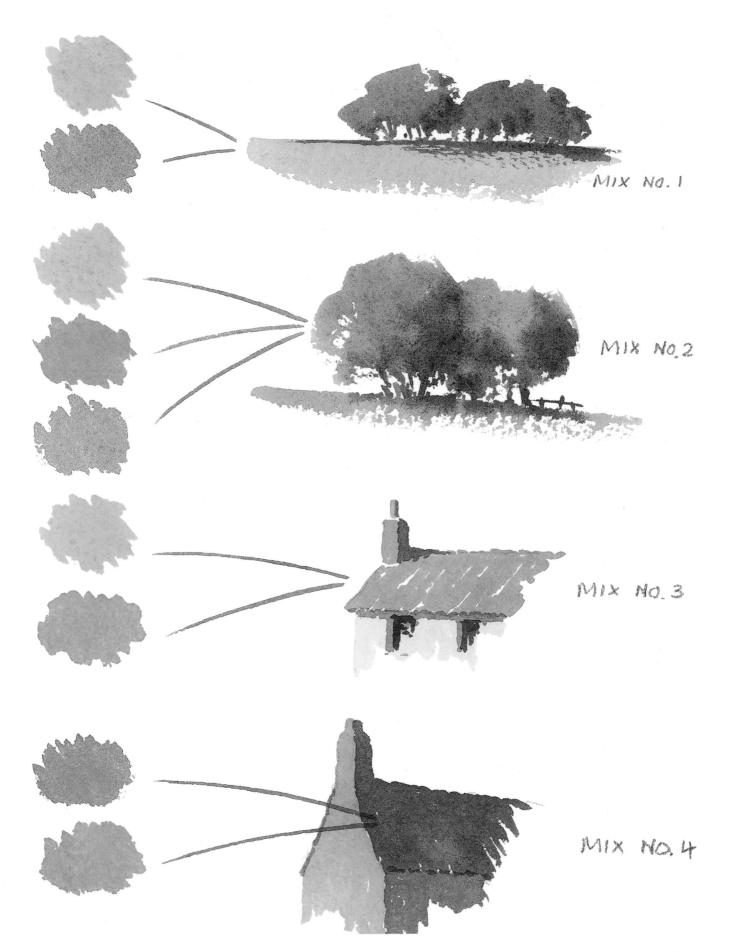

MIX No. 1

MIX No. 2

MIX No. 3

MIX No. 4

41

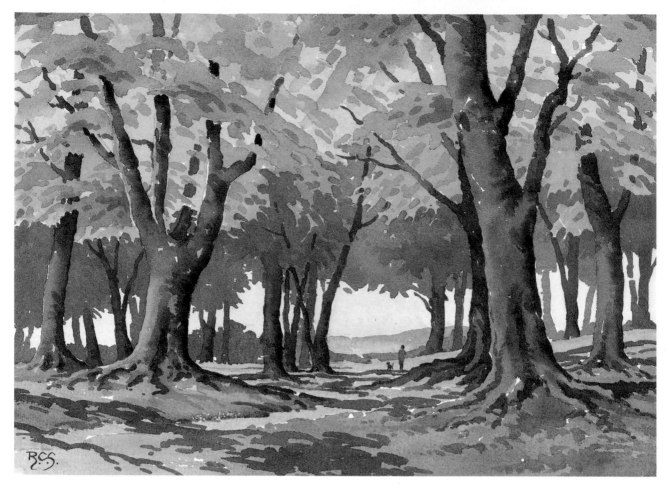

Beechwood (10¾in × 14⅝in)

Colour plays an important part in this painting. The sunlit foliage was raw sienna with just a touch of Winsor blue, the proportion of blue being increased a little for the leaves in partial shade. The more distant trees were in full shade, so still more Winsor blue was added and this was blended with a second wash of ultramarine and light red, which, much diluted, also served for the line of distant hills. The progressive 'greying' of the more distant features conveys a strong feeling of recession.

The ground, covered in dead leaves and beech mast, was indicated with a broken wash of burnt sienna, varied here and there with touches of green while the tree shadows falling over it were put in with bold washes and broken lines of ultramarine and light red. The tiny figure, strategically placed in a gap in the trees, was put in with pure light red and makes a crisp accent against the complementary green of the foliage.

(facing above)
Farmhouse, Buckland in the Moor (11in × 16⅜in)

There was a marked contrast in colour and tone between the sunlit and shadowed facets of the granite walls of these old farm buildings. A very pale wash of raw and burnt sienna with just a touch of ultramarine served for the sunlit areas and a few of the massive blocks of stone were added in various shades when the initial wash was dry. The shadowed walls were mainly ultramarine and light red, but this wash was modified here and there with raw sienna, light red and, closer to the ground, green. A few random blocks of granite were added with the same grey used for the weather-staining on the chimney stacks.

The grass was raw sienna with a little Winsor blue and a stronger wash of the same colour, plus a touch of burnt sienna, was used for the trees. The distant bank of trees on the right was put in with a wash of ultramarine and light red to which a little green was added while it was still wet. The same five basic landscape colours were used for this painting though a little alizarin crimson was added for the border flowers in front of the farmhouse.

(facing below)
The Bridge at Chioggia (10½in × 14¾in)

This painting of a canal near Venice reflects the warm light of early evening which makes the ochre and terracotta washes of the buildings glow. The colours used were various mixes of raw and burnt sienna and light red. There is rich colour, too, in the shadows and warm, reflected light can be seen in the buildings just above the bridge. Ultramarine was added for the more distant buildings to suggest recession. The colours of the buildings reappear more softly in the liquid rendering of the reflections.

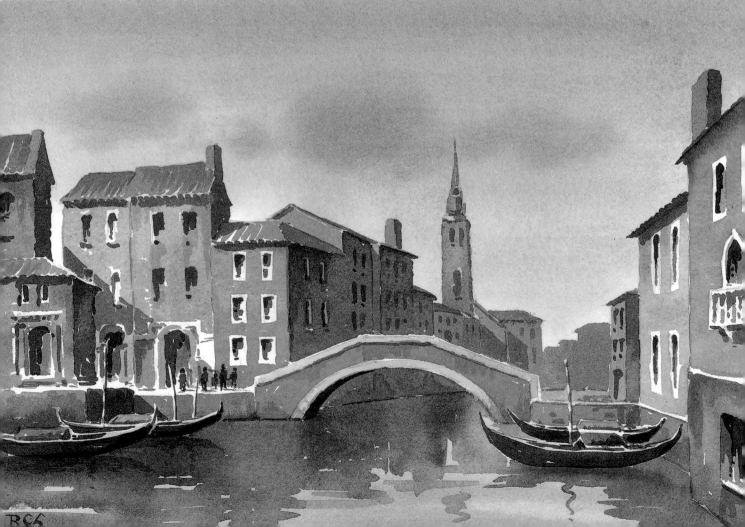

Misty Morning (11¼in × 14⅝in)

This painting illustrates two of the techniques described in Chapter 6: the variegated wash and the wet-in-wet method of painting. The outlines of the trees and banks were softened by the mist rising from the river, so hard edges would have been out of place. Speed is of the essence in a painting of this sort, for everything has to be put in before the initial wash dries to ensure a soft-edged effect – a matter of about twelve minutes in this case.

First of all, two generous washes were prepared, one of Winsor blue plus a little raw sienna, the other of pure, weak raw sienna. These were applied in horizontal sweeps of a 1in flat brush, starting at the top with the blue wash. About a quarter of the way down, the brush was dipped in the yellow wash and so a gentle gradation of colour occurred though, as planned, traces of blue still persisted. About three-quarters of the way down the process was reversed, and the brush again dipped in the blue wash.

The next problem was to indicate the broad masses of the trees, the banks and the reflections, in various combinations of raw sienna, burnt sienna and Winsor blue. By the time they were prepared, the graded wash was dry enough to receive them. In liquid washes of this sort some colour separation often occurs and the siennas bled slightly into the background wash to provide the desired halo effect. A slightly stronger wash of ultramarine and light red was used to suggest the soft areas of shadow and as still more drying had occurred, this spread rather less. An even stronger mix of these two colours was used for the tree-trunks and other dark areas. Because the graded wash had dried more and the mix was a stiff one, very little spreading occurred, but the dark accents remained soft-edged.

The success or otherwise of a painting of this type depends entirely upon correct judgment of the speed of drying.

6
Fresh Watercolour Techniques

Before we get down to the actual business of painting, there are two matters which need our careful attention. One of these concerns the angle at which our painting board should be tilted during the painting process. As with so much in watercolour, there are no hard-and-fast rules and the only yardstick is personal preference – in other words, work at the angle that suits you best. If the board is too upright, full washes are hard to control and tend to stream down the paper; if it is flat, the washes do not flow at all and tend to gather in puddles. A good compromise is about 15 degrees from the horizontal, for at this angle gravity exerts just enough, but not too much, influence. This gravitational effect which causes the washes to flow slowly down the paper, is particularly useful in the painting of skies, a topic dealt with later in the book.

The second point to be considered is the speed of drying of paint on paper, for an understanding of the drying process is vital to successful watercolour work. This is a far more complex matter than it sounds for drying time is influenced by all manner of things. Obviously, washes will dry far more quickly when the weather is hot and breezy than they will when it is still and humid, and extremes of this sort can add greatly to the painter's problems. In quick-drying conditions more water should be mixed with the paint to allow for quicker evaporation and washes should be applied even more quickly for, if they start to dry before they are completed, all sorts of difficulties can arise. It sometimes helps to dampen the paper to slow down the drying process. In the studio a hair-drier can speed up drying but the only answer to humid conditions in the field is patience. A further complication is that richer washes dry more slowly than weak ones and some colours dry more quickly than others. With growing experience, allowance for these factors becomes automatic.

Watercolour painting is firmly based on the technique of the wash, of which there are several varieties. A wash is simply a pool of paint mixed with water and applied to the paper, the proportion of water to paint determining the strength of the resulting colour. Washes are applied when large areas have to be covered and the important point to remember here is to mix a generous quantity. If the pool of paint runs out before the wash is complete, the result is usually disastrous for not only will drying have set in before a fresh supply has been mixed, but the second wash is unlikely to match the first exactly. So prepare too much rather than too little. Another point to remember is that washes fade appreciably on drying, so make due allowance for this in their preparation. A second wash can, of course, always be applied once the first is dry, to strengthen the colour, but in watercolour painting the fewer the washes the greater the clarity of the result. If a second wash has to be used, apply it quickly and deftly, so as to avoid disturbing the underpainting.

The simplest type of wash to be considered is the flat wash. It is usually applied with a series of horizontal strokes of a large flat brush. The tilt of the board causes the paint to run down and accumulate in a bead at the bottom of each stroke, but this is taken up with the next application of the recharged brush. Large areas can be covered in this way and provided the pool of liquid paint is well mixed and applied quickly and firmly, the result should be a smooth and even area of uniform colour. With some softer and more absorbent papers, the successive brush strokes may not merge together completely and may be visible after the wash has dried. Damping the paper first may prevent, or at least lessen, this effect. If the brush is too heavily loaded, the liquid may stream down the paper and spoil the evenness of the resulting wash. It is all a matter of practice!

The second type to consider is the graded wash. In this the colour of successive brushstrokes is progressively diluted by dipping the brush in water between strokes. If well carried out the result is a smooth gradation of colour from dark to light. This technique is particularly useful for clear skies and here a pale, warm wash may be used instead of clear water. This is called a variegated wash. The procedure is to prepare two

pools of liquid colour, the first for the upper part of the sky, the second for that area just above the horizon. The first could well be ultramarine, plus a little light red, the second raw sienna, also with a touch of light red. For the first two or three strokes, the brush is dipped in the ultramarine wash but thereafter it is dipped in the second wash. As the ultramarine in the brush gradually runs out and is replaced by raw sienna, so there is a gradual transition from blue to yellow on the paper. Try to avoid washes with complicated edges for these may slow you down so much that parts of the wash may start to dry before you are ready, and then you are in trouble. If, for example, you wish to paint a complicated skyline of light-toned, sunlit buildings against a dark, slaty sky, you should consider using masking fluid for the projecting towers, spires and gables so that you do not have to paint laboriously round them and can apply your sky wash with speed and panache.

While a variegated wash is still wet, it is possible to add soft cloud effects by applying a darker, slightly less liquid wash of, perhaps, grey. Here timing is particularly crucial. If the first wash is still too wet, the second will simply disperse and be virtually lost. If, on the other hand, it is beginning to dry, then the second wash will be patchy and thoroughly unsatisfactory. If the grey wash is more liquid than the original graded wash, then run-backs will occur and ruin the painting. This unwelcome phenomenon, also known as flowering or curtaining, occurs when liquid from the second wash is carried by capillary action across the surface of the paper, and when the drying process prevents it going any further, it deposits pigment in unsightly concentrations. It is sometimes possible to use run-backs to your advantage and use them to represent, perhaps, billowing clouds, but it is a chancy and unpredictable business, calling for skill, experience and luck!

In addition to the basic flat, graded and variegated wash, there are all sorts of permutations and variations with which you will become familiar as your experience grows. Bold and effective skies may be painted by applying several washes of contrasting liquid colour. One of these might represent the areas of sunlit cloud, another the cloud shadows and a third the patches of blue sky. This technique will be dealt with more fully in Chapter 9. For the present it should simply be remembered that washes may be modified while still wet, overpainted when quite dry but should be left strictly alone while they are in the process of drying. All sorts of interesting effects may be obtained by wet-in-wet painting, which is simply the adding of liquid colour to existing liquid washes, and these are especially useful for depicting misty and atmospheric subjects. It is sometimes useful to wet the paper first so that subsequent washes blend together to produce soft and mysterious effects. This is the exciting part of watercolour when the water often does the work for you and 'happy accidents' sometimes occur. The firmer, stronger rendering of foreground features can then provide telling contrast and enhance the feeling of recession.

We noted earlier that by concentrating on a limited number of colours, we really get to know them and their individual characteristics. One of these characteristics is a tendency to granulate, and this is possessed notably by ultramarine and to a lesser extent by some of the earth colours such as ochre and the umbers. Granulation simply means that the pigment tends to settle in the little hollows of the paper's surface to produce a grainy appearance. This property can be useful for representing a stretch of shingly beach or some other surface requiring a textured effect. Granulation is naturally more pronounced on rough-surfaced papers and it can be accentuated if the side of the board is tapped while the wash is still wet. Knowing how colours behave enables us to use their differing properties with advantage.

Some painters use tinted watercolour paper and there are undoubtedly occasions when, for instance, a warm-toned paper may exactly match the overall colour of the scene bathed in evening light. Far more often the tinted paper is not a good match and then an overall wash of a truer colour would be an improvement. A wash is also

King's College Chapel (13in × 11in)

The shining white limestone of this impressive medieval structure is a feature of the Cambridge skyline. Masking fluid was used to preserve its pinnacles and edges from the warm pearly grey of the variegated wash used for the autumnal sky (a pale mixture of raw sienna, light red and ultramarine, with a little more ultramarine towards the horizon). The sunlit tiles of the jumble of old roofs were varying mixtures of raw and burnt sienna and light red, with touches of green here and there to suggest moss and algae. A second, broken wash was applied to these tiled areas to provide texture and to indicate the slope of the roofs. The nearer trees were put in with washes of raw and burnt sienna and Winsor blue, and the more distant with a grey comprising ultramarine and light red, to suggest recession.

This famous chapel has been painted many times, but not, to my knowledge, from this angle. It often pays to spend a little time seeking an original viewpoint.

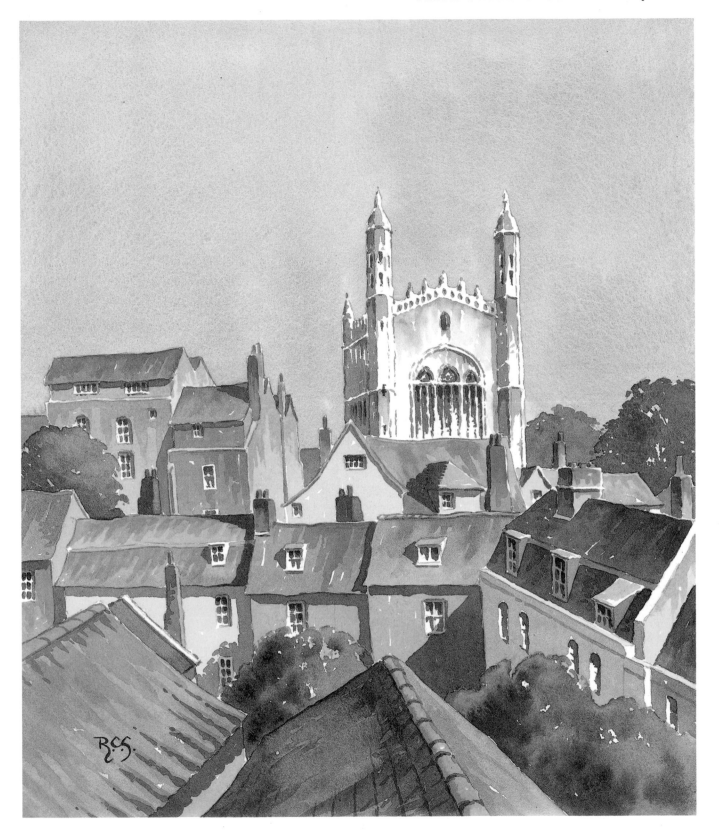

more versatile in that it can be modified to take account of local variations in the general tone and colour of the landscape. Although in broad terms it is good practice to use as few washes as possible, there are many occasions when a second, broken wash may be necessary to provide texture. Random blocks in a stone wall or weather-staining on a rendered wall are examples that spring to mind. There are a number of 'aids' to obtaining textured effects and some painters employ sprinkled salt and sand, soap, blowing straws, candle wax, leaves, fabrics and assorted ironmongery. By all means experiment with any that appeal to you, but use them with restraint and bear in mind that they are no substitute for sound painting technique.

Masking fluid and masking tape serve the useful purpose of enabling full washes to be applied without the need to paint carefully round small and intricate shapes. They can be applied both to the virgin paper and over areas already painted. Before use, always ensure that your

watercolour paper is sufficiently robust, for the dried latex can easily take surface fibres with it when removed from a soft paper. Papers vary, too, in the way they stand up to attempted alterations, and some of the hard-surfaced rag papers are surprisingly good in this respect; others are the reverse and with these any attempt to remove unwanted paint will ruin the surface. In most cases a bold, freshly painted error is preferable to a muddy, laboured correction and any attempt to remove paint from a pale passage such as a sky, is almost certain to be unsatisfactory. We have already noted that a bristle brush of the type used for oil painting is a useful tool for removing paint from a hard-surfaced paper, but care and patience must be exercised. Exact shapes can be removed with the help of masking tape: if, for instance, a triangle is cut in a length of tape which is then positioned and pressed down on the painting surface, a bristle brush will enable a white sail to appear against a darker sea. But work away from the tape,

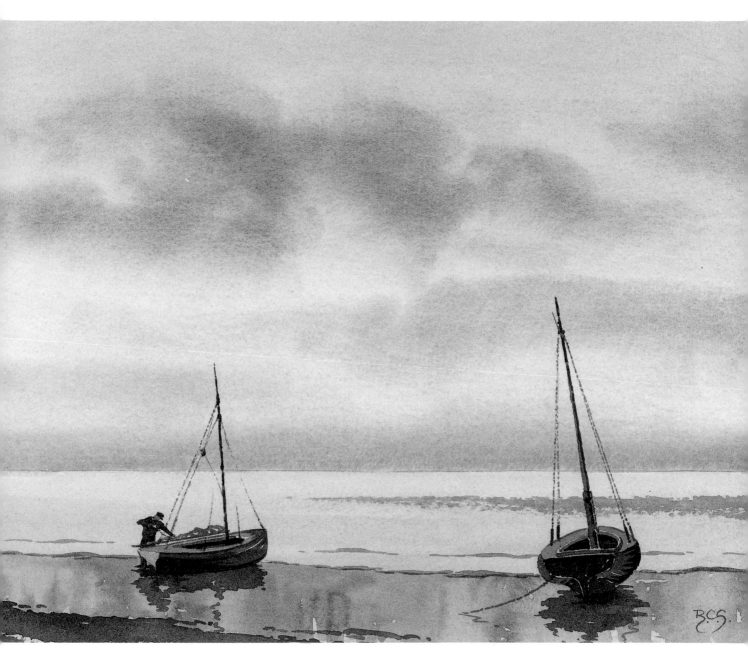

towards the centre of the triangle, or a ragged edge may result.

Constantly bear in mind that freshness and feeling are far more important than exactness and accuracy. Watercolour is at its best when it looks quick and spontaneous but this demands careful planning. Many painters fail because they experiment on their paper and consequently have to make many alterations and adjustments. If, instead, they thought their next step through, decided exactly what it entailed and then applied the required wash boldly, the result might not turn out precisely as planned, but it would be a vast improvement on a tired and overworked alternative.

Summer Evening, Norfolk (10¾in × 15in)
The sky was a pale variegated wash, Winsor blue and raw sienna at the top merging into raw sienna and a little light red above the horizon. While this was still wet, the soft-edged clouds were put in with a warm mixture of ultramarine and light red. The beached boats, the figure and the foreground sand were painted strongly to provide contrast with the pale sea and sky and emphasise their luminosity.

7

Demonstration

Plockton, Wester Ross (10¾in × 14¾in)
This group of white-washed buildings, on their little spit of land, stick out into a Scottish loch to provide a perfect natural composition. The light tone of the cottages made a crisp accent against the lowering, hump-backed hill beyond and the sunlit mountain towards the right contrasted pleasantly in tone and colour with its neighbours. The surface of the loch was ruffled by a gentle breeze so reflections were much reduced, particularly in the distance, where the two pale horizontal strips indicate the presence of stronger gusts of wind. The dark cliff on the right and the cloud shadows above help to balance the main weight of the composition, on the left.

Stage 1 It is often useful to make several quick sketches to find the best viewpoint. We will assume this is a full-size drawing of the most promising of the exploratory sketches. Until you are confident of your ability to capture a scene direct with the brush, a little careful drawing with a 2B pencil will ensure you get the composition you want. To aid reproduction, the pencil lines shown here are stronger than usual.

Study the sky – not for too long, or it will change – and decide how you will simplify it. Most cloudy skies are too complex for comfort and too many fiddly clouds would compete with the scene below instead of complementing it. Mix three full washes: the first of almost pure water with just a touch of raw sienna for the sunlit clouds, the second of ultramarine and light red

for the cloud shadows and the third of pale ultramarine, with the merest suggestion of light red to dull it, for the misty sky beyond. Now establish the areas of sunlit cloud, bearing in mind that the light is coming from the left, and continue this almost colourless wash down to the water line, to avoid any unwanted hard edges. Then put in the cloud shadows letting them blend with the first wash and finally paint in the area of misty blue sky at top left, where a hard edge will provide some contrast.

Stage 2 Use varying tones of ultramarine and light red for the distant mountains and the shadowed areas of the nearer mountains and a pale mix of raw and burnt sienna for the distant sunlit mountainside. Drop in a little green here and there to vary the colours of the nearer slopes. Use a strong but fairly liquid wash for the hump-backed hill to ensure drying does not begin until you have finished painting around the rather complicated outlines of the buildings. If you have any doubts about your speed of working, you could use masking fluid for the chimneys and rooftops to enable you to apply the wash with greater speed. Make quite sure everything is dry before removing the masking fluid; even when the surrounding paper is dry, a tiny bead or two of wet paint sometimes remains on the impervious latex and if not spotted can cause trouble. Now begin to paint in the cottages in pale tones so that they will still register boldly against the dark hillside beyond.

50

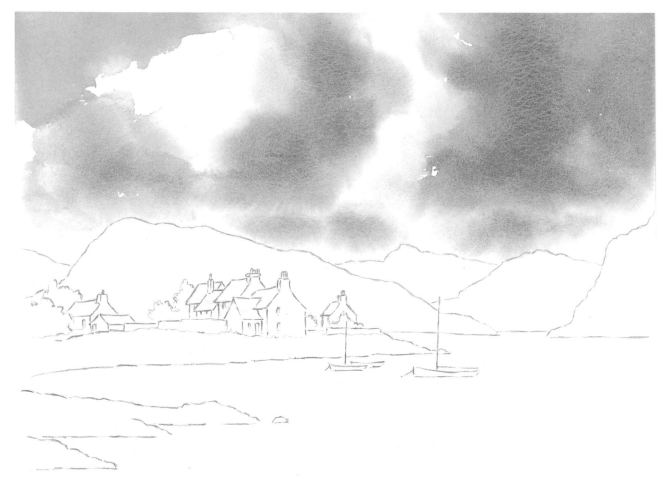

Stage 1 (above)

Stage 2 (below)

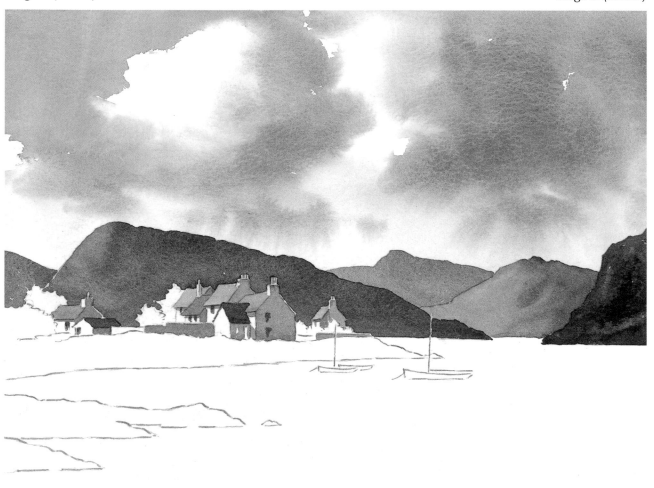

Stage 3 Continue painting in the cottages, paying careful attention to the shadows, using ultramarine and light red, with a touch of burnt sienna for the reflected light. Put in the trees and bushes with raw sienna and a little Winsor blue and add burnt sienna here and there for contrast and variety. Use a paler wash of the same green for the grassy area and when this is dry, add texture with a darker mix to indicate its rough surface.

Paint the water of the loch with a very pale wash of ultramarine and light red, using quick,

horizontal strokes of a large brush and leaving two narrow bands of white paper to indicate the distant wind-ruffled areas. If you sweep your brush quickly over the paper, you will leave flecks of white paper which will suggest sunlight sparkling on the water. While this wash is still damp, add a few soft vertical reflections, using very pale versions of the colours above. It only remains to paint in the boats and foreground rocks in strong colours so that they stand out boldly against the pale water, and add their reflections.

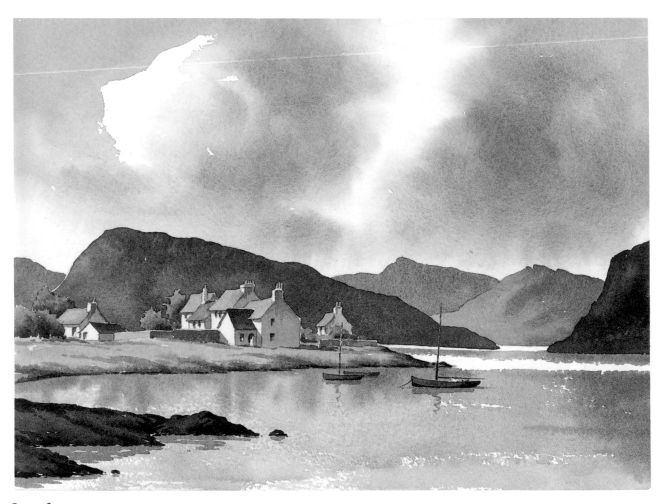

Stage 3

8
Light on the Landscape

The best-loved paintings are often those in which the artist has succeeded in capturing the effects of light, bringing life and a touch of magic to his work. The scenes which appeal to us most strongly as subjects are frequently those in which light plays an important or even dominant part. Light is the touchstone that gives a drab landscape radiance and a flat scene form and shape. It brings vibrancy to colour and, in reflected form, richness and depth to shadows. Turner was obsessed with light and spent his life trying to capture its elusive qualities in oil and watercolour. The French Impressionists rejected the drab palette of the artistic establishment and gloried in the prismatic colours of light to brilliant effect.

Artists cannot make their paintings emit light but, by knowledge and skill, they can create the illusion of radiance. How do they do it? The answer is by the clever use of tone and tonal contrast. If a light passage is surrounded by a much darker area, it will appear to shine by contrast. The watercolourist, by using clear, transparent washes, can let the paper shine through to create an impression of light. It is for this reason that students are always urged to make a thorough study of tone and to work out their tonal values with great care before committing brush to paper. Not only does tonal contrast help to suggest light; it also gives shape and form to the objects or scenes on which it falls.

Preliminary tonal studies are an excellent means of resolving, in advance, the problems of light and shade and, in addition, of assisting in the development of tonal judgment. In this context it is a good plan to ignore what you know of the local tone and colour of your subject and assess it objectively, which is not always as easy as it sounds. You may know the glazing bars of a window are white, but seen against a luminous sky they appear dark grey, and this is how they have to be painted. Students are sometimes advised to forget what their subject is, ignore what they already know about it and simply treat it as a mass of varying tones, shapes and colours. If they succeed, their work will be truer to life and may well be more effective and exciting.

Photographers, by controlling the amount of light that enters their cameras, can vary the tone of their subjects, to create mood and atmosphere. Artists can do much the same by raising or lowering the tone of their paintings, taking care that the relative tone values remain correct. Turner's watercolours of Venice are a case in point: by raising the tone of the scene before him, he created the illusion of light flooding the landscape. Lowering tone, to create a sombre mood, must be done with care, restraint and an understanding of the limitations of the watercolour medium. If used too strongly and heavily, it can easily appear dull and muddy and so lose its principal appeal.

One of the ways of focussing attention upon the centre of interest of a landscape is by bathing that part of it in light and by lowering the tone of less important areas. If the foreground were painted as though in deep shadow, the eye would quickly pass beyond it to the area of radiance. A brightly lit scene viewed through a shadowed doorway or window also commands immediate attention. These are both examples of playing lights against darks to good effect.

The sky is normally the lightest part of the landscape and here careful evaluation of tone is vital. If allowance is not made for the fading that occurs on drying, it could well finish up looking pallid, and if the rest of the painting is in tonal harmony, the end result will be weak and wishy-washy. If, at the other extreme, the deep tones of a stormy sky are overdone, there is insufficient in reserve for the still darker tones of the landscape below. So get all the practice and experience you can in assessing light values and judging tone, for competence will pay rich dividends in the future.

There are occasions when the sky is perceptibly deeper in tone than the landscape beneath, and this phenomenon can be used to powerful effect. A sombre sky can, by contrast, add brilliance to fresh snow and to shining water, while a sun-drenched landscape can create a dramatic counterchange against a stormy, grey sky. Such contrasts are a gift to the perceptive painter who will take full advantage of them.

Light can be used effectively in urban landscapes. An industrial skyline against a warm band of light above the horizon, and city lights reflected in wet streets are just two possibilities that spring to mind. A keen eye and a lively imagination will discover many more.

Light is often at its most subtle and intriguing in misty conditions and here the watercolour medium can be both sensitive and expressive. Mist has the effect of softening outlines, greying colours and reducing tonal contrast. Wet-in-wet techniques can soften edges and suggest slight gradations of tone. It is a mistake to assume, uncritically, that mist is a uniform, pale grey – the enquiring eye will usually discover a range of soft, pearly colours as well.

Light has an immense influence on colour and without it colours cease to exist. The strength of the light and its temperature both modify the colours on which it falls. The Impressionists were preoccupied with glowing colour and often broke it down into its constituent parts, building up their sparkling effects with dabs of brilliant paint. In its purest form this technique was known as Pointillism and its most enthusiastic advocate was Seurat. As explained earlier in the book, colours

Evening, Fowey Estuary (10¾in × 15¾in)
Sunsets change with daunting rapidity and speed is essential if their fleeting effects are to be captured in paint. The feature of this particular sunset was the area of radiance just above the horizon from which the warm-coloured clouds seemed to radiate. This was put in first with pure water just tinged with raw sienna, and the clouds were added, wet in wet, with previously prepared washes of light red and ultramarine, and burnt sienna and ultramarine. From both these washes the warm colours separated a little on the wet surface, as intended, and more ultramarine was then added towards the edges of the paper. The sky washes were carried roughly two-thirds the way down the paper, leaving a hard but broken edge to represent the upper margin of the water. While the sky was still damp the distant landforms were put in with a wash of ultramarine and light red, plus, on the right, a little Payne's grey, to produce a soft-edged effect. Care was taken to ensure these washes were not too wet, for if they had been, unsightly run-backs, or flowering, would have occurred (see Chapter 6). The painting was then left to dry.

The water was put in next with two large brushes, one containing pale raw sienna, the other ultramarine and light red. Quick horizontal sweeps left broken lines of white paper to represent light sparkling on the surface. Once this was dry, the two cloud shadows were added with a slightly darker mix of the second wash.

Finally the boats and foreground were painted with strong mixtures of burnt sienna, light red and ultramarine. Notice how the nearer boats are placed against the light patch of sky and how their deep tones help to make it shine by contrast.

Even though the whole painting took less than half an hour, the light was fading fast and the painting was completed in semi-darkness.

Break in the Clouds, Wharfedale (8¾in × 13¼in)
A sudden burst of sunlight through a gap in heavy cloud cover can create a dramatic landscape subject. Here the middle distance is brilliantly lit while the far horizon and the foreground remain in deep shadow. The light also catches the walls and roofs of the farm buildings and these contrast strongly with the surrounding areas of shadow. The sky and the area of radiance were painted, wet in wet, with a wash of palest raw sienna and another of ultramarine and light red. Here again some colour separation has occurred, to give variety to the clouds. The distant mountains were a darker mix of the second wash and the foreground was painted strongly in various combinations of raw and burnt sienna and ultramarine.

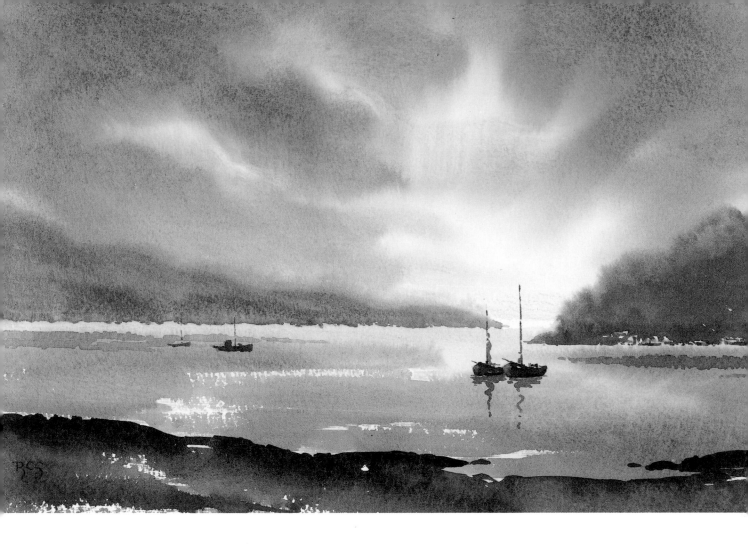

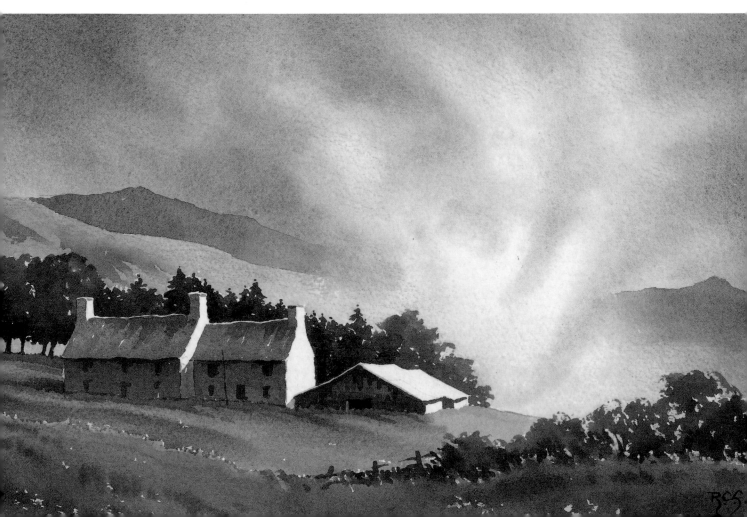

can be given added brilliance and impact by placing complementary colours against them.

Inexperienced painters frequently fail to study shadows in sufficient depth and are content to ascribe to them an all-over, flat grey. Just as the grey of the mist merits careful analysis, so the colours of shadows call for thorough investigation. Careful study will reveal all sorts of unsuspected colours and doing justice to them will bring shadows to vibrant life. This is particularly true when shadows are modified by reflected light, as, for example, when the shaded side of a street is warmed by light reflected from the sunlit buildings opposite. So ignore preconceived ideas and conventions, analyse tone and colour objectively and paint what you see with confidence and conviction. Light, in all its forms, is the key to it all.

First Snowfall (10in × 14⅝in)
On rare occasions the sky appears deeper in tone than the land below it but when snow has fallen this tonal inversion is the norm. The problem then is to emphasise the whiteness of the snow and this is done by painting the sky several tones darker. In this painting the snow is represented by the white of the paper except where a blue/grey has been used for the shadows. The lively, cloudy sky was painted in one go with a wash of ultramarine and light red and another of Payne's grey. Chips of white paper were allowed to remain to suggest highlights in the clouds and the use of both hard and soft edges gives interest and variety. The far hills were put in while the sky was still damp, and some controlled flowering suggests the ragged outline of distant coniferous woodland. The line of hedge was mainly dry-brush work and both the hedge and the man and his dog were painted in deep tones to provide contrast with the snow and make it shine.

(below)
The Weald of Kent from Chartwell
(9½in × 14½in)
Painting into the light can produce interesting effects. In this view over the clipped yew hedges of Chartwell, the back-lighting gives the trees haloes of radiance which contrast with the deeper tones of the shadowed foliage beyond. The effect of bright sunshine is suggested by the strong tonal contrast between the areas of light and shade, notably on the group of buildings which, incidentally, housed Sir Winston Churchill's studio.

Norfolk Creek (9¾in × 15⅛in)
Another simple painting, entirely concerned with light. Here the pale patch of sky and the light bands of water below are just the white of the paper and these contrast with the grey of the sky which is slightly warmed with light red just above the horizon. The darker, soft-edged clouds were dropped in while the first wash was still damp. The distant land forms of Gun Point and Scolt Head are grey silhouettes of ultramarine and light red. White paper also served for the sides and top edges of the two boats, to make a crisp note against the darker background.

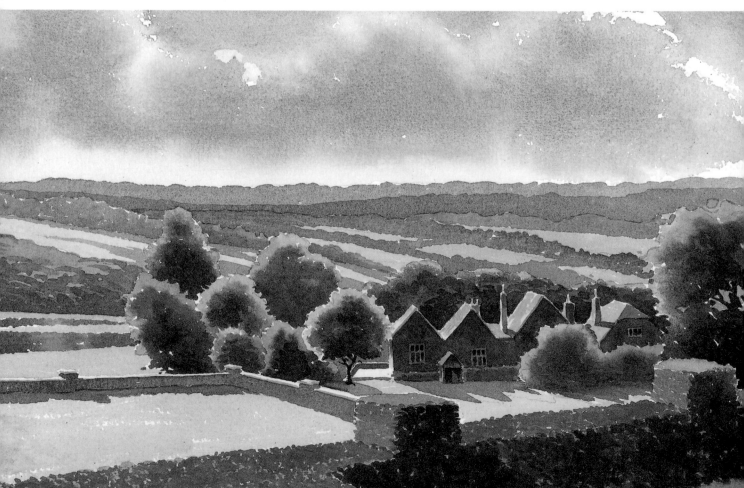

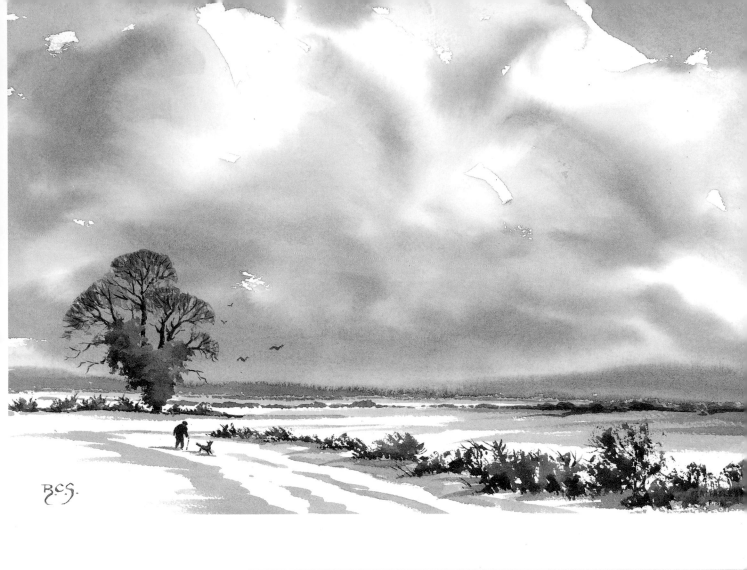

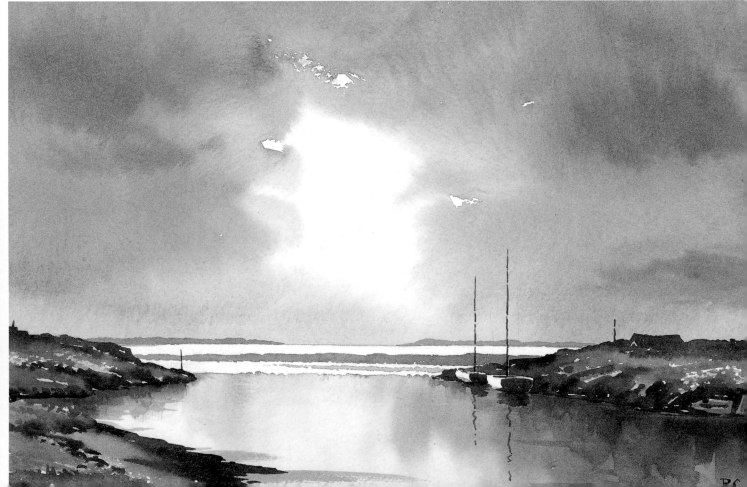

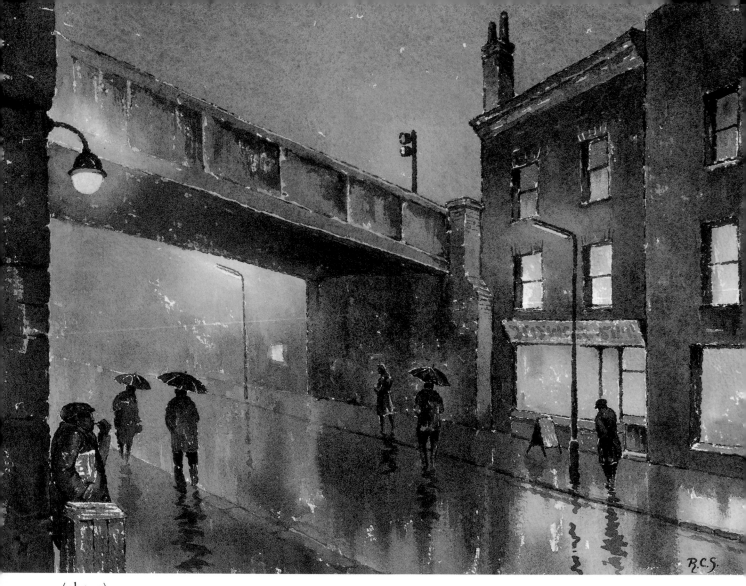

(above)
Railway Viaduct (10⅞in × 14¼in)
Street lights, lighted windows and their reflections in the wet street provide the only illumination in this painting of a foggy, drizzly urban scene. In the misty atmosphere the street lights produce a halo effect against the murky background. The dark figures stand out here and there against lighter areas. The only colours used were various combinations of raw and burnt sienna, light red and ultramarine and because of this the painting hangs together effectively. Despite the sombre mood there is plenty of tonal contrast.

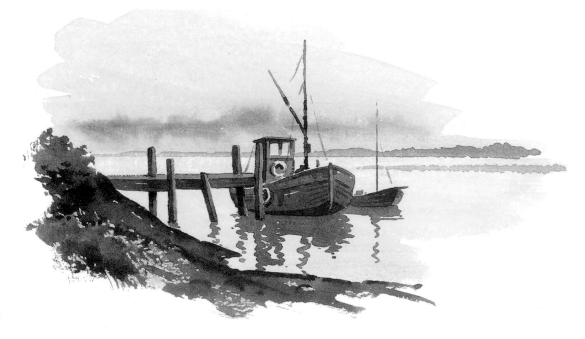

9
Reach for the Sky

Why is it that so many amateur painters fail to do full justice to their skies? Some seem to regard them as a necessary but troublesome background that has to be put in before they can get down to the more interesting bits of the landscape. Others stick to safe, graded washes because they have despaired of painting convincing-looking clouds. Even those who conscientiously try to get to grips with the problem often interpret too literally, put in far too much detail and in the process lose all life and freshness. Such failures are particularly unfortunate for the watercolourist because his medium, imaginatively used, is ideally suited to the painting of skies. Its clarity and freshness help to preserve essential luminosity and its speed of application makes it the ideal medium for capturing their fleeting changes of pattern and form.

In watercolour it is necessary to work fast and use plenty of water to achieve fresh and lively skies and this means that complex cloudscapes have to be much simplified. The meticulous portrayal of masses of tiny cloud shapes results in over-complication and a tired, over-worked

painting. It is far better to take your courage in both hands, employ a bold, watery technique and aim for strength and luminosity. A strong and dramatic sky can transform a painting and add enormously to its impact.

Skies are normally painted first for two main reasons. For one thing they are usually the lightest part of the scene and in watercolour it is best to paint from light to dark; for another, the sky exerts a vital influence over the rest of the landscape, and once it is established, the artist has a much better idea of how to treat the rest of the painting. A warm glow in the sky is reflected in the scene below and greatly increases the strength of the warm colours while an azure sky strengthens the blues of the shadows and of the far distance. This profound effect upon colour affects water even more strongly than land, as you would expect.

The placing of the horizon on the paper will depend to a large extent upon the nature of the sky. A strong, impressive sky merits plenty of space and this suggests a low horizon, perhaps

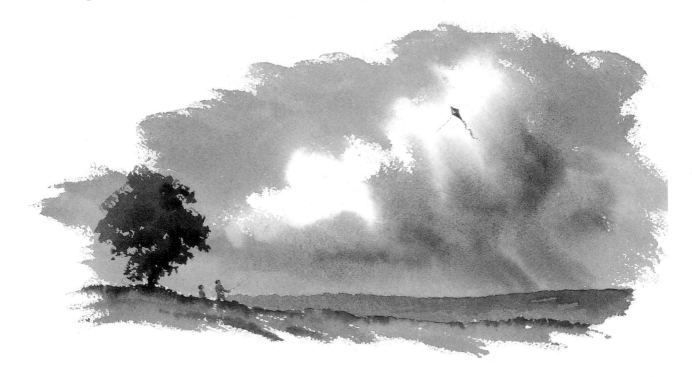

only a third or even a quarter of the way up the paper. If, on the other hand, the main interest is in the land, then a high horizon will be the answer and the sky will then play a secondary role. It is worth remembering that clouds and cloud shadows can be used to achieve tonal balance in a painting, a useful tip in a situation where most of the tonal weight occurs on one side of your chosen subject. Clouds are just as much a part of the composition as anything else and, if dominant, need careful positioning.

The most straightforward type of sky is the cloudless variety and this simply requires a variegated wash of the appropriate colours (the technique of the variegated wash is described in Chapter 6). Selecting the right colours is of the greatest importance and should be given careful thought. However brilliant the colour of the upper sky, an unmodified blue, straight from the tube, is likely to look too garish and ultramarine with a touch of light red is, for example, more pleasing in a watercolour painting than the pure

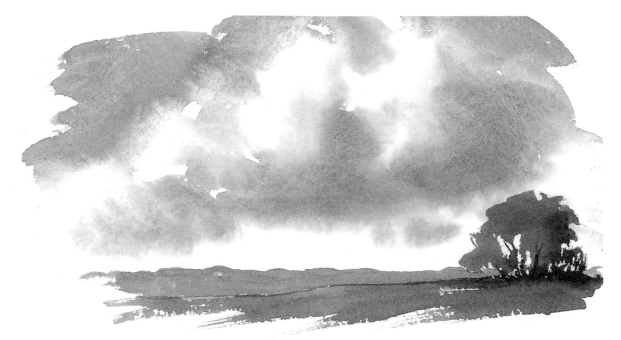

Cumulus.

Stratus.

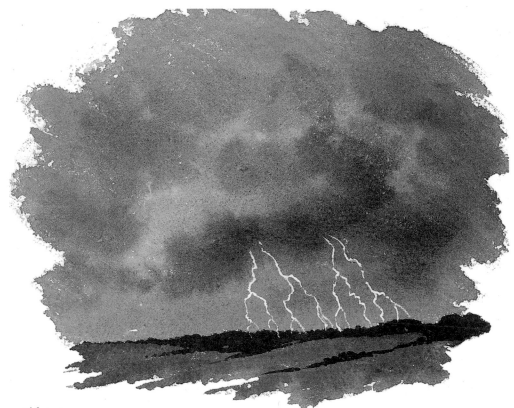

Nimbus

blue. The lower sky is seen through a much greater thickness of atmosphere and this has the effect of warming and softening its colour. Always remember to prepare washes strong enough to allow for the fading that inevitably accompanies drying.

You may wish to add a few clouds to your clear sky. If they are to be hard edged and darker than your variegated wash, you can safely wait until the paper is dry and simply paint them over that wash. If they are lighter in tone, you will have to paint your wash round them, blending the margins with clear water if you want them to appear soft edged. You can achieve the effect of darker, soft-edged clouds by dropping in greyish paint while the underlaying wash is still wet (the wet-in-wet technique) and here timing is all important. If the underwash is still too wet, the added paint will simply disperse into it, but if it has dried too much some hard edges and the unsightly effects caused by uneven drying will result.

There are four basic types of cloud and some knowledge and understanding of them is helpful to the painter:

Cumulus These are the full, rounded, billowing clouds with flat bases, the most paintable of them all.

Cirrus These are the high-level, fleecy-white clouds composed of frozen particles of moisture. Because of the strength of the wind at great altitudes they often seem to stream across the sky and in this form are known as mares' tails.

Stratus This is the term for the level cloud layers that may cover part of the sky or the whole of it.

Nimbus These are the ragged, shapeless storm clouds that usually presage bad weather. They are normally heavy and dark and can add drama to a painting.

Naturally, these classifications are not clear cut and there are often such combinations as cumulo-nimbus and cirro-stratus. There are occasions, too, when several of these cloud types are present at the same time. Another point to remember is that the laws of perspective apply just as firmly, if less precisely, in the sky as they do on the ground, particularly when the clouds in question are in fairly regular, serried ranks.

Once you have mentally simplified the cloud pattern before you, and reduced it to manageable terms, you have to decide upon the colours to be used, and prepare generous washes of each. Sunlit

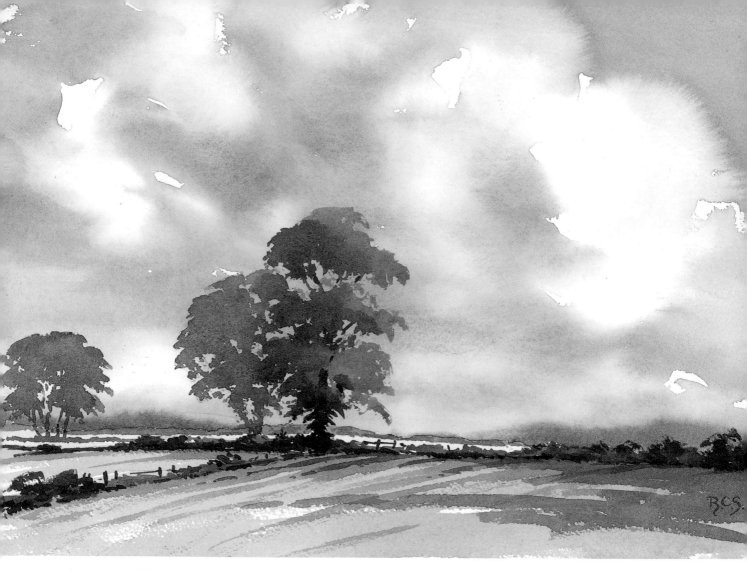

Autumn Fields (10½in × 14½in)

The clouds in this lively sky were a mixture of cumulus and nimbus and were painted at speed with a rich wash of ultramarine and light red and another of Payne's grey plus plenty of water. The billowing clouds at the top right were the result of flowering, as clear water was dropped on to the drying background wash.

The line of distant, blue-grey hills was painted while the sky wash was still damp, to achieve the desired soft-edged effect. The progressive greying of the trees conveys a feeling of recession. The broad treatment of the foreground fields does not attract undue attention as a more meticulous rendering would have done.

clouds may appear white, but there is usually a trace of warmth and the merest touch of raw sienna in the wash will produce this. Cloud shadows vary greatly in tone and colour. An excellent grey, with a hint of purple, may be made from ultramarine and light red, and this can be warmed or cooled by varying the proportions of these colours. Ultramarine and burnt sienna produce a cooler, softer grey. The same blue, slightly tamed by a touch of light red, is excellent for overhead skies, but has to be progressively softened and warmed as the horizon is approached. Once your washes are prepared, apply them boldly, using a separate large brush for each, allowing some blending to take place but preserving some hard edges to provide contrast. There are, of course, no hard-and-fast rules about this and some painters prefer the overall softness which results from wetting the paper first and allowing merging of washes to occur over the whole sky area. It is all a matter of personal taste. Some control of the washes will be necessary once they have been applied, to produce the effect you want, but the less manipulation and modification they receive, the fresher the final result will be.

Sunsets have a powerful attraction for artists and, in fact, for all who have feeling for colour, but they are fraught with difficulty. However faithfully you try to match the colours you see before you, they have a way of looking gaudy on your watercolour paper. This is especially true of multicoloured sunsets with their brilliant pinks, purples, reds, greens, oranges and yellows. It is usually safer to confine yourself to those in which related colours predominate and avoid those which show all the colours of the rainbow. This does not mean you should play for safety in your painting of skies; on the contrary you should always be alert to such wonderful natural phenomena as areas of radiance and slanting shafts of sunlight seen against dark cloud formations, the dramatic contrast of sunlit landscapes against stormy skies and the magic of mist. All this, and much more, is there for you to capture, once you have acquired the skill to do it justice. A sketchbook kept handy for quick watercolour impressions of any skies that appeal to you will help you on your way.

The Pool of London (7¼in × 10¾in)
In this quick impression of the Thames, the sky was a full wash of ultramarine, light red and a little raw sienna, the proportion of blue being increased as the horizon was approached, to indicate the misty, smoky atmosphere. The cloud shapes were a darker version of the same wash and were added when the background wash was dry. A dragged-brush technique was used to give the impression of light shining on the water and this was helped by the rough textured surface of the paper. The successive lightening of the tones, from the foreground, via the middle distance, to the background suggests recession.

(overleaf)
Farm near Lechlade (10¾in × 14¾in)
A sunlit landscape against a dark and threatening sky can create a dramatic effect. Here the tonal contrasts have been deliberately exaggerated to heighten this effect. A painting of this type depends heavily upon tonal values and these should be worked out in advance with the aid of a preliminary sketch or tone study.

63

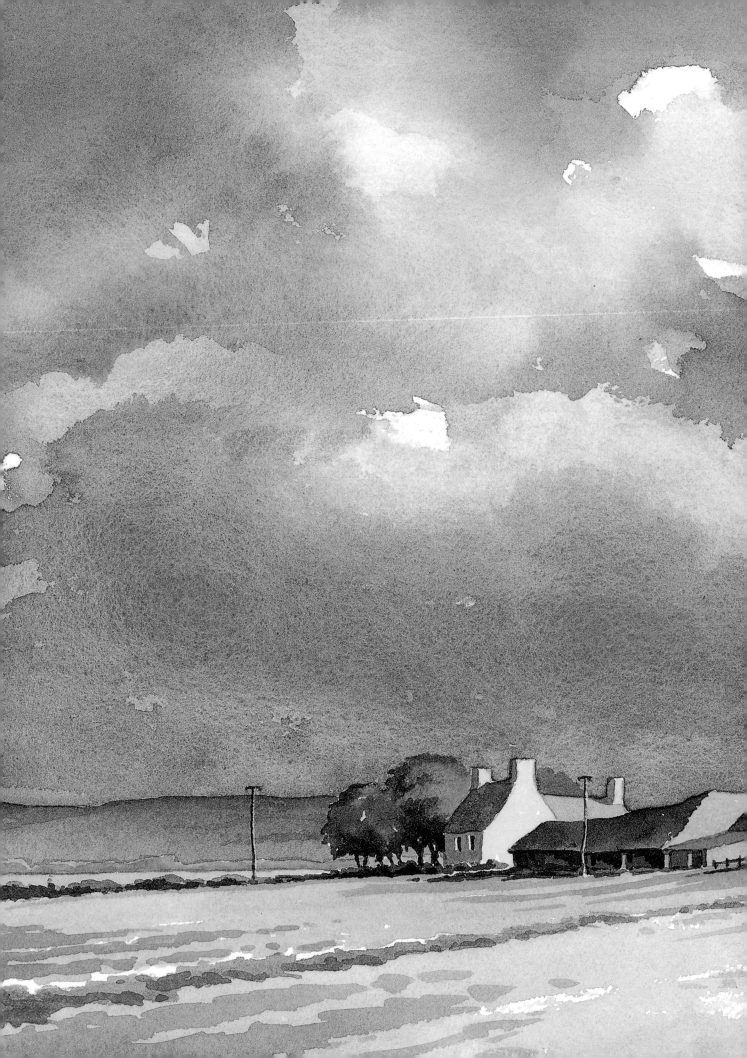

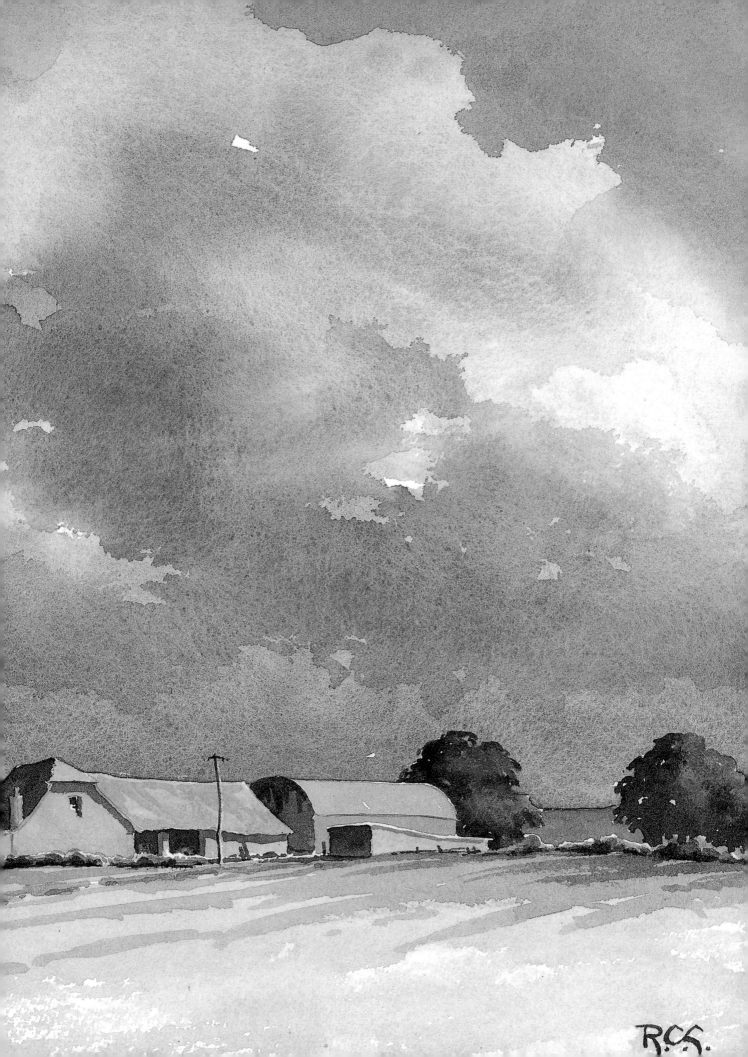

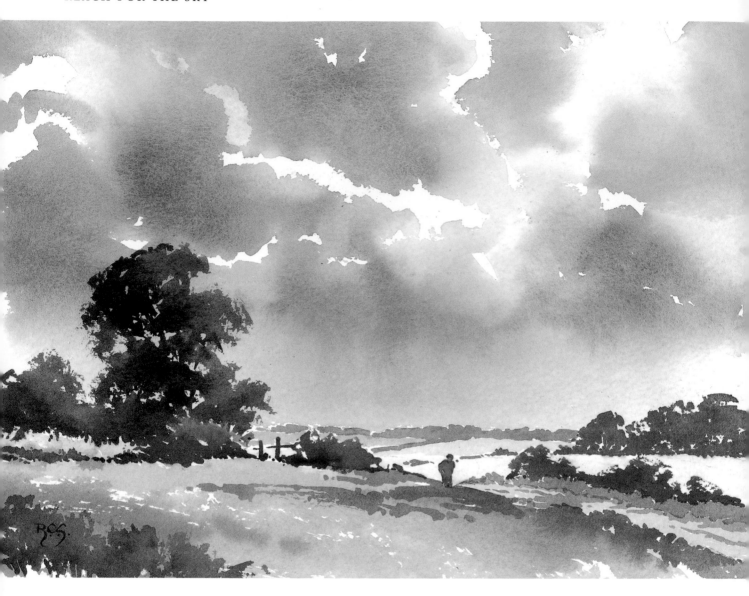

The Pilgrim's Way (10½in × 14½in)
This ancient route to Canterbury winds its way across the windswept downs beneath a lively sky. The loose treatment of the clouds suggests their form and movement while the combination of hard and soft edges lends variety and interest to the sky. Burnt sienna and light red, in varying proportions, were mixed with ultramarine to produce the warm and cool greys of the cloud shadows. The highlights were simply the unpainted white of the paper.

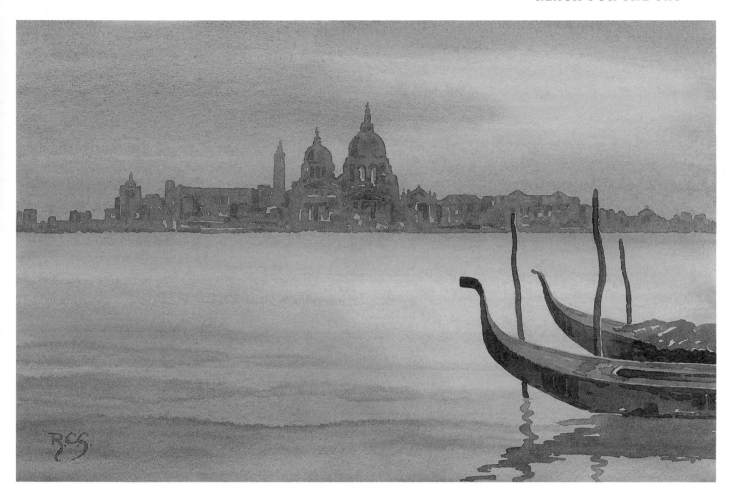

The Grand Canal (1) (8³⁄₈in × 13in)
This simple rendering of a Venetian sunset illustrates two of the points made in the text. Firstly, the sky colours are closely related and, though strong, do not create the garish effect of a mass of disparate, competing colours. Secondly, there is an area of subdued radiance in both sky and water towards the right of the painting and this is accentuated by the dark tones of the distant buildings and the still darker tones of the foreground gondolas and mooring posts.

10
Of Trees and Foliage

There is no doubt about it, trees are the main stumbling block to good landscape painting. Aspiring artists who can produce splendid farm buildings and barns often fall down badly when tackling trees. This is particularly unfortunate for trees are a vital part of the rural scene.

Beginners frequently start by trying to paint every leaf and twig – a method that is almost bound to lead to tired, overworked paintings. Even when they have abandoned this approach, their results are often unconvincing and disappointing. In this chapter the principal problems will be tackled and practical solutions suggested.

When small children paint trees they often represent them as green spheres resting on brown cones and to them these Toytown images are recognisable and perfectly satisfactory conventions. It is when the painter begins to look more closely and searchingly that problems really start. Trees are extremely complex objects and their very complexity poses problems for the painter; and yet close observation must be the starting point.

Failure to paint convincing trees usually stems from a lack of understanding of their underlying structure. This can be overcome by going out into the countryside in winter and conscientiously sketching the bare branches and trunks of trees of all shapes and sizes. Observe how the branches are joined to the trunk and how they taper towards their ends. Notice, too, how some branches come towards you while others go away – they are not all laterals as often painted by the inexperienced! The basic knowledge of arboreal anatomy that you will acquire will help you enormously to paint trees in full leaf.

The next problem, which we have already touched on, is the amount of detail to include. This will vary, depending on how near or far the trees in question are to the painter. At one extreme, a bank of trees close to the horizon may well be put in with a single stroke of the brush for at that distance detail and tonal difference will be lost and only a flat shape in grey silhouette will emerge. Middle distance trees will reveal more of their individual shapes, and differences in tone between sunlit and shaded areas will become more apparent. Foreground trees will, of course, show the most detail and the greatest difference between lights and darks. In varying the amount of detail and tone in this way you will also achieve a feeling of recession and this must be reinforced by increasing the soft grey-blue colour content of the trees as they recede into the distance.

In this discussion of the amount of detail required, no mention has been made of how it may best be suggested in watercolour. The answer is to school yourself to see trees as masses of tone and colour. If you screw up your eyes, detail is lost and foliage resolves itself into adjacent areas of light and shade. It is these areas that should be analysed for tone and colour and painted quickly and boldly with pre-mixed washes. They will not be clear cut, probably merging at their margins, and this effect may be obtained by allowing the adjacent washes to blend. In most trees there are 'sky holes', or gaps in the foliage through which the sky can be glimpsed, and these should be indicated, in simplified form, in your painting. It is through these gaps that trunks and branches are often seen. At all costs avoid superimposing a complete system of trunk and branches on top of the green of the foliage!

The outline of the typical tree, made up of thousands of twigs and leaf clusters, is a very broken and ragged affair and the problem is to achieve this effect without resorting to numerous little dabs of paint, which always look repetitious and laboured. One way is to hold the brush containing the green wash almost parallel to the paper, so that its side makes contact with the little hills in the paper's surface but misses the little hollows. The use of a rough-surfaced paper obviously assists this technique. The resulting rough outline has an unlaboured and unforced look about it and in watercolour the more spontaneous the effect the better. If all the foliage is painted in this way, with one wash, the outline may be perfectly satisfactory, but the tree will look somewhat flat, almost like a cut-out. To

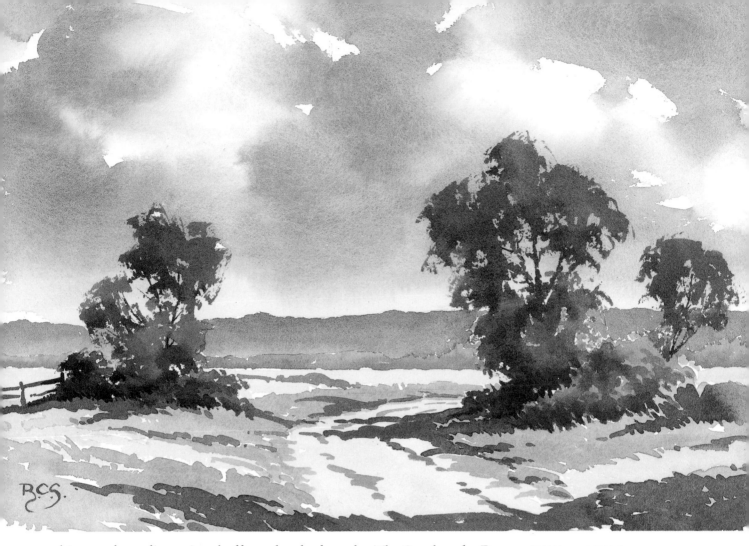

achieve a three-dimensional effect, the shadowed side of the tree and the undersides of the main branches should be painted in a deeper-toned wash, and the two washes allowed to merge. As you become more proficient, you may well employ more washes in this manner to deal with further colour variations that you have identified.

There are far more colours in foliage than beginners generally realise. Too often they content themselves with an overall green wash and their shadowed areas are just a deeper tone of the same green. In high summer, it is true, green is a very persistent colour in the rural landscape, but there *are* other colours and it is vitally important to search for them and perhaps even exaggerate them, to give life and interest to your painting. Look for those touches of yellow, orange and brown that give variety to foliage and observe the variations of green between trees of different species. Shadowed foliage, too, has variations in colour and is not just unrelieved dark green, so look for the purples, the browns and the greys that will give life and vibrancy to your shadows.

The colours of the trunks and branches of trees also need careful scrutiny for they are rarely the conventional brown they are often painted. Silver greys and grey-greens abound while the lower

The Road to the Downs (10½in × 14¾in)
The foreground trees were painted using the side of the brush to achieve a broken outline and a deeper wash was then dropped in to indicate the shadowed areas. Sections of trunks and branches were established in the 'sky holes' while the foliage was still wet. The distant wooded hills were a single wash of ultramarine and light red. Notice how the tree shadows reflect the unevenness of the ground.

trunks are frequently moss green. Pay particular attention to the way shadow falls on branch and trunk for this can help to describe their cylindrical form. Notice, too, how tree shadows are affected by the unevenness of the ground over which they fall, and avoid the mistake of painting them as though they are lying across a billiard table surface!

The intelligent use of shadows can add greatly to the impact of your work and help to solve a number of problems. An over-prominent road or track can be conveniently broken up by tree shadows falling across it. Always remember to make these shadows follow the contours of the ground, down the roadside bank, up over the camber of the road, with little indentations as they pass over ruts and wheel tracks, and then up over the other bank. All this will help to describe

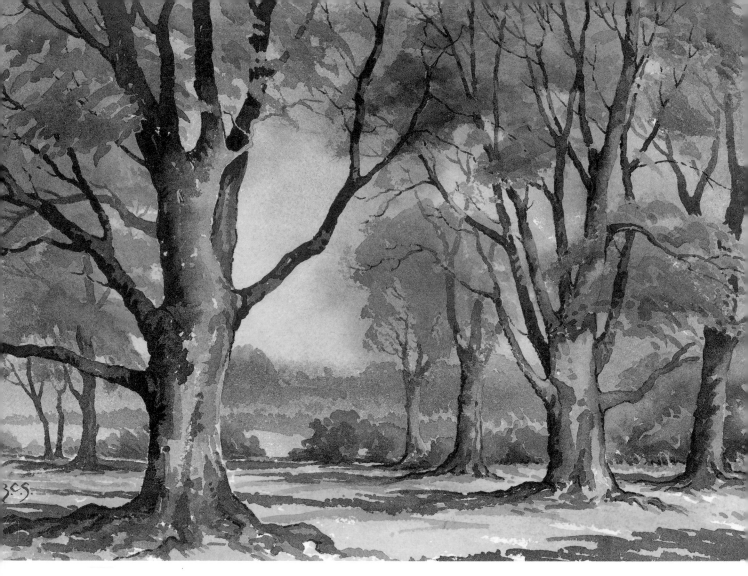

Autumn Woods (10¾in × 14¾in)
The colour green has been played down in this impression of beech woods in autumn and seasonal russets and browns have been emphasised. A soft purplish-grey for the distant trees and hills indicates recession. The beech trunks are a pale grey-green in the sunlight, but the shadowed branches are much deeper in tone, particularly when viewed against the sky. Once again the tree shadows suggest the unevenness of the ground.

the surface of the ground. Interest can sometimes be lent to an empty foreground by letting the shadows of trees outside the composition fall across it, again taking care to ensure they reflect the roughness of the ground.

The mass of twigs on bare winter trees needs just as much simplifying as summer foliage to render it amenable to broad watercolour techniques. Here the ends of the branches can be carried up into dry-brush work or into a pale wash of the appropriate colour. This wash must,

of course, be lighter in tone than the twigs themselves for it represents not only the twigs but the sky between them.

There are various ways in which the height of forest giants may be emphasised. They may, for example, be allowed to pass out of the top of the painting, or tiny figures may be placed alongside to provide scale. Variety may be introduced into the treatment of groups of trees by painting the trunks in contrasting tones: some may be light against a dark background, others may be dark against a patch of light foliage. Sometimes a sunlit scene may be accented by putting in a frame of foreground leaves in shadow. These are just a few examples of how emphasis, contrast and variety may be introduced into your painting: keen observation and your own imagination will suggest many more.

Make a habit of sketching trees or groups of trees whenever you see an interesting arrangement. This will not only improve your technique but will provide you with material for future use.

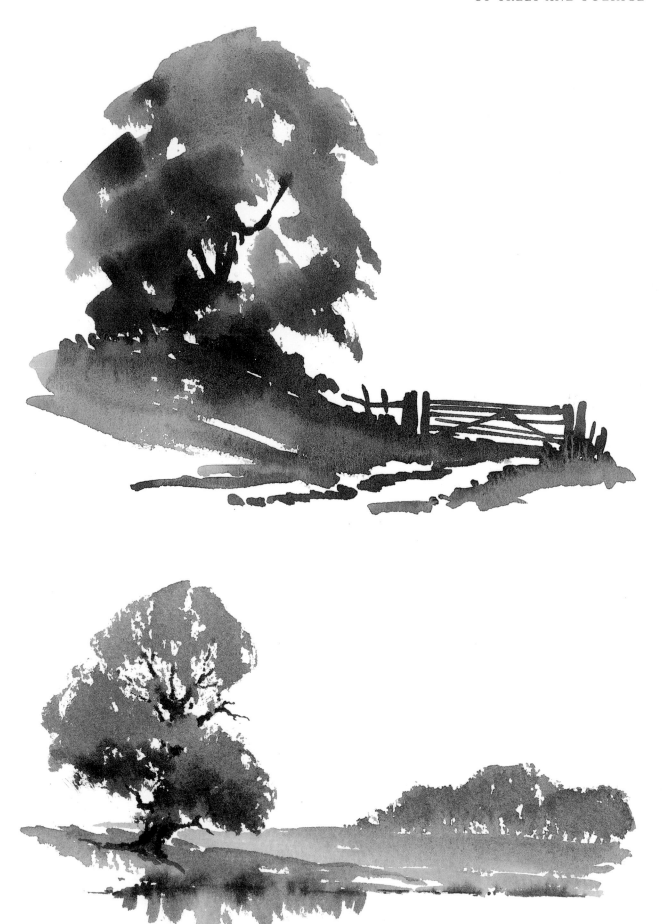

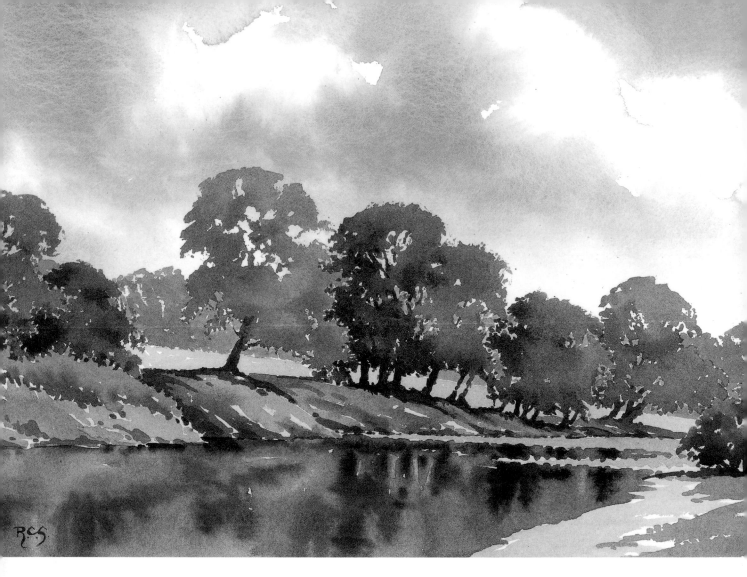

The River Medway (10¼in × 14in)
*Here the breeze has ruffled the surface by the bend in
the river to produce pale stretches of water which
conveniently separate the mass of foliage from its
reflection below. The wide variation in the colour and
tone of the trees has been emphasised while the use of
blue-grey for the distant hillside suggests recession.*

Brush and Indian ink sketches of tree groups.

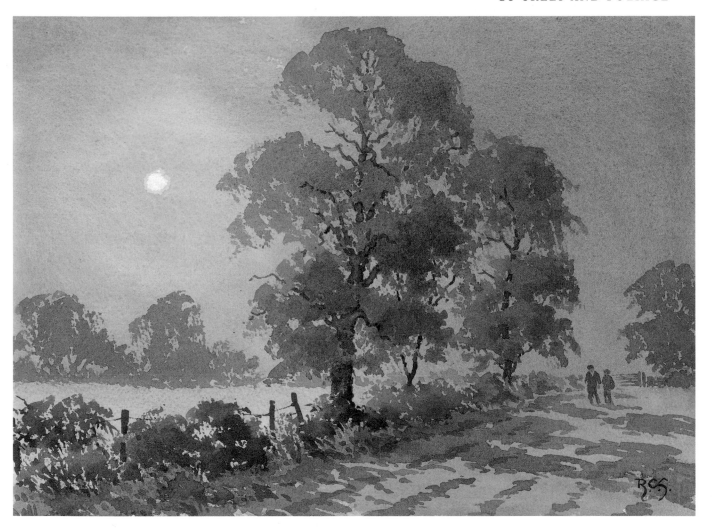

Autumn Mists (10¾in × 14⅜in)
The glow from this misty evening sky influenced every part of the scene so the trees, hedges and fields were painted in suitably warm colours : various combinations of raw sienna, ultramarine and light red.

The broken outlines of the trees and hedges were effected by using the side of a no 10 brush on rough rag paper. The line of distant trees is about one-third the way up the paper and the group of foreground trees is placed to the right of centre. Notice how the line of hedge carries the eye to the two small figures which provide scale.

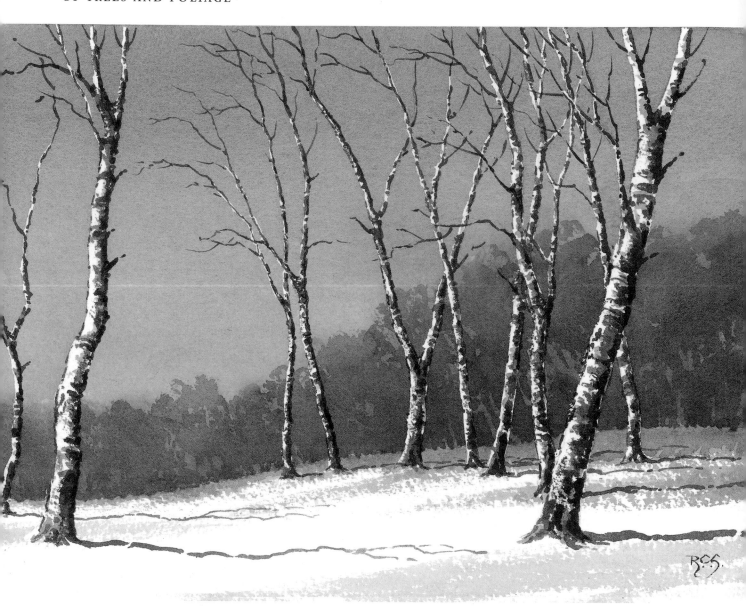

Birches in the Snow (10¾in × 14½in)
*Masking fluid was used to preserve the whiteness of
the birch trunks and main branches while a graded
wash was applied for the sky (ultramarine touched
with light red shading into ultramarine and raw
sienna). While the paper was still damp a mixture of
light red and a little ultramarine was painted wet in
wet, for the bank of trees. Once drying was complete,
the same mixture, plus a little more ultramarine was
applied to provide form and texture for the distant
trees. A very pale wash of ultramarine slightly
warmed with light red was applied to the snow
beneath these trees and a darker version of the same
mixture provided the shadows of the foreground
birches.*

*When the paper was again completely dry, the
masking fluid was removed and texturing applied to
the white trunks and branches. Quick, tapering
strokes of the rigger dealt with the smaller branches
and twigs which appeared dark against the sky.*

11
The Trouble with Foregrounds

The last part of the painting to be completed is usually the foreground. If everything has gone well up to that point, you will be understandably anxious not to spoil what you have already achieved. But beware! Your anxiety may easily lead to overworking and over-elaboration which will spoil your work in several different ways.

If your foreground consists, for example, of grass or foliage of some kind, excessive care may result in your attempting to paint every leaf and every blade of grass. This labouring after detail may easily produce a tired, over-meticulous painting from which the main attractions of watercolour – its freshness and clarity – will have departed for good. Excessive preoccupation with the foreground has another serious disadvantage, for it draws the attention away from the important part of the painting. Instead of supporting and complementing the centre of interest, the foreground then competes with it and the whole balance of the painting is upset. And if there is too much detail in just one area, the painting will no longer 'hang together'.

It is, therefore, good sense to make a determined effort to avoid fussy foregrounds and to simplify whenever you can. This broad treatment is in line with what you see, for if your eyes are focussing on your centre of interest – perhaps an attractive group of buildings in the middle distance – the foreground will be on the periphery of your field of vision and will not be seen sharply or in detail.

The overworking of foregrounds is often due to the painter's compulsion to paint exactly and literally what he sees, and to his inability to simplify. His treatment of distant foliage may be perfectly satisfactory because he is too far away to see small details and is forced to paint broadly. It is when he *can* see every leaf and twig that his troubles start. The solution is to throw the subject matter out of focus by viewing it through half-closed eyes, a ploy suggested in an earlier chapter. In this way detail is lost and only broad areas of tone and colour remain.

Large brushes will help you to achieve bold effects and will make it difficult to include fiddly details. Bold strokes of the brush may leave clusters of white specks in their wake and these can suggest texture of some kind. In watercolour, quick, almost accidental effects are far more telling than careful, meticulous ones and nowhere is this more true than with foregrounds. There are, of course, occasions when the foreground is the centre of interest and the background plays a secondary role. Foreground features will then be painted more strongly while the distance and middle distance are played down and softened.

Texturing techniques are useful for describing the appearance of such materials as old wood, masonry, rock, rough grass, scrub and so on. These are worth practising to enable you to obtain the desired effects boldly and without labouring after detail. Conventional brushwork can do all that is necessary though there are a number of tricks which can produce specialised effects. There is no harm in experimenting but remember that too many tricks can impart a gimmicky appearance to your work.

Practise broken washes, to suggest light sparkling on water, light catching seed-heads in a meadow and many other effects.

Light sparkling on water

Meadow – broken wash

Use the side of the brush and the roughness of the paper to paint foreground scrub or a line of hedge.

Foreground scrub

Line of hedge

Dry-brush work can be used to capture the rough textures of old wood or rock.

Old Wood

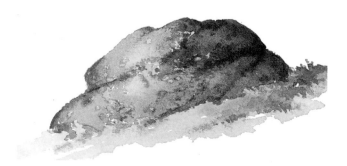

Rock

Now for a couple of tricks! Salt sprinkled on a wet wash can produce a speckled or mottled effect. Sand and various other materials can be used in much the same way. Crumpled paper pressed onto a drying wash can suggest rock and other rough surfaces.

Sprinkled salt

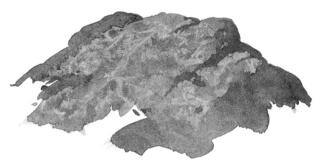

Crumpled paper

There are many more tricks, and indeed books have been written on the subject, but you will do better to rely on your brushwork. As with so much in painting, it is all a matter of practice, but gaining dexterity and skill with the brush is well worth the effort.

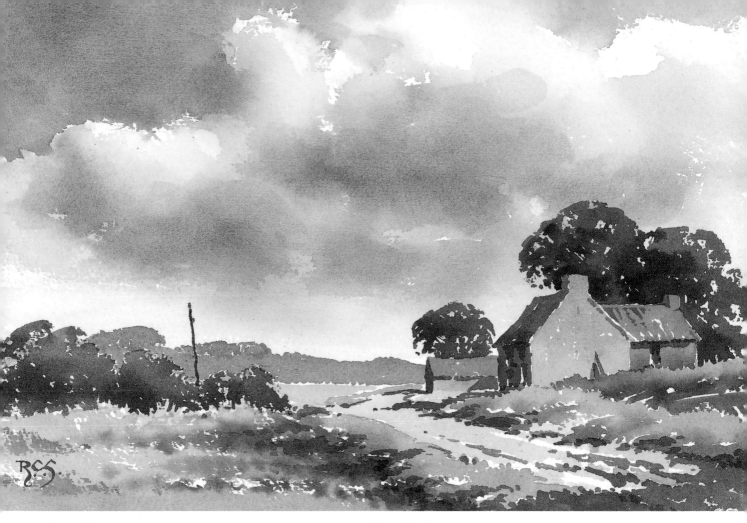

Farm Lane (10½in × 14⅝in)

*A simple subject, simply treated. The farm buildings
and trees on the right are balanced by the bushes and
the heavy clouds on the left, while the low horizon
enables justice to be done to the lively sky. Notice
how the farm track leads the eye into the heart of the
painting.*

*The blue-grey of the distant wooded hill contrasts
with the warmer colours of the foreground and
strongly suggests recession. The dark trees throw the
lighter tones of the farm buildings into relief and the
dark line of hedge on the left contrasts with the pale
colours of the adjacent fields.*

*The general treatment is free and direct and if there
had been any over-elaboration of the foreground, the
balance of the painting would have been destroyed.
As it is, the foreground has been tackled even more
boldly and loosely and so does not attract undue
attention at the expense of the rest of the painting.*

*A rough rag paper was used and its textured
surface made its contribution to the broken outlines
of fields and trees. The rapid technique left many
specks of white paper, but these impart life and
sparkle to the painting.*

*The sky and the distant wooded hill were various
mixtures of ultramarine and light red. The fields were
mainly raw sienna, with darker accents of light red
and ultramarine; the grass on either side of the track
was raw sienna plus a little Winsor blue and the trees
and bushes were various combinations of raw sienna,
burnt sienna and Payne's grey.*

(overleaf)
White House Farm (10½in × 15in)

*In this painting the strong verticals of the conical
oasthouses contrast with the mainly horizontal forms
of the fields and the receding banks of trees. The time
is autumn, the hops have long since been dried in the
oast kilns and the rich scent that pervades the late
September air has also gone. The light is coming from
the left as the shadows falling across brickwork and
whitewash indicate.*

*The foreground was rather overgrown and the long
tangled grasses and weeds have been suggested very
loosely, advantage again being taken of the roughness
of the paper's surface to obtain a broken effect. The
dog daisies on the right have been given a little more
detail, but not enough to enable them to compete
with the centre of interest, in this case the old white
farmhouse. The colours used in this painting were
raw sienna, burnt sienna, light red, ultramarine and
Winsor blue.*

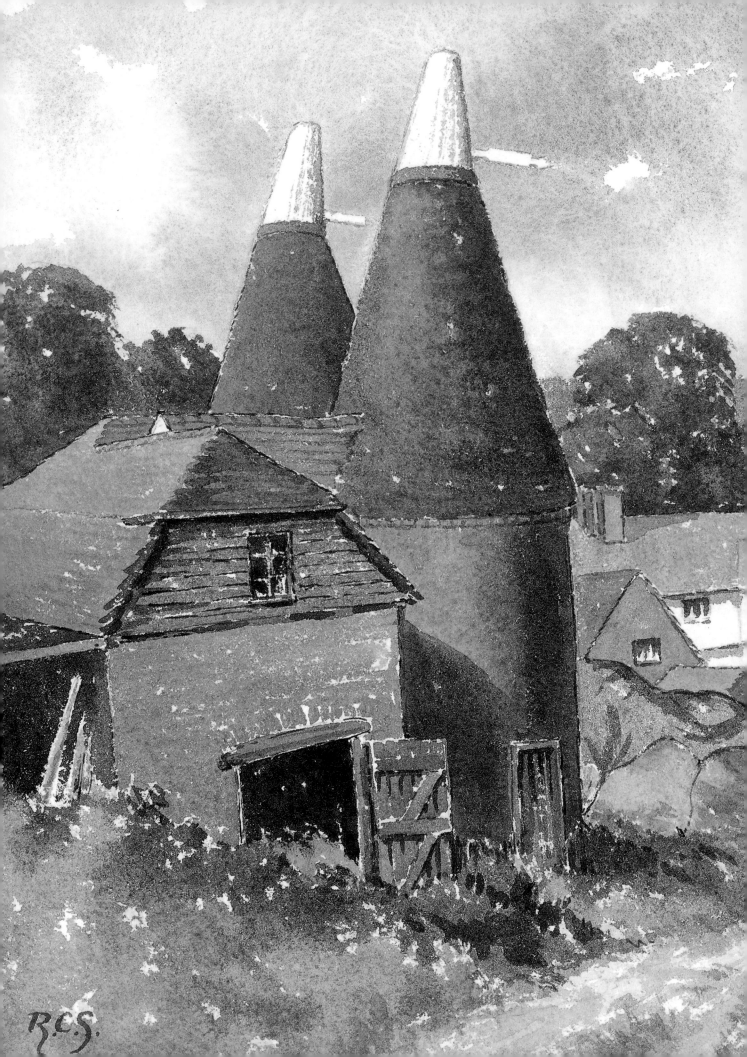

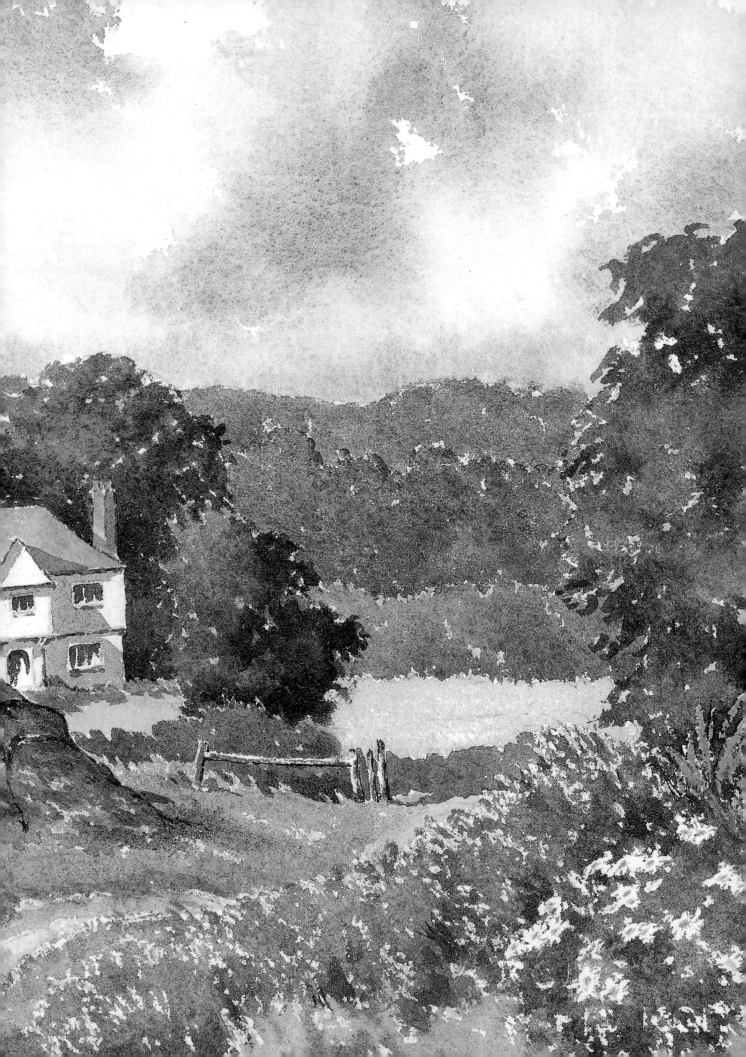

12

Demonstration

Sailing Barge at Anchor (9¾in × 13¾in)
The old wooden sailing barge, anchored in a sheltered estuary, is surrounded by several smaller craft and their reflections make an interesting pattern in the calm water. It is a fine evening in late summer, with not a cloud to be seen and were it not for the distant stretch of land, sky and water would be indistinguishable at the horizon. The dark foreground of mud and shingle makes a strong contrast with the expanse of shining water.

Stage 1 Make several quick sketches from different viewpoints and let the most promising of these be the basis of your composition. Boats are tricky subjects and require careful drawing. The lines of this sketch are, once again, stronger than they would normally be, to aid reproduction.

The sky is a soft blue, shading into a pale warm yellow above the horizon and these colours are reflected in the water. A variegated wash over the whole paper is the best answer here. Prepare two generous washes, the first of ultramarine and Payne's grey, the second of raw sienna with a little light red. With a 1in brush start painting horizontal bands of blue, starting at the top of the paper and working your way down. After several sweeps, start dipping the brush into the second wash, so that a gradual change to the soft yellow

occurs. Right at the bottom of the paper reverse the process, and again dip your brush into the blue wash. If you have been successful, there will be an even transition from cool to warm colour and, at the bottom of the paper, a hint of a return to the cool. If this technique causes you difficulty, you may find it helps to dampen the paper evenly all over before starting to apply the bands of colour.

Allow the paper to dry and apply a wash of ultramarine and light red to the strip of land beyond the water. This should be stronger on the right, with a hint of green, and weaker on the left, where the land recedes.

Stage 2 Now paint the furled, russet sails of the barge with light red and burnt sienna tinged with ultramarine. They should stand out boldly against the light sky, so use a strong wash. While this wash is still damp put in the shadows and the folds with a stronger version of the same wash, plus a little more ultramarine. Use various combinations of burnt sienna, light red and ultramarine for the old wooden hull and the smaller craft, again using fairly strong washes so that these shapes will register decisively against the shining water. Take particular care to preserve the top edges of the boats where these catch the light.

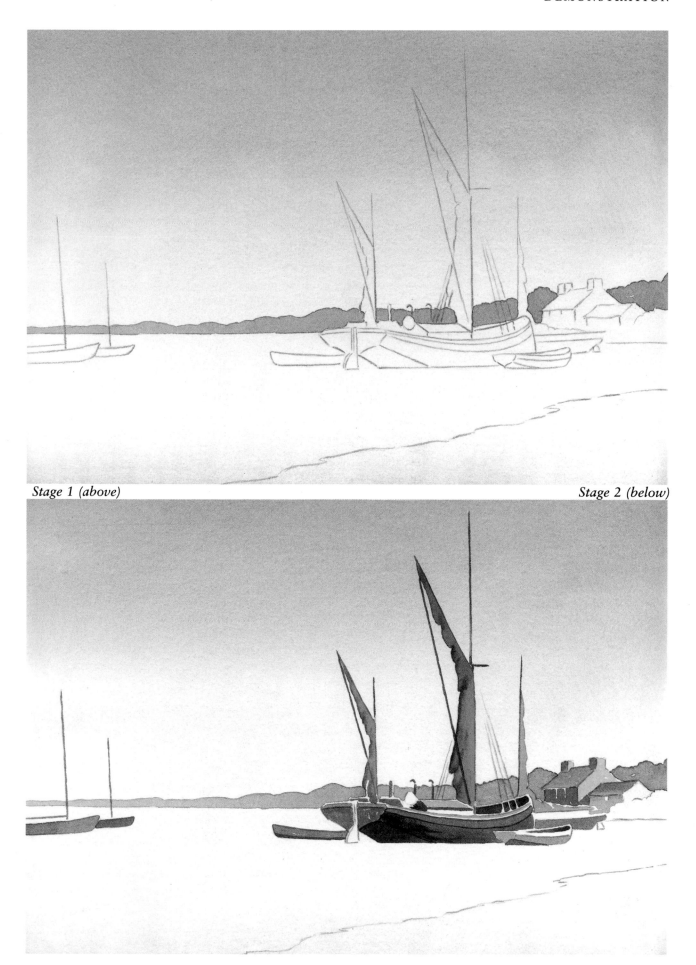

Stage 1 (above)

Stage 2 (below)

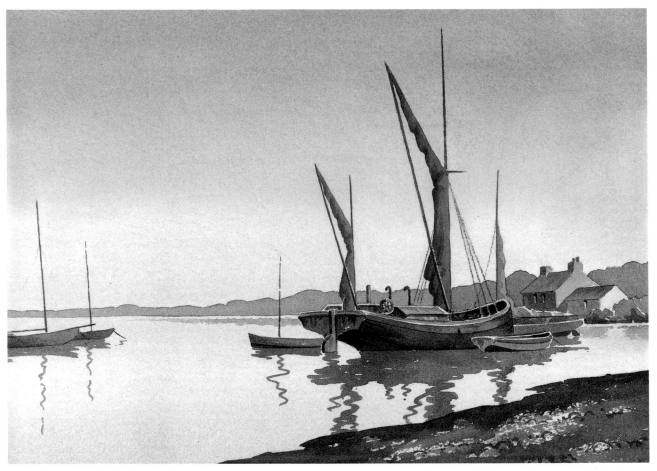

Stage 3 Complete the painting of the boats, add a little texturing to the weathered hull and put in a suggestion of rigging. Do not try to include every rope or the painting will end up looking like a cat's cradle.

Now for the important part – the reflections in the smooth water. These are best put in quickly, in one operation, so prepare several liquid washes, of brown, blue and grey, to correspond roughly to the colours above. Remember the adage: light objects are reflected darker, dark objects are reflected lighter, so ensure that these reflections are lighter in tone than the boats above them. Use bold, rapid brushwork so that the blended washes remain clear and fresh.

It now only remains to paint in the dark foreground. Quick strokes of a 1in brush loaded with a strong mixture of burnt sienna and ultramarine will produce a broken wash which will suggest shingle. With a stronger mix of the same colours accent the margin with the water to provide contrast and, with a small brush, outline roughly a few foreground stones and pebbles.

(opposite)
The Packhorse Bridge (9⅛in × 13¼in)
This wild and empty scene needed a focal point in the foreground and the old stone bridge provided just what was required. It stands out boldly against the deeper tones of the middle distance stretch of moorland and its reflection adds interest to the shallow river. The stormy sky is strongly painted and the crest of the main peak, placed just left of centre, gains impact from being in deep cloud shadow, contrasting as it does with the lighter patches of sky and the gleams of sunlight on the lower slopes.

The light areas of cloud were put in first with a wash of palest raw sienna and the grey cloud shadows added with a mixture of ultramarine and light red. When this was dry, the same grey wash was used to strengthen the cloud shadows above the peak, and here some hard edges were left while others were softened with clear water. The same grey was used for the distant mountains and while this was still wet a little liquid raw sienna was dropped in to suggest the misty areas of sunlight. Still darker accents were added, wet in wet, to the peaks to increase their dramatic impact.

For the stretch of middle distance moorland the light red content of the same wash was increased to indicate dark patches of heather and here, too, raw sienna was used to suggest sunlight. The foreground rocks and grass and the river itself were put in quickly and boldly with various combinations of the same three colours.

13
The Magic of Mountains

I can still recall the feeling of wonder I experienced on seeing my first mountains. They were in the Lake District and although by international standards they were pretty modest affairs, to a small boy who had seen nothing higher than the North Downs they represented excitement and adventure. I lost no time in climbing them and painting them. My paintings, I remember, grossly exaggerated both their altitude and their steepness and were no doubt intended to impress my peers with my prowess in conquering them. This love of mountains has never faded and is shared, I believe, by most painters. They make magnificent subjects for the watercolourist with their subtle tones and colours and their interrelation with mist and cloud.

One of the problems of painting mountains is their inaccessibility, particularly for those who no longer possess the vigour of youth. True, there are many wonderful compositions beyond the reach of all but the strongest and fittest but there are many more visible from points in the valley which anyone can reach. Of all natural subjects, mountains repay most generously the effort of painting them in situ, and rough impressions done on the spot nearly always have more punch and appeal than more finished paintings made in the comfort of the studio. The fleeting changes of light, the cloud shadows moving over the fells and the effects of mist and low cloud have to be seen at first hand and nothing else can provide the same inspiration.

It makes good sense to limit the amount of equipment you take with you on painting expeditions to high places. The watercolourist is fortunate here for apart from his drawing board he can carry all he needs in a small haversack and still have room for his picnic lunch. If you paint

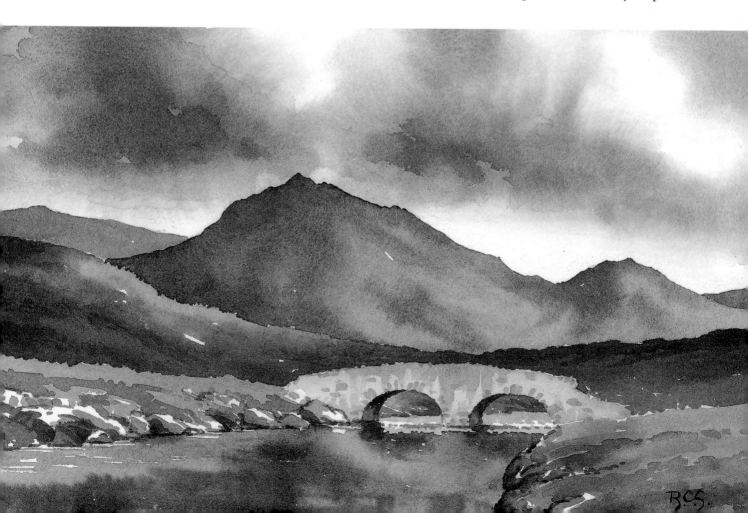

In the Alps (10½in × 14in)

In this quick impression of an Alpine scene, the tones are reversed and the sunlit, snow-covered peak is a brilliant white against the dark grey sky. The snow is untouched white paper, but the deep tones of the cloudy sky make it shine as do the dark patches of rock which are exposed near the summit. The snow shadows are pale ultramarine with just a touch of light red.

The foreground is treated boldly and freely and the figures of the two climbers, painted in silhouette against a patch of white snow, add scale and interest to the scene.

with the drawing board on your knee, you can dispense with an easel which in any case is vulnerable in the strong winds often experienced at high altitudes. With plenty of rocks about, even a folding stool is an unnecessary luxury. A piece of plastic sheeting can protect your work in the event of a sudden shower and can double up as a small groundsheet if the ground is wet.

Maps are indispensable for trips into the mountains and if you read them carefully they will show you where there are extensive views and where to find rivers, streams, rocky outcrops, isolated buildings and so on. Sometimes you will wish to emphasise the loneliness and emptiness of the mountain scene; at other times the inclusion of a lonely farmhouse will provide a focal point and suggest scale. The human figure can perform much the same function. It all depends upon the composition of the scene before you and upon the mood you wish to create.

Foregrounds have a vital part to play in planning your composition. Strongly painted rocky foregrounds not only set the scene but, by tonal contrast, can emphasise the feeling of aerial space and the mystery of the distant vista beyond.

Just as groups of trees from the sketchbook can be used to fill empty spaces in the landscape, so studies of rocks can be pressed into service to provide foreground interest where none exists. So here, too, a well-stocked sketchbook is of real value.

The very extent of the mountain panorama makes it imperative for you to simplify and concentrate upon the main features of the scene. A dominant mountain peak will have far more dramatic impact if painted boldly and in broad outline than if every rock and indentation were painstakingly recorded. So aim for atmosphere and omit insignificant detail.

Mountain scenery is often at its most dramatic when the weather is at its worst and it is sometimes necessary to brave low cloud, mist, rain squalls and even snow to capture the effects you want. So be prepared for the worst that nature can throw at you and remember it is nearly always colder at high altitudes than you expect.

In Upper Wharfedale (10¾in × 14½in)

The subject of this painting is a very different type of mountain scene, with a strong domestic flavour. Here the accent is on the jumble of cottages rather than the hilly background. Indeed, the stark outline of the ridge is little more than a flat wash of grey and even the nearer shoulder of hill has only a broken, secondary wash added to suggest woodland and scrub. They do, however, form an effective background and provide an authentic setting.

The geometric shapes of the cottages, with their solid stone walls and their rough stone slates, form an interesting pattern. This is emphasised by the strong interplay of light and shade which helps to give the scene a three-dimensional appearance. No attempt has been made to paint every stone in the cottage walls, but the inclusion of a few random blocks suggests their construction and leaves something to the imagination.

Notice the reflected light in the shadowed elevation of the centre cottage and the hint of green algae in the lower courses of the stone slates – little touches such as these can breathe life into a painting.

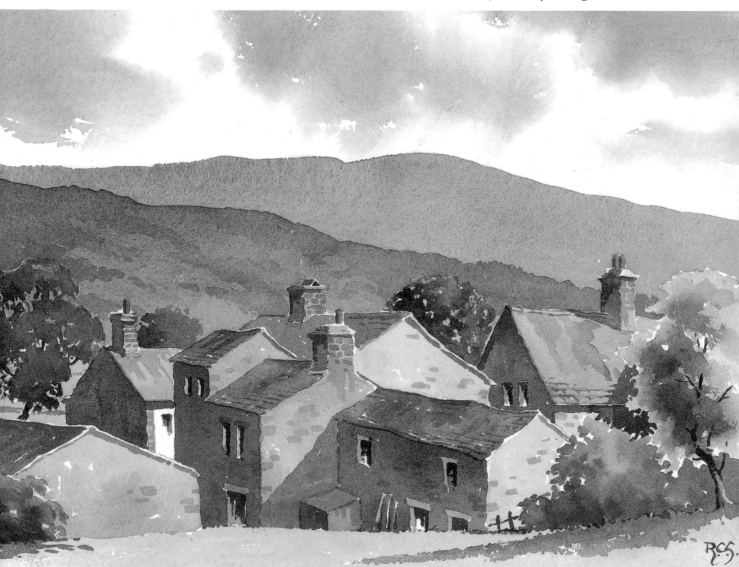

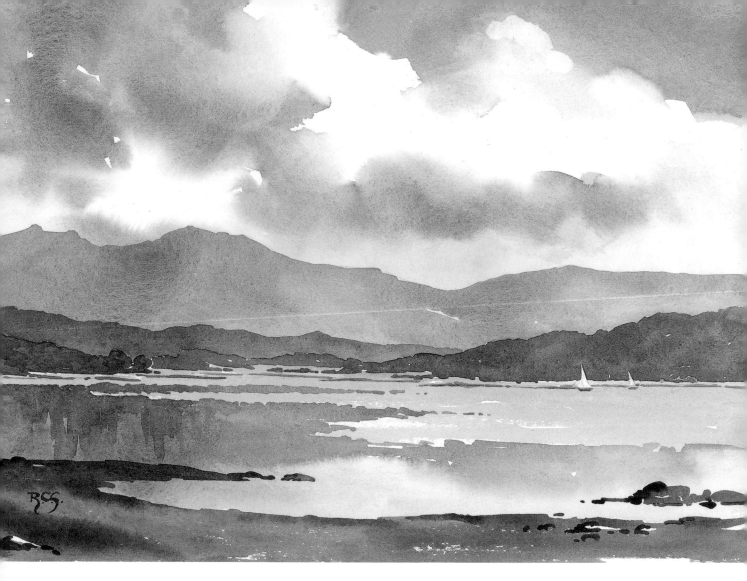

Derwentwater (10¾in × 14¾in)
*This is an example of a scene reduced to its essentials
and painted in a series of flat, variegated washes. The
backdrop of mountains comprises one wash to which
blue/grey has been added, wet in wet, to denote
shadow. The bands of distant woodland, painted
progressively paler in tone and greyer as they recede,
are single washes into which several different colours
have been dropped to provide variety.*

*The wind-ruffled water is a pale wash of blue/grey
while the smooth stretches reflect the colours above.
Even the foreground is a single brown wash to which
darker accents were added during the drying process.
This simple wash technique gives a painting a feeling
of peace and tranquility.*

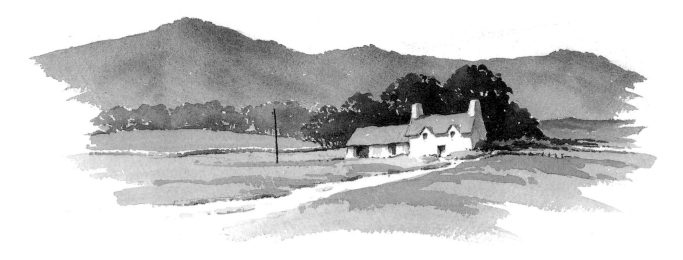

Loch Long, Wester Ross (10¾in × 16¼in)
*The dark promontory makes a strong statement
against a light patch of sky and the low clouds hide
the higher peak to the right. Although the water
reflects the grey of the sky, it appears pale against its
darker banks. The white sail makes a crips note
against the dark hillside.*

*The warm-coloured bush, to the right of the
painting, prevents the eye sliding off the paper. The
eye is, in fact, carried to the bend in the lock, to
which the distant land forms appear to be pointing.*

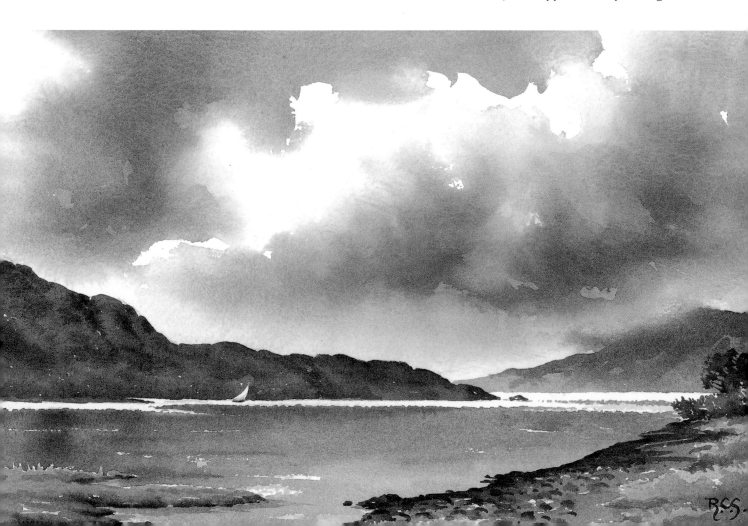

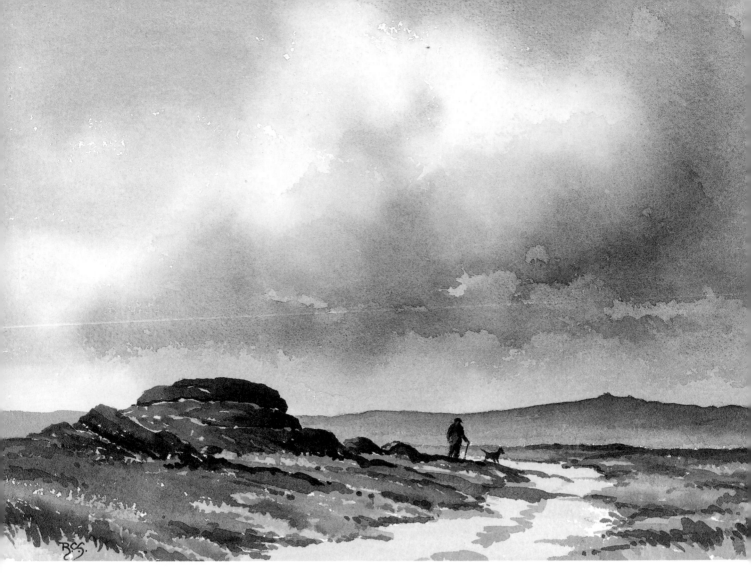

On Dartmoor (10½in × 14¼in)
*Mountains do not have to be lofty to possess
grandeur and atmosphere, as the weathered heights of
Dartmoor demonstrate. In this moody impression the
dark mass of the granite outcrop on the left is
silhouetted dramatically against a light patch of sky
and is balanced by the distant tor and the heavy cloud
shadow on the right. Despite the sombre treatment of
the scene, there is plenty of foreground colour in the
moorland vegetation.*

14
Buildings in the Landscape

Most art club exhibitions consist largely of rural landscapes and there are few paintings of the places where the members actually live. This is not surprising for as the urban sprawl spreads ever further, people need to remind themselves of the vanishing rustic idyll and feel that the rural scene is the proper source of artistic inspiration. A further consideration may be that attractive landscapes are more likely to appeal to potential buyers than impressions of the local supermarket. This is perfectly understandable and painters have a right to choose subjects that attract them. The danger is, however, that this attitude may lead them to ignore promising material on their doorsteps. So what can they do? They can train themselves to respond to stimuli of all kinds and learn to use their eyes and their imaginations more freely, to discover possibilities in unlikely urban subjects.

Straight rows of identical houses do not usually make appealing subjects, but groups of older, inner-city buildings are another matter and can provide intriguing compositions. Light and atmosphere have a big part to play and industrial landscapes silhouetted against glowing skies can have a compelling beauty of their own. *Railway Viaduct* (see page 58) and *Dockside Road* (see pages 97–9) are examples of the type of urban scene that has much to offer the watercolour painter. Lowry's vision of industrial Lancashire demonstrated how ugly factories and mean streets may inspire paintings rich in feeling and character.

Simple domestic scenes are another interesting but often neglected source of subject matter and many fine paintings have been made of suburban gardens, the backs of neighbouring houses, views from attic windows and so on. As with urban landscapes, what really matters is imaginative treatment and originality of interpretation. *Over the Garden Wall* (see page 90) is an example of a simple domestic scene of this type.

Buildings really come into their own in cities such as Venice, Bruges, Paris and London. Though insensitive planning has ruined much of the skyline of the two capitals, there are still superb subjects to be found there while there is hardly a canal in Venice which is not a painter's delight. Buildings also have an important part to play in rural landscapes. They can provide focal points and centres of interest and can contribute much to the character of the country scene.

Whenever possible avoid head-on, four-square compositions and look for oblique angles and contrasting planes of light and shade, for these can add greatly to the interest and attraction of a subject. The inexperienced often give more thought to the correct and exact outlines of their buildings than to their artistic appeal and some-

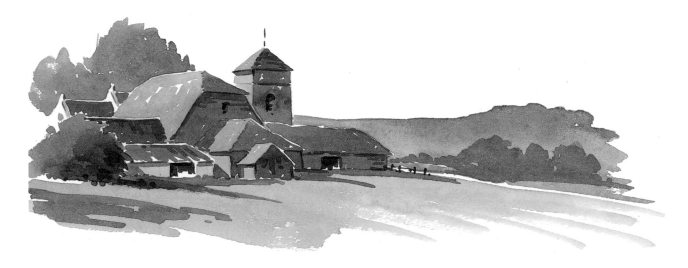

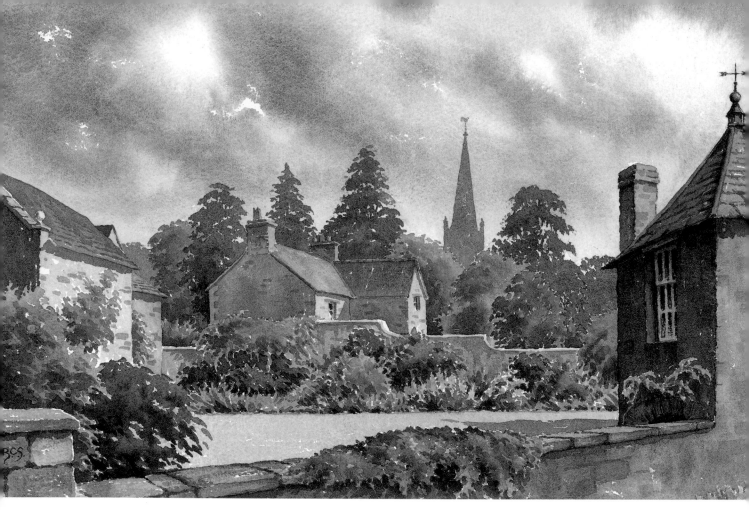

Over the Garden Wall (12¾in × 18½in)
This was painted one fine autumn day in my daughter's garden in the Cotswolds. The buildings, set at various angles, are an interesting blend of light and shade and their material is suggested by a few random blocks of honey-coloured stone. The church spire, offset to the right of centre, is just a grey silhouette. The trees show variety of colour and shape and provide tonal contrast with the stonework. The atmosphere is one of peaceful domesticity.

times even tidy up the wayward lines of old cottages and barns. Far better to exaggerate these signs of age and use them to give your buildings character. Of course, the basic structure and perspective of your buildings must be correct, but do not try to reproduce exactly every detail and every feature. A few random bricks or blocks of stone are sufficient to suggest the structure of a wall and you should be more concerned to show local variations in its colour, the effects of algae and weather-staining and, most importantly, the shadows falling across it. These are the things that really matter. This sort of treatment will be more telling than the meticulous painting of every brick and tile. Of course, these blemishes are more obvious with older buildings, but they are always there to some extent and it is up to the artist to discover them and do them justice.

Always look for colour in your shadows and never be content to paint them a flat, unrelieved grey. The inclusion of rich colour and the glow of reflected light add enormously to their appeal. Make sure, too, that you paint them in such a way that they reveal any unevenness of the surface on which they lie.

Chimneys and windows need more thought than they commonly receive. Chimneys are usually seen against a bright sky and should be painted in strong, dark colours to make the necessary impact. Window panes are often shown as uniform oblongs of dark grey. This is bad enough if there are just one or two in the painting, but when there are many more, the effect can be monotonous in the extreme. So study your windows, note the areas of reflected light, the tone and colour of curtains and other features and make sure that these variations are included or at least suggested.

Maldon Quayside (13½in × 10¾in)
This jumble of old buildings makes a pleasing pattern of light and shade. The church tower on the left balances the moored sailing barge on the right and the geometric shapes of the houses contrast with the softer forms of the trees. The overall warmth of colour suggests late afternoon light and unifies the painting.

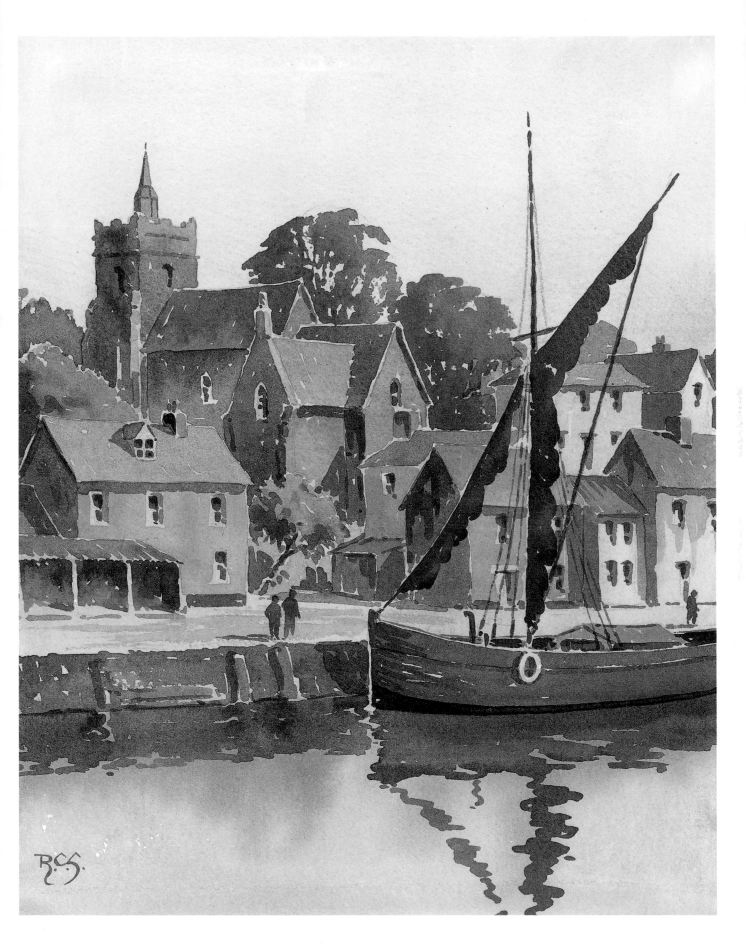

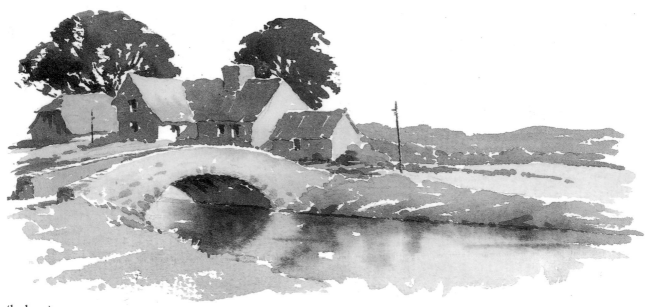

(below)
Grand Canal (2) (10¼in × 14⅝in)
The object of this loosely painted impression of Venice was to attempt to capture the special quality of the light of that lovely city. The paper was allowed to shine through the pale washes of sky and water and the distant buildings were indicated in soft grey. The foreground buildings were painted more strongly, in warmer colours, and although they contain more detail this, too, has been handled loosely.

(opposite)
Sacré Coeur (14¾in × 11in)
This much-painted corner of Montmartre was tackled just as the sun emerged after a shower and the object was to capture something of the sparkle of the Gallic scene. The domes of Sacré Coeur make a pale accent against the grey sky and the lights and darks of the buildings and trees are reflected in the wet street.

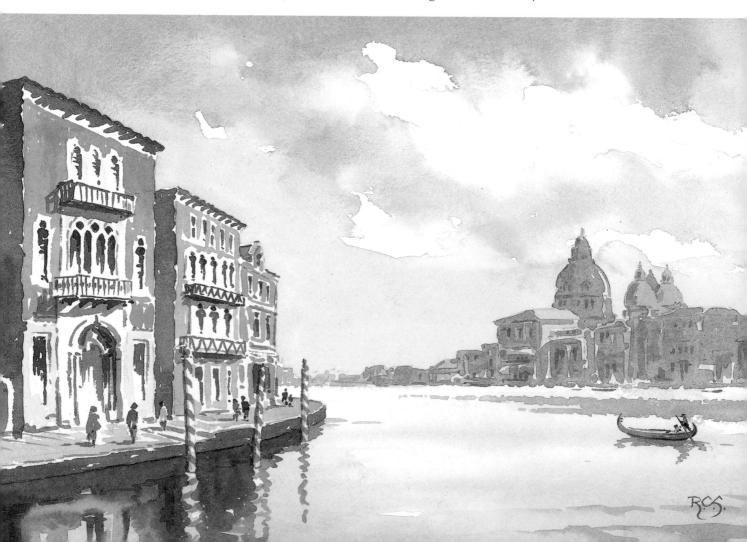

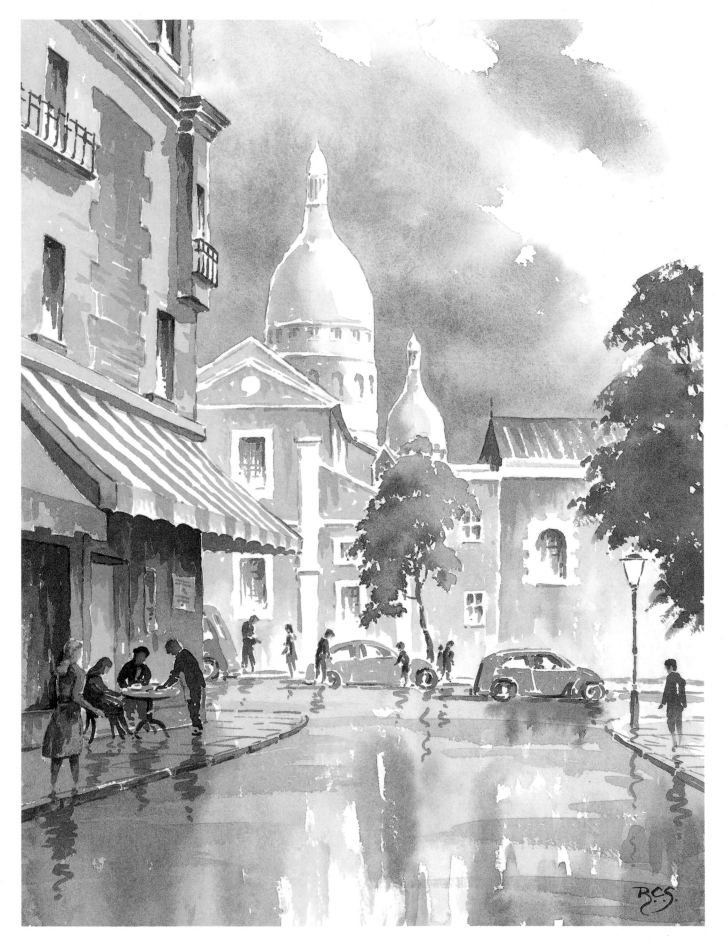

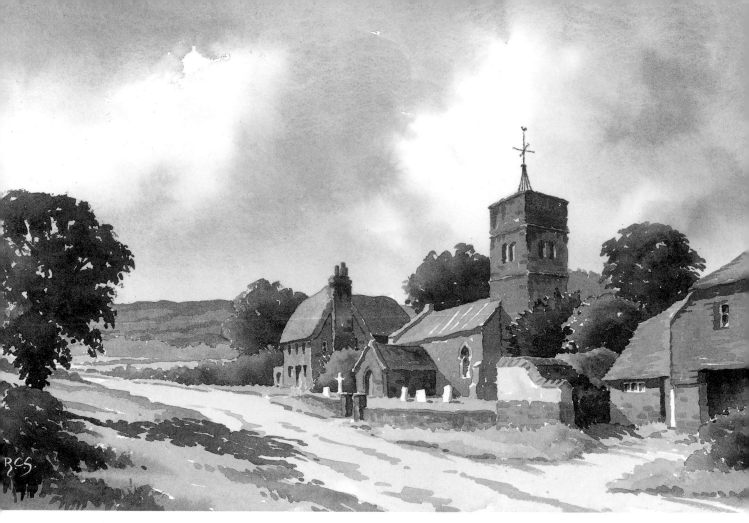

Dorset Village (11in × 16¼in)
In this simple village scene the group of old buildings fits naturally into the landscape and becomes an integral part of it. The colours of nature find an echo in the colours of the weathered building materials so an overall harmony is established.

Line and Wash

An interesting offshoot of watercolour is line and wash. It is not suitable for every type of subject and would be out of place in gentle, atmospheric landscapes, but it comes into its own where strong, positive drawing is required. It can be used to particularly good effect for buildings and street scenes.

The term 'line and wash' includes many different approaches. At one extreme a fine nib may be used to produce a delicate line; at the other, a blunt instrument, such as a shaped stick, may give a stronger, more textured result. There are various drawing instruments on the market which produce a rather mechanical line of uniform thickness and while these have their uses, flexible nibs, which can produce both fine and strong lines according to the amount of pressure used, are far more expressive. The old-fashioned goose quill is excellent in this respect, though more difficult to control.

Village Street (8in × 9in)

The West Gate, Canterbury (7½in × 10½in)

It is often useful to make quick, preliminary studies in line and monochrome. In these two examples, a flexible nib and varying washes of lamp black were used.

94

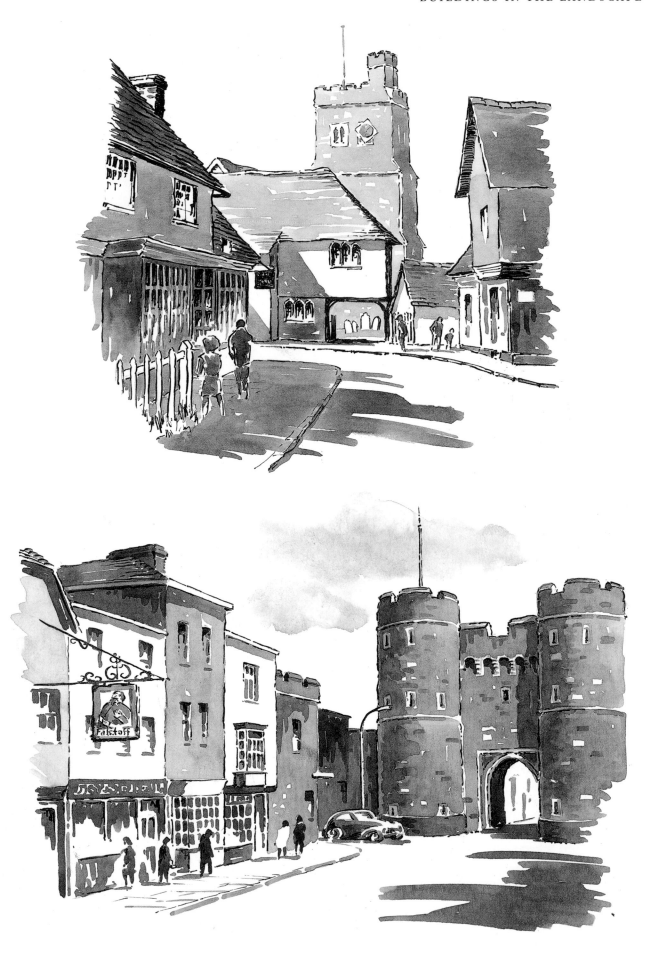

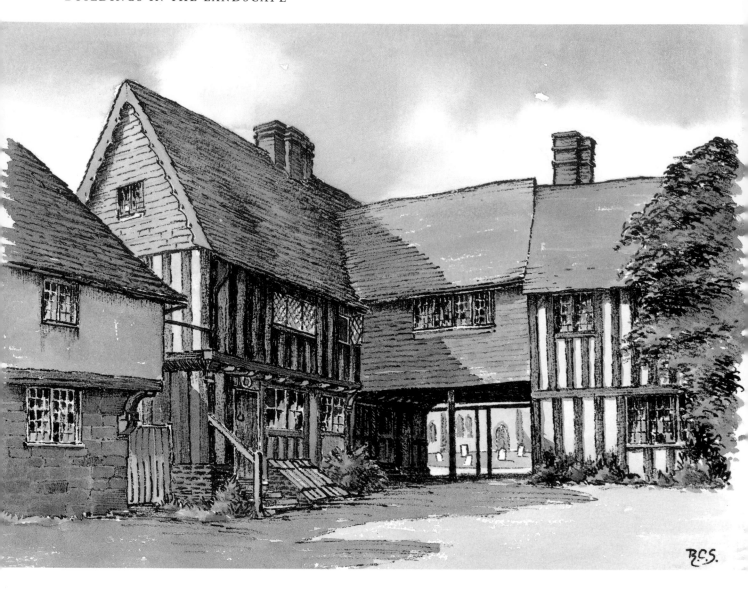

Old Houses, Penshurst (17in × 13in)
A good example of the type of subject that lends itself to the line and wash treatment. It is architectural, with bold forms and strongly contrasting lights and darks. A balsa stick was used to capture the rough textures of old beams, stones and tiles.

The composition enhances the shapes of the old buildings and the pale tones of the centre of interest – the glimpse of sunlit churchyard – are emphasised by the dark archway through which they are seen.

A sharpened stick of balsa wood makes a good drawing implement and can produce a strong, interesting line. Its absorbent texture enables it to carry more ink than a stick of ordinary wood, and as this begins to run out, a soft mark, more akin to charcoal, results. This softer effect can be enhanced by using quick, light strokes which skate over the surface of the paper. If you try this type of implement, remember to tackle the dark passages immediately after dipping it in the ink,

and deal with the lighter ones as the ink begins to run out.

Waterproof Indian ink is normally used for line and wash work, though some artists find it too strong and prefer sepia, or something similar. A smooth (HP) watercolour paper is suitable if you are using a pen but a Not surface gives a more expressive and broken line if your preference is for a stick.

Once the ink drawing is dry, you can safely begin to paint. Avoid the use of harsh, bright colours which rarely look well in watercolour and never in line and wash. So use light red rather than vermilion and Payne's grey rather than ultramarine. Keep a balance between the two elements, line and wash: if your line drawing is too complete, there is little left for the wash to say, and the result is a coloured drawing. And if your line is free and bold, the wash should be applied in a similar manner so that there is harmony between the two.

96

15

Demonstration

Dockside Road (11in × 10¼in)
This simple urban scene relies heavily on atmosphere for its effect. The evening light casts a warm glow over the mean street and the sharp accents of the street lamps and lighted windows help to suggest the gathering dusk. Notice how the curve of the road is prevented by the foreground buildings from carrying the eye off the painting.

Stage 1 First sketch in the main construction lines of the composition and apply masking fluid to the street lamps and one upper window. Now pre-

pare two washes, one for the warm upper area of sky, the other for the cooler, slightly darker lower part. Use raw sienna and light red, with just a touch of ultramarine for the first, and ultramarine and light red for the second. Starting at the top and using broad, horizontal strokes of a large brush, begin to apply the first wash. About one-third of the way down, start dipping the brush into the second wash, finally reverting to the first wash for the bottom third of the paper. This should produce a smooth variegated wash over your whole paper.

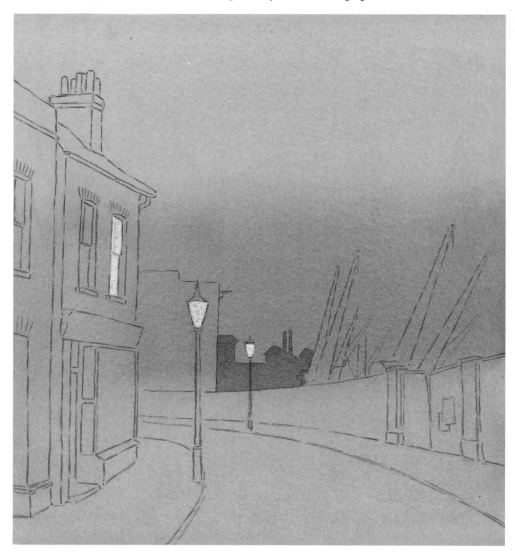

Stage 2 When the background wash is completely dry, start painting in the most distant buildings with a weak wash of ultramarine and light red, treating them as a pale, warm grey silhouette. With a slightly stronger wash of the same two colours put in the cranes and the middle distance building, adding a little raw sienna and light red to the area round the street lamp to suggest radiance. With a still stronger mix of the same colours paint in the curving wall and the foreground buildings, but this time add a little burnt sienna here and there to provide variety. When everything is thoroughly dry, remove the masking fluid and paint the resulting white shapes with very pale yellow but use some warmer colour for two of the first-floor windows.

Add a little weather-staining and texturing to the brick walls and paint in the dark accents of the window frames and shadowed areas. Paint the dock gates with dull green, leaving rectangles for the posters.

Stage 3 Complete the painting of the foreground buildings, using combinations of the same colours. The roadway and pavements are wet from a recent shower and show soft reflections of the objects above. Paint a weak wash of raw sienna, light red and a little ultramarine over the whole area and while it is still wet apply vertical strokes of the appropriate colours: raw sienna and light red under the shop window, ultramarine and light red for the darker reflections and so on. When all this is dry, put in the lines of the kerbs, a few lines suggesting the edges of the paving stones and some vague curved lines to stand for wheel marks in the wet road. The darker accents go in last: the lamp posts, a few darker reflections and the little figure against the lamp-lit wall.

Stage 2

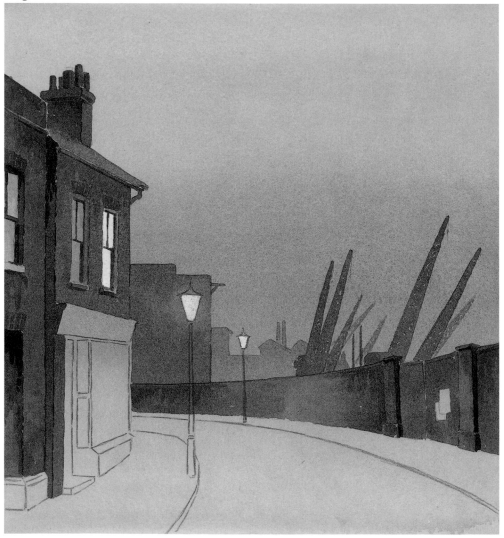

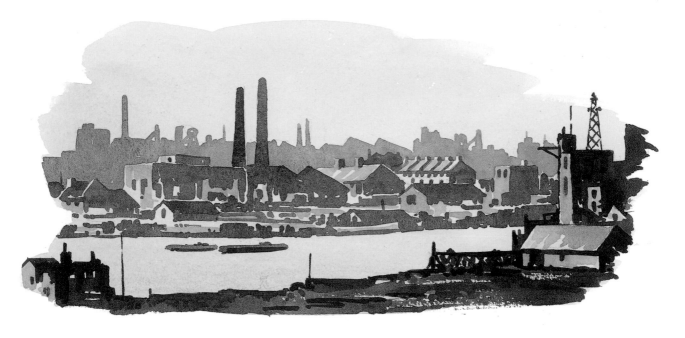

Stage 3

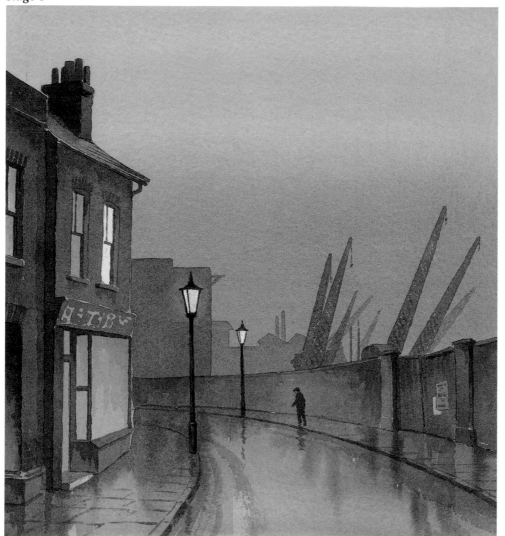

16
Waterscapes

Rye Harbour (10¾in × 14⅝in)
There is a lot of detail in the old harbour scene and this is an instance in which any attempt to paint a mirror image would have led to an over-complicated result. Soft reflections were the answer and these were put in with vertical strokes of large brushes dipped in pre-mixed washes of the appropriate colours. Again, pale stretches of wind-ruffled water conveniently separate land from sea. The foreground reflections of the baulks of weathered timber and the old hulk on the right of the painting were put in boldly with a wash of sludge green (Payne's grey with raw and burnt sienna).

Many students experience difficulty painting water and often play for safety by avoiding subjects in which it occurs. This is a mistake because water can add an extra dimension to the landscape and impart a sparkle to an otherwise drab scene. The shine of a river meandering across a flat plain or even the waterlogged ruts of a muddy farm track, reflecting the bright sky beyond, can make a dull landscape scintillate. The horizontal plane of river and lake can also provide a useful foil for the more vertical forms of nearby trees and buildings.

Of course, painting water presents all sorts of difficulties and complications. You only have to imagine trying to paint a stretch of water where

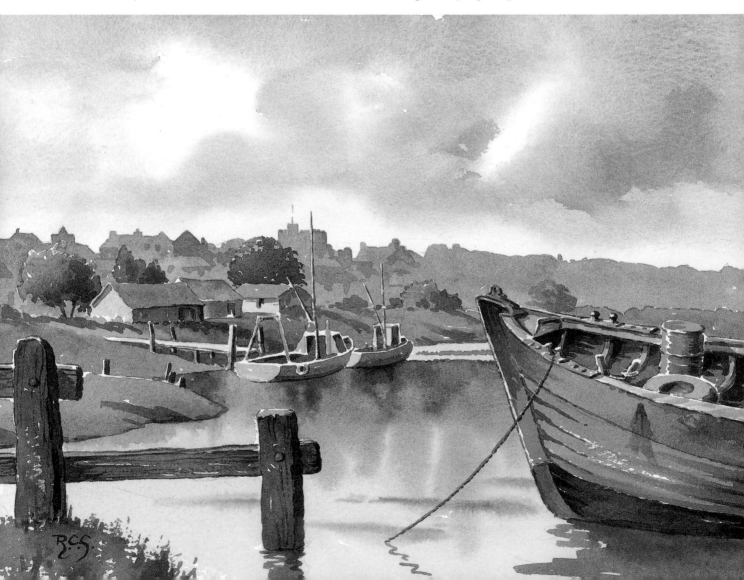

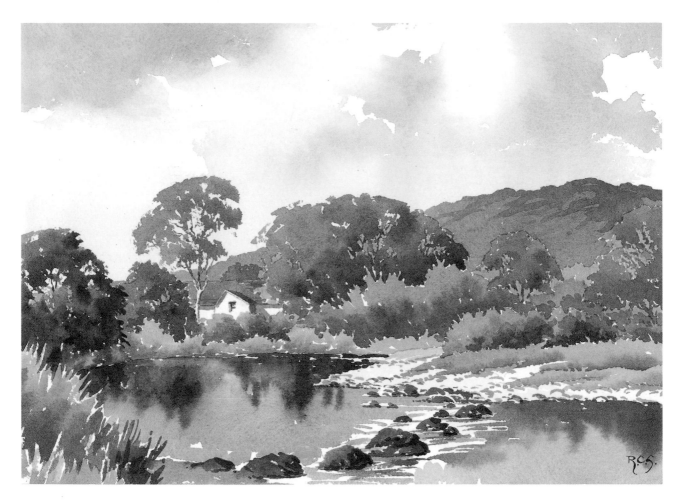

the bed and the reflections intermingle to appreciate the sort of problem that can arise. Reflections can present a number of difficulties. They may, for example, be broken up by innumerable tiny ripples and form a pattern far too complex for any loose watercolour technique. They can form excessively complicated mirror images which can not only lead to over-elaborate compositions, in which land and water compete for attention, but also, by their very complexity, can make a bold approach virtually impossible. All this may sound very daunting and likely to discourage the faint-hearted still further, but do not despair, these are all problems that can be solved or at least circumvented. You can, for a start, choose places where the water will respond to a bold treatment and avoid those that present particular difficulty.

In earlier chapters, the problem of the mirror image was considered and suggestions made for softening it in certain circumstances. A complex scene can become confused if an equally complex reflection is painted beneath it, but a softer treatment of the reflection can provide a welcome contrast. Much the same solution may be applied to simplifying the effect of an impossibly large number of minute ripples. In both cases the water may be looked at through half-closed eyes in order to lose detail, and the softer image which

The River Wharfe (10¾in × 14⅜in)
The movement in this Dales river showed itself where the water flowed past the rough stepping stones. The unevenness of the disturbed surface was caught by the light and has been indicated here by unpainted chips of white paper. These could have been preserved by the use of masking fluid. Where the water was less confined and deeper, it appeared smoother and produced soft, vertical reflections. These contrast in tone with the lighter foliage and the bleached limestone pebbles beyond, to produce a clearly defined edge to the river.

(overleaf)
Bend in the River (15¼in × 21¾in)
With the exception of the rough foreground grass on the left, the water in this painting was put in last, so helping to ensure that the reflections were correctly placed. An errant breeze ruffled the more distant stretch of water and this disturbance of its surface is represented by two narrow bands of pale blue-grey. The nearer water was smooth enough to show soft reflections, but not mirror images, of the trees above. Several full washes were prepared in advance for the reflections of the light clouds, the cloud shadows, the distant hills, the reeds and the trees. These washes were applied with vertical strokes of large brushes, the paler colours first. The darker accents were added last with a stiffer mix of dark green (Payne's grey with raw and burnt sienna). The paint was applied quickly so that the washes merged together to produce a soft-edged result.

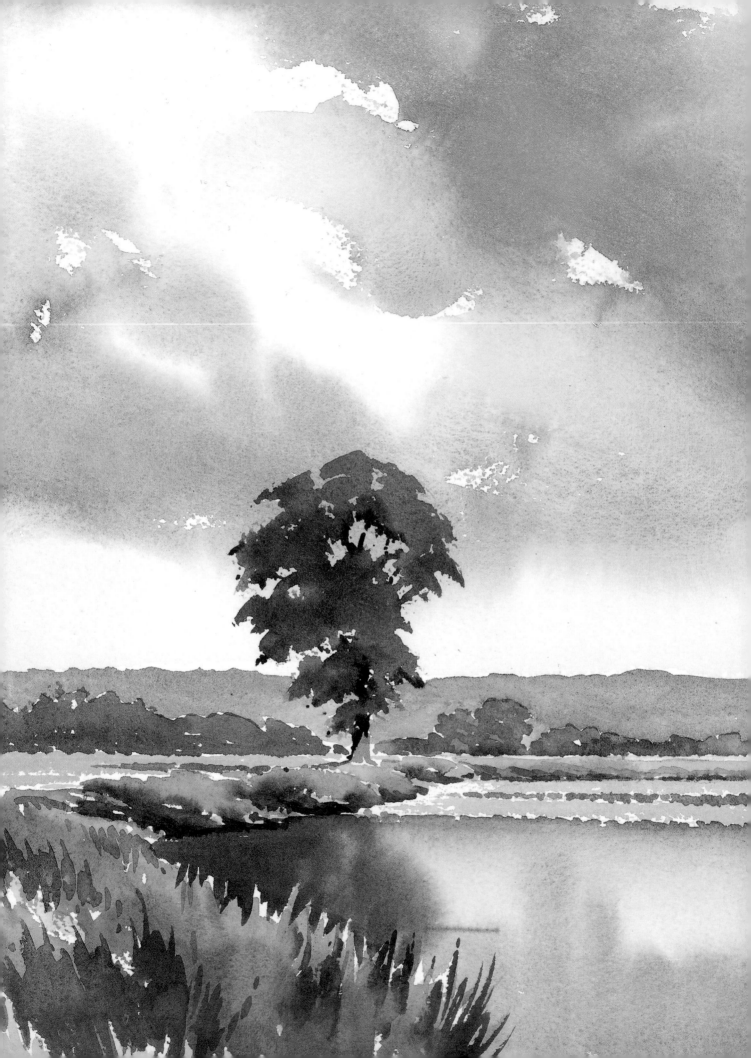

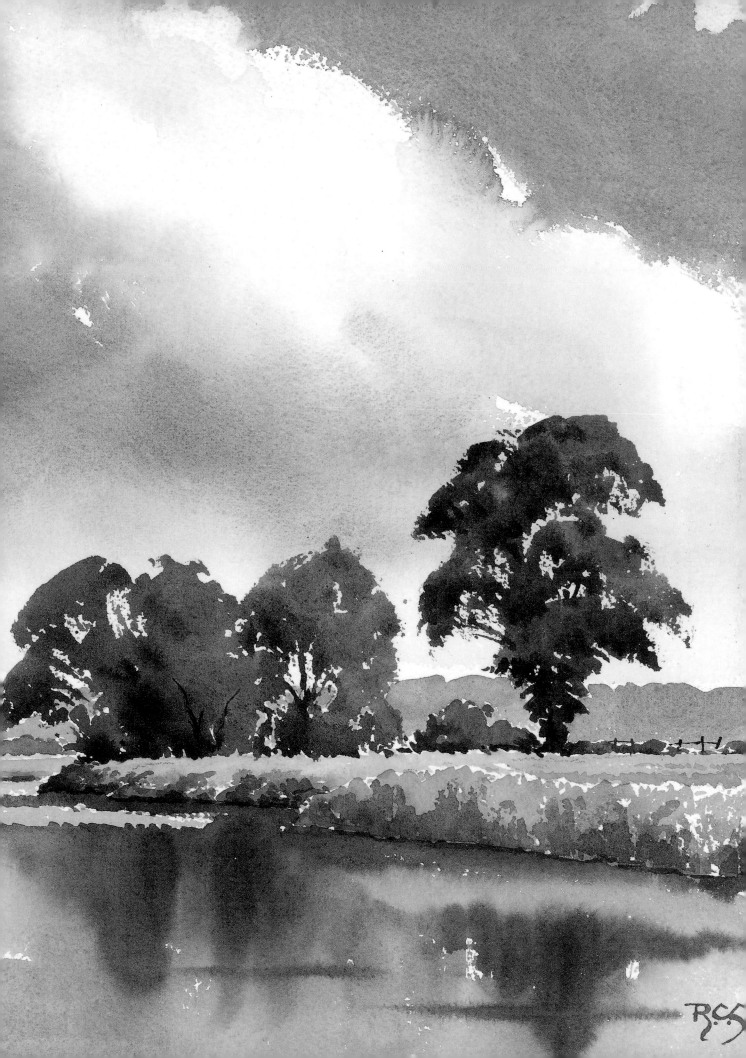

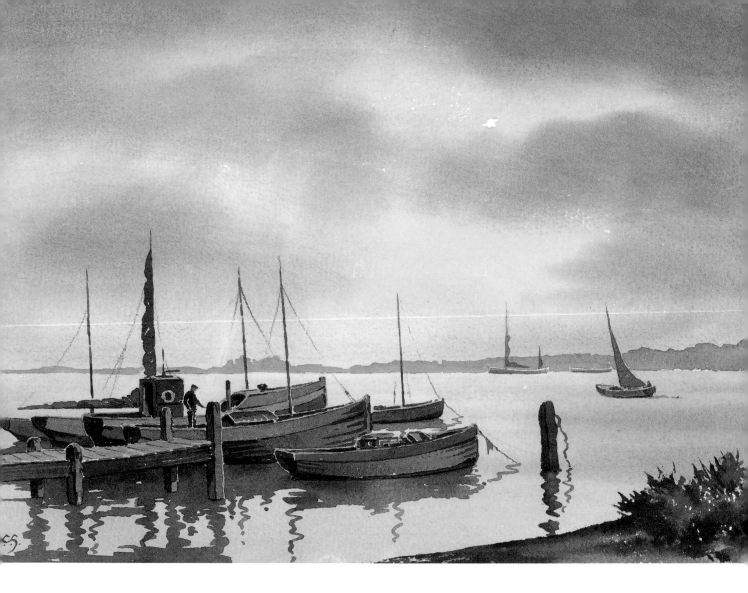

Landing Stage, Walberswick (10¾in × 14½in)
The sky and the water were painted together in one pale, variegated wash and while this was still wet, soft clouds and cloud shadows were added in a warm grey (ultramarine and light red). When this was dry, the far bank was painted in a single wash of the same grey and the boats and landing stage were added in deeper tones and a variety of colours. The near reflections were a uniform grey-green and were put in with a single wash of Payne's grey and raw and burnt sienna. Finally the dark foreground was added and this helps to balance the composition.

results painted boldly and loosely. This simple expedient alone will, with practice, solve many of the problems associated with painting water.

Watercolour is at its best when used loosely and freely and nothing should be allowed to cloud its freshness and purity. This means in practice that it should be used quickly and boldly and this, in turn, requires the omission of much irrelevant detail. How, then, should you go about painting a stretch of water? The first step is to study your subject thoroughly and analyse it carefully. The second is to plan how you are

going to simplify it and decide what inessential detail you can omit. The third is to study the tones and colours of your subject and prepare suitable washes. Only then, when everything is ready and you have planned your strategy, should you begin to apply paint. The painting process should be carried out as planned and as swiftly as possible. Changes of mind in mid-wash and attempted alterations will mean loss of freshness, so stick to your guns and carry your plan through to fruition. If there are mistakes, let them be bold and fresh, not timid and muddy.

Moving water requires even more careful planning, for here the reflections are broken up

Dorset Mill (8¾in × 11¾in)
Though many water mills were built in the early days of the Industrial Revolution, few remain in their original state. This example from Dorset is a fortunate exception. The shape of the building is a simple one, but the oblique angle gives added interest. The deep tones of the bank of trees contrast with the paler tones of the mill, and the trees themselves contain colours other than green.

by surface indications of that movement. These can sometimes be represented by horizontal chips of white paper left during the application of the initial wash or preserved by the use of masking fluid applied with discretion. These and other techniques are described in more detail in the captions in this chapter.

(overleaf)
Dartmoor Stream (10¾in × 14¼in)
This rushing stream, flowing down from the high moors, presented a very different problem, that of conveying a powerful feeling of movement.

The sombre mood of the brooding moorland setting had to be established first. The clouds were fast-moving cumulo-nimbus, put in with pale raw sienna for the lighter areas and fairly strong ultramarine and light red for the shadows. These washes were softened here and there but given some hard edges to represent the ragged outlines of the clouds.

The stark expanse of distant moorland, all in cloud shadow, was a single, deeper-toned wash of the same grey, plus a little more ultramarine, and its

uncompromising outline helped to establish the mood of the painting. More light red was added for the purplish moorland in the middle distance. The nearer banks of the stream were made up of wet rock, tawny grass and several types of moss and lichen and these were painted boldly with various washes of green, brown and tan. The deep tones of the rock were emphasised to provide contrast and make the water shine.

The peaty colour of the stream was very evident as it tumbled over a rock ledge in the foreground and for this a wash of burnt sienna, light red and a little ultramarine was used. This was applied loosely with the side of a no 10 brush, and rough arcs of white paper were left to suggest foam in the downward curving sweep of the cascading water. Before this wash had dried, its lower edge was softened with clear water to suggest foam and spray and this was given form by the addition of some pale blue-grey shadow. The water above the cascade was painted in pale tones with horizontal strokes of the brush, with plenty of paper left untouched to suggest foreshortened stretches of white water.

The treatment throughout was bold and uncompromising, to match the rugged nature of the subject.

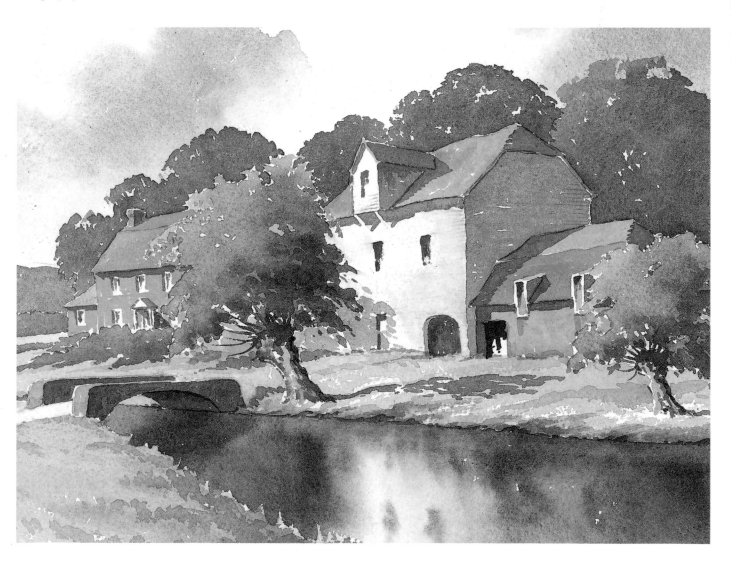

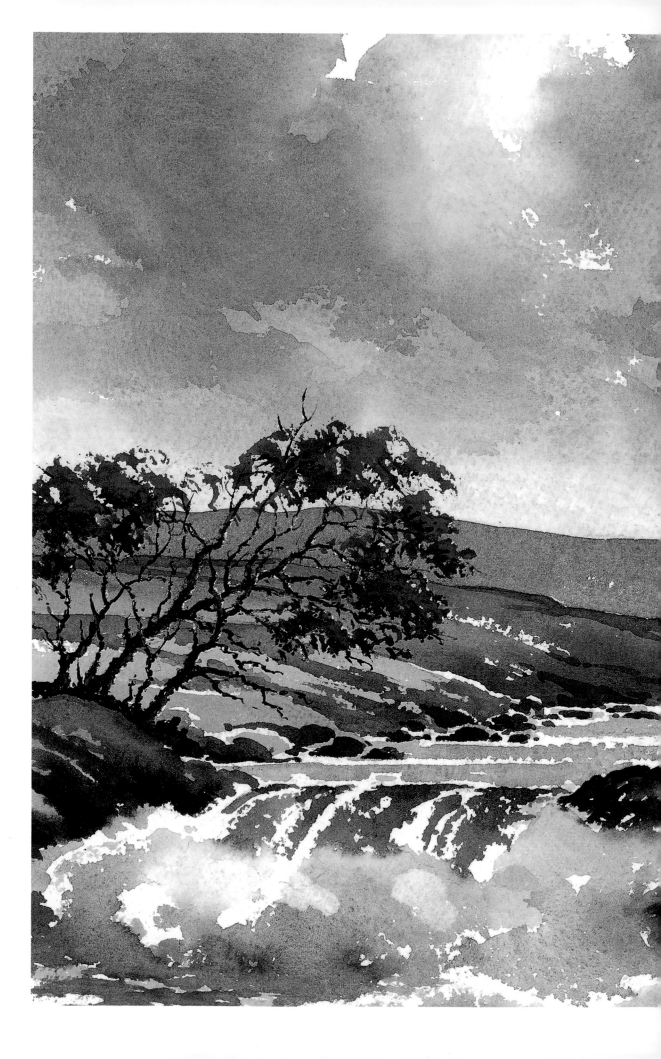

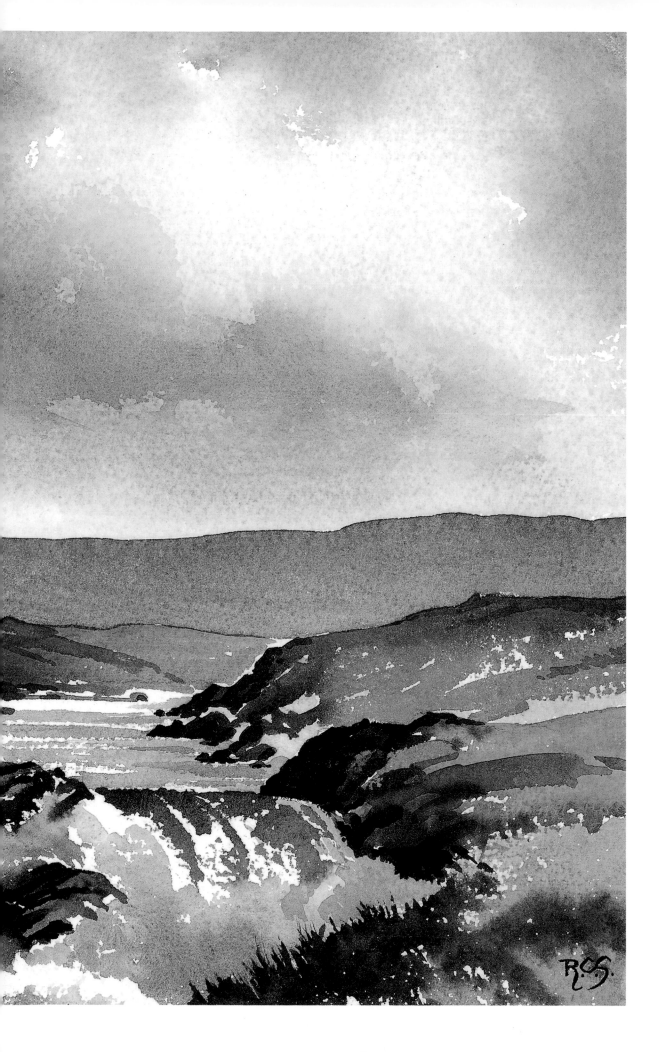

17
The Coastal Scene

The margin between land and sea has an appeal for almost everyone, an appeal which has its roots, perhaps, in happy memories of seaside holidays long ago. Whatever the origin, the shoreline and all that goes with it has a special place in our affections and this is particularly true of painters. The coastal scene is rich in subject matter and atmosphere: bustling harbours, busy boatyards, rugged headlands, broad expanses of sand, misty seascapes and many more are subjects that have appealed to artists of all eras, as our artistic heritage confirms, and will continue to provide inspiration.

There are too many areas where man's activities have destroyed this beauty, but there are others, happily, where they have enhanced it. In Cornish fishing villages, for example, cottage and harbour walls are solidly built of local stone and seem to be extensions of the living rock. Even ramshackle fishermen's huts, surrounded by nautical clutter and old boats, provide a rich feast for the perceptive painter. The important thing, as with so much in painting, is to concentrate on

mood and feeling and include only that detail which has something positive to contribute.

The sky has an even more important part to play in seascape than it has in landscape painting, for water is far more reflective than land and reacts more strongly to light and colour. So consider sky and sea together and make sure they are in harmony. The flatness and emptiness of the open sea makes you more aware of the sky above and if this is a dramatic one it may well be worth featuring by the adoption of a low horizon.

A common fault in painting seascapes is to include too many waves and we have all seen paintings in which the regular wave forms stretch away in serried ranks almost to the horizon, looking for all the world like green corrugated iron. It is far better to concentrate on no more than two or three waves and merely suggest the others. When painting the sea from the shore, remember to include the wet patch of sand left by the last retreating wave; this will be darker in tone and more reflective than the dry sand. The lines of seaweed or flotsam left by the tide are also

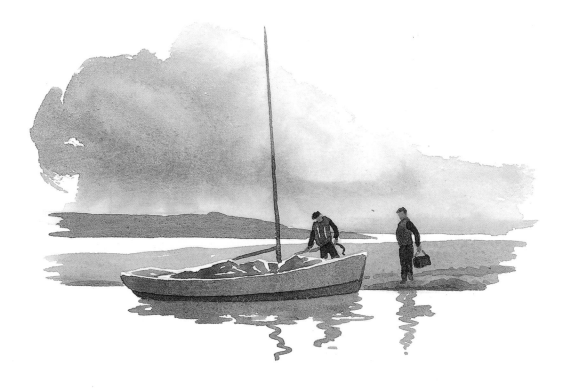

Dungeness (12in × 18¼in)
*An example of a low horizon with a lively sky
occupying over three-quarters of the paper. The
loosely painted sea features just one wave form, with
the merest suggestion of two more behind. The wet
strip of sand and the hint of a 'flotsam line' help to
describe the curve of the shoreline. Dry-brush work
has been used to suggest foam on the left and shingle
on the right of the painting.*

worth putting in for they follow the curving line
of the shore and help both composition and
perspective. This applies with particular force if
you have adopted an oblique viewpoint and are
not looking straight out to sea.

Always bear in mind that the higher you are
above the sea, the greater will be the distance to
the horizon. I remember reading somewhere a
rule of thumb to the effect that the distance to the
observed horizon in nautical miles is roughly
equal to the square root of the height in feet of
your eye above sea level. I do not include the table
of square roots in my painting haversack and
have not been able to verify this rule, but it is
clear a direct relationship exists!

Boats are a vital part of the coastal scene and
can add greatly to the interest of a painting. They
come in all shapes and sizes from pleasure yachts
with their sleek and elegant lines to beamy old

fishing craft with their solid, uncompromising
shapes. Boats are notoriously difficult to get right;
viewed in profile there is no particular problem,
but at an oblique angle the subtle curves of hull
and gunwhale demand close observation and
careful drawing.

Rigging is another problem and the best advice
here is to leave out all but the principal and most
obvious ropes and even these may be the better
for being merely suggested. The inclusion of every
rope in sight is a recipe for disaster, and the craft
in question will end up looking like the proverbial
cat's cradle. How you actually tackle ropes will
depend largely upon your watercolour style; if
your approach is fairly loose, accurately painted
rigging will be out of place and quick, broken
lines will look better. Lines of rigging are usually
seen against the sky so any errors are virtually
impossible to correct, so practise on scrap paper
until you are confident you have mastered the
effect you want.

Coastal scenes can benefit greatly from the
inclusion of well-placed figures so here too it is
worthwhile cultivating the sketch-book habit so
that you have material to press into service when
you need it. Children playing on the sands and
fishermen tending their boats are not always
available when you want them and this is when
a well-stocked sketch-book can come to your aid.

Quick figure studies are fun to do and regular practice will sharpen your observation and improve your technique. Even a lonely stretch of coast can sometimes do with a figure or two to give scale and provide a focal point and a sandy shoreline can be given extra interest by the inclusion of children building sand castles or fishermen digging for lugworms. In bright conditions there is great radiance over the sea and figures will appear very dark against it. So use deep tones and these will help to make the water shine.

Rocks along the shoreline need more careful observation and treatment than they often receive and are sometimes made to look like shapeless lumps of brown putty. Even when smoothed by the action of tides they have a distinct structure which derives from the underlying stratum of the original rock mass. This often shows itself in parallel faults, fissures and lines of weakness. These are constantly attacked by the waves and a definite, if random, pattern results. Their colour will, of course, depend upon the type of underlying rock and will be modified by seaweed.

Coastal scenery provides a wonderful diversity of subject matter for painters of all tastes and techniques. Subjects such as boatyards and har-bour scenes call for a considerable amount of detail. Others, consisting of sea, sand, sky and little else, are tailor-made for quick watercolour studies and it is with these that the medium is perhaps at its best and most expressive. Misty conditions, when sky and sea merge, can inspire the watercolourist to produce paintings rich in atmosphere and mystery.

Norfolk Fishing Boats (10⅝in × 16¼in)
These venerable, clinker-built hulls, which now boast more modern superstructures and radio equipment, and still fish the North Sea in most weathers, were moored in a sheltered tidal inlet. They were carefully drawn and rapidly painted with plenty of tonal contrast. The calm water was a broken wash of pale blue-grey applied with quick horizontal strokes of a large brush. When this was dry the pale reflection of the far bank was added and the much stronger foreground reflection put in with a deep wash of grey-green. While this was still wet a little dark grey, red and blue were dropped in to provide local colour.

Children on the Beach

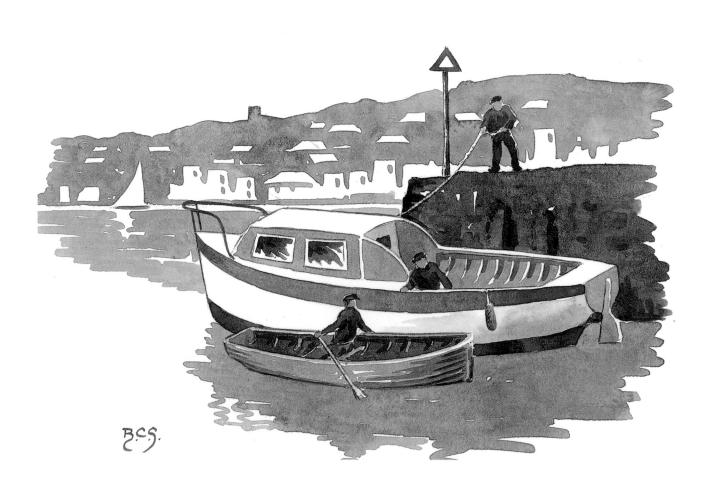

Shrimpers (10⅞in × 14½in)
The deep tones of the two figures register strongly against the pale treatment of sea and sky. A spent wave and a strip of wet sand occupy most of the foreground. Only one wave has been given any prominence though several more have been broadly indicated.

The sky is a pale, variegated wash, shading from pale blue to warm yellow at the horizon. A distant cloud shadow and a slightly firmer treatment of the wave forms on the right help to balance the figures and their reflections.

The dark accents of the figures impart a shine to the backdrop of sea and sky and this is what the painting is really about.

(overleaf)
Beached Fishing Boats (13¾in × 19¾in)
A favourite theme, this, of solid, wooden fishing boats drawn up on a shingly beach. Once again, a low horizon gives full scope to a strongly painted cloudy sky. The deep tones of the boats and the winch make a strong statement against a luminous patch of sky. The clutter by the boats and the foreground shingle have been painted quickly and loosely in deep tones that also contrast with sea and sky. A similar subject to Dungeness but a very different treatment.

113

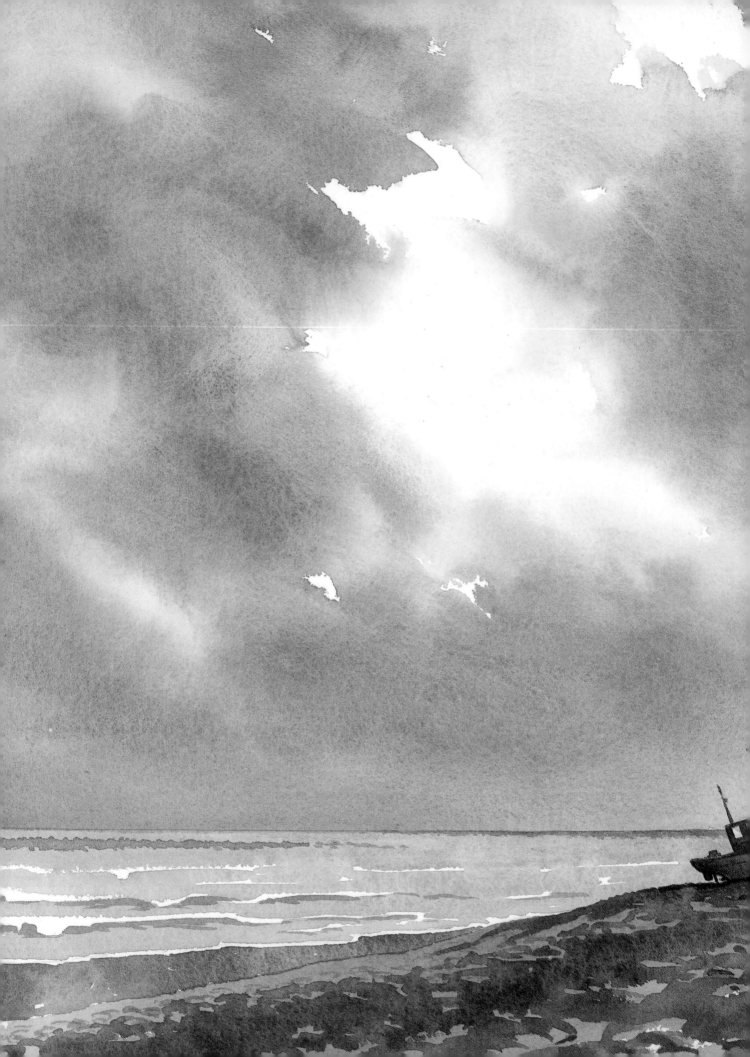

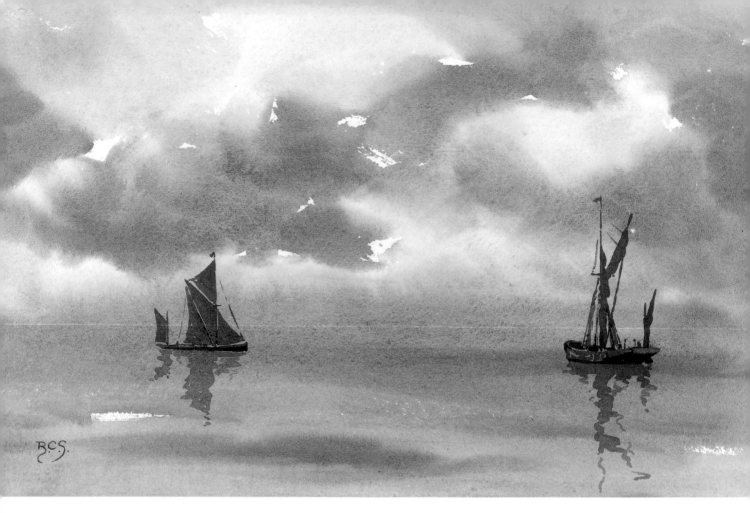

Lost Horizon (10¼in × 15¾in)

The soft clouds, the mist-obscured horizon and the calm sea combine to produce a feeling of tranquillity and the restrained use of colour reinforces this atmosphere of peace.

Three liquid washes were prepared, the first of raw sienna slightly warmed with light red, the second of ultramarine and light red and the third of Winsor blue with a little raw sienna. The wash of pale raw sienna was applied first, with a 1in brush, and the cloud shadow added with a second large brush dipped in the wash of warm grey. The third wash of pale Winsor blue was applied with broad, horizontal strokes of another 1in brush to represent the sea and to this several touches of the warm grey were added. All this was done in a matter of seconds, painting wet in wet, and the paper allowed to dry.

All that remained was to paint in the two old sailing barges, one in full sail to catch the light breeze, the other at anchor, and add their greenish reflections in the calm sea.

Digging for Lugworms

18
Atmosphere in Watercolour

For the landscape painter, mood and atmosphere are largely determined by the weather and by the quality of the light. Mist and fog, by softening outlines and obscuring detail, can lend an air of mystery, and sometimes of magic, to a mundane scene. The presence of grey cloud can establish a sombre mood while dark and lowering storm clouds can create an atmosphere of menace and doom. Sunlight has the opposite effect and evokes a sense of happiness and well-being. Between the extremes of violent storm and tranquil sunshine is a whole range of atmospheric effects for the artist to study, to analyse and to interpret. He should always be keenly aware of the quality of the light and its effect upon the landscape, for these are the main ingredients of mood and atmosphere in painting, and everything else should be subordinated to them.

A loose style of painting which suggests the subject matter instead of describing it in exact and literal detail, helps considerably in the creation of atmosphere. It leaves something to the imagination and when people's imaginations are stirred, they supply their own answers to the questions the painter has left unanswered. They will react differently and the individual's imagination will fill the gaps in different ways. This does not matter provided the painter has succeeded in striking a chord and in touching their emotions. Subject matter also has a part to play in building atmosphere but it is a subordinate one and the effects of light are dominant.

In this chapter we shall consider the moods which result from various types of atmospheric and light conditions and find out how they may be most effectively created by the watercolourist. Some of this advice has already been offered in a slightly different form in the chapter on skies, but it is at the heart of the landscape problem and bears repetition and emphasis.

Watercolour is the perfect medium for capturing the subtle effects of mist and fog. Painting wet in wet produces the blurred images and the soft outlines that such conditions demand, where detail is unimportant and mood is everything. The more distant the objects, the more they will be softened by the intervening atmosphere and if this effect is faithfully reproduced, a strong feeling of recession will be created. The immediate foreground, where the influence of the mist is

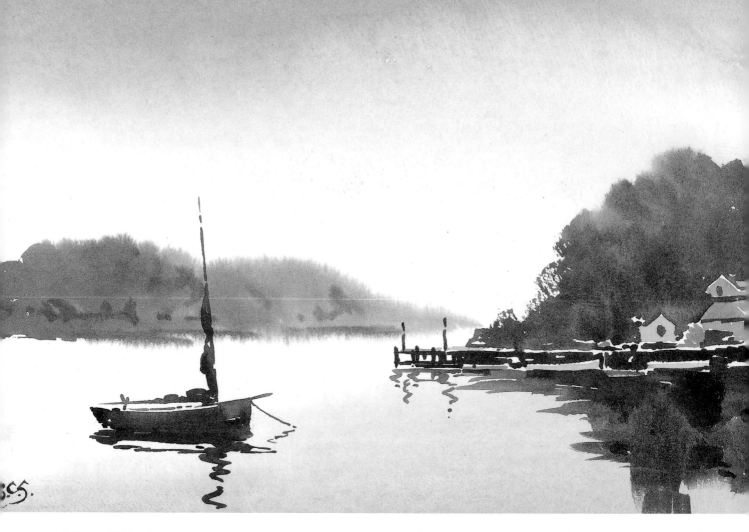

Moored Dinghy (9¼in × 13in)
*The early morning light which flooded the estuary
was the inspiration for this quick impression. While
the pale, variegated wash of the sky was still wet, the
distant shoreline was painted, wet in wet, to capture
its misty outline. The nearer land form on the right
and its reflection were added in stronger, warmer
colours when the sky wash was almost but not quite
dry. The moored dinghy, in deep grey silhouette, and
the deep-toned foreground were added last, and, by
contrast, impart a shine to sea and sky. The soft-
edged grey of the distant land strongly suggests
recession.*

minimal, can be painted sharply and crisply and
will create a dramatic contrast with the mistiness
of more distant forms.

Mist is rarely given credit by beginners for
possessing any colour of its own and is frequently
painted a pale and indeterminate grey. While this
can be true in certain conditions, mist often has
a suggestion of warmth about it, particularly in
urban areas, and can also possess a range of
subtle pearly colours. These are well worth
seeking out and will add greatly to the truth and
the appeal of your work.

The wet-in-wet technique demands a sure

touch, quick execution and correct timing, and
these will only come with practice. Once washes
have been applied they should be left alone for
any attempted modification, once the drying
process has begun, invariably spells disaster. If
some alteration is unavoidable, wait until the
washes have thoroughly dried, then wet the area
with clear water and apply more paint as neces-
sary. This must be done with the lightest touch to
avoid disturbing the earlier wash.

When painting clouds, always allow for the
inevitable fading that occurs on drying. What, in
liquid form, may look impressive and menacing,
may well dry out to look tame and anaemic.

Woodland Walk (14¼in × 10¾in)
*The object of this painting was to capture the effects
of soft sunlight filtering through the misty foliage of
an autumn wood. The luminous patch of sky was
palest Winsor blue and raw sienna and while this was
still wet, a warm grey of ultramarine and light red
was painted, wet in wet, to suggest the surrounding
misty foliage. Warmer greens and browns were added
to the grey for the nearer masses of foliage. The sunlit
areas of the tree-trunks on the left were preserved
with masking fluid. The figures were added last to
provide a focal point.*

118

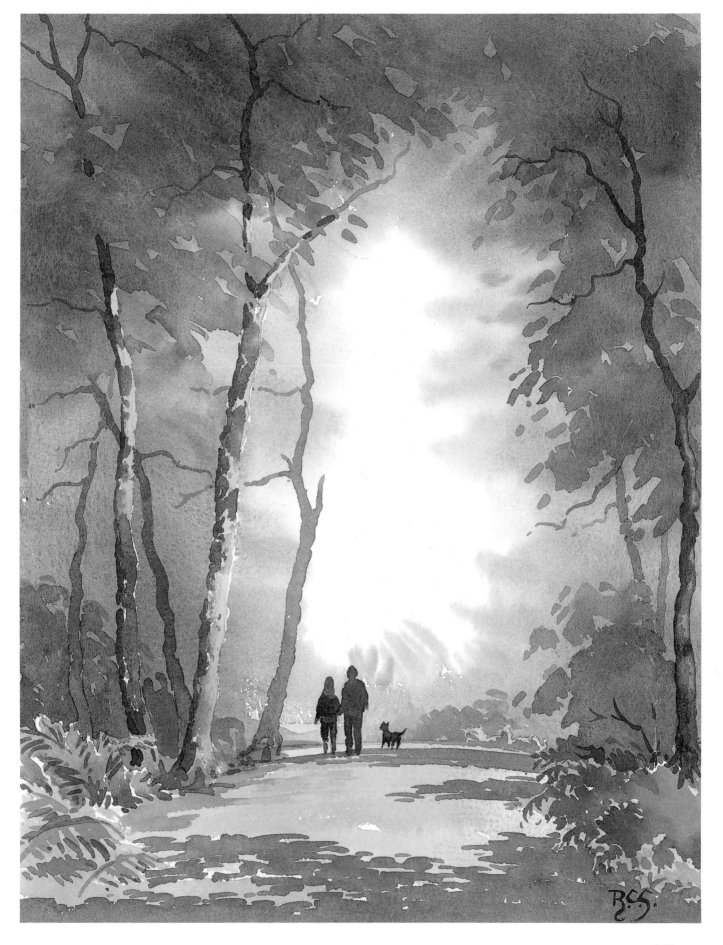

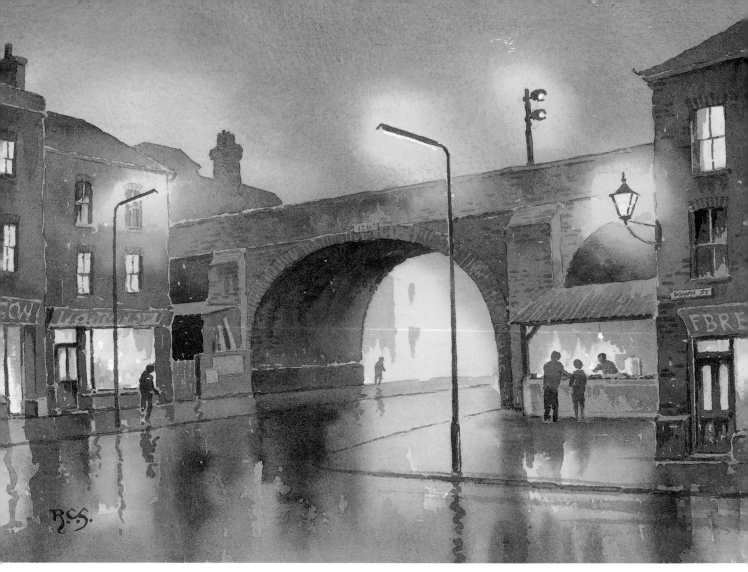

The Coffee Stall (10⅛in × 13¾in)

This is a mood painting of a very different kind in which the object was to capture the misty, drizzly atmosphere of an inner city scene by night. Only three colours were used: ultramarine, light red and raw sienna. Pale raw sienna was used for the areas of radiance round the street lights and, warmed here and there with light red, for the lit house and shop windows. Various mixtures of ultramarine and light red were used for the murky sky and raw sienna was added for some of the houses and the brick viaduct. The tone and colour of the old brickwork have been varied to provide interest and the material has been indicated by the painting of a few random bricks.

The diagonals of viaduct and roadway provide a more pleasing composition than a four-square arrangement would have done. The reflections in the wet road are a mixture of hard and soft edges. The figures were placed against patches of light to provide tonal contrast.

While it is always possible to add strength by applying a second wash, the result will never be as lively and impressive as a strong initial wash. Boldly painted clouds and their equally bold shadows on the land below can add enormously to the power and the atmosphere of a landscape. A cheerful summery atmosphere is created by tiny puffs of white cloud in a blue sky while the smooth, level layers of stratus cloud generally produce a calm and peaceful mood, as do most horizontal forms.

Rain squalls, particularly when they occur over mountain or sea, can add to the interest and the character of a painting. They are best described by slanting, soft-edged strokes of a broad brush, from the base of a dark cloud. Attempts to paint individual drops of rain by a succession of oblique lines are rarely successful.

Always assess carefully the temperature of the light which can be warm on the coldest of days and analyse the quality of the sunshine: is it bright and strong or weak and watery? Is it warm or cold, clear or misty? The answers to these questions will vitally affect the mood of your painting.

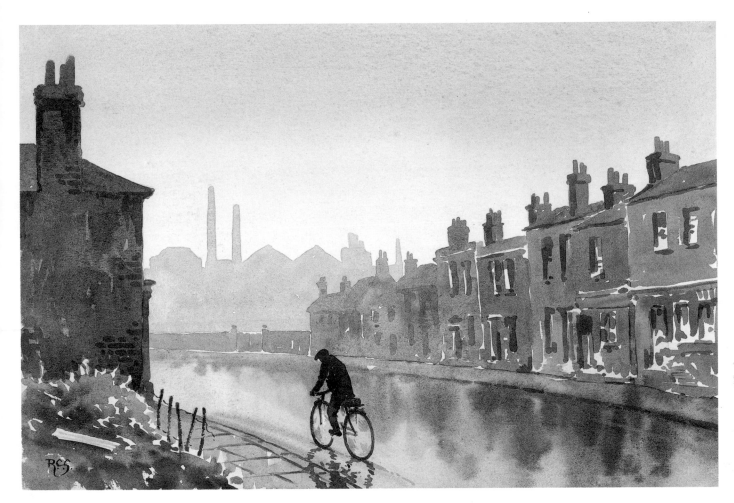

An overall glaze can sometimes pull a painting together, particularly in cases where the sky and the land do not seem to be entirely in harmony. A warm-coloured wash applied over the whole paper can provide a unifying glow, but a word of warning here: the operation must be carried out quickly and gently or the underlying painting may be disturbed. Earth colours, particularly when used heavily, are the most vulnerable to disturbance by glazing washes of this kind.

The effects of light falling on the landscape need careful consideration, especially on days when there is much broken cloud. If these areas of radiance are distributed widely, they can produce a patchy, disjointed effect and it is usually better to concentrate them in one area which could be your centre of interest.

Light and shade are the twin keys to atmosphere in the landscape and if you do them justice they will add immensely to the success of your painting.

Early Shift (9¾in × 14¾in)
The atmosphere of this quick watercolour sketch relies mainly on the subject matter: a damp and cheerless early morning scene in which a lonely, hunched figure pedals doggedly towards the distant factory. This mood is reinforced by the loose, watery style of the painting and by the muted colours which suggest the 'cold, grey light of dawn'. The misty atmosphere is established by the progressive lightening and greying of the buildings as they recede into the distance.

(overleaf)
Near Shap Fell (10¼in × 10¾in)
This painting illustrates some of the points made in the text. The heavy cloud mass on the left looked altogether too dark while it was wet, but, as expected, it dried out about right. A loose, diagonal wash from its base suggests an approaching rain squall and the deep tones of the cottages and foreground register strongly against the bright patch of sky and make it shine.

Notice how the low horizon focusses attention upon the strongly painted sky which determines the mood of the painting.

121

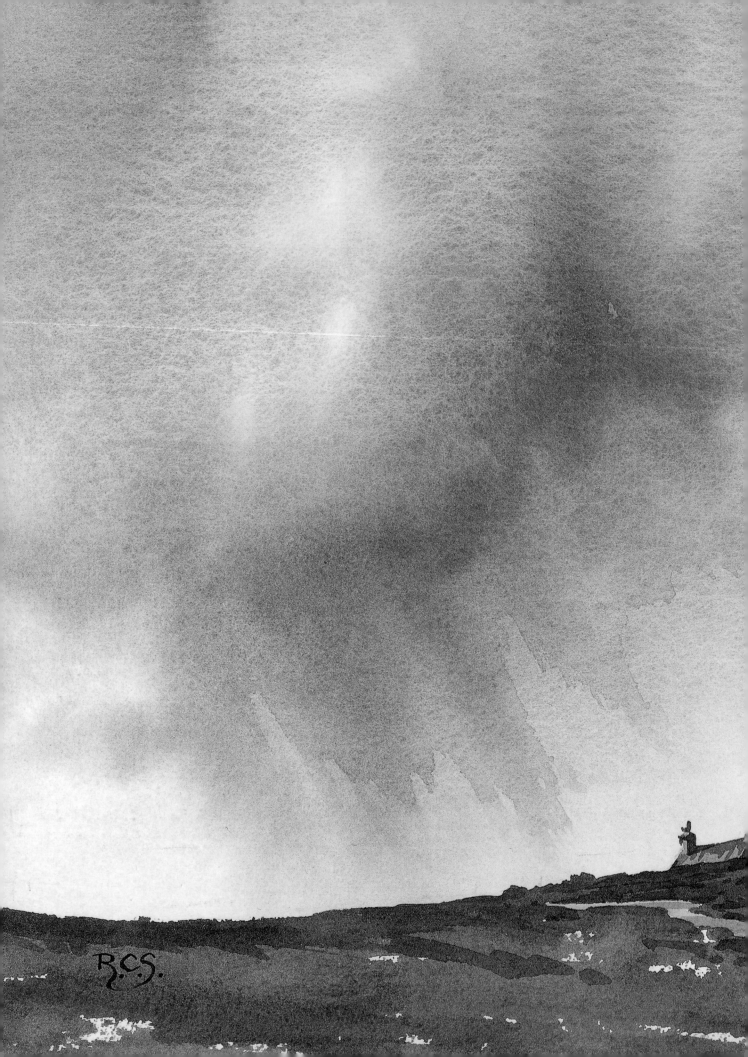

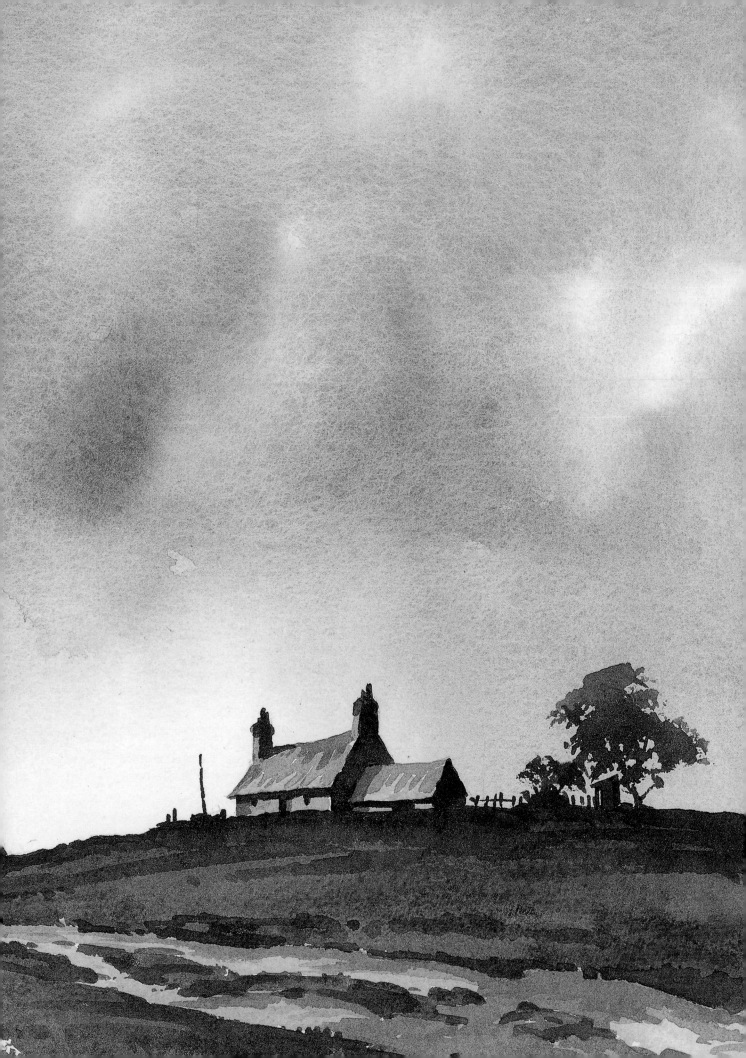

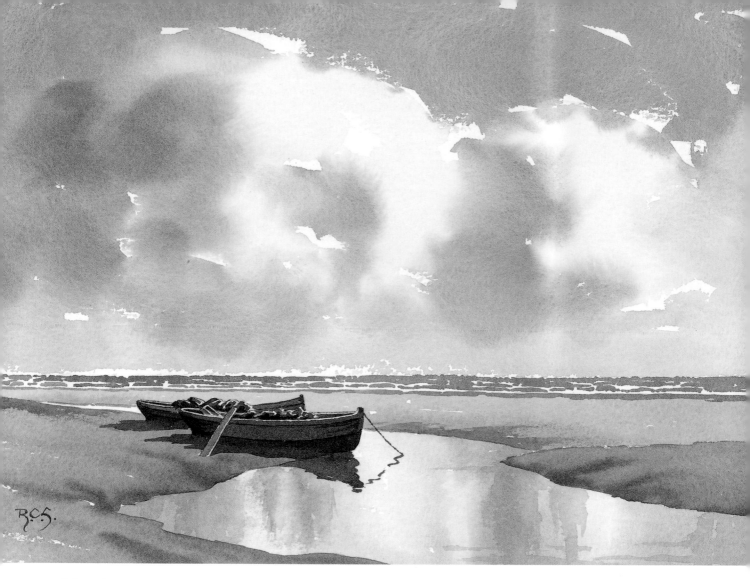

(above)
Lonely Shore (10½in × 14⅜in)
The mood engendered by this painting stems largely from its theme – two boats against a deserted shore – and from the treatment of the subject matter. The boats, deep-toned against a pale background, emphasise the emptiness of the scene while the horizontal composition and the smooth foreground water reinforce the feeling of peaceful isolation.

In Conclusion . . .

Most students long to develop a distinctive style of their own and sometimes set out deliberately to acquire one, perhaps by imitating the mannerisms of established painters. This is a road that leads nowhere. It is far better to let your style develop naturally, as it will do in time. We are all influenced by the work of painters we admire and our own painting is bound to reflect this, but that is a very different thing from consciously trying to reproduce their manner of painting.

Style is an amalgam of many things: the way we put on paint; the colours we use; the sort of compositions we prefer; and in the last resort reflects the way we see our surroundings. So be true to your vision of the world, paint in the way that is natural to you and in time a genuine style will develop.

Bon voyage!

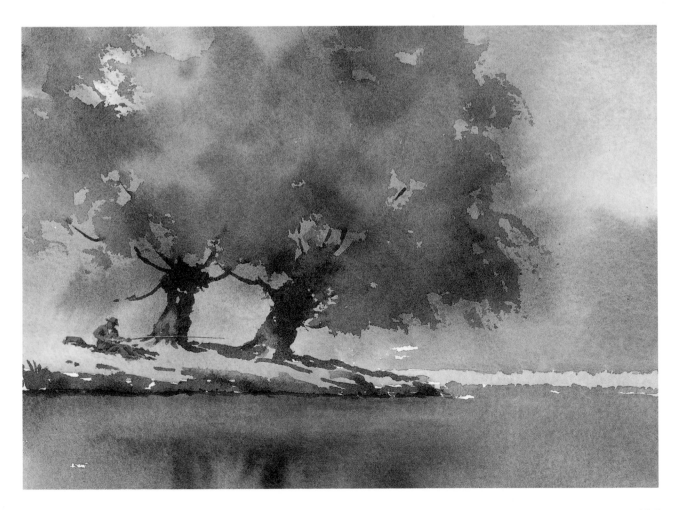

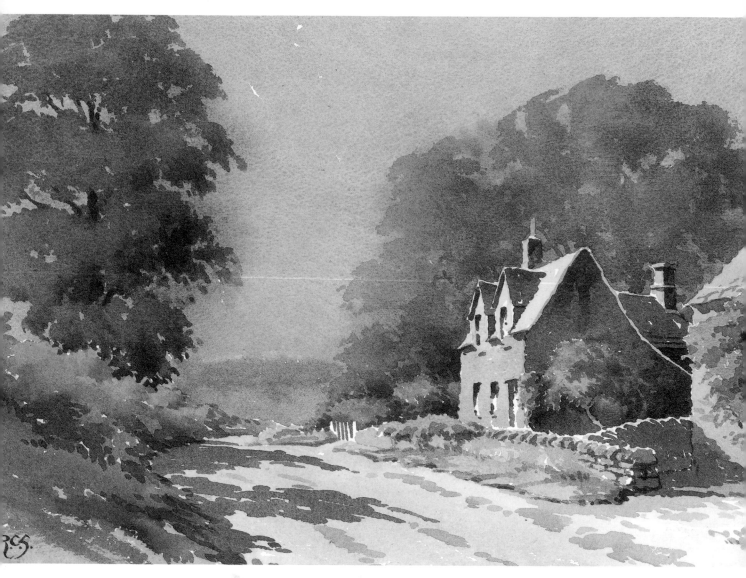

Autumn in East Leach (10½ × 15in)

Acknowledgements

I would like to thank my editor, Faith Glasgow,
for her help and advice; Maureen Gray for
converting my scrawl to orderly typescript;
and my wife Eileen, for her constant
encouragement and support.

Index

Colour pictures are indicated by the use of **bold** type for page numbers.

USDesign
1975–2000

INTRODUCTION
R. CRAIG MILLER

ESSAYS BY
ROSEMARIE HAAG BLETTER
DAVID G. DE LONG
THOMAS HINE
PHILIP B. MEGGS AND
R. CRAIG MILLER

USDesign
1975–2000

PRESTEL VERLAG
MUNICH · LONDON · NEW YORK
IN ASSOCIATION WITH THE **DENVER ART MUSEUM**

This book is published in conjunction with the exhibition of the same name organized by the Denver Art Museum.

Editor, Denver Art Museum: Anne Hoy
Publication assistants: Shannon K. Corrigan, Mindy Besaw
Editorial direction at Prestel: Courtenay Smith
Editorial assistance at Prestel: Danko Szabó, Curt Holtz, and Beatrix Birken
Production at Prestel: Ulrike Schmidt
Index compiled by: Michael Robertson, Augsburg, Germany

EXHIBITION TOUR
DENVER ART MUSEUM DENVER, COLORADO **FEBRUARY–MAY 2002**
BASS MUSEUM OF ART MIAMI, FLORIDA **FEBRUARY–MAY 2003**
AMERICAN CRAFT MUSEUM NEW YORK, NEW YORK **JUNE–OCTOBER 2003**
MEMPHIS BROOKS MUSEUM OF ART MEMPHIS, TENNESSEE **NOVEMBER 2003–FEBRUARY 2004**

NOTES TO THE READER
In measurements, height precedes width precedes depth. The information in the biographies and captions is the most recent available and was submitted to all designers for verification. We are pleased to publish biographies of all those who responded. For further reading about the subjects of the essays, please consult the endnotes.

Library of Congress Cataloguing-in-Publication Data
R. Craig Miller, Rosemarie Haag Bletter et al.
USDesign 1975–2000. Catalogue of an exhibition organized by the Denver Art Museum. Includes index.
ISBN 3-7913-2734-8 (softcover)
ISBN 3-7913-2684-8 (hardcover)
1. American design. Exhibitions.
I. Miller, R. Craig, 1946. II. Bletter, Rosemarie Haag. III. Denver Art Museum

Design and typography by SMITH, London
Lithography by Repro Ludwig, Zell am See
Printed by Jütte Druck, Leipzig
Bound by Kunst und Verlagsbuchbinderei, Leipzig
Printed in Germany on acid-free paper

Prestel books are available worldwide. Visit our Web site at www.prestel.com or contact one of the following Prestel offices for further information.

PRESTEL VERLAG
Mandlstrasse 26, 80802 Munich
Tel. +49 (0) 89 38 17 09-0, Fax +49 (0) 89 38 17 09-35

4 Bloomsbury Place, London WC1A 2QA
Tel. +44 (0) 20 7323-5004, Fax +44 (0) 20 7636-8004

175 Fifth Avenue, New York 10010
Tel. +1 (212) 995-2720, Fax +1 (212) 995-2733

Foreword

As an institution, the Denver Art Museum is now 109 years old, but its growth has been most rapid in the last quarter century—the vital period in American design appraised in this book and exhibition. This transformation has occurred as Denver itself has gone through a phenomenal period of expansion, much like that of Los Angeles after World War II. Recognizing that Denver is a relatively new urban center in the American West, the Museum has made a major commitment to the art of our time and, in particular, to contemporary design on a number of levels.

In terms of architecture, there was an important precedent. When the Museum trustees elected to build a new building in 1965, they decided to hire an internationally acclaimed architect, the Italian Gio Ponti, to design a signature structure, completed in 1971. When it was decided to build a new wing in 1999, an international competition was held, and Daniel Libeskind, the American architect based in Berlin, was selected. His dramatic crystalline structure will open in 2005.

Commissioning architecturally significant buildings is only one part, however, of the Denver Art Museum's involvement with the design arts. Over the past decade, the Museum has made a major commitment to building one of the preeminent modern design collections in the United States. This effort began in 1990 when R. Craig Miller moved to Denver to take on the responsibilities of the newly formed Department of Architecture, Design & Graphics. Since that date, Mr. Miller has organized a number of important exhibitions on aspects of modern architecture, design, and the graphic arts. Indeed, the Department's modern design collection—stretching back some 250 years to the very beginning of the modern movement—is unusual among American museums in its encompassing view of international design and in its decision to place the present in a larger historical perspective.

A centerpiece of this encompassing program has been the *Masterworks* series of exhibitions focusing on contemporary design. It began with *Italian Design, 1960–1994*, which opened in the fall of 1994 and was subsequently toured in North America by the American Federation of Arts. The exhibition **USDesign 1975–2000** is the second project in this series. The genius of the *Masterworks* series lies not only in defining the aesthetic currents of countries preeminent in design, but also in selecting and celebrating the most extraordinary designs that their artists have created.

A second and equally important function of the *Masterworks* series is the creation of an encyclopedic contemporary design collection for the Denver Art Museum. It is Mr. Miller's intention that a majority of the works exhibited in the series would be acquired for the Museum and would become the core of its larger modern design holdings. I would like especially to acknowledge the generous assistance of Mrs. David M. Stewart and Joel and Carol Farkas in helping to make many of these acquisitions possible. It has been, of course, marvelous as Director to watch these two exhibitions take shape, bringing clarity to this complex field of art history. And it has been rewarding to see a collection take form that reflects the dominant tastes of the late twentieth century and a new century, periods that are as beautiful and as dynamic as any represented within the Denver Art Museum's other permanent collections.

I commend Mr. Miller for his vision and acknowledge the support of the Denver Art Museum, its Board of Trustees, and especially The Design Council, whose members have so tirelessly supported Mr. Miller in this series of exhibitions and the collections that have grown from them.

In order to realize an exhibition of the breadth and complexity of **USDesign**, Mr. Miller invited a number of nationally recognized scholars to work with him to shape the show and to write major essays to define its areas of interest. Two guest scholars need to be acknowledged for their important contributions. Thomas Hine, an author on design, architecture, and social history, has written an engaging essay that deals with the impact of American popular culture on architects, designers, and graphic artists of the twentieth century. Rosemarie Haag Bletter,

Professor at the City University of New York Graduate Center, has focused her essay on the theoretical and philosophical issues confronting the designers and the culture for which their art was created. Two guest curators must also be thanked for their assistance in this project. David G. De Long, Professor of Architecture at the University of Pennsylvania, has written an illuminating essay on major architects and important trends in American architecture since the 1960s. Philip Meggs, Professor at the Virginia Commonwealth University, contributed an essay taking on—as he has so often—the complex topic of contemporary graphic design. And, of course, Craig Miller has written an essay on American decorative and industrial design during this quarter century. This group of guest scholars and curators defined the show intellectually with Mr. Miller, participated in a number of meetings from which the exhibition checklist evolved, and collaborated as an insightful team to create the **USDesign** exhibition and catalogue.

Special thanks are owed to the Museum's Department of Architecture, Design & Graphics on this occasion— and in general. As department head, Mr. Miller has, of course, shaped the long-term vision of the Department, and he has been ably and creatively supported by his colleagues there. Carla Hartman, Master Teacher for the Department, has been a close collaborator, finding a host of inventive ways to introduce objects and design concepts relating their genesis to the Museum's many visitors. Shannon K. Corrigan, Curatorial Assistant and Project Manager, has been a mainstay of **USDesign**, aiding Mr. Miller and the staff of the museum as this complex exhibition became a reality. Mindy Besaw, Project Assistant, has ably seen to hundreds of details as an invaluable partner in this endeavor.

Acknowledgment and thanks must also be given to a number of project consultants. David A. Hanks has been a critical sounding board to Mr. Miller and the guest scholars and curators in the organization of this exhibition. His firm, Exhibitions International, has worked closely with the Denver Art Museum to organize the national tour for **USDesign**. We greatly appreciate the expertise of Mr. Hanks and Exhibitions International in bringing this important show to a wider audience.

A special note of gratitude always needs to be given to the editor of a catalogue, and in this case Anne Hoy must be acknowledged. Working with a team of authors is always a challenge and Ms. Hoy has done it capably, helping to produce an informative and attractive publication that will have a lasting value to the field of twentieth-century design. Melissa Martin made a significant contribution as the editor of the biographies of the designers included in the show. And we are extremely fortunate in the publication of **USDesign** to have collaborators of the stature of Jürgen Tesch and his staff, notably Courtenay Smith at Prestel in Munich and the designer Stuart Smith of SMITH, London. Their reputation and proficiency have guaranteed the quality of this catalogue and the circulation that a book of this subject matter deserves.

A very special thanks must be given to the project's two primary patrons. The entire field of American art is indebted to the Henry Luce Foundation in New York. In this case, it supported the research for the exhibition and catalogue with a substantial grant to the Denver Art Museum. I am always deeply appreciative of the Luce Foundation's willingness to support new ventures that enable us to better understand the arts of this country.

And, finally, we express our gratitude to the National Endowment for the Arts. Without its ongoing support for museum projects across the country, so many of the exhibitions and programs that museum professionals dream about creating for their institutions would never become a reality.

Lewis I. Sharp
Director, Denver Art Museum

Acknowledgments

USDesign 1975–2000 and the exhibition it accompanies are the result of the dedicated work of talented colleagues both inside and outside of the Denver Art Museum. It is a great pleasure to acknowledge them here.

When the project was in the conception stage, Suzanne Frantz, David A. Hanks, Ellen Lupton, Nina Stritzler-Levine, and Adele Chatfield-Taylor and the staff of the American Academy in Rome provided invaluable ideas and advice.

In realizing the exhibition and publication and assembling their myriad components, we could not have proceeded without the generous assistance of all the architects, designers, and graphic artists represented in these pages. For their special help, we thank the following architects and the staff of their firms: Winka Dubbeldam, Peter Eisenman, Michael Graves, Craig Hodgetts and Ming Fung, Steven Holl, Jim Jennings, Ronald Krueck and Mark Sexton, Maya Lin, Mark Mack, Thom Mayne, Eric Owen Moss, Donald Powell and Robert Kleinschmidt, Bart Prince, George Ranalli, Stanley Saitowitz, Frederic Schwartz, Stanley Tigerman and Margaret McCurry, Billie Tsien and Tod Williams, Robert Venturi and Denise Scott Brown, and James Wines.

Equally helpful were the following designers and design manufacturers and their staffs: Alessi Inc., Harry Allen, Baldinger Architectural Lighting, Constantin and Laurene Boym, Eric Chan, Comfort Products Inc., Craftwood: Division of Sonnerberg Industries Limited, Christopher Deam, Design Central, Design Logic, Nick Dine, frogdesign, Lyn Godley and the late Lloyd Schwan, Michael Graves, the late David Gulassa and Gulassa & Co., Dorothy Hafner, Katrin Hagge, Herbst Lazar Bell, Steven Holl, Daven Joy, Kravet Couture, Knoll Inc., Lisa Krohn, Ronald Krueck and Mark Sexton, Henner Kuckuck, Susan Lyons, Thom Mayne, Ross Menuez, Oakley, Josh Owen, Pollack Studio, Radius Toothbrushes, George Ranalli, Karim Rashid, Frederic Schecter, Frederic Schwartz, Smart Design, Michael Solis, Spy Optic, Peter Stathis, Gisela Stromeyer, Ali Tayar, Thomson multimedia Inc., Suzanne Tick, Stanley Tigerman, Vent Design, Robert Venturi and Denise Scott Brown, Tucker Viemeister, Allan Wexler, and Ziba Design.

We are also particularly indebted to the following graphic designers and their offices: Erik Adigard, Charles S. Anderson, Fabien Baron, Michael Bierut, David Carson, Art Chantry, Peter Comitini, Cronan Design, Ned Drew, Duffy Design Group, Louise Fili, Alexander Gelman, Tomás Gonda Estate, Gr8 Inc., April Greiman, Clifford A. Harvey, Kit Hinrichs, Jonathan Hoefler, Alexander Isley Inc., Seth Jaben, Haley Johnson Design Co., Chip Kidd, Barbara Kruger, Willi Kunz, Warren Lehrer, M & Co., Katherine McCoy, Modern Dog Design Co., Morla Design, Frank J. Oswald, Pentagram, Woody Pirtle, R/GA, Reverb, Paula Scher, Carlos Segura, Helene Silverman, Nancy Skolos and Thomas Wedell, Sussman/Prejza & Co. Inc., Turner Duckworth, Michael Vanderbyl, Rudy VanderLans, James Victore, Tamotsu Yagi, and Yee-Haw Industries.

There were many individuals who gave special assistance or advice during this project. We would especially like to acknowledge the Boyd & Drief Fine Textiles and Furnishings LLC, LeRonn Brooks, Eric Chan, Roberta Gilboe, Lisa Green, Sheila Hicks, Katherine Hiesinger, Seth Hinshaw, Gretchen Holt, Suzanne Hyndman, Fran Kessler, the Knoll office in Denver, Jack Lenor Larsen, Denise McLee, Keith Mendenhall, The Monterey Museum of Art, Victoria Newhouse, David Shearer, William Whitaker, Michael Regan, the Library Archives of the University of California, Berkeley, Frederic Schwartz, Sarah Wayland-Smith, and Tucker Viemeister.

In addition to those designers who graciously lent works from their collections, we would also like to thank the following individuals and institutions for their loans to the exhibition: Rheda Brandt, the Canadian Centre for Architecture, the Cranbrook Art Museum, DesignTex Inc., the Deutsches Architektur Museum, Joe Duke of Off Road America, Ken Friedman, George Kovacs Lighting Inc., Fred Hoffman, Mark Holeman, Jenette Kahn, Elliot Kaufman, Knoll Inc., The Metropolitan Museum of Art, the Philadelphia Museum of Art, Max Protetch, Ronald Feldman Fine Arts, Tom and Betsy Schifanella, Susan and Mark Strausberg, Nan Swid, Totem Design Group LLC, the University of

Cincinnati Fine Arts Collection, and V'Soske. The exhibition could not have taken place without the aid of the exceptional staff of the Denver Art Museum. In our Registrar and Collection Services Department, we are pleased to name DeAnn Barlow, Mitchell Broadbent, Monica Dean, Mark Donato, David Finch, Lori Iliff, Shannan Kelly, Mark Knobelsdorf, Emily Kosakowski, Laura Lee, Amy Linker, John Lupe, Erin Singrin, Angela Steinmetz, and Douglas Wagner. In our Conservation Department, we are indebted to Judy Greenfield, chief conservator for the project, ably assisted by Jessica Fletcher and Carl Patterson; and we appreciate the work of the independent conservation specialists Mark Minor and Eileen Clancy.

The exhibition design team included Art Bernal, Carol Campbell, Pamela De Bellis, David Kennedy, Dan Kohl, Elena Momich, Lee Murray, and Sarah Nuese. We also thank the exhibition construction team: Perri Barbour, Greg Bryant, Susan Fitzgerald, Dave Griesheimer, Marianna Gronek, George Jorgensen, and Steve Osbourne. The handsome graphics for the exhibition were designed by Mary Junda.

To produce the innovative educational components of the exhibition, Carla Hartman assembled a creative team including Elizabeth Coman, Celia Franklin, Robert Nauman, Jennifer Rose, Sarah Strauch, and Ellen Turner. We would like to thank Marlene Chambers and Amy Reid in our Publications Department. Other Museum personnel whose help was invaluable include Julie Behrens, Andrea Kalivas, and Deanna Person in our Public Relations Department; Daniel Fonken, Elizabeth Gilmore, and Dan Sterns in our Audio-Visual and Information Technology Departments; and Tony Fortunato and the staff of the Security Department.

The beauty of this catalogue derives in large part from the photographs by William O'Connor, senior photographer in the Museum's Photographic Services & Image Rights Department. His fellow department members also deserve to be recognized for their many hours of work on the project: Ken Furlong, Kevin Hester, Carole Lee, Daniel Perales, and Jeff Wells. In pursuing the countless organizational details of the text and images, we are indebted to Mindy Besaw. Lisa Binder, Meredith M. Evans, and Katharina Papenbrock of the Department of Architecture, Design & Graphics also rendered essential services.

For providing the financial support to make the exhibition and catalogue possible, we are profoundly grateful to the Luce Foundation, the DaimlerChrysler Corporation, the National Endowment for the Arts, and the Colorado citizens who support Denver's Scientific and Cultural Facilities District. In helping to secure these funds, the Museum's Development Department was essential. Our thanks go to Noelle DeLage, Cindy Ford, Karen Gilmore, and Matt Wasserman for their hard work.

Lastly, one other person at the Denver Art Musuem must be acknowledged: Shannon K. Corrigan. Without her patience, good humor, and extraordinary attention to the myriad details that must be dealt with in such an ambitious undertaking, the **USDesign** exhibit and catalogue could not have been realized.

I would also like to add my voice to that of Lewis Sharp, the Museum's Director, in thanking the four guest scholars who contributed to **USDesign**. For almost five years Rosemarie Haag Bletter, David G. De Long, Thomas Hine, and Philip B. Meggs were part of this project's gestation, helping to generate and refine its themes and giving tirelessly of their expertise and enthusiasm. Their probing essays will assure the lasting importance of this striking catalogue long after the exhibition it reflects has completed its travels.

Finally, I am privileged to thank all the designers for the splendid works represented here—and for the promise these individuals offer of the continued vitality and creativity of American design in the twenty-first century. They seize our imaginations and lift our spirits. We dedicate this book and exhibition to them.

R.C.M.

INTRODUCTION
R. CRAIG MILLER

USDesign is the second project in a series of exhibitions—called *Masterworks*—organized by the Denver Art Museum. Envisioned as a means of introducing significant aspects of contemporary international design to the American public, the series has sought to revive a tradition that had begun in the United States after World War I and extended into the 1950s. During those decades, institutions such as The Metropolitan Museum of Art and the Museum of Modern Art mounted influential shows on a periodic basis that featured the latest in American and European design.[1] Denver's series, however, marked a new approach in two ways: a critical assessment would be made of major movements and the roles of seminal designers within them and, secondly, larger blocks of time would be examined to provide a historical context. Our inaugural show, *Italian Design, 1960–1994*, reflected this innovative tack: it offered one of the first critical assessments by a museum in the United States of the simultaneous Modernist and Postmodernist developments in industrial and decorative design in that major center for Western design, and it spanned a period of more than three decades.[2]

 USDesign is even more encompassing in its goals. It is one of the first exhibits to offer a critical assessment of American design in this quarter century. It has also attempted to bring a larger unity to a field that splintered into many independent directions during this period, by encompassing two other major media, architecture and graphic design. But this project—the exhibition and accompanying catalogue—in no way pretends to be a survey of everything that has happened in American design since the 1970s; nor have we attempted definitive assessments of a plethora of designers' careers. Rather, **USDesign** is a measured, thoughtful appraisal of some of the most significant developments in the design arts in the United States during those decades, as defined by the organizing team of scholars. Thus we have attempted to characterize a number of the definitive ideas that have shaped this period, the major American designers of this epoch, and some of their most influential works. We have also attempted, where appropriate, to note how American design relates to international developments during this quarter century and, with the fresh perspective of a new century, how it relates to larger trends that have evolved through the entire twentieth century. To find some balance between the intellectual scope of the project and the physical size of a show and a catalogue, very clear parameters were set by the team from the beginning.[3]

 There is, first of all, the question of what constitutes an American designer and design. The United States has had a long tradition of welcoming émigrés, from Benjamin Henry Latrobe in the 1790s right to Karim Rashid in the 1990s. We have defined an American designer as a person who largely resides and works within this country. Given the current globalization in the field, we have also recognized that American designers now build as well as manufacture their design objects internationally: the critical criterion was the designer, not the country of origin per se.

 It was also determined that the project should focus on three generations of designers. The first was largely born in the 1930s and began to produce their first mature work in the late 1960s and 1970s; these designers are now internationally acclaimed stars. The second was born after World War II and came to international attention in the 1980s; they are "the next wave" eagerly watched by critics. There is also a third generation, now largely in their thirties. This group has had a more discernable effect to date on graphic, industrial, and decorative design rather than on architecture (since architects rarely produce major buildings until well into their forties). Nevertheless, these promising designers have inherited the task of carrying American design into the twenty-first century—no small challenge. There are, of course, significant designers—such as Jack Lenor Larsen and Massimo and Lella Vignelli—whose prolific careers extend right up to the present; but they achieved their signature styles before 1975, so they are not included here.

 Certainly one of the most difficult decisions in shaping the exhibit was the choice of media. **USDesign** focuses on developments in the fields of architecture, graphic design, and decorative and industrial design. Functional craft

has to some extent been included, but only when it moves beyond the "one-off" object to serial production.[4] Thus whole aspects of the design arts were excluded by necessity, although the **USDesign** team in no way wishes to diminish the enormous contributions of the designers representing landscape architecture, interior design, automotive design, fashion, and other design arts.

One of the defining characteristics of American design in this quarter century, for better or worse, has been its lack of any predominant theoretical or stylistic approach. **USDesign** celebrates this pluralism and considers it within two larger currents that coalesced during these decades. One arose in reaction to the various manifestations of mid-century Modernism; it began in the 1960s and became into an influential movement by the mid-1970s. "Postmodernism" is the term most often given to this development, one that has been much debated and often misunderstood. **USDesign** has sought to present this movement in a larger historical context and to demonstrate its diversity of expression, one approach being a concern with a decorative, historicizing tradition and the other a fascination with the vernacular and everyday. The second larger current arose in reaction to Postmodernism in the mid-1980s. It likewise has two discernable variations: a highly intuitive, expressive design approach and one that is more rationalist, recalling earlier Modernist directions. These four directions in **USDesign** have been respectively christened: "Inventing Tradition," "Celebrating the Everyday," "Redefining Expressionism," and "Expanding Modernism." The exhibit team has also noted, however, that within these larger movements and submovements are designers and objects that can be considered transitional, for in any discussion about categories there are, invariably, subtle shades of gray.

There were also the inevitable challenges of terminology, because these developments are so close to the present and new assessments of major twentieth-century design currents are now underway. The exhibition has focused primarily on the four directions noted above, while the catalogue essays have allowed for more nuanced interpretations.

During this period the design arts have been viewed by many scholars from a variety of new perspectives: political, cultural, economic, and even gender-specific. All of these approaches are, of course, legitimate ways of looking at and interpreting design; and they have made a major contribution to the field, particularly in the academic world. Thus the introductory essays contributed by Thomas Hine and Rosemarie Haag Bletter to the catalogue are especially important, as were their contributions to the shaping of the exhibition itself. Because the Denver Art Museum is an institution dedicated to preserving and exhibiting works of art, however, a primary criteria in selecting designers and objects for **USDesign** has been an aesthetic viewpoint.

During this quarter century, many museums have reacted against installations that presented art in a highly formalist manner and that have often been aimed largely at a cognoscenti of professionals and patrons. Thus they have explored a number of new approaches, including presentations featuring the larger cultural or historical contexts in which artworks of all kinds function. Some museums have also abandoned chronology and have installed works by larger themes than leap decades or centuries. Other institutions have even on occasion eliminated the traditional role of the curator, relying instead on artists themselves to create installations.[5]

The Denver Art Museum has taken a more catholic approach for **USDesign**, bridging tradition and the new, for they are not necessarily enemies. What the director Peter Brook wrote about the noted actor John Gielgud might best capture this attitude: "John is always in the present; he is modern in his restless quest for truth and new meaning. … [But] he is also traditional, for his passionate sense of quality comes from his understanding of the past. He links two ages."[6] Museums are keenly aware that they have a much more diverse public today, one that perceives design in entirely new ways, especially given the impact of forces such as the information age and globalization.

The Denver Art Museum is exploring innovative approaches to bridge this divide between past and present, primarily through new kinds of educational and interpretive programs to reach adults, families, and children. Thus the installation of **USDesign** is arranged in a loosely chronological manner and takes a largely stylistic approach; but throughout the show, there are interactive components that are intended to make the exhibition readily accessible not only to professionals but to our general public.

These are a few of the criteria that helped shape the outlook of this catalogue and exhibition. There have, however, been a number of substantive forces—both old and new—that have also decisively shaped design in this quarter century. They are perhaps worthy of brief comment, since they have in no small part contributed to making this quarter century difficult to assess, but ultimately exhilarating.

For all the talk generated by cultural and theoretical issues, designers are still absorbed with form and the development of an individual style. One simply has to look at the range of singular modes in this brief time period.

Designers also continue to grapple with finding suitable theories to buttress their approach. The reaction to the variants of mid-century Modernism included a revival of a decorative, historicizing tradition; a return to American popular culture as a source of inspiration; and a renewed interest in a highly intuitive, expressive approach.

Some designers have also sought to reintroduce a social mission to design. Their positions have ranged from a concerted critique of American society and culture to a simple buoyant belief by some new Modernists that they can change the future.

The changes in methods of production over the last quarter century have presented a variety of problems. For industrial designers, there is the overriding issue of globalization. The dramatic shift in so many media—from furniture to textiles—to the pervasive contract market may have also proved to be something of a Faustian bargain. As many major American manufacturers grew ever more affluent, they lost, in many respects, their design leadership role—especially in comparison to their commanding position in the immediate post-World War II era. Witness how many objects in this exhibit are made in limited or studio production versus mass production.

Nationalization and globalization run concurrently with hidden undertows. Design centers have been diffused from the East to the West Coast. Emigrants are attracted to the United States because of our technological and economic might. But though global communication can happen with the press of a key, the Atlantic and Pacific are still significant barriers for many American designers, for there is not the easy back and forth of exchange inside the European Union. The sheer annual increase in the amount of knowledge and the rate of technological change are quite staggering. This is increasingly leading to anonymous design teams in fields like product design and textiles. Will the individual designer with a unique aesthetic viewpoint be able to survive independently much longer?

And lastly, design has endured something of a spiritual crisis over the last quarter century. A number of design museums and schools in recent years have taken "art" out of their names and mission statements. Rather, they define their task as examining any and all aspects of our culture as equals. For many, the idea that a design object might impart a larger meaning to life—an aesthetic or spiritual dimension—has fallen by the wayside. Perhaps Josef Hoffmann, the Viennese designer, best captured this central responsibility of a designer: "I concede everything practical and necessary but, I think, we also have the duty to give joy. That joy is … the main asset of our existence."[7] It is so simple, yet so complex: that incredible jolt of energy and sheer elation when one first catches a glimpse of a great work of art such as Frank Gehry's Guggenheim Bilbao or even his *Bubbles* chaise. And it is ultimately that enduring quest—the designers' drive to infuse a sense of joy in their work and in our lives—that **USDesign** has sought to document and, once more, to reassert as a cause for celebration.

THINGS AND CHANGE: **HOW LIFE SHAPED DESIGN** (AND DESIGN SHAPED LIFE) IN THE FINAL QUARTER OF THE TWENTIETH CENTURY **THOMAS HINE**

fig. 2
F-117A Stealth fighter-bomber, in 1999 photo
(design first tested 1981)

As the twenty-six-year period considered by this book drew to an end in 2000, the United States was in a state of design-induced political upheaval. A presidential election had ended not in a decision but in ambiguity, and all eyes were focused on a few counties in Florida (fig. 1).

In one county, the issue was bad graphics. In order to make the lettering on the ballot more readable for the county's elderly voters, an election official had created a ballot layout—the infamous butterfly—that nearly everyone agreed was very confusing.

Meanwhile, in other counties, the problem was one of bad industrial design. The punch card voting machines seemed to have been so clogged from accumulated votes that a significant number of those who went to the polls were unable to punch through their ballots. How should those ballots be counted?

In the end, the election was decided by the Supreme Court, in large part on the basis that the truth would never be known in time, and that even a vote is a matter of interpretation.

Most Americans seemed not to be shocked by these events. We are used to things that do not work as well as promised. And anyone who has tried to navigate a Web site knows that what you think you're choosing isn't necessarily what you will get.

Still, the 2000 election and its aftermath serve as a reminder of how pervasive a role design plays in our lives. Design is not just a matter of making things look pretty. It is an essential part of making things work. Sometimes it empowers us. Sometimes it manipulates us. Sometimes it exasperates us. It helps us feel comfortable using complex technologies. It provides much of the imagery and the metaphors of our global, materially abundant, media-saturated lives. It is how cultures talk to themselves and each other.

Virtually everything we see and touch is designed. Somebody draws a line, moves a mouse, shapes a form. The designers' decisions are not always good ones. As in the case of the butterfly ballot, good design intentions can have unforeseen and undesirable consequences.

Half a century ago, design was a cause. Advocates promised "Survival through design."[1] "Good design" was believed capable of making a better world, not the cluttered one in which we live. Today, design is simply a fact of life, not necessarily good or bad, but certainly inescapable.

One difference between looking at **USDesign**—the book and the exhibition—and visiting, for example, a supermarket or a discount store is that **USDesign** contains far fewer items. It is a very small selection from an enormous universe of buildings, images, and objects produced over a quarter of a century. As you might expect from an effort organized by an art museum, it is organized primarily in visual terms,

previous page
Oakley: "O" Design Team
Juliet Glasses, 1996
Titanium alloy, 4 x 17 x 8 cm (1 ½ x 6 ½ x 3 in.)
Romeo Glasses, 1996
Titanium alloy, 4 x 18 x 8 cm (1 ¾ x 7 x 3 in.)
Design Director: Colin Baden. Manufacturer: Oakley. Collection of Oakley

fig. 1
Officials in Tallahassee, Florida, scrutinize disputed Miami-Dade County ballots following the 2000 U.S. Presidential election.

according to historical sources and twentieth-century artistic movements.

It is also based on the premise that design is primarily the work of an individual creator. Nevertheless, many of the works here resulted from collaborations between two or more designers, and they were also, often decisively, shaped by nondesigners—such as engineers, marketers, government regulators, and venture capitalists.

Does anyone setting out to design a pair of sunglasses do so with the intention of redefining expressionism? Of course not. She is more likely to be paying attention to the way the glasses are likely to be worn, the tastes of the presumed buyers, the price at which the glasses will sell. Expressionism is part of the repertoire of visual expression on which she can draw. And it's possible that what she designs will do a good

job and keep glare out of your eyes, impress your friends by being fashionable, make a profit for the manufacturer, and, somehow, redefine expressionism all at the same time. There are few objects of this era that better embody the angularity and darkness we associate with expressionism than does the F117 Nighthawk Stealth fighter plane (fig. 2). Yet we must assume that visual communication played little or no role in shaping this craft. After all, the purpose of its design is to elude detection by radar, and it is used only on nighttime missions so that its distinctive profile remains invisible. Nevertheless, even such inadvertent expression contributes to the look of our times.

If design is about communication and understanding, in our culture that means that it is also about selling products, ideas, or brands. Often, design is art for money's sake. An

effective design can create a market, but, just as often, a well-defined market helps shape the design.

Design is, by its nature, compromised. Indeed, that's one of the things that make it interesting. Just as we can look at a chair and imagine the posture, and hence the attitude, of the person who will sit in it, we can look at a building, a piece of athletic equipment, or a set of movie titles and learn something about the social and economic transaction of which it is a part. We see what the design is for, and, equally significantly, whom it is for and what role it is meant to play in their lives.

Design is exciting because we're all part of the show. Using things, making images, building shelters are among the things that make us human. And so is having things both ways—or many ways—ascribing a variety of emotions and meanings to buildings, objects, and images. Often the most effective designs are those that embody a contradiction—the hand-held computer that convinces us that the device is technologically sophisticated, yet easy to use, the beer label whose message is that the beer is "light," yet robustly flavorful.

Every item in **USDesign** has its own complicated, multidimensional story. Telling all the stories, though, would go beyond the space available, and reading them would probably exceed your endurance. Thus, the writers on the individual design disciplines discuss the objects in terms of important men and women in each discipline, and the grammar of forms and historical sources they use in their work. You might see these designers and architects as cultural surfers, who respond to external currents in ways that are personal and memorable.

My job is to say something about the waves on which these creators surf, the attitudes, the expectations, the styles, and the political, economic, and social forces that help shape our buildings, our tools, our toys, our trash, and the handwriting on the wall. Because twenty-six years is a long time, I will sketch just a few of these waves of change and suggest some of the ways they shaped and colored the stuff of American life.

Back from the Future

"Long ago, in a galaxy far, far, away …" So began the text that trailed into the universe at the start of the blockbuster 1977 movie *Star Wars*. This phrase signaled a big change in how popular culture imagined progress. Space travel had been seen, up to then, as something that would happen in the future, within a context of ever-increasing technological perfection. Since the rise of streamlining during the 1930s, the public had been accustomed to ideas of speed and power leading to an irreversible improvement of life. But while *Star Wars* celebrated space travel, it also offered memorable images of high-tech dilapidation of a kind that was beginning to be evident in the real world as well (fig. 3). By 1977, five years after the end of the Apollo program, the moon was a place that nobody went to any more.

As a profession, industrial design had begun in the United States as a way to package technology. Many of its earliest practitioners had spent their careers designing casings for everything from copying machines to locomotives to make them exciting and expressive of speed, change, and collective advancement. Progress was seen as little more than the unfolding of technology over time, and Modernism was its expression. *Star Wars* showed fast spacecraft, but it also offered the deeply traditional sentiment that the really

fig. 3
Joe Johnston
"Rear View Computer," design sketch for space ship interior in
Star Wars, 1977, produced and directed by George Lucas

important story was not about the progress of hardware, but the progress of a soul. And the familiar pop imagery of the future was simply one possibility among many.

Americans' belief in the inevitability of progress had been shaken by several events in the 1970s, including the withdrawal from Vietnam and the Watergate scandal which led to President Richard M. Nixon's resignation. But very likely, the principal shock was the Arab oil embargo of 1973, which made people aware of the precariousness of their expansive lifestyles, and created, for the first time since the Great Depression of the 1930s, a sense of systemic scarcity.

The three decades following World War II were marked with substantial increases in real wages and decreases in income inequality. But the year 1973 marked the beginning of a quarter century in which the wages of men declined and the wages of women were stagnant, accompanied by a widening gap between the rich and the rest.[2]

While designers of mid-century Modernist furniture, architecture, and objects had at least aspired to put them within the reach of all, the economic downturn of the 1970s—and the shrinking income of all but the rich during the 1980s and early 1990s—set the stage for a greater concentration on luxury items, made specifically for those who could afford them. And with the death of the idea of progress and the disappearance of common agreement about what the future would look like, all sorts of possibilities arose. The result was a return to a mix-and-match approach to the historical past, which appealed, more often than not, to the sensibilities of Americans on the make. (Indeed, architecture and furniture based on historical styles never disappeared during the heyday of Modernism; they simply weren't taken seriously.)

In his architectural projects and in his furniture, carpets, and decorative items, Michael Graves presented a vision of unified design, from teacup to city, that was every bit as comprehensive as his Modernist predecessors'. But while the Modernists were trying to create a technological utopia, Graves's designs seemed to add up to an arcadia, a timeless, storybook realm, fit for philosophical shepherds with lots of money (see pp. 80–81, 130–35).

In their profoundly influential 1972 book, *Learning from Las Vegas*, Robert Venturi, Denise Scott Brown, and Steven Izenour advocated building what they called "decorated sheds." In such buildings, two-dimensional images of traditional decoration are applied to conventional structures (see p. 44). Venturi and Scott Brown argued that every culture and epoch has produced decorated sheds, but they said that such an approach was particularly suited to the present, a time of diminished budgets and expectations.[3]

Their idea was taken to its logical conclusion when a team led by the graphic design firm Sussman/Prejza designed an instant, classical identity for the 1984 Olympic Games in Los Angeles. The local committee had decided to produce the games inexpensively, without building any new facilities.[4] So the designers' vibrantly colored arches, portals, and pylons provided monumentality on the cheap, and the graphics looked great on television, where they brought visual unity to dozens of disparate, scattered locations (see p. 222).

The candy-colored classicism of the Los Angeles Olympics provided a stark contrast with the grim future that George Orwell had depicted for 1984. But a few designers recognized the dark side of the technological utopia promised by Modernism. On commission for Best Products

fig. 4
SITE (James Wines)
Best Products store, view of "Indeterminate Façade," Houston,
Texas, 1975

fig. 5
Paul MacCready
Gossamer Albatross, 1980, during test flight

in 1975, James Wines designed a generic, "big-box" retail store in Houston that appeared to be in an advanced state of decomposition (fig. 4).[5]

In a sense, then, the luxurious, historically based buildings, furniture, and decorative items found in this section of **USDesign** have a lot in common with the twisted, funky, dark buildings, the black, slightly scary objects, and the cacophonous graphics of the section of the exhibition titled "Redefining Expressionism." Both affirm that the post-World War II vision of the modern future—clean, clear, and inevitable—was no longer convincing.

The Green Moment

Some responded to the oil crises of the 1970s as an opportunity to bring both visual coherence and moral purpose to the material world. There was great interest in passive solar architecture—buildings whose very form and materials reduced the need for energy for heat, cooling, and lighting. Americans began purchasing smaller, more fuel-efficient automobiles, most of them made overseas.[6]

Perhaps the most memorable icon of this impulse to use less to achieve more was Paul MacCready's seventy-pound, human-powered airplane, the *Gossamer Albatross*, which was pedaled twenty-three miles across the English Channel in 1979 (fig. 5). MacCready subsequently worked with General Motors to design an ultra-lightweight concept car.[7]

For the most part, though, the new ethic of efficiency and conservation was embodied in ways that weren't visually memorable. Buildings incorporated multipaned windows and more efficient heating, ventilating, and air-conditioning systems. Packaging became lighter and thinner, in order to reduce the quantity of materials used and the expenses of transportation. Graphic designers were able to employ high-quality recycled papers, and industrial designers could choose a range of strong, lightweight plastics, ceramics, and composites that were more effective and less wasteful.[8]

By the 1990s, however, the energy scare that had produced these improvements was virtually forgotten, as great numbers of Americans indulged themselves by buying huge, exurban mini-mansions and fuel-thirsty sport utility vehicles.

fig. 6
Charles S. Anderson Design Co.: Charles S. Anderson and Paul Howett
Buttons with Turner Classic Movies logos, 1992

All Ephemera, All the Time

In the late twentieth century, the remnants of commercial culture were recycled far more ardently than was solid waste. The proliferation of cable television channels brought endless reruns of old television programs and movies, which reminded viewers of the range of decorative and graphic styles of the twentieth century. The introduction of the videocassette recorder meant that everyone had access to films that, for decades, had been seen only in university and museum series. Perennial TV showings and videocassette sales of cartoons helped revive such characters as Donald Duck and Bugs Bunny, not to mention Rocky and Bullwinkle, Scooby Doo, and Huckleberry Hound. And Superman and Batman starred in a series of big-budget, live-action movies.

Disney emerged as a major client of architects and designers.[9] Many of them returned the favor by creating buildings that incorporated Disney characters, or objects that sported mouse ears. (Graves did both.) James Victore's *Disney Go Home* poster was an unauthorized use of the image, a guerrilla protest against the juggernaut of corporate whimsy (see p. 195).

Many more designers were engaged by anonymous commercial imagery, the kind of stock images used on labels, matchbook covers, letterheads, and such. Charles S. Anderson, who first became famous for putting Classico pasta sauce into an old-fashioned mason jar, created a whole style based on his trove of found images, which he also makes available to other designers. Though Anderson's look is distinctive, its personality comes from its manipulation of images that are generic. His rerun-based design is particularly well suited for the corporate identity of the Turner Classic Movies cable channel, with its animated images of Art Deco buildings and fedora-wearing detectives (fig. 6).

Enthusiasm for the world found in the violent, silvery, black and white movies of the 1930s lasted far longer than architecture's revival of high styles. During the 1980s, President Ronald Reagan was, for much of the population, a Warner Brothers memory. During the 1990s, people with no memories of the Depression embraced streamlined toasters, long-necked beer bottles, and tin candy boxes. And with the successful introduction of the Chrysler PT Cruiser—first as a concept in 1998 and then as a production model in 2000—it became clear that automobile styling could look backward as well as forward (fig. 7). The Cruiser is a 1930s throwback that looks like a getaway car for Little Caesar or Bonnie and Clyde. But it's worth noting that Chrysler uses retro style to give glamour to what is essentially a minivan, a very contemporary, if uncharismatic, vehicle type.

fig. 7
Bryan Nesbitt
Chrysler *PT Cruiser*, production version, 2000

fig. 8
Richard Sapper, chief designer
IBM *Thinkpad 701C* with "butterfly" keyboard, 1995

in the hope that products tailored to California dreams would find markets throughout the world. Global companies were giving rise to global design strategies.

Thus, it is ever more difficult to identify designs by nationality. The IBM *Thinkpad* series of personal computers provided an exciting design signature for one of America's best-known companies (fig. 8). Yet the series was overseen by Richard Sapper, a German based in Milan, working with teams that typically included several U.S. and Japanese designers as well. Volkswagen's new Beetle, a reinterpretation of the classic design by Ferdinand Porsche, was designed under the supervision of an American, J. Mays, then working in Europe, but now back in Dearborn, Michigan, heading up design for Ford (fig. 9).

Some design firms have become global to match their clientele. For example, the industrial design firm frogdesign, which became famous for designing the original Macintosh computer (fig. 10), was started in Germany by a German, Hartmut Esslinger, but it now has offices throughout the world, and an entirely cosmopolitan workforce. Similarly, the graphic design firm Pentagram began in England, went global, and now includes some of the most distinguished American graphic designers.

One finds global connections even, maybe especially, in products aimed at a rarefied audience. For example, the 1995 book *S,M,L,XL* had a strong impact in the fields of architecture and graphic design (fig. 11). It was a collaboration between Rem Koolhaas, a Dutch architect, and Bruce Mau, a Canadian graphic designer, and published in New York. It's not, therefore, a U.S. design, but it is one that's characteristic of our time.

Global Brands, Designer Labels

Throughout the last quarter of the century, the expansion and consolidation of businesses across national barriers accelerated. During the post-World War II era, the growth of multinational industries had largely involved American companies expanding overseas, but since the 1970s, foreign products and foreign companies have played larger roles in American life. Indeed, large chunks of our most culturally significant industries—including music, film, and publishing—are now in foreign hands.

Such previously important industries as appliances and home entertainment devices atrophied, and Detroit's "insolent chariots" gave way to Japanese imports.[10] But by the 1980s, several Japanese automobile manufacturers were maintaining studios on the West Coast, staffed by American designers,

fig. 10
frogdesign
First Apple Macintosh personal computer, 1984

Koolhaas is an international star of a sort who scarcely existed before the period we are discussing. Today, those who wish to build ambitious buildings look beyond their city, region, or country and assemble a short list that includes architects from throughout the world. Architects get on such short lists through publications, exhibitions, and publicity, sometimes even before they have even completed a major building. On the model of couturiers before them, they must establish themselves as international avatars of style—in effect as global brands. Those who create clothing remain the best-known people who bear the label of "designer."

And like fashion designers who cash in on the value of their names with perfumes, sheets, and other ancillary products, a few contemporary star architects have success-fully expanded their product lines by designing dishes, silver, carpets, fabrics, and other decorative items. Indeed, Graves, with his extensive mass-market line for Target, has literally become a brand name, with his signature emblazoned on wares from telephones to toilet brushes, all of which are marketed as reflections of his personal vision.

This phenomenon peaked during the 1980s, however. The French architect Philippe Starck is one of the few such designers who have a look and commercial following, while Graves has ascended to the role of mass tastemaker, a rival to the omnipresent Martha Stewart.

Power to the Person

In 1979, Sony introduced the Walkman in Japan, a little tape player with earphones that made it possible to live in one's own sonic realm. It swept through the United States and much of the rest of the world the next year.

It was a new kind of product, a piece of personal technology that was easy to carry, easy to use, and it gave its owners power over their own experience and their own space.[11] It led the way to other instruments of autonomous entertainment and productivity, including the videocassette recorder, the personal computer, the hand-held electronic organizer, the mobile telephone, and other wireless communications devices.

The Walkman not only opened the door to many of the characteristic product designs of our day, but it probably had an impact on buildings and graphics. Architects could no longer assume that their spaces dominated the consciousness of their inhabitants; graphic designers had to work harder to win the attention of people living in several realms at once. Experience was fragmented in a way it had never been before.

fig. 9
J. Mays
Volkswagen New *Beetle*, 1998

fig. 11
Chart of architectural projects by personnel at Koolhaas's Office
of Metropolitan Architecture, from Rem Koolhaas and Bruce Mau,
S,M,L,XL (New York: Monacelli Press, 1995).

The videocassette recorder, which was introduced by
Japanese companies in 1975, was seen during the 1980s
as a case study of American decline.[12] An American
company had patented the technology in 1956, and it was
used widely by broadcasters. But no American company
understood that people might wish to be free from network
schedules, and to watch prerecorded movies in their homes.
By the end of the 1980s, VCRs were in three out of four
American homes. This was one of the most successful
products ever introduced, and none were made in the U.S.A.

The triumph of the personal computer eventually restored
confidence in Americans' ability to conceive products that
change the way people think and behave, although initially
the personal computer was virtually a countercultural
invention. It depended on the introduction by Intel, in
1971, of the first microprocessor, "a computer on a chip."
Nevertheless, the idea that individuals would want to own
computers was not obvious. Big companies and institutions
needed computers, but most were unsure about what
the machines did. How many of us needed to do so
much computing?

It was left to hobbyists, enthusiasts, and young
entrepreneurs to try to figure out what people would want to
do with them. The "new economy" that so dominated the
American prosperity of the 1990s was created not by the
established big companies, but by new businesses originally
backed by risk-taking venture capitalists.[13]

The first Apple computer was introduced in 1975,
and several now-forgotten manufacturers produced kits for
those who wanted to make their own. Enthusiasts soon
wrote programs that did useful things, such as Visicalc,

fig. 12
Steve Jobs demonstrates the NeXT personal computer at a 1989 conference in San Francisco.

the breakthrough software that could instantly recalculate financial spreadsheets. Others created programs for organizing large databases, and for transforming writing into word processing, while others worked on less obviously useful things, such as games. Finally all this helped convince a broad public that owning a computer could be both worthwhile and fun.

At that point, in 1981, IBM introduced its Personal Computer, which gave the device a name, launched an industry, and eventually led to a revolution in what individuals expect to be able to do at work and play.[14] It proved to be a useful tool for practitioners in all fields of design, eliminating many routine drafting jobs. Meanwhile, the computer induced many amateurs to try their hand developing house plans and designing flyers, letterheads, and newsletters. The results have not always been pretty.

With a handful of exceptions, the computers themselves haven't been that pretty either. Among desktops, the pale, cube-shaped NeXT, designed by frogdesign with graphics by Paul Rand, was an eye-catching failure (fig. 12). Steve Jobs, father of the NeXT, returned to a similar geometry in 1999 with the white and transparent Apple *Cube* (see p. 175). Meanwhile, some portable computers, such as the Apple *G-4 Titanium Powerbook*, introduced in January 2001, were clearly intended to embody technological perfection (fig. 13). Like a fine wristwatch, this high-end portable computer was a practical luxury, meant to impress.

It is a mistake, though, to look only at the outside of a computer. The most important aspect of its design concerns what happens on the screen—the interface. The Graphical User Interface—with its icons and mouse pointer—was

fig. 13
Apple design staff
Apple *G-4 Titanium Powerbook*, 2001.

developed by Xerox and introduced commercially by Apple in 1984.[15] It created a powerfully influential aesthetic for what would become a ubiquitous technology. The principle has been copied several times since, most successfully by Microsoft's several generations of Windows, and by the highly simplified, stylus-based interface that makes the Palm Pilot personal digital assistant so popular and useful.

A device is useful only if people feel comfortable using it. During the 1920s and 1930s, the first generation of industrial designers made machinery friendly by hiding the mechanism and giving the entire product a unified sculptural shape. Similarly, the Graphical User Interface hides the computer's code and programming, and makes the computer useful for people who cannot begin to understand it. It is a design that is so much a part of how we use the computer that it seems less a design than a necessity—like the wheels of a car.

The Disappearing Machine

Michael Vanderbyl's Modern/Postmodern poster (see p. 186) shows the historically based architecture of the 1980s for what it was—a thin veneer over a conventional modern box. This was the premise behind Venturi and Scott Brown's idea of the decorated shed: the modern condition, in the form of construction methods and materials, is inevitable. The architect and designer shouldn't try to make sculpture of this modern technology, but merely clothe and ornament it in interesting ways.

Today, the technologies that shaped the idea of Modernism—steel frame and reinforced concrete construction, plate glass, turbines, gears, pistons and cylinders—seem to be closer to the nineteenth century than to our own twenty-first. Yet they were powerful visually as well as literally.

By contrast, the key technology of the late twentieth century, the microprocessor, is tiny and, in most products where it is used, invisible. In the mid-1980s, some industrial designers became concerned that this freedom posed a challenge. Unlike architects, they weren't decorating sheds. They were finding forms for something new that had no real form of its own.

This gave rise to the notion of "product semantics," represented by several conceptual designs, such as Lisa Krohn and Tucker Viemeister's *Phonebook* answering machine (see p. 163).[16] The idea was to give a digital product a form similar to that of a familiar prototype, while offering new kinds of usefulness. By alluding to old products, these designs appear to be related to the architecture that reintroduces tradition. But by taking a sculptural form that was, strictly speaking, unnecessary, they were representing precisely what Venturi and Scott Brown opposed.

Answering machines are not buildings, of course, and the real question was whether the use of product semantics enhanced function, increased satisfaction, or augmented sales. We really do not know the answer, because very few devices that embody product semantic principles ever made it to the stores. Manufacturers apparently concluded that the problems that product semantics purport to solve were more important to designers than they were to consumers. Portability, not readability, proved to be the grail of designers during the 1990s.

And, as it has turned out, the increase and diffusion of information processing power has made it possible for

designers to think differently about what seemed to be the givens of Modernism. Most notably, buildings were able to escape from the rectangular frame, because computers made it easier to design, analyze, and refine an eccentrically shaped building almost as easily as one with a conventional frame. This ability is particularly important to the works of Frank Gehry and of younger architects, such as Greg Lynn.

Now all sorts of shapes are possible, thanks in part to a chip-based technology that has no shape of its own.

Many Stories, Many Voices

In his 1975 film *Nashville*, Robert Altman traced five days in the lives of twenty-four characters. Each of these characters had a memorable presence, a distinct goal. Their lives didn't fit together neatly but overlapped. With its layers of dialogue and snippets of story, the movie was disconcerting to those accustomed to clear narrative. But the very confusion and disorientation *Nashville* created made it an exciting evocation of contemporary experience.

Multiple, often conflicting narratives were characteristic of twentieth-century culture, both high and low. From the late 1960s on, historians documented the voices of powerless people who were usually excluded from mainstream history. Literary scholars deconstructed the narrative voice as an assertion of power and often of sexual dominance.

And on television, especially following the influential police series *Hill Street Blues*, which aired from 1981 to 1987, it became virtually a formula for drama programs to feature many key characters and several ongoing plots in every episode.[17] Admittedly, both Homer's epics and daytime soap operas provided precedents. But like *Nashville*, *Hill Street Blues* felt new because it substituted evolving narratives for neatly resolved plots and because its characters seemed to experience the chaos so vividly.

It is not surprising that Peter Eisenman, the most intellectualizing of architects, embraced multiple narratives within his buildings. In a single building, he often included two or more structural grids that collided or overlapped, and these were sometimes justified by a desire to relate the building to disparate settings and scales. The buildings presented the opposite of clarity. They were saying several different things at once.

This impulse is even more evident in graphic design, where designers began layering elements and juxtaposing geometries even before the computer made it easy. The most extreme case is probably that of David Carson, who often set typography and words in conflict with each other (see p. 206). This was a severe break with more than four centuries of effort to make words and letters harmonious. It called attention to some often unrecognized facts: type is always expressive, even when we don't notice it. And words can carry meaning, even when we can't read them.

And while designs by Alexander Isley and others for *Spy* magazine employed essentially Modernist grid layouts, the pages they designed were invaded by marginal notes in tiny type, and other forms of passive-aggressive graphic disruption (see p. 224). From the margins—quite literally in the case of *Spy*—other voices demanded to be heard.

Layers of Information

One of the key inventions of the quarter century may have been the Post-it note, a deceptively simple design that made

a profound impact. Introduced in 1980, it was developed by a 3M engineer who was having trouble keeping bookmarks from falling out of his hymnal.

At the time, the company was reluctant to introduce a product whose chief competition was scrap paper, but when a group of secretaries were supplied with prototypes, they began using them in ways that had never been anticipated. Nobody had imagined that so much needed annotating.[18] The Post-it note enabled and encouraged a layering of information. It fosters commentary, elaboration, and the making of real, though not necessarily logical, connections.

The Post-it is a real-world analogue to the random access to information that the computer enables. The computer's ability to aggregate and sort data in countless ways reveals relationships that may not have been foreseen. This power became fully apparent with the introduction, in 1993, of the graphics-driven World Wide Web, designed by Tim Berners Lee, an Englishman who has since moved to the United States, and of the Web browser.[19] The Web opened a new kind of space and a new kind of experience in which one thing leads quite rapidly to another and another and another. The only things that structure the journey are the user's curiosity and desire.

This is an environment that, throughout the 1990s, has fascinated both graphic designers, who found an exciting new medium in which to work, and industrial designers, who have tackled usability problems in a virtual world. In a wholly artificial environment, everything you find on the World Wide Web is an act of design, though much of it has been created by amateurs.

Elusive Identities

In the late 1970s, marketers often analyzed consumers according to the VALS (values and lifestyle) model developed during that decade by SRI International, a consulting firm.[20] This divided the population into nine categories, such as conservative "belongers," upward-looking "emulators," and self-assured "achievers." A similar study released in 2000, based not on sociological analysis but on sales and survey data, breaks the U.S. population into sixty-two consuming clusters.[21] The largest of these comprised only 3.5 percent of the public. This fragmentation seems to be more than a pollsters' artifact. For example, high schools, which have always had a handful of cliques, are now typically occupied by dozens of self-identified tribes, defined by their music, their garb, their extracurricular activities, and their bad habits. With so many potential identities available, it is easy for the consumer to move from one to another. A band geek can turn herself into a Goth for the weekend, and scare her parents, or herself.

Industrial design, and especially graphic design, has traditionally been preoccupied with establishing identity. This remains true, but sometimes the identity is established by the way in which you change it. The MTV logo, for example, has gone through countless metamorphoses; change is part of its identity.

In a video by M&Co for Talking Heads, moving images are projected across lead singer David Byrne's face, one identity atop another (see p. 213). Many young people choose to superimpose new identities on their bodies by getting tattoos. In this case, the tattoo won't change, but the body wearing it will.

fig. 14
Smart Design
OXO swivel vegetable peeler, 1989

For Fossil Watches, Charles S. Anderson designed a large variety of tin boxes from which the buyer could select (see p. 196). All of them have Anderson's signature look, but the identity of the brand came not from a single image but from the promise of many possibilities.

Among the most unlikely products to become fashion statements are snowboards and surfboards, both of which are used by young, extremely fickle markets whose members pride themselves on going to extremes. The board in **USDesign** is by Art Chantry and it is covered with hundreds of small images that are, at once, anonymous and iconic (see p. 196).

A New Universe

A half century ago, Modernism seemed not so much a style as an inevitable consequence of the way things work, the way things are. It was believed to have universal applicability, as all utopian ideas do. It was the shape of the future.

During the last decade or so of the luxuriantly pluralistic era represented in **USDesign**, something came along called "universal design." But even though designs that represent this approach are placed in the "Expanding Modernism" section of the exhibition, the universe they contemplate is very different.

The Modernist universe was unified by technology and systems of organization. A more recent idea of the universe is defined by human frailties and limitations. What we now call "universal design" was once called "accessible" or "barrier-free" design, and before that, design for the disabled, handicapped, or crippled. The shift of nomenclature reflects a change in attitude. Limited vision, mobility, or manual dexterity is not a problem for a tiny minority, but for everyone, sooner or later, either because of injury or old age. The goal of universal design is to create products and places everyone can use, regardless of their infirmities, excluding as few people as possible.

In nearly all developing countries, the average age of residents is increasing. This trend is less evident in the United States than in Japan or Western Europe, largely because of a continued influx of younger immigrants.[22] Still, as we discovered in the 2000 election, a handful of old people faced with bad designs could throw the future of a nation into doubt.

In 1990, President George Bush signed into law the Americans with Disabilities Act, a far-reaching piece of civil rights legislation that has already had a tremendous impact on the design of buildings, sidewalks, parks, and products.[23]

In the product category, for example, Smart Design's OXO line of kitchenware is probably the best-known and most successful example of universal design. It originated with the desire of a veteran kitchenware manufacturer to make cooking tools that could be used by his wife, an enthusiastic cook and arthritis sufferer.[24] Among the first products in this line, the peeler works well not only for those with hand problems, but for everyone else as well (fig. 14). Its thick handle may not be to everyone's taste, though its virtues become obvious with use. It is truly a case of form following function.

A Happy Ending?

In January 1979, the erstwhile Modernist mandarin architect Philip Johnson appeared on the cover of *Time* magazine

fig. 15
Philip Johnson with model of AT&T building
on the cover of *Time* (January 9, 1979)

holding a model of his new skyscraper, New York's AT&T Building (fig. 15). The building, which seemed to remind everyone of a Chippendale highboy, appeared radical and conservative at the same time. It was radical because it combined so literal a use of historical forms with the most modern of building types. But it was conservative because its traditionalism seemed so perfect an embodiment of its client, Ma Bell, a company that made phones built to last decades, a dull but reliable fixture of American life.[25]

No sooner did AT&T acquire its notorious split pediment than it became, as the result of an antitrust settlement, a split company. The company was broken into seven parts, a fragmentation that unleashed tremendous competition in the telecommunications industry, flimsy telephones in all shapes and colors, and billions of calls urging people to change their long-distance carriers. The granite-clad tower projected an image of permanence, but in the real world things were even more complex and contradictory than anyone expected.

In retrospect, AT&T's tower, now occupied by Sony, appears altogether too assertive of tradition, a bit desperate perhaps. One is a bit embarrassed by the generation of highly ornamented skyscrapers of which it was a part: Johnson's gothic glass tower in Pittsburgh and his gothic stone-faced one in Houston; Helmut Jahn's Chrysler Building clones in Philadelphia and San Diego; Kohn Pedersen Fox's towers just about everywhere. These now appear to be monumental displays of insecurity.[26] How then can we read the history of the last quarter of the twentieth century through **USDesign**?

One way is to understand that there were many voices. The work of Graves and Venturi, Scott Brown dominates the "Inventing Tradition" section, but it is important to see that Graves charms and Venturi, Scott Brown provokes. One reason for this is that they are trying to do very different things.

And there are paradoxes. We associate modernity with the celebration of technology. Yet the section of this show that most explicitly addresses technology is the "Expressionism" section, where we find electronic products and athletic equipment that celebrate technology, architecture and graphic design that exploit its possibilities, and a few pieces of furniture that seem to call it all into question. By contrast, much of what we find in the Modernism section is concerned with old-fashioned craftsmanship. Arguably, it contains the best-made items in the exhibition and book.

Are you confused yet? Is this a case of what the novelist Thomas Pynchon termed "the situation as omni-dimensional mishmash?" The short answer to the question is "Yes." But faced with a welter of events and sensations, what humans

do is make up stories about them. The structure of this book and exhibition—a classification of buildings, objects, and graphics on the basis of certain formal qualities—tells one possible story. But many others are possible.

One approach might see the sometimes overwrought celebration of tradition as an attempt to find stability amid shocking change. This gives way to incessant commercialism, and a nostalgia for the naïve, old-fashioned Main Street way of life. Design that is colorful, undemanding, and backward-looking becomes the new face of the corporation, in an increasingly competitive and ruthless marketplace.

This is followed by a backlash against commercialism, a celebration of emerging technologies, and an exploration of the expressive possibilities of conflict and chaos. This produced graphics, products, and furniture that were more difficult to love—or even understand—at first sight. This effort had some commercial success of its own. While critics noted that work by such designers as Gary Panter to promote raves and rock bands had expressionist roots (fig. 16), the intended audience saw them as emblems of youth culture and extreme sports. Especially among the young, rebellion sells.

Then came the 1990s, a period of tremendous prosperity and confidence, in which designers were eager once again to explore the progressive ideas of Modernism.

Perhaps such a progressive sort of story doesn't satisfy you. How about a cyclical story. In this telling, the first and last sections—about tradition and Modernism—are mirror images. In the first, architects and designers seek to free themselves from the strictures of Modernism and to explore other architectural and ornamental traditions. In the final section, designers trained in a more eclectic age explore

Modernism as an important tradition that has recently been ignored. They are, you might say, nostalgic for the future, and they deploy Modernism not as a historical necessity, but as a matter of taste. And in between, in the second and third sections, are designers exploring other sorts of heritage: in one case, commercial imagery and, in the other, modern approaches that were largely ignored during the post-World War II era. And the generations go on and on, incessantly rediscovering the enthusiasms of their grandparents.

In this essay, I have suggested that the posters, chairs, buildings, packages, and other items shown here are largely byproducts of changes in the ways we communicate and access information. That's a story whose moral may be that we have such easy access to the artifacts of the past that no designer will ever again feel the exhilaration of creating something new.

There are many stories you can tell about the years and the objects covered in **USDesign**, many of which may contain truths. But if there is anything we have learned in the last quarter of the twentieth century, it is that no single story tells *all* the truth.

fig. 16
Gary Panter, designer
Buy or Die, artwork for Ralph Records music sampler record and poster, 1980

MODERNISM IN CRISIS?
ARCHITECTURAL THEORY OF THE LAST THREE DECADES
ROSEMARIE HAAG BLETTER

previous page
Peter Eisenman. Eisenman Architects
Interior, Aronoff Center for Design and Art, University of Cincinnati,
Cincinnati, Ohio, 1988–96
Photo: Jeff Goldberg/Esto

fig. 17
Le Corbusier
Façade detail, Maisons Jaoul, Neuilly, France, 1951–56

By the 1970s, the Modernist canon came to be openly questioned as a model for architecture and design. Some even saw this as a "crisis" for modernity in general. In fact, the rethinking of early twentieth-century "orthodox" Modernism had been underway for some time. The progressivist, rationalist, and scientific optimism that had pervaded Modernist attitudes in the arts during the 1920s and even during the Depression was dashed by World War II. International conferences from 1928 to 1959 organized by CIAM (Congrès Internationaux d'Architecture Modernes) had come to stand for both the solidification and the academization of Modernism. And by the 1950s, a younger generation of architects from within the ranks of CIAM, known as Team Ten (they were entrusted with the preparation for the tenth CIAM conference), rebelled against the rationalist assumptions about urbanism and architecture of the prewar years.[1] They demanded an approach that was centered on social congregation rather than on technology and abstracted planning schemes, and they proposed the notion of "habitat," small clustered spatial configurations, and imagery that derived from human functions such as the dwelling, the threshold, and the everyday life of the street. Seeking to avoid the schematic nature of earlier CIAM planning, they insisted that social identity proceeds from the small to the large, from the house to the street to the city. If they were not entirely successful in humanizing urbanism, Team Ten asked questions that would preoccupy architects and designers for the rest of the century.

The Philadelphia architect Louis Kahn had given a lecture at the 1959 CIAM conference in Otterlo, Holland, and was aware of the discussions of Team Ten; his work was published in the *Team 10 Primer*, and the Dutch architect Aldo van Eyck, one of the young radicals of Team Ten, was at the University of Pennsylvania in 1960–64. While New York had been the epicenter of the traditional Beaux-Arts approach in the early twentieth century and of a corporate Modernism in the 1960s, and Los Angeles the locale for a vigorous reinvented Modernism in the immediate post-World War II period, Philadelphia would become the locus for what in retrospect came to be called Postmodernism. Such design features a particular kind of populist brashness coupled with a down-to-earth quality that recall the architecture of the late nineteenth-century Philadelphian Frank Furness and the post-Civil War period that Lewis Mumford called "the Brown Decades."[2]

Although Le Corbusier had in effect controlled the prewar CIAM conferences, his own architecture had undergone a change away from some of his earlier technocentric imagery,

and had moved toward the folkloristic, neo-primitive, and anthropocentric. This was typified by his use of the Modulor, a proportional measure in part influenced by Renaissance proportions, combining the Golden Section, a reference to the music of the spheres, and the human body.[3] The self-consciously naïve, hand-crafted look of brickwork together with the roughness of exposed concrete in his Maisons Jaoul, Neuilly (1951–56), for example, set the stage for so-called New Brutalism, an attempt at a break with early twentieth-century Modernism and its technological progressivism (fig. 17).[4] Louis Kahn was to become one of the most prominent exponents of New Brutalism. In a number of his seminal works, such as his Richards Medical Research Building at the University of Pennsylvania, Philadelphia (1957–65; fig. 18), Erdman Hall at Bryn Mawr College, Bryn Mawr, Pennsylvania (1960–65), and the Salk Institute for Biological Studies, La Jolla, California (1959–65), he used the enclosing gestures of defensive towers and walls to create spaces that look inward (figs. 19–20).[5] These notable buildings lack the welcoming public spaces of the American Beaux-Arts tradition in which he had been trained and to which he otherwise referred in his axial and symmetrical plans. At the Salk Institute, for instance, the central courtyard with its forceful axis suggests the traditional Beaux-Arts forecourt, flanked on either side by buildings. But while this passage would lead to the most prominent structure in the conventional schemes, in Kahn's updated version, the concluding element is missing: he deliberately created an empty center. Such arrangements reflect an angst that had not been evidenced in architecture since Expressionism. The links to postwar Existentialism and the loss of optimistic ideals are evident. Already in 1961 Kahn had spoken of "wrapping ruins around buildings."[6] For one of his last works, the capital at Dhaka, Bangladesh (1962–83), he perhaps had in mind the powerful Roman ruins of Hadrian's villa at Tivoli and the passage of time they suggest. The image of ruins for a new capitol, despite its arresting visual effect, however, seems to question the very idea of permanence. Kahn's fortress-ruins

fig. 18
Louis I. Kahn
Perspective, Richards Medical Research Building, University of Pennsylvania, Philadelphia, 1957

figs. 19/20
Louis I. Kahn
North façade and courtyard, Salk Institute, La Jolla, California,
1959–65

are aggressively monumental, but they also suggest a pathos
and uncertainty through their symbolism and defensive
configuration. Abstract Expressionism, which became the
first American movement in painting with an international
impact, had likewise relied on Existentialist concepts in its
stress on the process of painting.[7] The self-aware spontaneity
of Action Painting is comparable to the neo-primitive, rough
gesture in New Brutalism.

Another questioning of received Modernism was
apparent in a revival of Expressionism in the 1950s
and 1960s by architects such as Hans Scharoun in his
Philharmonie, Berlin (1960–63), Jørn Utzon in his Sidney
Opera House (1956–68), and Eero Saarinen in his TWA
Terminal at John F. Kennedy Airport, New York (1956–62;
fig. 21) and Dulles Airport, Chantilly, Virginia (1958–63).
In their unconventional, animated designs, these neo-
expressionists seemed to search for forms that had an
emotive immediacy. Scharoun had been among the original
Expressionists after World War I, and Saarinen and Utzon
appeared to be inspired by Erich Mendelsohn's projects of
the 1910s (fig. 22).

At the same time at mid-century, the influence of European
Modernism that emanated from Ludwig Mies van der Rohe,
and established American firms such as Skidmore, Owings
& Merrill, had been adapted by lesser practitioners and
speculative developers as a kind of generic, corporate
Modernism. It became blander, cheaper looking, and, most
disturbingly, giant in scale and all-pervasive in most American
cities. It was this type of bastardized, gargantuan sameness
pervading most downtowns of American cities by the '60s
that a younger generation would react against, often

fig. 21
Eero Saarinen
TWA Terminal, John F. Kennedy International Airport, New York,
New York, 1956–62

confusing it with early twentieth-century Modernism, which was, however, more varied, lower-scaled, and often driven by social ideals, rather than the later corporate impulses. Possibly because Modernism had devolved in the United States into a pervasive commercial style, in contrast to Europe, the Postmodern reaction here would be more thoroughgoing than anywhere else. In Europe the changes occurred more gradually, without the wholesale rejection of Modernism that began to characterize this as a particularly American development.

In addition to the questions raised about Modernism by Team Ten, the New Brutalists, and the neo-expressionists, there were also changes in the approach to writing about architecture. *Existence, Space and Architecture* (1971) by the Norwegian architect-critic Christian Norberg-Schulz concretized an Existentialist view of architectural space.[8] He relied especially on the philosopher Martin Heidegger's conviction that "existence is spatial" and that, above all,

space is experienced through everyday human action rather than through some abstract notion of it. The book *Meaning in Architecture* (1969), edited by Charles Jencks and George Baird, was another attempt to address the loss of confidence in the idea of architectural meaning, something that used to be taken for granted.[9] With the increasing power of new secular institutions in the nineteenth century, like schools, public libraries, and museums, and with the rise of new technology and transportation, the explosion of new public building types, such as railroad stations, for which there had been no historical models whatsoever, tended to make the differentiation of such structures and their expression exceedingly difficult. For example, it was not readily evident how a library could be distinguished through its formal vocabulary from a museum. Jencks and Baird attempted to apply the methodologies of linguistics and semiology (the study of signs) to architecture and the visual arts in general, to make them "readable" for the public. In short, if we

fig. 22
Erich Mendelsohn
Sketch for imaginary hall, ca. 1915

understood the visual arts as readily as a language or communication system, we might be able to transfer to the making of visual form the directness of speech, and thereby lessen the difficulty in telling the story of architecture to the public. To some degree, this concern with communication signaled not simply the desire for meaning, but also a concern for reaching as wide a public as possible. In the pre-modern period, reception had not been an issue because the public was equated with commoners, whose opinion was of no consequence. In any case, linguistics proved to be less than clear as a solution to the problem of meaning and communication in building and design. In the end, a linguistic analogy can be carried only so far because architecture and design do not function according to the strict rules of a language and its grammar. Rather, design is an art that does not fall within fixed rules: elements from various traditions can be collaged together, making their meaning less concise than language. At the same time, visual forms can "communicate" on a more general and international level than speech. Although *Meaning in Architecture* did not come up with a convincing solution, Jencks and Baird highlighted that meaning and its transmission were seen as a problem that needed to be dealt with.

Inventing Tradition: Postmodernism

The term "Postmodernism" was coined by the American architect and educator Joseph Hudnut, Dean of the School of Architecture at Columbia University and later at the Harvard Graduate School of Design. In his essay "The Post-Modern House" of 1945, he acknowledged the enduring importance of Modernism and his continued belief in

major Modernists such as Le Corbusier and Mies, but he complained that technological imagery has "a strictly limited value as elements of expression," and that it was time to reassert emotive factors and architecture as an art: "Space, structure, texture, light—these are less the elements of a technology than the elements of an art. They are the colors of the painter, the tones of the musician, the images out of which poets build their invisible architectures."[10] Lewis Mumford in his *Technics and Civilization* (1934) had already voiced a similar warning.[11] Despite his general sympathy for modern architecture, he had criticized our over-valuation of the machine and its products, and the mechanistic tendency to use machine models to explain human functions instead of the other way around. He wrote: "Our capacity to go beyond the machine rests upon our power to assimilate the machine. Until we have absorbed the lessons of … the mechanical realm, we cannot go further in our development toward the more richly organic, the more profoundly human." Mumford's and Hudnut's stress on anthropocentric values prefigures similar demands by Team Ten. "The Post-Modern House" was also published in Italian in Bruno Zevi's periodical *Metron* in 1945; it was later reprinted in revised form in Hudnut's own *Architecture and the Spirit of Man* (1949), and, significantly, in Lewis Mumford's anthology *Roots of Contemporary Architecture* (1952). Despite the essay's several republications, the term "Postmodernism" did not become part of the general vocabulary until later. "Postmodernism" was also occasionally used in the 1960s in discussions of film studies.[12] It was not until the 1970s, however, that it was specifically applied to the by-then widespread malaise of Modernism.

Robert Venturi was instrumental in introducing Post-modernism as a concept without using this specific term, and without becoming a full-fledged participant in its application in the mid-1970s. His *Complexity and Contradiction in Architecture* of 1966 proclaimed itself a "gentle manifesto."[13] But it had the impact of a bombshell in questioning the then-current clichés of Modernism with the now-famous words: "Architects can no longer afford to be intimidated by the puritanically moral language of orthodox Modern architecture. I like elements which are hybrid rather than 'pure,' compromising rather than 'clean,' ... boring as well as 'interesting,' conventional rather than 'designed' ... I am for messy vitality over obvious unity."[14] Venturi responded to the chaotic contemporary American environment by embracing an approach that accepted perceptual contradictions, and that sprang from Mannerism, the architecture of Frank Furness, American Pop art, and even recent American literary criticism such as Stanley Edgar Hyman's *The Armed Vision* and William Empson's *Seven Types of Ambiguity* (both of 1955), which saw duality, ambiguity, and irony as the source of poetic vision. Venturi's rather complex and subtle understanding of architecture, however, kept him from an outright rejection of Modernism. Instead, he intended a friendly nudge in a new direction more than a complete break.[15]

In 1972, together with Steven Izenour and Denise Scott Brown (by then his partner and wife, who brought a strong interest in urbanism and planning to the firm), he published *Learning from Las Vegas*.[16] It was based on a 1968 field trip of a class of Yale graduate students to study the Las Vegas strip. This pilgrimage to the American interior was first reported on in a series of articles beginning in 1968. *Learning from Las Vegas* electrified the profession, but with incomprehension and outrage. Las Vegas had been chosen as an archetypal example of the American main street. Apparently flying in the face of any decent Modernist urbanism, the study team had chosen this unlikely site—then a seedy gambling mecca—precisely because of its exaggerated flashiness, epitomized by the giant signs that dominated the strip. They studied the car culture and the impact of speed on the legibility of buildings and signs. Tom Wolfe had already observed this aspect of Las Vegas with morbid fascination in his essay "Las Vegas (What?) Las Vegas (Can't Hear You! Too Noisy) Las Vegas!!!" published in his *Kandy-Kolored Tangerine-Flake Streamline Baby* (1965). *Learning from Las Vegas* was intentionally as stridently loud as rock'n'roll. A number of critics objected to the book's implied laissez-faire approach to American commercial culture. Nonetheless, *Learning from Las Vegas* dealt openly with the reality of the car, the parking lots that form the new forecourts for many commercial and public buildings, and the need for overscaled graphics to make buildings visible amid the sea of vehicles. The authors of *Learning from Las Vegas* attempted to distill new design principles from this reality of everyday American life.

Out of the experience of Las Vegas came proposals for a "readable" architecture that did not derive from linguistics, as in Jencks and Baird's *Meaning in Architecture*, but from the commercial media, which were visual in the first place, such as graphic design in advertising and road signs. The billboard became the nucleus for an updated symbolic definition of architecture. To this Venturi and Scott Brown

fig. 23
Robert Venturi and Denise Scott Brown
"Duck" and "Decorated Shed," from *Learning from Las Vegas*
(Cambridge, Mass.: MIT Press), 1972

added the model of the ordinary American roadside building, another commercial vernacular, detailed and made significant only along the street by a higher façade as a kind of advertising sign. They termed this model a "decorated shed" (fig. 23). Behind this façade was usually an ordinary, unremarkable, boxlike container that was not defined architecturally. This adopted schema withdrew from architecture any customary notion of spatial development and substituted an essentially two-dimensional billboard as the most remarkable element of a building. For architecture the concept was seen as perverse because it took its cue from graphic signage

and relegated the attached space to an apparent afterthought. Amusingly but consistently, Venturi and Scott Brown referred to Amiens Cathedral as "a billboard with a building behind it" and called the Italian palazzo "the decorated shed *par excellence.*"[17] Looking at the Doge's Palace in Venice, Denise Scott Brown remarked with an ironic twinkle in her eye, "It's just like Las Vegas, isn't it?"[18]

In the early work of Venturi, a reduction to strong scenographic effects was already evident in the house he designed for his mother, the Vanna Venturi house, Chestnut Hill, Pennsylvania, (1959–64), where the front and back façades rise above the roof line of the house (fig. 24 and p. 73). Although the interior seems to be squeezed between these two walls, its space is surprisingly open. A similar external scenographic definition also appeared in the unexecuted projects for the Meiss house (1962) and Mills pool house (1966). In several of his early designs Venturi used large graphics, as in the Guild House, Philadelphia (1961–66), the Fire Station No. 4, Columbus, Indiana (1966–68), and the Lieb beach house, Barnegat Light, New Jersey (1967–69). His most archetypal expression of the "decorated shed"—a contained space fronted with a prominent signboard—was an unexecuted competition project, the National Collegiate Football Hall of Fame (1967), and a building that returned the idea to the commercial context from which it derived, the BASCO showroom and warehouse in Philadelphia (1977–78; fig. 25). BASCO was an existing warehouse that was painted blue with giant, freestanding red letters placed in front of the façade and spelling out the name of the company. The decorated shed, with its billboard façade

fig. 24 *opposite, top*
Robert Venturi. Venturi & Short, Architects
Rear façade, Vanna Venturi house, Chestnut Hill, Pennsylvania,
1959–64

fig. 25 *opposite, below*
Venturi and Rauch
Showroom and Warehouse, BASCO, Inc., Philadelphia,
Pennsylvania, 1977–78 (demolished)

and advertising signage, is transformed by a simple gesture into an astonishing American Pop version of this vernacular convention.

Robert Venturi and Denise Scott Brown's brash search for an architecture that communicates in the cacophonous setting of signs seems a valid response to market conditions that in the United States are rarely controlled by zoning and land use laws. Their response could be considered practical: the overwhelming presence of commercial culture would be difficult to alter by individual architects. Although Venturi and Scott Brown together introduced an intelligent questioning of Modernism, as well as an unprejudiced interest in high and low art and in Pop art and popular culture, they did not regard themselves as Postmodernists. "Freud did not claim to be a Freudian, and Marx did not claim to be a Marxist. And we certainly don't claim to be Postmodernists," as Denise Scott Brown said in 1983.[19] At a time when their work and ideas were beginning to be copied by the then-Postmodernists Philip Johnson and Robert Stern, and adopted by many lesser-known architects, Scott Brown's disclaimer was at the same time a sly comment on their central position in the development called Postmodernism that took over with the power of a convoy of Mack trucks in the late 1970s and 1980s.

The economic recession of the 1970s affected architecture and design more directly than the other arts, and commissions became scarce. With the dearth of jobs, architects and designers were more eager to rethink their position, or to believe that there might be a groundswell of popular support and new patrons if design could be made less esoteric. Increasingly, the "abstraction" of Modernism came to be seen as the problem. It was thought that if some-what more traditional forms were used, they might be more "readable" and therefore more comprehensible to the public.

In retrospect, one of the central events that helped to move Postmodernism away from the playful, reinvented traditions of Venturi and Scott Brown toward a blander, nostalgic neo-traditional direction in American design was "The Ecole des Beaux-Arts" exhibition at the Museum of Modern Art in New York in 1975–76, curated by Arthur Drexler.[20] Given that Philip Johnson and Henry-Russell Hitchcock's 1932 exhibition at the Museum of Modern Art of the "International Style" had defined "orthodox" Modernism for America (albeit in a narrow, aestheticized form), it was ironic for the museum to make this apparent 180-degree turn to a nineteenth-century historical exhibition, and to a history the Modernists had wanted to leave behind. The exhibition included impressive, large-scale watercolor renderings, many done by teams of students. That the exhibition emphasized ideal, grandly conceived projects, usually not adaptable to modern urban conditions, and stressed the presentation drawing over the site plan or model, was not questioned even in the catalogue. The show also displayed the Beaux-Arts influence on America into the early twentieth century. There is no doubt that it had been formidable. Louis Kahn's training, for example, had been in this tradition, and the buildings of his later career, as mentioned earlier, employed reconfigured Beaux-Arts plans. At some schools of architecture, such as Princeton University's, the Beaux-Arts approach never quite disappeared, with teachers like the Beaux-Arts-trained Jean Labatut and the historian Donald Drew Egbert still teaching there well into the postwar period. Such influential figures as Robert Venturi and the architect Charles Moore

received their schooling at Princeton. In fact, the architectural historian and critic Colin Rowe suggested as early as 1973, in his "Neo-Classicism and Modern Architecture," that there was a continued undercurrent of Neoclassicism in the United States.[21] At any rate, the Beaux-Arts exhibition at the Museum of Modern Art struck a chord among those dissatisfied with the narrow Modernism that had been popularized by the same institution and especially with the bastardized, postwar corporate Modernism that, through its sheer dominance and scale, had come to stand for Modernism in general. The

exhibit revealed an eclecticism that had become a dirty word among Modernists. It may also have contributed to the reception and influence of Charles Jencks's writing on Postmodernism and "Post-Modern Classicism."

In 1974, Peter Blake published *Form Follows Fiasco: Why Modern Architecture Hasn't Worked.*[22] In it he took to task many of the "Modern Dogmas" that he saw as overly abstract notions and as obstacles to a social notion of architecture. And he repeated in more detail some of the criticism of Modernism that had been advanced by Team

fig. 26
Minoru Yamasaki
Pruitt-Igoe public housing, St. Louis, Missouri, 1952–55,
block dynamited in 1972

Ten. The publication that galvanized these attitudes into a movement was, however, Charles Jencks's *The Language of Post-Modern Architecture* of 1977.[23] More popular and less overtly reliant on linguistic structures than the earlier *Meaning in Architecture*, it pursued a similar quest for a meaningful, legible architecture. Jencks presented his argument through a fairly short text together with copious illustrations: their extensive captions form a synopsis of the polemic. For this reason the book made an impact even on those who did not like to read books. Jencks demanded an architecture that would be "multivalent" and "double-coded," i.e., buildings that cannot be reduced to a single meaning. At first glance, one could hardly disagree with the rich symbolism he called for. But he neglected to note that there are in fact few buildings that are not multivalent.

Far more noteworthy was Jencks's attack on Modernism: he criticized Mies for his use of "universal" space and he referred to it as "univalent form." More specifically, he complained that Mies's Lakeshore Drive Apartment Towers, Chicago (1948–50), look like offices, and that the chapel on the Illinois Institute of Technology campus, also in Chicago (1952), can be confused with the school's boiler house (1947). Jencks's criticism was lively but somewhat limited in its reasoning. He did not ask, for instance, whether pre-modern building types can be readily distinguished from each other whether in the Beaux-Arts tradition, for instance, one can easily tell a library from a museum. In many such structures, function is identified through a series of engraved names, such as *Plato, Shakespeare*, etc., for a library and *Raphael, Rembrandt*, and the like, for a museum. In the nineteenth century, already a complex world with a multiplicity of building types, "name tags" were needed, and language was used literally because it is more precise than visual form.

Possibly the most extreme point Jencks made in regard to Modernism appeared in the opening part of his book, called "The Death of Modern Architecture." To illustrate this section he showed the dynamiting in 1972 of Minoru Yamasaki's Pruitt-Igoe public housing, St. Louis (1952–55), a photograph that Peter Blake had already reproduced in his *Form Follows Fiasco* (fig. 26). With this strong graphic image Jencks announced bluntly: "Modern Architecture died in St. Louis, Missouri on July 15, 1972" Following Oscar Newman's argument in *Defensible Space* (1972),[24] he faulted the housing's modern design for its high crime rates which led to its dynamiting. This is refuted by the findings of the sociologist Herbert Gans, who has argued convincingly that the problem of such housing was primarily a social one, such as white flight from the city, high unemployment, and reduced social services, rather than the architecture itself.[25] Similar devastating changes occurred, for example, in the South Bronx in the 1970s, even though this section of New York consisted primarily of prewar apartment houses and low-rise walkups.

In his call for an architecture with mixed metaphors, Jencks illustrated his point with the "California Colonial" house of Lucille Ball (ca. 1955) and the "Pseudo-Tudor" house of Jimmy Stewart (ca. 1940) in Beverly Hills, which he described as close to the ideal of the American Dream House. He clarified their direct "language without speech" with explanatory balloons surrounding the rendering of each house. This type of investigation of conventions of visual symbolism in the everyday house (as well as the cartoonish

balloons) had been undertaken by Venturi and Scott Brown in their 1976 exhibition "Signs of Life: Symbols in the American City" at the Smithsonian Institution's Renwick Gallery, Washington, D.C., as Jencks acknowledged. And overall Venturi had already questioned Modernism, and with grace and wit, in his *Complexity and Contradiction*. One could even say that Jencks's idea of mixed metaphors is simply a popularization of "complexity and contradiction" and an extension of it to an extraordinarily wide range of contemporary architecture.

Yet the term "Postmodernism" attained wide acceptance through Jencks's breezily written book. Blake's *Form Follows Fiasco*, and Brent Brolin's *The Failure of Modern Architecture* (1976) never made the same impact.[26] Even Tom Wolfe's best-seller *From Bauhaus to Our House* (1981) did not change the argument substantially, though it extended it to a popular audience.[27] Wolfe, with considerable xenophobia, described those European Modernists who came to the United States as if they were foreign invaders. On the other hand, in holding up Beaux-Arts traditions as a preferable counterpoint to Modernism, Wolfe conveniently failed to mention that the Beaux-Arts had also originated on foreign shores. Meanwhile, Jencks had edited *Post-Modern Classicism* (1980) a year earlier, wherein he viewed the classical tradition as an already established visual language which might be more legible, even when inflected by Postmodernism, than some of the more idiosyncratic inventions he touted as multivalent in *The Language of Post-Modern Architecture*.[28] In his introduction to *Post-Modern Classicism*, Jencks suggested that because the old dominance of Classicism was broken by Modernism, it could now

be applied in a playful, freewheeling spirit. He called it "Classicism without tears," and wrote, "the usage has become diffuse and common enough to pick up these overtones generally without entailing an exact reference ... Mass-culture has opened classicism to the masses as well as the classes"[29]

Following Jencks's popularization of the term "Postmodernism," it subsequently cropped up in a large number of cultural critiques outside the confines of architecture and design. For instance, Jean-François Lyotard's *The Postmodern Condition* (1979) was a diatribe against American capitalist culture, while Charles Newman's *The Post-Modern Aura: The Act of Fiction in an Age of Inflation* (1985) applied the term to literary criticism.[30] Andreas Huyssen's *After the Great Divide: Modernism, Mass Culture, Postmodernism* (1986) was by far the most thoughtful of several other publications on late twentieth-century culture.[31] As had been the case in the architectural debate, in these broader discourses on culture, "Postmodernism" was generally used to signal a change from the optimistic progressivism and certainties of rationalism in early twentieth-century culture. But at the same time it simply represented an evolution from an earlier Modernism, rather than the announced "failure" of Modernism that had been part and parcel of the more polemical texts in architecture. In painting, for instance, we do not generally talk of the failure of Cubism, Expressionism, or Futurism, even though they were superseded by other concerns.

By the mid-1980s, Postmodernism in architecture had come to mean "Postmodern Classicism," as Jencks had defined it in 1980. Because of the presence of the Beaux-Arts

fig. 27
Michael Graves
Model, Keystone House (Plocek house), Warren Township,
New Jersey, 1977–83

approach in most American urban public buildings, this seemed to provide a more coherent model than Jencks's earlier, open-ended notion of "multivalence." But nearly all architectural movements were now looked at again with renewed interest, except, of course, Modernism. Postmodernism in architecture and design took on more than a historicizing guise: in many later built examples it devolved into a nostalgia for a premodern past, a sentimental attitude that was not shared by its erstwhile polemicists.

Influential early instances of Postmodern Classicism in architecture are two buildings by Michael Graves, the Plocek house (or "Keystone House"), Warren Township, New Jersey (1977–83), and the Portland Public Service Building, Portland, Oregon (1980–83; figs. 27–28). Graves had started out as a Modernist, but in place of the light, abstracted, open framework typified by his earlier Hanselmann house, Fort Wayne, Indiana (1967), in the Plocek house he turned to deeper colors, an anchoring, traditional base, columns that frame its entry, and above the door, an allusion to the use of keystones, a conventional element in the construction of an arch. To show that this was not just an imitation of Neoclassicism, he projected these gestures onto a flat wall that does not contain an arcuated

construction. Further, he omitted the central keystone, which would normally lock an arch in place. The whole, therefore, becomes an ironic reference, an allusion that requires familiarity with a standard architectural form in order to be comprehensible. Like Jencks, Graves had become increasingly concerned with the legibility of architecture. Whereas the entrance to the Plocek house seems to be clearly signaled in the street façade, the actual approach to the building tells a different story. This rather large "entry" for a residential building turns out to mark the entrance to the basement only. As a sign, this ceremonial gate to the house is thus quite misleading. The driveway in fact passes the front of the house and leads to the side where parking space and the garage are located. The much less conspicuous but main entry is here. While the Plocek house seems to promise clarity, it is in the end just as confusing as a Modernist house might be. The difficulty of Postmodern Classicism in communicating any better than Modernism is evident.

Similarly, in his design for the Portland Public Service Building, Graves used a classical three-part division, with a base, a midsection, and a slightly set back termination. Giant abstracted pilasters are suggested through a series of vertical strips, surmounted by an overscaled, nonfunctioning keystone. Flattened ribbons between the pilasters are meant to conjure up the garlands of classical ornament. Although the Portland Building is flanked by the early twentieth-century City Hall and the Courthouse, both done in a dry Beaux-Arts style, the three-part division of Graves's design is difficult to see from most approaches because the whole group is set in a dense urban context of undistinguished, postwar Modernist office buildings. Above the main entry to the building hovers

fig. 28
Michael Graves
Rendering from park showing what became the service entrance,
Portland Public Service Building, Portland, Oregon, 1980–83.

the sculptural image of a female figure, "Portlandia,"
a mythological invention of Graves's. While the public
may not know exactly what this figure represents, it does
help to mark the entrance. The rest of the classical references,
such as the abstracted pilasters, however, remain too
obscure to be seen by the general public as ironic gestures.[32]
Nevertheless, Graves's Postmodernism and that of others
did, in the end, open the design vocabulary to a wide range
of historicizing modes.

Beginning in the late 1970s, Graves and Venturi, Scott
Brown also turned to the design of furniture and objects.
Whereas Graves's designs are often updated versions of
Biedermeier and Art Deco, styles he also alluded to in his
buildings, Venturi and Scott Brown embrace the cardboard-
like flatness of some of their architecture, with styles quoted
in an exaggerated cartoon fashion, as in their *Sheraton* chair
(see p. 122). In furniture and smaller objects, the question of
legibility that architects raised for buildings is hardly an issue:
no matter how they are designed, we have no trouble
recognizing the purpose of a chair or a candlestick. In
design, therefore, we are dealing with a transference of
Postmodern concepts to a smaller scale where problems in
communication are not as crucial. Postmodernism in design
represents less a search for meaning than a response to the
playful, eclectic possibilities introduced in architecture.

By the mid-1980s, Postmodern Classicism in architecture
had come to be used widely for its fashionable details, even
in the most pedestrian speculative buildings. Often such
structures merely received one Postmodern dollop at the
entrance and another at the top, just enough to distinguish
them from equally pedestrian, late Modernist speculative

buildings. Vulgarized more rapidly than Modernism,
Postmodernism was soon simply a public relations "sign"
showing a building was up-to-date, rather than an attempt
to communicate with the public. The populist ingredient in
Postmodernism, though deriving from a sincere intention by
designers, became a palliative fiction.

The Everyday and Vernacular Regionalism
At about the same time that Venturi began to question
Modernism in *Complexity and Contradiction*, another
impulse within the late twentieth-century populist search
for meaningful design led to a serious consideration of
vernacular forms. Le Corbusier had always been interested
in the folkloristic, and when he became disenchanted with
rationalism, he incorporated it increasingly into his own
architectural expression. Some members of Team Ten had

looked to West African architecture as a model for communal clusters and to anthropocentric design as an alternative to the technological paradigms of Modernism. In 1964, Bernard Rudofsky was the curator of the "Architecture without Architects" exhibition at the Museum of Modern Art in New York, which featured anonymous buildings from many cultures.[33] It was remarkable that this kind of material was shown in a museum dedicated to modern art. "Architecture without Architects" could be regarded as an architectural response to the hugely successful "Family of Man" exhibition of 1955, organized for the Museum of Modern Art by its photography curator, Edward Steichen. Although the "Family of Man" show did not feature the work of anonymous photographers, many of the images had previously appeared in general-interest magazines like *Life* and were not "art photographs," but rather were chosen to depict universal experiences and daily relationships such as birth, play, marriage, and family.

The 1960s was also the period when environmentalism, ecology, and historic preservation became important topics both within and outside the academy. This was so because it was becoming obvious that the American landscape was being overtaken by suburban development, and in cities as well as the countryside historic structures were disappearing at a rapid pace, constantly displaced by the new. The expanding car culture of the postwar years, encouraged by such government policies as the National Highway Act of 1955 and mortgage support for new suburban houses (but not for the renovation of old urban structures), encouraged outward expansion at the expense of older town and city centers.[34] One had to drive to work and to market. Encounters with others were impossible on the highway, and impersonal in parking lots and shopping centers.

Awareness of the displacement of community and longing to reestablish a sense of place against formidable odds permeate the writing and design of Charles Moore. His book *The Place of Houses* (1974) summarized what he had been practicing since the 1960s.[35] The exterior of his own house in Orinda, California (1962), constructed while he was teaching at Berkeley, has the simplicity of a barn. The interior

fig. 30
Alvar Aalto
Town Hall, Säynätsalo, Finland, 1948–52

contains two areas marked by "aediculae," small structures consisting of four columns covered by their own roof. Moore had looked at ancient Roman houses and their aediculae for household gods, which had given these dwellings their religious center. He was also interested in the miniaturized "places" found in other centuries, such as baldacchinos in Baroque cathedrals, which designated particularly sacred spaces within the larger structure of the church. With these and other devices he tried to create an intimate domestic setting to counteract the externally imposed sense of placelessness. But the procedure was restricted and defensive in scope because it did not tackle the larger environment on which it was a comment.

Between 1963 and 1965, the Charles Moore firm, together with the landscape architect Lawrence Halprin, designed the Sea Ranch, a vacation community on a cliff overlooking the rugged Mendocino coast of Northern California (fig. 29). The central feature of this development is a series of condominium apartments housed in a group of small buildings of varying heights. Clustered tightly around several courtyards, the buildings are faced with vertical wood siding, which was inspired by an old sheep barn that was left standing on the property.[36] From a distance this collection of structures resembles a village. Their grouping around interior courts was, first of all, an ecological response to the cold winds that sweep in from the ocean. In this and in the overall approach, the Sea Ranch was probably inspired by Alvar Aalto's Säynätsalo Town Hall complex, Finland (1948–52; fig. 30), though translated into a Northern California regionalist style. Furthermore, whereas Aalto's complex actually is a town center with social functions, from stores

and a library to the town hall itself, the Sea Ranch simply looks like one: the sense of security that comes from the image of a town does not go beyond the visual. In addition, because this is a vacation getaway, the apartments' owners are not always there at the same time. The communal liveliness and congregation of even a tiny village is lacking. Though the Sea Ranch as a town is rather incomplete, it clearly exhibits a longing for community.

Andres Duany and Elizabeth Plater-Zyberk's master plan for Seaside, Florida (1981–present), a central instance of what has come to be called "New Urbanism," exhibits some of the same nostalgia as the Sea Ranch (see p. 82).[37] Larger than Moore's condominium complex, Seaside is a tightly

fig. 29
MLTW. Charles Moore, Donlyn Lyndon, William Turnbull, and Richard Whitaker
Sea Ranch Condominium Apartments, Sonoma, California, 1963–65

sited accretion of separate houses by a number of different architects. Seaside's urban code, developed by Duany and Plater-Zyberk, imposed a unified traditional look, although some buildings belong to Postmodern Classicism, and others to several regional vernaculars. Most important, Seaside is, like the Sea Ranch, a resort. Although there are some home-owners who live there year-round, most use it only for vacations. For this reason, Seaside's picturesque pastel houses do not constitute a real town. Its unreality is heightened by the messy commercial strips on either side of its town limits.

In 1965 Moore published "You Have to Pay for the Public Life" in *Perspecta*, the first serious architectural discussion of Disneyland, in Anaheim, California (1955).[38] Moore looked in particular at its Main Street, a three-quarter-scale reproduction of Victorian buildings. When he taught at UCLA, he took his architecture students there on field trips. He wondered how Disneyland functioned on a social level, what was done to keep it looking clean despite its thousands of visitors, and how the vast underground network of tunnels services the buildings. Whereas Venturi, Izenour, and Scott Brown turned to the noisy strip in Las Vegas, made to be seen from a moving car, for their study of an archetypal "main street," Moore used as his model an enclosed theme-park main street with only pedestrians and no cars, designed to look like something from a Currier & Ives print. This, like the Sea Ranch, reveals Moore's preoccupation with an older, smaller, pre-industrial notion of place and town, even though he was fully aware of Disneyland's make-believe quality. He was also interested in the hidden, underground city where invisible puppeteers, or "imagineers" in this case, make the visible world function, but he did not use this supermodern

aspect of Disneyland as a model in his own architecture.

At his Kresge College at the University of California at Santa Cruz (1965–73), on a large, densely wooded site, Moore and William Turnbull used a method slightly different from the vernacular allusions of the Sea Ranch to create the semblance of a village street (fig. 31). More visually eclectic here, Moore and Turnbull quote at once the simple Spanish Mission Style, the florid tile work of early twentieth-century Mission Style-inspired buildings in Southern California, the supergraphics of Pop art, and Hollywood set design. Buildings that contain offices, classrooms, and dormitories are arranged along a steeply rising, meandering path that terminates in a small structure with a courtyard containing a restaurant. The general effect is of two-dimensional sets flanking the "street." Though the social functions of Kresge College are more varied than at the Sea Ranch, and its disposition of a collection of buildings facing a public space is superior to the large, traditional college dormitory, the community and place it wants to invoke remains mediated rather than genuine. While Moore was engaged in creating these kinds of references to settled, traditional towns and streets, he himself was frequently moving from place to place, creating a new domicile with images of stability for himself in each location. His nomadic existence mirrored the extreme mobility of American life, which even the most forceful symbols of a stable community cannot conceal.

The clustering of buildings to make them resemble a town, or the breaking up of a single building into several constituent elements to achieve the same effect, is also present in Graves's unexecuted proposal for the group of small temples on top of his Portland Public Service Building (to amuse

fig. 31
Charles Moore and William Turnbull
View of dormitories, Kresge College, University of California,
Santa Cruz, 1965–73

fig. 32
Frank O. Gehry
Winton guest house, Wayzata, Minnesota, 1983–87

workers in nearby offices). It is a device found in other contexts as well. Frank Gehry, who works within a broadly defined Modernist idiom, even in his recent neo-expressionist design, has broken up the massing of a building into smaller parts in his projects from the 1980s onward. He has said this helps him control a large design, but he has used the method in small residential buildings as well.[39] Although never overtly nostalgic, his Indiana Avenue Studios, Venice, California (1979–81), Winton guest house, Wayzata, Minnesota (1983–87; fig. 32), Schnabel house, Brentwood, California (1986–89), Experience Music Project, Seattle (1995–2000), and Disney Concert Hall project (1987–present), among many others, create the semblance of community through an aggregation of forms.[40] These sorts of allusions crop up in miniaturized form even in other architects' design of objects, such as the tea sets by Venturi and Stanley Tigerman resembling hamlets of small structures (see pp. 124, 137). Is the teapot the town hall and the creamer the barn?

Kenneth Frampton, in his widely read essay of 1983, "Towards a Critical Regionalism: Six Points for an Architecture of Resistance," in *The Anti-Aesthetic: Essays on Postmodern Culture*, addressed placelessness and the loss of cultural identity caused by technological modernization and globalization.[41] His was a neo-Marxist critique of commodity culture and, in particular, of the convergence of populism with advertising and the "scenography" introduced by Postmodernism. Advertising and scenographic effects in his opinion are merely signs that sublimate direct, critical experience with information. He wrote that architecture must resist the Enlightenment idea of progress and at the same time the reactionary attempt to return to pre-industrial forms. Because the tactile, the tectonic, and the local can only be fully understood through direct experience, Frampton suggested that such devices make architecture immune to the media society. When he came to specific examples of a "resistant" architecture, buildings that have a regional identity without resorting to nostalgia, he was much less convincing. For instance, the nature of Aalto's extraordinarily tactile architecture cannot be transmitted properly in photographs, to be sure, but commodification through visual reproduction of his work still takes place. Another proposed model was Mario Botta's harshly defined houses in southern Switzerland, with terraced siting that to Frampton suggested their "place-form" in the mountains without recourse to sentiment. But Botta's severe houses can also be seen as an example of internationalization, as they seem to have been inspired by the architecture of Kahn. Further, tactile and tectonic expression does not in itself protect architecture from commodification, since New Brutalism, like most other twentieth-century movements, was in the end vulgarized. If one agrees with Frampton that the influence of capitalism is all-pervasive, then it is hard to believe that "resistant" regionalism will not also be consumed by the culture industry.

Feminism and Minority Studies

Women, although constituting a majority of the American population, have always had a difficult time entering the architectural profession, where to this day they are not well represented. They had, however, begun to make an impact in the decorative arts in the early twentieth century as crafts schools opened their doors to women. When more women came to the Bauhaus in Germany (1919–33) than Walter

Gropius had expected, he steered them toward the weaving and ceramics workshops: he did not consider them proper candidates for the architecture seminar.[42] Even in the areas that were considered "female" crafts, however, women were not named as heads of Bauhaus workshops (with the exception of one, Gunta Stölzl, who was in charge of the weaving workshop from 1926 to 1931). Although some schools of architecture were open to women, it was considerably more difficult for women to enter them than crafts schools. The few that did faced greater obstacles as practicing architects in getting commissions. In the 1970s, this state of affairs began to change slowly with the rise of feminism. Today, about half the students in most architecture schools are women, but they still do not make up a solid proportion of practitioners. Even such an established figure as Denise Scott Brown, who has practiced with Robert Venturi since the late 1960s, is still engaged in a constant struggle to be recognized as a designing partner of the firm. Maya Lin is among the few highly successful women architects in the U.S. who practice independently without an association with a male partner.

A 1977 exhibition at the Brooklyn Museum, "Women in American Architecture: A Historic and Contemporary Perspective," organized by Susana Torre, was a path-breaking effort to look at the history of women in this field.[43] Women have been active longer and in greater numbers in design than in architecture, but interestingly, the exhibition "Women Designers in the USA, 1900–2000," a historical overview organized by Pat Kirkham for the Bard Graduate Center for Studies in the Decorative Arts, New York, took place only in 2000–2001.[44] That sexism does not affect the decorative and graphic arts as much as architecture is evident from the considerable list of women in **USDesign**, the subject of this book and exhibition: Laurene Boym, Amy Chan, Beth Elliot, Louise Fili, Catherine Gilmore-Barnes, Agnethe Glatved, April Greiman, Dorothy Hafner, Katrin Hagge, Belle How, Mary Lou Kroh, Lisa Krohn, Barbara Kruger, Zuzana Licko, Susan Lyons, Lisa Mazur, Katherine McCoy, Jennifer Morla, Marie Reese, Paula Scher, Nancy Skolos, Helene Silverman, Gisela Stromeyer, Deborah Sussman, Nicole Trice, and Suzanne Tick.

Feminism and architecture became part of a critical discourse in the early 1990s with publications such as Beatriz Colomina's *Sexuality and Space* (1992), Daphne Spain's *Gendered Spaces* (1992), *Architecture in Fashion* edited by Deborah Fausch and others (1994), and *Architecture and Feminism* edited by Debra Coleman and others (1996), in which Mary McLeod's essay, "Everyday and 'Other' Spaces," was especially noteworthy.[45] McLeod demonstrated that although the much-cited French theorists Michel Foucault and Jacques Derrida both claim to deal with "otherness" in spaces used by the disenfranchised and previously repressed, those writers are not truly concerned with everyday places, such as the residence, the workplace, the street, or the shopping center. Because of this elision they did not address women as participants in the private and public realms. Further, McLeod saw the current language of architectural theory as full of machismo: "One is reminded how often avant-gardism is a more polite label for angry young men, sometimes graying young men."[46] By contrast, she singled out Venturi and Scott Brown for their empathy for the everyday and their discussion of, for instance, Levittown, mobile homes, and fast-food stores in their writings.

Regarding public space, Jane Jacobs was undoubtedly in the vanguard in her reexamination of the theme in *The Death and Life of Great American Cities* of 1961.[47] Her approach was not feminist as such—she wrote this book before feminism had become a full-fledged topic—but she included the perspective of women in the social context of the street and home. Her descriptions of New York City's West Village and Boston's North End evoke an informal public life, as McLeod put it: "The world of the stoop, the neighborhood bakery, the dry cleaning establishment, and, most importantly, the street; and with these come new subjects—mothers in the park, children, grocers, and newsstand attendants."[48] Writing from the vantage of the stay-at-home housewife of the 1950s, Jacobs saw the city as liberating for women, whose social life in the bedroom communities of suburbia was, by contrast, one of isolation during the day. While Jacobs's book contained a crucial convergence of appreciation for the everyday and proto-feminism, her analysis of the urban condition appears narrow and nostalgic in retrospect: she was, after all, lauding the small-scaled nineteenth-century street in the second half of the twentieth century. Nor did she fully examine the connection between space and power, as McLeod stated. Lewis Mumford, who was particularly acute in understanding the relationship between politics and architectural space, understandably criticized Jacobs's book, as did other critics. But he had a blind spot about her concern for public space from the woman's point of view. He was shockingly dismissive in his 1962 review in *The New Yorker*, "Mother Jacobs' Home Remedies for Urban Cancer," in 1962.[49] Despite the book's shortcomings, *The Death and Life of Great American Cities* has achieved a central place for its early insights into the connection between space and the daily experience of women.

In recent years, various minority groups have achieved official standing in academic institutions through the establishment of, for example, African-American and gay and lesbian study programs. Much has been written on "queer space," but relatively little on African-American conceptions of space, with the exception of some monographic studies and publications that deal with specific neighborhoods and places. Among the few books that address racial identity and architecture in some of its essays is *Sites of Memory: Perspective on Architecture and Race*, edited by Craig E. Barton (2001).[50] *African American Architects in Current Practice*, edited by Jack Travis, contains a useful but brief essay by Richard K. Dozier, "The Black Architectural Experience in America," and a chronology that together begin to fill in a historical picture.[51] For instance, Robert R. Taylor graduated in 1892 with an architecture degree from the Massachusetts Institute of Technology and was class valedictorian. Julian Abele, who graduated from the University of Pennsylvania in 1902, became the chief designer for Horace Trumbauer and Associates in Philadelphia, and was responsible for the design of Duke University. Paul Williams, a 1919 graduate of the University of Southern California, became well known for his houses for movie stars, such as Tyrone Power, Betty Grable, and Frank Sinatra. By the 1980s about two percent of architects practicing in the United States were African-American. There were thus important figures in this field, but a full-fledged history remains to be written.

fig. 33
Peter Eisenman
House III (Mr. and Mrs. Robert Miller house), Lakeville, Connecticut,
1969–71, diagram of design development.

The decorative arts by African-Americans have been covered somewhat better, most probably because crafts constitute a continuous tradition within much of Black culture. Crafts could be practiced at home without formal schooling, while entry into architecture remained a great obstacle because of the requirement for academic training or an apprenticeship. John Michael Vlach's "Afro-American Tradition in Decorative Arts" was an important exhibition at the Cleveland Museum of Art in 1978, and Bard's exhibition catalogue *Women Designers in the USA* contains a chapter on Black women.[52] The comparative dearth of general investigations of African-American architecture, as opposed to those in gay studies, is simply a sign of the relative cultural power of gays compared to Blacks. The latter were poorly represented among practicing architects in the past, and even today they are less often steered toward a cultural study of the visual arts, than to "practical" programs in sociology or education. Soon, one hopes, this state of affairs will be remedied.

Deconstructivism, "Expressionism," and Lyrical Modernism

Just as Classicism has never completely disappeared, so Modernism, despite redefinitions and attacks, has not faded entirely into oblivion.[53] The history of visual forms is multi-layered, with certain developments placed at the top of the heap, while the rest become more or less invisible. But they are still there. Unlike the Postmodernists, Venturi, Scott Brown had never fully rejected Modernism. Architects such as Peter Eisenman and Frank Gehry have never deviated from their own broad reinterpretation of Modernism, and by the 1990s

they both showed expressionist tendencies in their work. This recent neo-expressionism has no counterpart in theoretical discussions, and most critics would interpret it as a response to Surrealism, which has been elevated, wrongly, as the source of late twentieth-century interest in the irrational and anthropomorphic. But somewhat earlier, Expressionism contained these same ingredients, the anti-rational and anti-technological as a response to the technological devastation of World War I. Further, while Surrealism, though important for literature, painting, and photography, did not include architecture, there is a veritable treasure trove of Expressionist visionary drawings. Whether one sees Expressionism or Surrealism as a source for contemporary design, both can be seen as part of an expanded view of Modernism, which is no longer confined to ideas of technological progress.

The considerable differences between Gehry and Eisenman suggest the inclusiveness of this late twentieth-century Modernism. Where Eisenman insisted first of all on a theoretical framework for his designs that runs from Noam Chomsky's linguistic concept of "deep structure" to the idea of "self-similarity" derived from fractal geometry, Frank Gehry was inspired by contemporary artists such as Ron Davis and Robert Irwin, who were among his friends. Whereas Eisenman claimed that architecture is "free of external values," Gehry related his work to contemporary culture, but on the whole did not discuss his strategy and concepts.[54] Eisenman performed cartwheels of the mind, a talmudic acrobatics, to show us the working transformations from simple cube to elaborate, gridded construct (fig. 33), while Gehry concentrated on tactile contrasts between hard metallic surfaces and rough-hewn wood. Eisenman's

early weekend houses, however, share something of the Modernism of Minimalist sculpture of the 1960s, as in the work of Donald Judd and Sol LeWitt, and they can be experienced, despite Eisenman's imposition of mental superstructures, on a sensory level as elaborated sculptures. Gehry's early work, such as his studio and residence for Ron Davis, Malibu, California (1968–72), and especially his own house in Santa Monica, California (1977–78), can be theorized despite his lack of interest in a theoretical stance: their corrugated metal and chain-link fence exterior can be seen as a defense against a threatening environment, and their exposed floor joists and plywood interiors as a protective nest (see pp. 87, 151). Further, the work of the sculptor Gordon Matta-Clark, who was trained in architecture, forms an important background for both architects, but especially for Eisenman (although he might reject the connection). The critic Michael Sorkin wrote in 1988: "Asked to participate in the 1976 'Idea as Model' show at the old Institute for Architecture and Urban Studies [New York], Gordon Matta-Clark arrived with a set of photographs of housing projects in which all the windows

had been broken. He also brought a rifle and shot out every pane in the exhibition room. His behavior was judged scandalous, the glaziers were hastily summoned for amends, and Matta-Clark's contribution was suppressed by the Institute's director, Peter Eisenman."[55] Under these circumstances one wonders why Eisenman, who readily acknowledges indebtedness to current philosophical and intellectual ideas, has not credited Matta-Clark. Would his own work thereby seem less subversive?

Matta-Clark's deconstruction, splitting, and hollowing-out of old buildings about to be torn down—intentionally temporal monuments of the early 1970s whose only record today is the photograph—stand in powerful opposition to early twentieth-century Modernism with its utopian hopefulness. His *Splitting: Four Corners* (1974)—a very ordinary house in Englewood, New Jersey, that is cut in two and propped up to make the gash more apparent—prefigures the slots that bisect Eisenman's design of his House VI (for Suzanne and Richard Frank), Cornwall, Connecticut (1972–76; figs. 34, 35). Similarly, the project for the Bye house (1972–74) by Eisenman's friend John Hejduk—a conceptual house that is

fig. 35
Peter Eisenman
House VI (Richard and Suzanne Frank House), Cornwall, Connecticut, 1972–76

fig. 34 *opposite*
Gordon Matta-Clark
Splitting: Four Corners, house in Englewood, New Jersey, 1974

reduced to a wall from which rooms are hung like pods—suggests a procedure that is also present in Eisenman's House VI, with its two high "walls" that bisect each other and rise above the "rooms" (fig. 36). These "walls" are visually prominent yet do not enclose space
in a conventional manner: rather, they appear to slice aggressively through the structure like a magician's blade "cutting" through the body of his passive assistant. Though openly proclaiming theory as his territory, Eisenman in sum is not nearly as forthcoming about his indebtedness to contemporary art and architecture. (This is, however, not unusual among architects.) He freely invokes theoretical constructs, and erects them as a defensive screen through which he wants us to read his architecture, which is, nevertheless, often a beautiful sculptural abstraction of proto-architectural forms.[56] When questioned about the difficulty of transferring Chomsky's "deep structure" to the actual structure of architecture, he offered no explanation but claimed to have moved on to a newer theoretical construct. He referred to the geometries of urban grids, the nineteenth-century Greenville Trace (where the different surveying methods of the Virginia and Connecticut Land Companies collided), and to fractal geometry, but these remain completely abstract systems in Eisenman's explications of his works. Whereas his references never show the Postmodernists' concern with popular conventions and legibility, Eisenman calls on mapping devices that derive from geometry used to measure and depict human habitation and the environment. He insists that architecture refers only to itself, but he undercuts his own claim, since calling on geometric and philosophical theories to legitimize architecture is calling on values *outside* of architecture.

fig. 36
John Hejduk
Bye House project, 1972–74

In 1988, the Museum of Modern Art exhibited a group of seven architects, including Gehry, Eisenman, and several European designers, under the title "Deconstructivist Architecture." Many but not all of the works displayed angular slashes and concatenations of shattered forms, which were most visible in the projects by Daniel Libeskind and Zaha Hadid. (This approach is categorized as "expressionist" in **USDesign** and is viewed as belonging less to Russian Constructivism and more to a generalized expressionism originating in the crystalline projects of the German architect Bruno Taut and his circle).[57] Curated by Philip Johnson and Mark Wigley, "Deconstructivist Architecture" was the Museum's self-conscious attempt to redirect architecture toward a form of late Modernism, another 180-degree turn since Arthur Drexler's influential "Ecole des Beaux-Arts" exhibit.[58] Johnson had become a camp follower of Postmodernism, and had also begun to watch Gehry's work with interest. Although both he and Wigley insisted that Deconstructivism was not a new style, they clearly wanted to present their group of architects as a new direction. In the catalogue Wigley stated that the term "deconstructivism" did not derive from "deconstruction" in contemporary philosophy or Matta-Clark's work, as most observers had assumed. Instead, Wigley related the new architectural tendency exclusively to Russian Constructivism. Thus, he supplied Deconstructivist architecture with its own narrowly circumscribed Modernist history. Wigley insisted that the unstable-looking, unbuilt projects of the Russian Constructivists "posed a threat to tradition by breaking the classical rules of composition," and he wrote that the projects exhibited were symptomatic of a disruption of the dream of pure form of

architecture in which disorder has been banished.[59] Wigley did not explain this shift in contemporary architecture in social terms, but only in psychological ones that referred back to the forms themselves: "The deconstructive architect puts the pure forms of the architectural tradition on the couch and identifies the symptoms of repressed impurity … the form is interrogated."[60] His assumption that architecture in general, including other forms of Modernism, upholds a belief in pure form is highly questionable. Wigley's assertion that Modernists "argued that form follows function" is patently incorrect, though a widespread misapprehension. "Form follows function" was a phrase that the American architect Louis Sullivan coined in the late nineteenth century. And Wigley's claim that "functionally efficient forms necessarily had a pure geometry" is even more fantastic. Functionalism as it was pursued by Modernists had many permutations.[61] It never posited a link between efficiency and pure form.

Most curious in Wigley's text was the language of aggression that he used to describe architecture, such as "the wall is tormented," or "tortured from within, the seemingly perfect form confesses its crime …."[62] Although Wigley never clarified this posture, his aggressive concepts are heavily indebted to the subversive, Surrealist-inspired, Paris-based group of intellectuals (among them were poets, sociologists, and artists) called the Situationist International (1957–72), whose goal was a transgressive approach to the experience of the city. The only architect among the Situationists, Constant Nieuwenhuis (usually referred to only as Constant) had used the idea of deconstruction for his own designs.[63] The Museum of Modern Art's projects by Eisenman, Bernard Tschumi, and Rem Koolhaas were not truly "deconstructivist"

in their formal aspect but could be called late Modernist, while Eisenman's and particularly Tschumi's theoretical stance reflected that of the Situationists. On a visual and theoretical level, therefore, "Deconstructivist Architecture" was confusing.

In the manner of Eisenman, Wigley's interpretation was highly formalist, referring everything about the seven projects back to earlier architecture, without acknowledging any trace of contemporary culture. Architecture, he wrote, "expresses" nothing. But the architectural designs on display in "Deconstructivist Architecture" could be interpreted as a rejection of progressivism and other earlier certainties, and a turn toward a pessimistic view of society. Wigley predicted correctly that this episode in design would be short-lived. Like Postmodernism before it, Deconstructivist architecture became the latest fashion, and, as soon as it was commodified and coarsened, it no longer seemed to be subversively avant-garde. Though Wigley's essay was poorly argued, the exhibition nevertheless made an impact in demonstrating that late Modernism was an expanding field.

Perhaps more meaningful for an understanding of late twentieth-century Modernism is the German social critic Jürgen Habermas's essay "Modernity—An Incomplete Project," published in English in the American book, *The Anti-Aesthetic* (1983). Habermas was not directly concerned with architecture, but argued that Enlightenment rationalism should not be rejected, and that it plays a central role in what he called "communicative rationality." A communicative rationality mattered, he wrote, because "everyday communication, … moral expectations, subjective processes must relate to one another."[64] The negation of meaning that arose in the arts with Surrealism (which was carried on by the Situationists and resurrected by some of the Deconstructivists), did not lead to a transgressive resistance to capitalist modernization. All such attempts must fail, Habermas concluded, because they do not engage in the praxis of everyday life.

"Light Construction," the large Museum of Modern Art exhibition of 1995, indicated a more comprehensive turn to a late twentieth-century Modernism than the "Deconstructivist Architecture" show.[65] While it did not create a new label for architecture, it reached beyond the agonized forms of the Deconstructivists, and pointed to a more inclusive late Modernist impulse that depended less on shocking forms than on poetic methods of revealing a building. Its curator, Terence Riley, described the new architecture as enticing and unafraid of sensuous effects. He used the antique, somewhat sexist, motif of "Poppea's veil" to suggest how intriguing, mysterious aspects were created through incomplete revelation. In addition, Riley cited the expressionist preference for polychrome glass to suggest transformation away from the material toward the synaesthetic and its emphasis on sensory experience, in the way stained-glass windows transubstantiates the interior of the Gothic cathedral. Technology in these projects was used in a relaxed fashion, and not made an important feature. Many of the designs eschewed the clear glass of early twentieth-century Modernism, and instead relied on subtly opaque glazing, such as etched glass, or glass with silk-screened patterns. In some schemes, varied light effects were produced through metal strips and metal screens, while others used narrow screen-like spaces as their exterior envelope. None of the works had the acute, slashing forms of Deconstructivism, but instead used quieter, right-

angled compositions. Altogether "Light Construction" sketched a new Modernism, whose earlier technology-inspired hard edge and bravura were replaced by a reinstated vocabulary of the sensuous, the mysterious, and the poetic. The emphatically pleasurable aspects of this architecture represent a revival of Expressionist concepts without an imitation of its forms. In an earlier Modernism, the overt invitation to enjoyment might have been regarded as "feminine," but since the "consciousness-raising" of feminism and gender studies from the 1970s on, it can be made without fear of seeming unmanly and unheroic. Examples of this approach in the **USDesign** exhibition include, among many others, Maya Lin's Langston Hughes Library, Haley Farm, near Clinton, Tennessee (1996–99; see p. 107), Greg Lynn, Douglas Garofalo, and Michael McInturf's New York Presbyterian Church, Long Island City, New York (1999; see pp. 96–97), Karim Rashid's *Garbo* trashcans (1996; see p. 175), Harry Allen's *Daylight* lamp (2000; see p. 145), Mike Solis's *Grid Six* cabinet (1996; see p. 172), Ali Tayar's *Plaza* screen (1999; see p. 169), Ross Menuez's *Vanilla Fudge* chaise longue (1998; see p. 170), and the *iBook* computer (1999; see p. 175). All of these works display a delicate use of translucent and reflected light.

In summary, architecture and design today modulate and play with a wide range of Modernisms: Deconstructivist allusions are present in the work of Daniel Libeskind (see p. 89), softened Modernist orthogonal forms with translucent, reflective, or layered envelopes are used in the work of Jacques Herzog and Pierre de Meuron (who were included in the "Light Construction" exhibition), and more overt Expressionist references appear especially in recent designs by Frank Gehry. Gehry saw his Vitra Design Museum in Weil am Rhein, Germany (1987–89) as forming a triad with the Expressionist Goetheanum by Rudolf Steiner in Dornach, Switzerland (1924–28), and Le Corbusier's expressionist and Surrealist Chapel of Notre Dame du Haut, Ronchamp, France (1950–55), all not far from each other (figs. 37, 39).[66] Gehry's building constitutes a move away from the collaged metallic and wooden materials of his own earlier house. In his designs for the Guggenheim Museum in Bilbao, Spain (1991–97; see p. 86) and the Disney Concert Hall project, Los Angeles (1987–present), the biomorphic forms recall the Expressionist projects of Erich Mendelsohn and Hermann Finsterlin. Even Eisenman's work of the last few years seems neo-expressionist in its non-Euclidian forms, as in his design for the unexecuted Max Reinhardt Building (1992), whose inspiration was the continuous surface of the Moebius strip; his Aronoff Center for Design and Art, University of Cincinnati, Cincinnati, Ohio (1988–96; see pp. 94–95); or his project for the Staten Island Institute of Arts, New York (2000). However much he claims them to be based on complex geometry, they appear more responsive to the popularity of Gehry's recent work.

Notwithstanding the currency of a comparatively freewheeling, inclusive, and modified Modernism, there has not been a return to the technological progressivism, or the belief in the future and in social improvement, common to orthodox Modernism. Directly affected by contemporary public relations and the economic market, developments in design function today much like fashion. Venturi, Scott Brown's adaptation of a commercial vernacular openly accepts this state of affairs as part of our present visual

fig. 37
Rudolf Steiner
Goetheanum II, Dornach, Switzerland, 1924–28

language. Those designers who might try to "resist" commodity culture cannot really control its effects. Under these circumstances of constant change and obsolescence, it has become more difficult to read architectural forms as meaningful symbols of cultural production. There are some features, however, that are common to a range of practitioners over the last few decades. From the forcefully architectonic, defensive structures and inward-looking definition of Kahn, to the decorated sheds of Venturi, Scott Brown, the scenographic mode of Moore, and the metallic armor of Gehry, there is a notable turning away from the "public" space of the street.[67] The notion of space itself has undergone a change; and it is no longer open and volumetric as in early Modernism. Venturi and Scott Brown present a billboard-like wall attached to a "dumb box"; Hejduk contracts space to a wall to which rooms are attached; and Eisenman (fig. 38) and James Wines in his Aquatorium, Ross's Landing, Chattanooga, Tennessee (1989–93; see pp. 100–01), develop dense, constricted layers of narrowly sliced space. Though as inventive forms such spaces may be intensely intriguing, all of them suggest an anxious approach to contemporary life. Further, the use of accreted multiple forms that evoke a village-like setting, whether in Moore's literal references or Gehry's more abstracted devices, reflect the loss of a sense of place and the alienation of the social sphere in our car culture and global economy.

fig. 38
Peter Eisenman
Model, House IV project, Falls River, Connecticut, 1970–73, model

fig. 39
Frank O. Gehry
Vitra Design Museum, Weil am Rhein, Germany, 1987–89

POINTS OF VIEW IN
AMERICAN ARCHITECTURE DAVID G. DE LONG

The look of American architecture keeps changing, and we are probably the better for it. The austere, classic Modernism widely prevalent in the decades immediately following the Second World War, so rationally conceived that many imagined it would prevail forever, has long since given way to a multitude of seemingly conflicting viewpoints. Even those who steadfastly sought to uphold the tenets of Modernism have so expanded its boundaries as to transform it forever. Indeed, these late manifestations are so different that no informed observer of late twentieth-century architecture would confuse them with those of five decades earlier any more than a Greek citizen would have confused fourth-century B.C.E. temples with those of the immediately preceding fifth.

Even more provocative than late Modernism are newer approaches of a sort barely imagined before the 1960s, and the resulting variety is astonishing. Complex, intellectually stimulating theories that architects provide to help explain their emerging vocabularies can further complicate the situation. Yet visual similarities can be identified among the designs themselves, however diverse the theories that underlie them, and these similarities help us locate structure within the seeming turbulence of design in the last quarter of the twentieth century.

The beginnings of change that have so transformed late twentieth-century American architecture can be traced back to the late 1950s, and especially to the work of Louis I. Kahn. He challenged the very fundamentals of Modernism as it had been defined in the 1930s,[1] fundamentals so widely accepted that they had been developed with little more than surface-bound variations in the years that followed. Thus, in Kahn's hands, light, volumetric enclosures gave way to more massive forms; open, continuous interiors began to be more firmly differentiated; clear, simply organized shapes began to be broken apart and juxtaposed in unexpected relationships; and enclosures began to be layered, so that exteriors were separately shaped from the interior spaces they contained.[2]

Kahn encouraged both his colleagues and his students to push further, and two in particular did: Robert Venturi and Denise Scott Brown. More radically than Kahn, they challenged conventional order based on Euclidian geometries and questioned rational structure as an essential component of meaningful form. They argued for an architecture of their time that would be "anti-spatial," with an emphasis on applied ornament carrying representational information that could act as signs, or symbols; these largely two-dimensional images would take precedence over space as a primary means of architectural expression.[3]

Venturi's seminal tract, *Complexity and Contradiction in Architecture*, completed by 1963 but only published in 1966, laid these ideas out before an astonished public. In 1972, together with Denise Scott Brown and Steven Izenour, he presented an equally controversial, more strongly polemical argument in *Learning from Las Vegas*, as noted in these pages by Rosemarie Haag Bletter.[4] While the earlier book focused on the visual analysis of a wide span of historical examples, speaking in favor of their meaningful complications, the later examined vernacular manifestations of commercial culture, particularly as illustrated by Las Vegas's famous strip, arguing not for its emulation, but rather for an understanding of its vibrancy and popular appeal.

Both firms—Kahn's and Venturi, Scott Brown's— reconnected architecture with history, but in different ways.

Kahn drew inspiration from the massive forms and underlying structure of the historic models that he studied, seeking, as had the ancient Greeks, an integral ornament developed from abstractions of construction. Venturi and Scott Brown, on the other hand, were drawn to historicizing as well as popular motifs that were applied as decoration, and that were thus purposely separated from the structural realities that lay beneath. To draw a parallel with nineteenth-century practice, Kahn sought to ornament construction while Venturi and Scott Brown devised constructed ornament. Their more obviously historicizing attitude, seen in one of Venturi's first designs to be realized, the Vanna Venturi house for the architect's mother (Chestnut Hill, Pennsylvania, 1959–64; fig. 40), provoked widespread criticism. Yet at least one sensitive critic perceived deeper implications in that house: "The whole, in its studied disjointedness, appears to express the discontinuity and fragmented quality that characterizes contemporary life."[5]

Venturi, Scott Brown and Kahn were by no means alone in laying groundwork for change. On the West Coast, for example, Charles Moore had begun to explore aspects of history and popular culture in his Orinda, California, house (1962). Within an exterior shell shaped very much like an ordinary barn, it contained elegant classical pavilions as enclosures for specified activities. In Europe, architects such as Aldo van Eyck explored themes closer to Kahn's.[6] Yet in America, Venturi, Scott Brown and Kahn provided the more immediate points of departure, offering ideas that a younger

generation of architects began to develop with remarkable originality.

The discussion of American architecture between 1975 and 2000 that follows, with its emphasis on visual qualities, deals mostly with issues of style, as does the exhibition that this catalogue accompanies. Not style as defined by Meyer Schapiro—an inescapable summation of any given culture as reflected through its art—but style as more commonly defined today: a manner or mode that is essentially a matter of choice within the broader framework of a stylistic, or cultural, period.[7] Thus, as I will define it, within the overarching period of Postmodern culture that characterizes our time (or style, as Schapiro might have described it), various manners of expression can be discerned. Some, incorporating different levels of historical or popular quotation, are often called Postmodernist, or even "Postmodern Classical," terms sometimes applied interchangeably to the Postmodern period itself. The different usages signal an evolutionary phase in which the meanings themselves are still being determined. Other manners, reflecting developments of more obviously twentieth-century vocabularies, tend to be called late Modernist, or rationalist; still others are labeled Decon-structivist, or, more broadly, neo-expressionist. Still more terms abound, and assuredly still more will be invented. Together, in all their diversity, these complicated, sometimes overlapping, manners give voice to individual interpretations of our Postmodern era.

Although such secondary, elective styles (or manners) are part of our culture, their existence, when identified, tends to make architects and even some critics uneasy, like bad odors.

As Witold Rybczynski has written,

> Architects don't like to talk about style. Ask an architect what style he works in and you are likely to be met with a pained expression, or with silence. … [N]othing enrages an architect as much as being categorized according to a particular style. … In other words, although architects are willing to accept the notion that buildings embody ideas, they don't like to acknowledge the manner in which these ideas are expressed.[8]

Probably this attitude stems from that period of early twentieth-century Modernism when architects, in rejecting the eclectic styles of a previous generation, imagined they had jettisoned the existence of style itself. Believing their architecture to be based so fully on rational expressions of structure and function as to render aesthetic determinants of secondary importance, they claimed that style as a matter of artistic choice no longer pertained to their work. But as Reyner Banham demonstrated long ago, their claim never really held up.[9]

In focusing on style—that is, the way recent buildings by American architects look—a wide range of sources can be discerned, however much those sources may have been transformed to achieve new expression. Beginning with the broadest possible division, they can be grouped into two categories that I have chosen to call near sources and far sources. Underlying the buildings in question are widely differing philosophies, and often deeper meanings, as explained in the essays in these pages by Thomas Hine and Rosemarie Haag Bletter. Yet when the buildings themselves are grouped according to visual characteristics, some

unexpected adjacencies result, and theoretical differences can seem of slightly less consequence. Far sources, as I define them, include those distant in time or remote in terms of modern expectations, at least as regards architecture. They reflect pre-modern, or historicizing, images at one extreme and popular, or commercial, images at the other; the two are sometimes intertwined in single examples. Historicizing images include motifs drawn from the entire history of architecture as well as from intentionally decorative vocabularies of the twentieth century, such as Art Deco. All were firmly rejected by orthodox Modernists. Popular images include motifs drawn from ordinary buildings and objects, from commercial sources and vernacular culture. Parallel with the Pop art of the 1960s, these images are not transformed through sophisticated modification, but openly celebrated for what they are. This has led some critics to judge them harshly for their apparent lack of sophistication. Buildings incorporating far sources deal with figural or representational imagery, with qualities of symbol and iconography, and with the reestablishment of architecture as a communicative art in a traditional sense.

Near sources, from my perspective, derive from modern vocabularies of the twentieth century, and thus are close, or near, in time as well as in memory. They are essentially non-figural and abstract. At one extreme, the buildings in this category suggest a renewed awareness of early twentieth-century expressionism, especially German Expressionism, but also Italian Futurism and Russian Constructivism.[10] They are characterized by non-Euclidian geometries, by exaggerated textures and sculptural forms. At the other end of near sources are those derived from orthodox Modernism, signaled in part by their simple Euclidian geometries and clearly defined volumetric enclosures. Buildings incorporating near sources, from whichever end they are drawn, tend to communicate through their forms alone rather than through secondary elements, or images, applied to those forms.

Both ends of these near sources, like both ends of far sources, can be found in single examples, further diffusing any sense of rigid boundary within each group. Yet the extremes themselves, like bookends, offer alluring images for purposes of categorization. For the exhibition of **USDesign**, they have been given identifying names that apply to architecture as well as design and graphics: for far sources, "Inventing Tradition" at one end and "Celebrating the Everyday" at the other; for near sources, "Redefining Expressionism" at one end and "Expanding Modernism" at the other. Among other things, these titles are intended to indicate that the works grouped within them are not literal replications of any specific source, but instead are creative, transforming adaptations.

As pertains to architecture, each of these four categories can be illustrated by an example so striking, and so familiar, as to be iconic. Other examples, less subject to simplistic categorization and in some instances less known, enrich the field.

Inventing Tradition

Nowhere has tradition been more pervasively invented than in communities planned to evoke images of another time, as famously demonstrated by the vacation enclave of Seaside, Florida, on which construction began in the early 1980s. It has been described as "the recreation of a small-town

fig. 41
Scott Merrill
Honeymoon Cottages, Seaside, Florida, 1981ff
Photo: Steven Brooke Studios

other architects, like most of its buildings) are advertised as having six styles: Classical, Victorian, Colonial Revival, Coastal, Mediterranean, and French.[14] Nostalgia clearly figures heavily in New Urbanism, and the town of Celebration has been described as a "revival of Norman Rockwell's America."[15] Yet the immediate roots of New Urbanism are strong: Plater-Zyberk worked in the office of Robert Venturi and Denise Scott Brown, and two books of considerable renown are credited as being fundamental to its conception: Colin Rowe and Fred Koetter's *Collage City* and Jane Jacobs's *The Death and Life of Great American Cities*.[16]

Buildings with the look of another time such as those in Seaside or Celebration, and especially those that replicate some specific style of the past, illustrate an aspect of what has come to be called Postmodernism: a historicizing mode that expresses one part of our Postmodern era. Examples abound, and no architect is more facile in skillfully adapting a multitude of styles than Robert A.M. Stern, since 1998 the dean of Yale's School of Architecture.

Critics tend to identify Robert Venturi and Denise Scott Brown as the parents of this Postmodernism, and in large part they are, yet they have come to reject what it has become in its more obvious elements, while in their recent work they expand upon the very themes that they did so much to initiate. They use historic motifs for symbolic purposes rather than reproducing them literally, manipulating them in ways that stimulate our memories, but never fool or charm us into seeing them as anything but clearly identifiable attachments to late twentieth-century buildings. They tend to criticize those such as Stern who seem to replicate the vocabularies of the past without rigorously reconstituting them. As Scott Brown has written,

America that in truth never existed"[11] Little wonder that it provided a perfect setting for the satirical motion picture, *The Truman Show* (1998), in which the town itself was portrayed as an elaborate stage set of imagined perfection.

The revival of traditional planning values that Seaside illustrates with its cozy densities, low-scaled ambience, and pedestrian-friendly layout has come to be known as "New Urbanism." Its most acclaimed proponents to date are Andres Duany and Elizabeth Plater-Zyberk, the planners of Seaside, who are also credited as founders of the approach. Their incorporation of local building styles at Seaside completed a convincing ensemble that has challenged modern concepts of larger-scaled, more automobile-dependent planning. Also comfortably imbedded within Seaside's townscape are strongly evocative historic images, such as the Honeymoon Cottages by Scott Merrill, meant to recall Thomas Jefferson's cottage at Monticello (fig. 41).[12]

Later examples of New Urbanism include Celebration, the town created by the Disney Corporation near their theme park in Florida.[13] Duany and Plater-Zyberk contributed to its planning, which is generally praised; its houses (designed by

fig. 42
Robert Venturi and Denise Scott Brown. Venturi, Rauch, and Scott Brown, Architects. Sheppard Robson, Associated Architects.
Exterior, Sainsbury Wing, National Gallery, London, England, 1985–91
Photo: Matt Wargo

"Contextual borrowings should never deceive; you should know what the real building consists of beneath the skin."[17]

In their approach, Venturi and Scott Brown have defined an intellectual core of Postmodernism in its most positive sense, yet in their statements they seem determined to limit their use of the term to those charming, literal, Disney-like manifestations of another time that reflect a simplistic interpretation of the concept. They prefer to think of themselves as mannerists and to emphasize their ties to the Modernism out of which their work evolved. On the cover of a recent periodical, Venturi is shown with a scowling visage, proclaiming, "I am not now and never have been a Postmodernist."[18] How ironic that he applies the term so narrowly as to deny himself credit for the very movement that he and Scott Brown did so much to initiate.

In their Sainsbury Wing of the National Gallery in London (1985–91), Venturi and Scott Brown show how very challenging and of its time that Postmodernism can be (figs. 42–45).[19] Attached to the main building (1832–38) by William Wilkins, the front façade incorporates classicizing elements adapted from it, establishing a sympathetic relationship. But as the distance between this new façade and the older building increases, these elements gradually flatten out and become more widely spaced, which subtly reveals them as modern representations. The façade itself lacks the customary monumentality and formality of classicism, but instead steps back asymmetrically, a deferential gesture toward the part of Trafalgar Square that it overlooks. Unframed openings cut into the façade lead to a quiet, unassuming entrance. Inside, on the upper floor, the Sainsbury galleries acknowledge the main building's formally linked rooms, but the new axes of the Wing are angled in ways that animate conventional regularity, and the enclosed areas along these new axes are framed by a robust, inventive Tuscan order that works yet another transformation of traditional imagery. In these and other ways, Venturi and Scott Brown honor, but never replicate, the eclectic classicism of the nineteenth century. The result is an invented tradition of a very high order indeed. And transcending issues of style, the Sainsbury Wing, through a perimeter shaped and detailed to respond to its surroundings, reinforces its urban setting.

Other architects, working with historical precedents, have invented vocabularies that are more specific than allusive, but with such variety and even playfulness as to express their own time as well. In his seductive design for

figs. 43/44/45 *left to right*
Robert Venturi and Denise Scott Brown. Venturi, Rauch, and Scott Brown, Architects. Sheppard Robson, Associated Architects
Sainsbury Wing, National Gallery, London, England, 1985–91
Detail of gallery plan, marker on yellow tracing paper, 51 x 30 cm (20 x 12 in.)
Collection of Venturi, Scott Brown and Associates
Detail of perspective of galleries, marker on yellow tracing paper, 46 x 102 cm (18 x 40 in.)
Collection of Venturi, Scott Brown and Associates
Interior view, photo: Matt Wargo

figs. 46/47/48 *top to bottom*
Michael Graves. Michael Graves, Architects
Clos Pegase Winery, Napa Valley, California, 1984–87
Model, mixed media, 43 x 74 x 145 cm (17 x 29 x 57 in.)
Collection of Michael Graves & Associates
Site Plan, gouache on paper, 91 x 122 cm (36 x 48 in.)
Collection of Mark Holeman
Forecourt façade study, pencil and colored pencil on yellow tracing paper,
25 x 53 cm (10 x 21 in.)
Collection of Michael Graves & Associates

DOMAINE CLOS PEGASE WINERY
SITE PLAN
N →

the Clos Pegase Winery (Napa Valley, California, 1984–87), Michael Graves illustrates this approach (figs. 46–49).[20] The diversity of its shapes, and their responsive enhancements of the local landscape, recall the spirit and even the image of ancient Roman villas, and an actual villa (the client's own house) sits regally atop a hill where it overlooks the adjoining winery. Other Roman ties include a circular rotunda (as yet unbuilt) that alludes to the ancient Mausoleum of Augustus in Rome, yet with an unexpected inversion. The steep terraces enclose not a tumulus at the center, but instead a circular *nymphaeum*, its water drawn by an axial channel from a source on the hill above. It is meant to recall the spot in Greek mythology where the

imprint of Pegasus's hoof caused the spring of the Muses to flow. The muscular classicism of the winery suggests both a *villa rustica*, as the ancient Roman architect Vitruvius might have described it, and the late eighteenth-century designs of Claude-Nicolas Ledoux. In this, Graves has worked a witty comment on Modernism itself, for the forceful geometric shapes of Ledoux's architecture had been suggested in the 1950s as one of the sources of modern architecture in its broadest sense.[21] Yet Modernism is far from obvious in this romantic complex, which, with an enviable perfection in its Napa Valley setting, seems to embody those relaxed pleasures associated with its product since the beginning of history.

fig. 49
Michael Graves. Michael Graves, Architects
Exterior, Clos Pegase Winery, Napa Valley, California, 1984–87
Photo: Grant Mudford

fig. 50
Andres Duany and Elizabeth Plater-Zyberk. Duany Plater-Zyberk & Company
Detail of Seaside, Florida, 1981ff
Photo: Steven Brooke Studio

Celebrating the Everyday

Within the town of Seaside, new buildings reflecting a local vernacular abound. As seen in overall views, they blend so smoothly and represent styleless anonymity so successfully that captions often leave their architects unnamed, even though they include such successful practitioners as Deborah Berke, Thom Christ, and Walter Chatham, among others (fig. 50). Together with buildings recalling traditional styles of a more elevated sort, these structures also help evoke some golden age of uncertain origin, an age remote from the more immediate reality of our own time. Elements such as folksy porches, simple gables, and low turrets indigenous to older buildings in the area are not reworked, or refined, or disguised, but embraced for their very obviousness. Again, the sense of friendly communication seems part of the objective, and the result has obvious, accessible charm.

For Robert Venturi and Denise Scott Brown, making art out of the ordinary has long been their way of celebrating the everyday. In the Mielmonte Nikko Kirifuri hotel and spa (near Nikko, Japan, 1992–97), they honor the anonymous buildings of Japanese villages as well as the messy vitality of

the village-scaled shopping streets found in Tokyo (figs. 51–54).[22] Thus, in emulation of the look of vernacular houses, they affixed rafters to the otherwise simply profiled wings of the hotel. The rafters themselves are not structural, but decorative, and presented frankly as the flattened, representational devices they are rather than detailed to create a false sense of heavy, load-bearing weight. They read as stage props decorating an otherwise modern structure, recalling but not imitating vernacular building. Similarly representational is their design of the hotel's lobby, conceived to suggest a typical street of small Japanese shops, here embellished with cartoon-like, two-dimensional images of streetlights, public telephones, hanging baskets, and the like. With the billowing flag of their 1989 competition design for the United States Pavilion at Expo '92 in Seville (unbuilt, fig. 55), the Venturis had earlier shown how architecturally-scaled

fig. 51
Robert Venturi and Denise Scott Brown. Venturi, Scott Brown and Associates with Marunouchi Architects & Engineers, Associated Architects
Elevation, Mielmonte Nikko Kirifuri Hotel and Spa, Nikko, Japan, 1992–97
Marker on yellow tracing paper, 46 x 47 cm (18 x 18 ½ in.)
Collection of Venturi, Scott Brown and Associates

figs. 52/53/54 *clockwise, from left*
**Robert Venturi and Denise Scott Brown. Venturi, Scott
Brown and Associates with Marunouchi Architects &
Engineers, Associated Architects**
Mielmonte Nikko Kirifuri Hotel and Spa, Nikko, Japan, 1992–97
Section, black and colored marker on yellow tracing paper, 36 x 65 cm (14 ¼ x 25 ½ in.)
Collection of Venturi, Scott Brown and Associates
Interior, photo: Kawasumi Architecture Photograph Office
Exterior, photo: Kosuge

graphics could suggest qualities of national identity. In the
Nikko lobby, smaller, less obvious images record a parallel
exploration. They line its sides and contribute to a visual
impression of agreeable density. Venturi and Scott Brown
believed such representations could effectively evoke a
genuine element of modern Japanese culture, and it was to
this element that they were drawn on their first visits to Japan,
rather than to the more traditional temples and palaces that
had so captivated architects earlier in the twentieth century.[23]

Stanley Tigerman and Margaret McCurry also celebrate
the everyday in their work, as in the Power House Energy
Education Center (Zion, Illinois, 1993–99; figs. 56–58).[24]
Its stepped profile and clean detailing derive from the simple
lines of anonymous industrial buildings, or, more particularly,
of barns. Placed at regular intervals along the structure are fire
stairs projecting out at an angle of thirteen degrees to its main
axis, positioned so they parallel nearby structures and help
unify the building with its setting. These projecting elements,
together with angled exhibition enclosures inside, provide a
degree of sophistication that distances the 336-foot-long
building from nostalgic romanticism.

figs. 56/57/58 *left to right*
**Stanley Tigerman and Margaret McCurry. Tigerman,
McCurry Architects**
Power House Energy Education Center, Zion, Illinois, 1993–99
Model, mixed media, 61 × 183 × 38 cm (24 × 72 × 15 in.)
Collection of Tigerman, McCurry Architects
Sketch, ink on yellow tracing paper, 30 × 65 cm (12 × 24 ½ in)
Collection of Tigerman, McCurry Architects
Exterior, photo: Bruce Van Inwegen

fig. 59
**Frank O. Gehry. Frank O. Gehry and Associates with
IDOM, Associated Architects**
Exterior, Guggenheim Museum, Bilbao, Spain, 1991–97
Photo: Erika Barahona Ede

fig. 60
Hermann Finsterlin
Model, Project for Casa Nova, ca. 1919

America. An exhibition in 1988 at the Museum of Modern Art in New York helped to signal this ascendancy and also supplied the label by which much of the work is known: Deconstructivism.[25] The term is a useful one in focusing on the fractured, disjointed geometries employed, and the exhibition revealed theoretical ties among the architects exhibited, as explained in these pages by Rosemarie Haag Bletter. Yet similar geometries, together with others that are similarly complex but more sculpturally coherent, have been employed by other architects whose theories differ. They are equally expressionistic, but fall outside the narrower definition of Deconstructivism itself.

Among those architects included in the 1988 exhibition was Frank Gehry, and he was one of the first to protest the label, feeling awkwardly positioned within a movement in which he believed he had no part, a bit like Venturi rejecting his own Postmodernism. Nevertheless, Gehry's work continues to be seen as an example of the term even if it better illustrates the broader current of a revived expressionism. No building more fully embodies this current, nor is more famous for just this accomplishment, than his Guggenheim Museum in Bilbao, Spain (1991–97; fig. 59).[26] Clad in titanium, the whole appears as seamless and devoid of scale as the hand-sculpted, working models through which Gehry develops his concepts. It offers striking parallels with examples of German Expressionism dating from the late 1910s and early 1920s (fig. 60), as others have also noted.[27] Unlike those earlier conceptions, however—unbuildable fantasies conceived to illustrate utopian ideals of a better world—Gehry's were, and are, not only buildable, but remarkably free of the verbal rhetoric that characterized German

Redefining Expressionism

During the last quarter of the twentieth century, a revived expressionism has risen to a position of stylistic prominence in

fig. 61
Frank O. Gehry
Exterior, Frank O. Gehry Residence, Santa Monica, California,
1977–78; addition 1991–94

fig. 62
Bruce Alonzo Goff. Bruce Goff, Architect
Perspective View, Joe Price Studio No. 1, Bartlesville, Oklahoma, 1953–54
Pencil and colored pencil on tracing paper, 68.5 × 109 cm (27 × 43 in.)
Collection of the Art Institute of Chicago, Gift of Shin'enkan, Inc.

fig. 63
**Daniel Libeskind. Architectural Studio Daniel Libeskind
with Gordon H. Chong & Partners**
Model, Jewish Museum, San Francisco, 2000ff

Expressionism. The forms of his buildings speak for themselves.

Gehry's reconfiguration of his own house (Santa Monica, California, 1977–78; addition, 1991–94; fig. 61) initiated the series of which the Guggenheim Bilbao is a part, and each design seems ever more remarkable as the series lengthens, now with his project for the Guggenheim New York (begun in 2000).[28] Without the sophisticated computer software that can translate his conceptual models into practical form, the designs of the series would probably remain as unrealizable as the German Expressionist fantasies they recall, but technology has made them all possible.[29]

Pioneering historians of modern architecture suppressed German Expressionism in their accounts of the twentieth century, perhaps, as one told me, because it had seemed to lead nowhere.[30] Also largely excluded were examples of a less theoretical expressionism, one incorporating similar vocabularies of exaggerated curvilinear or angular shapes, but dealing with idealized conceptions of function or material. Some of these works—for example, Erich Mendelsohn's Einstein Tower (Potsdam, 1919–21)—were realized. Frank Lloyd Wright infused his early modern architecture with expressionistic forms beginning in the 1920s, such as his exotic spiral for the Gordon Strong Automobile Objective (unbuilt; Sugar Loaf, Maryland, 1924–25); it had apparently been influenced by Mendelsohn.[31] The generally awkward manner in which these seeming exceptions to modern architecture were explained left younger historians less prepared to deal with later examples, such as Le Corbusier's Chapel at Ronchamp (1950–55) and Eero Saarinen's TWA Terminal at Idlewild Airport, New York (now John F. Kennedy; 1956–62; see p.

40). It can now be seen that expressionism, together with an emerging Modernism that came to dominate mid-twentieth-century design, was an ongoing, if sometimes overlooked, current of modern architecture. And as contemporary examples also illustrate, architects have been drawing from both themes.

Today's architects have redefined the expressionism of the early twentieth century in various ways, not least by making it buildable, however fantastic the designs themselves appear. They also deal more readily with actual needs, and accommodate real functions. More important, they have responded to context, and in urban settings they have established persuasive coherence, as Gehry does at Bilbao by joining his building to adjacent streets and even bridges in ways that infuse the city with renewed energy. The Guggenheim's complex geometries are thus part of a larger whole. In some cases, this context relates to the reworking of a preexisting building, notably the Jewish Museum of San Francisco (scheduled for completion in 2002; fig. 63) by Daniel Libeskind.[32] In this instance, Bruce Goff's first, unbuilt design for the Price Studio (Bartlesville, Oklahoma, 1953–54; fig. 62) provides an obvious antecedent.

Libeskind may have been aware of Goff's design, as it had been published on several occasions,[33] but more probably the resemblance is coincidental, or at least subliminal. Goff, a follower of Wright, had begun his own study of German Expressionism by the mid-1920s, and in his classes at the University of Oklahoma had stressed those designs in his lectures.[34] Gehry himself has acknowledged a longstanding awareness of Goff's work, which he has described as "a role model for students to use in exploring

figs. 64/65 *top to bottom*
Thom Mayne. Morphosis
Diamond Ranch High School, Diamond Bar, California, 1994–2000
Model, mixed media, 25 x 137 x 208 cm (10 x 54 x 82 in.)
Collection of Morphosis
Aerial perspective, computer rendering, 43 x 51 cm (17 x 20 in.)
Collection of Morphosis

their own world and in finding themselves …. Goff talked about the intuitive in a way that I find familiar …. He talked about awkwardness, irresolution, and the unfinished. These are all issues and ideas that move me also."[35] It seems the history of modern architecture could now be rebalanced, the better to anchor recent examples of American practice.

Thom Mayne (whose office goes by the name Morphosis), a younger architect practicing in the Los Angeles area, once worked for Frank Gehry, but he has developed a vocabulary of fractured, folded planes closer in appearance to work by Libeskind. Mayne's Diamond Ranch High School (Diamond Bar, California, 1994–2000; figs. 64–67)—acclaimed at the time of its completion as "Clearly the best American building of the year"[36]—derives part of its expression from its undisguised industrial materials, as many buildings in this category do. Corrugated metal, precast concrete planks, and the like give hard edges to the forms and augment the energy of their seemingly random juxtapositions.

In shaping his building, Mayne sought to amplify the underlying geometries of the place itself, for the high school is sited on a large, hilly parcel at the edge of suburban Los Angeles, without a conventional context of preexisting buildings. Frank Lloyd Wright had responded to open sites in a parallel way, but he employed the simpler geometries of an earlier age. As Mayne said of Diamond Ranch, "I am interested not in making isolated objects, but in how plates can become forms."[37] Here those forms define clusters of related facilities along each side of an open, internal street; rectangular tubes containing classrooms cantilever out beyond the building's perimeter, overlooking terraced playing fields that are an integral part of the complex. That so

figs. 66/67 *top to bottom*
Thom Mayne. Morphosis
Diamond Ranch High School, Diamond Bar, California, 1994–2000
Exterior, photo: Kim Zwarts
Exterior, photo: Tom Bonner

remarkable a design successfully accommodates both the budget and function of a public high school compounds the accomplishment and signals a widespread acceptance of such expressionist vocabularies. Totally absent from this design is the sense of strict regimentation easily associated with the more rigidly ordered forms of orthodox Modernism. Instead, Mayne's active, irregular composition seems, through its exuberant vitality, to reaffirm individual choice in a manner sympathetic to the building's educational purpose.

Eric Owen Moss has worked predominantly within an existing urban environment, but an unusual one composed of largely abandoned industrial buildings. In his adaptations of existing warehouses in Culver City, California, he has developed another kind of landscape, yet with a related vocabulary of folded, angular forms.[38] With the support of the developers Fred and Laurie Smith, he has, over a period of years in the 1990s, transformed these ordinary structures into

extraordinary sculptures, not by celebrating the everyday, but by elevating it to something it never was. Like the artist Gordon Matta-Clark, he treats anonymous buildings as raw material to be variously cut, revealed, and reshaped; but unlike Matta-Clark, who treated such buildings as sculpture alone, Moss made them into working lofts for private offices, and he interconnected the structures in this expanding complex to create an entire neighborhood.[39] His Stealth Building (1999–2000; figs. 68–70), named for the United States Air Force bomber it partly resembles, is exceptional in being a newly constructed element rather than a reworked building. Nevertheless, Moss conceived it as part of that larger whole of which it is an inseparable part, and it serves as a façade, or frontispiece, for the reworked Umbrella Building behind while also defining a gateway leading to outdoor courtyards and related cultural facilities that will be added beyond.

figs. 68/69/70
Eric Owen Moss. Eric Owen Moss Architects
Stealth Building, Culver City, California, 1999–2000
Interior, photo: Tom Bonner
Model, mixed media, 46 x 237 x 63.5 cm (18 x 93 ½ x 25 in.)
Collection of Eric Owen Moss
Exterior, photo: Tom Bonner

figs. 71/72 top to bottom
Peter Eisenman. Eisenman Architects
Aronoff Center for Design and Art, University of Cincinnati,
Cincinnati, Ohio, 1988–96
Model, mixed media, 46 x 157 x 107 cm (18 x 62 x 42 in.)
Collection of University of Cincinnati Fine Arts
Roof plan with partial sections, generated print on paper, 73 x 105 cm (28 x 41 ⅜ in.)
Collection of Centre Canadien d'Architecture. Canadian Centre for Architecture, Montreal

Through deeply theoretical explanations accompanied by intense spatial analysis of existing sites, Peter Eisenman gives special resonance to the complicated forms of his work. His competition-winning scheme of 1999 for Hell's Kitchen South, in New York City, shows a potential for creative urbanism as yet unmatched by other architects; this visionary project, conceived as nearly a mile in length, expands expressionism to the scale of the city.[40] In the Aronoff Center for Design and Art at the University of Cincinnati (1988–96; figs. 71–74), he reconfigured three existing buildings into a unified structure through an addition that transforms those earlier, relatively anonymous structures into something of singular importance.[41] As his diagrams record, the plan derives from abstractions of chevron-like shapes—his interpretation of the essential qualities in those preexisting forms. The twisting volume that results allows each major space to be individually shaped, a characteristic evident in the differently angled elements of the elevations. Generated between the new and old structures is a grand, street-like space appropriately energetic for the shared activities it contains. As Eisenman explained, "the formal container is so fractured that the space is no longer contained by form—it's rattled loose."[42]

Among younger architects who have worked with Peter Eisenman, Greg Lynn stands out for his computer-generated forms. They are often likened to blobs, and Lynn himself is one of several younger architects known as "blobmeisters."[43] He is described as creating

> buildings based on "attractor" software that
> assigns weights or pulls to such forces as views,
> landscape conditions, or the theoretical importance
> the designer ascribes to an element. The result is a

figs. 73/74 opposite, top to bottom
Peter Eisenman. Eisenman Architects
Aronoff Center for Design and Art, University of Cincinnati,
Cincinnati, Ohio, 1988–96
Exterior, photo: Jeff Goldberg/Esto
Interior, photo: Jeff Goldberg/Esto

collection of forms that has a fluid look [To Lynn] such soft forms represent the instability that underlies our reality[44]

Of Lynn's group of architects another critic has written, "They seem on the verge of creating a new system for organizing space and, by logical extension, time as well."[45] A hint of this can be seen in the New York Presbyterian Church (Long Island City, New York, completed in 1999; figs. 75–77), which Lynn designed in collaboration with Michael McInturf (who also worked in Eisenman's office) and Douglas Garofalo.[46] Again the architects have reconfigured an older building, in this instance a 1932 laundry. In addition to recladding the exterior, they added to its top, placing the sanctuary within a new enclosure with a ceiling of sculptural undulations.

Nearer the edge of what I have termed a redefined expressionism are architects whose theories depart decisively from those discussed above, but who explore similar vocabularies. For example, Bart Prince—a former apprentice of Bruce Goff—remains committed to the structural determinism of his mentor, conceiving his buildings as part of a comprehensive program that relates to specific conditions of material, assembly, and site.[47] Prince tailors each building to his individual clients' needs as he interprets them, often incorporating richly decorative elements (such as lighting, furniture, and fountains) of his own invention. In recent years, his work has become more abstract, as seen in the Boyd and Mary Kay Hight house (near Mendocino, California, 1992–96; figs. 78–80). Its structural frame of twisted supports recalls work by Mayne or Moss; from the outside,

figs. 75/76 top to bottom
Greg Lynn. FORM with Douglas Garofalo, Michael McInturf Architects, Associated Architects
New York Presbyterian Church, Long Island City, New York, 1999
Design process animation, computer rendering, NTSC format VHS videotape
Collection of Greg Lynn
Plan, computer rendering, 46 x 81 cm (18 x 32 in.)
Collection of Greg Lynn

fig. 77
**Greg Lynn. FORM with Douglas Garofalo, Michael
McInturf Architects, Associated Architects**
Exterior, New York Presbyterian Church, Long Island City,
New York, 1999
Photo: Jan Staller

figs. 78/79 *top to bottom*
Bart Prince. Bart Prince, Architect
Hight House, Mendocino, California, 1992–96
Model, chipboard and wood, 23 × 62 × 102 cm (9 × 24 ¼ × 40 ⅛ in.)
Collection of Bart Prince
Plan, pencil and colored pencil on tracing paper, 42 × 46 cm (16 ½ × 18 in.)
Collection of Bart Prince

fig. 80
Bart Prince. Bart Prince, Architect
Exterior, Hight House, Mendocino, California, 1992–96
Photo: Michele M. Penhall

figs. 81/82 *opposite, top to bottom*
James Wines. SITE
Ross's Landing Park and Aquatorium, Tennessee Aqua Center,
Chattanooga, Tennessee, 1989–93ff
View of model
Axonometric view, ink wash and watercolor on paper, 64 x 71 cm (25 x 28 in.)
Collection of SITE Environmental Design, Inc.

this frame is partly revealed through irregular openings in the curving, shingled enclosure. The enclosure itself could almost be described as "bloblike." In seeming contrast to its complicated shapes, the plan, although far from simple, is generated by recognizable Euclidian shapes. In this Prince reaffirms his ties to the work of Goff and Wright; together with those architects he helps sustain a long current of American expressionism.

James Wines (whose office, SITE, is an acronym for Sculpture in the Environment) is one of several architects designing buildings responsive to the environment; this is sometimes called "sustainable," or "green," architecture.[48] In describing his work, Wines speaks of "architecture as a filter," emphasizing his belief that it is also an art, thus distancing it from that of other environmentalists who seem to rule out art altogether.[49] His design for Ross's Landing Park and Aquatorium (or Tennessee Aqua Center) has been partly completed in collaboration with others (Chattanooga,

Tennessee; phase I, 1989–92; phase II, the Aquatorium, 1993ff, is still unrealized; figs. 81–83). Its plaza incorporates landscaped bridges and sculptural terraces, with walls defined by planes of flowing water, and a pavement described as "fractured."[50] The projected Aquatorium is meant to focus on the fundamental role of water within human society. Its loosely circular form is to be defined by serpentine walls that will carry inscriptions and other narrative information; water features and plantings penetrating the circular outline will soften its formality. From above, as seen in the model, the Aquatorium resembles similarly expressive profiles that Eisenman conceived for more urban prospects. Recalling work by such early twentieth-century Expressionists as Erich Mendelsohn and even Bruno Taut, Wines seems to seek the inner natures of the materials themselves in his designs—in this instance, not concrete or glass, but earth and water. This imbues his work with poetic meaning.

fig. 83
James Wines. SITE
Exterior, Ross's Landing Park and Aquatorium, Tennessee Aqua
Center, Chattanooga, Tennessee, 1989–93ff
Photo: SITE Environmental Design Inc.

fig. 84 *left*
Richard Meier. Richard Meier & Partners
Exterior, The Getty Center, Los Angeles, California, 1984–97
Photo: John Stephens

fig. 85 *below*
Cover, *Architecture* magazine, December 1997
Showing Gehry's Guggenheim Bilbao and Meier's Getty Center

panded Modernism. Although the buildings of this complex are tenuously linked by thin passages, they seem almost as clearly detached from each other as those of earlier Modernist assemblages such as Mies van der Rohe's campus for the Illinois Institute of Technology (Chicago, 1939–41ff). The individual shapes of the separated components are more varied than those of the earlier prototype; the scale of the outdoor spaces is far grander; and the whole is more richly embellished with elegant materials and sumptuous components, but still the spirit of Modernism prevails, as its architect intended. It seems no other twentieth-century arts complex can surpass the Getty for sheer size and cost.

Expanding Modernism

Twentieth-century Modernism, as indicated earlier, has remained an ongoing tradition. But since the 1970s that tradition has been expanded to include a wider range of materials and shapes, so late Modernism now incorporates richer textures and more complex geometric variations than its antecedents. Some examples remain oriented toward structural expression and a clear definition of interior space, but typically with less emphasis on those elements than in earlier decades. The United States seems to lack the likes of Great Britain's Norman Foster or Richard Rogers, whose designs remain more forcefully generated by rationally conceived structural systems.[51] Instead, the decorative qualities of an earlier Modernism are more frequently manipulated, often by exaggerating the scale of selected elements, so that everything can seem bigger, and often is.

Surely the Getty Center in Los Angeles (1984–97; fig. 84), by Richard Meier, stands as the most prominent icon of an ex-

architecture December 1997

archit

Guggenheim Museum Bilbao

The Getty Center

fig. 86 *opposite*
Jim Jennings. Jim Jennings Architecture
Exterior, Barclay Simpson Sculpture Studio, Oakland, California, 1990–93
Photo: Alan Weintraub

The Getty forms an obvious pendant with Gehry's Guggenheim Bilbao, helping to define two ends of that continuum linking Modernist and expressionist imagery; the two were even paired on a cover of *Architecture* magazine, suggesting them as opposite sides of a single coin (fig. 85).[52]

The *New York Times* critic Herbert Muschamp has coined the term "baseline modern" for other, less bombastic examples of an expanded, or late, Modernism; he describes work by the New York architect James Stewart Polshek, for instance, as "revealing the inherent stability of modern architecture."[53] The San Francisco architect Jim Jennings might also be cited for his "baseline modern" buildings, for example the Barclay Simpson Sculpture Studio (California College of Arts and Crafts, Oakland, 1990–93; figs. 86–88).[54] A roughly cast concrete base and strongly textured glass block walls expand upon its Miesian model, recalling the early twentieth-century work of the French Modernist, Pierre Chareau. In other designs, Jennings seems to explore the later work of Louis I. Kahn, reflecting a deeper than usual understanding of Kahn's underlying principles.[55] In this regard, Jennings's recent work parallels that of his contemporary, the Japanese architect Tadao Ando.

If work by Jennings can be related to examples by Mies van der Rohe and Kahn, then the Roger Thomas house (Las Vegas, 1997–98; figs. 89–91) by Mark Mack can be related to design by the great Mexican Modernist, Luis Barragan.[56] Planar elements define its orthogonal spaces, and in places the walls are detailed to suggest discontinuous screens. Bold colors reinforce this sense of separated parts and also enrich the framed views of distant spaces. Mack emphasized these qualities in his early renderings of the

figs. 87/88 *top to bottom*
Jim Jennings. Jim Jennings Architecture
Barclay Simpson Sculpture Studio, Oakland, California, 1990–93
Shadow plan, computer rendering, 28 x 22 cm (8 ½ x 11 in.)
Collection of Jim Jennings Architecture
Elevation, etched glass, 46 x 46 cm (18 x 18 in.)
Collection of Jim Jennings Architecture

figs. 89/90/91 *from top left*
Mark Mack. Mack Architects
Roger Thomas House, Las Vegas, Nevada, 1997–98
Exterior, photo: Richard Barnes
Courtyard, photo: Richard Barnes
Courtyard perspective, watercolor on paper, 23 x 31 cm (9 x 12 ¼ in.)
Collection of Mack Architects

house which, like Barragan's sketches, evoke images of ceremonial space.

Somewhat closer to orthodox Modernism are the Yerba Buena Lofts by Stanley Saitowitz (San Francisco, 1999–2001; figs. 92–94).[57] Designed as artists' housing, they recall in their function those numerous and far larger complexes for workers and artisans that formed a social underpinning of Modernism as it developed in Europe in the 1920s. Saitowitz works elegant variations on those earlier prototypes. Setbacks soften the slab-like form, relieving the regularity of the gridded structure, and a seemingly random pattern of glazing provides a welcome sense of spontaneity.

Maya Lin, justly celebrated for her design of the Vietnam Veterans Memorial in Washington, D.C. (completed in 1982), showed in that early example of her work that she is both sculptor and architect (fig. 95).[58] Transcending stylistic categorization, it stands as one of the most successful and poignant memorials of the twentieth century, and one of the few in Washington to escape that city's classicizing mandate. Her more recent designs incorporate a stricter Modernist vocabulary, yet retain a similar depth of feeling. This is apparent in the Langston Hughes Library (Haley Farm, near Clinton, Tennessee, 1996–99; figs. 96–98), in which she adapted an older, vernacular structure not by exaggerating or replicating its ordinary shapes, nor by sculpting it to create something different, but instead by honoring its intrinsic qualities. An indigenous barn of the 1860s was carefully dismantled, then painstakingly reassembled around its new core: a sleek, even noble interior that reinforces the quiet dignity of the older building. From the outside, the new

figs.92/93/94 *top to bottom*
Stanley Saitowitz. Stanley Saitowitz/Natoma Architects, Inc.
Yerba Buena Lofts, San Francisco, California, 1999–2001
Night perspective, inkjet print, 86 x 82.5 cm (34 x 32 ⅝ in.)
Collection of Stanley Saitowitz/Natoma Architects, Inc.
Exterior, photo: Stanley Saitowitz
Interior, inkjet print, 86 x 102 cm (34 x 40 in.)
Collection of Stanley Saitowitz/Natoma Architects, Inc.

fig. 95 *below*
Maya Lin.
Vietnam Veterans Memorial, Washington, D.C., 1982

figs. 96/97/98 *clockwise from top right*
Maya Lin. Maya Lin Studio
Langston Hughes Library, Haley Farm, near Clinton, Tennessee,
1996–99
Exterior, photo: Timothy Hursley
Interiors, photos: Timothy Hursley

fig. 99 *below*
Tod Williams and Billie Tsien. Williams, Tsien & Associates
Exterior, Neurosciences Institute, La Jolla, California, 1993–95

fig. 100 *opposite*
George Ranalli. George Ranalli, Architect
Interior of K-Loft, New York, New York, 1993–95

interior is revealed with unusual subtlety. For example, two pedestal-like corn cribs that help support the main structure were relined with frosted glass to produce usable space; the openings between the original logs remain unchanged, but at night they now glow from within. Lin has described the building as "like a diamond in the rough. . . . When you cut into it, it reveals a more polished inner self."[59]

Other architects move more freely along the continuum joining Modernism and expressionism. For example, in their Neurosciences Institute (La Jolla, California, 1993–95; fig. 99), Tod Williams and Billie Tsien (of Williams, Tsien & Associates) seem to combine equal portions of both—the early California Modernism of Richard Neutra and the more complex forms of their own, later age. Meanwhile, George Ranalli draws more fully from a Modernist vocabulary and like Jim Jennings is partly influenced by Kahn. In many examples by Ranalli, strong textures and complicated patterns of fenestration provide expressive qualities. In the renovated interior of his K-Loft (New York, 1993–95; fig. 100), interlocking shapes and the play of wood against plaster and brick are reminders of work by the Italian architect Carlo Scarpa, a figure Ranalli has studied with care.[60] Scarpa's poetic reconfigurations of medieval buildings similarly reveal underlying layers, but of a much older history.[61]

Like Ranalli, Ron Krueck interprets a primarily Modernist vocabulary in his work, for instance, the Brick and Glass House (Chicago, 1994–96; fig. 101).[62] The composition of hovering planes parallels that in Mark Mack's Thomas house, here more elegantly detailed in accord with its more urbane setting. Designs by Mies van der Rohe provide the obvious point of departure for Krueck's development, but he

fig. 101
Ron Krueck. Krueck & Sexton, Architects
Exterior, Brick and Glass House, Chicago, Illinois, 1994–96

figs. 102/103 *left and right*
**Ronald Krueck and Keith Olsen. Krueck & Olsen, Architects
with Mark Sexton**
Painted Apartment for Celia L. Marriott, Chicago, Illinois, 1983
Isometric, black and colored ink on paper, 71 x 71 cm (28 x 28 in.)
Collection of The Art Institute of Chicago, Gift of Krueck and Olsen, Architects

Interior, black and colored ink on photograph, 71 x 71 cm (28 x 28 in.)
Collection of The Art Institute of Chicago, Gift of Krueck & Olsen, Architects

has expanded upon that source in different ways. Thus the curved partition of Mies's Tugendhat house (Brno, the Czech Republic, 1928–30; fig. 105) becomes the compositional theme of the Painted Apartment for Celia L. Marriott, (Chicago, 1983; figs. 102–04). On the floor's surface, painted decoration that gives the apartment its name amplifies the ambience of sensuous, interlocking spaces. These are defined by curvilinear, partly fragmented

screens of varying translucencies which infuse the apartment with an expressionist quality, yet one extracted from a Modernist source.[63]

The work of Steven Holl mediates more consistently between Modernism and expressionism, incorporating aspects of both to achieve enviable balance. Thus the plan of the Stretto House (Dallas, 1989–92; addition, 2000ff; figs. 107–110) defines regular, orthogonal spaces that

are roofed by fragmented vaults of a more complicated
geometry. Holl likens the design to musical composition, and
particularly to Béla Bartók's "Music for Strings, Percussion,
and Celeste." He writes,

> I decided to explore the musical concept of
> "stretto," which is analogous to the site's
> overlapping ponds. In a fugue stretto, the imitation
> of the subject in close succession is answered
> before it is completed. This dove-tailing musical
> concept could, I imagined, be an idea for a fluid
> connection of architectural spaces Like the
> score, the building has four sections, each
> consisting of two modes: heavy orthogonal
> masonry and light curvilinear metal.[64]

The care with which Holl resolves masonry and roof details
to achieve an integrated sense of ornamentation echoes
Kahn's similar attention to just such elements in the nearby
Kimbell Art Museum (Fort Worth, Texas, 1966–72). Yet
Holl has energetically reworked that prototype, fragmenting
both walls and vaults to achieve a decidedly different
result.[65]

Holl's fusion of Modernist and expressionist vocabularies
may signal a future direction of special appeal. Others seem
to be reaching a similar position, such as Billie Tsien and
Tod Williams, as well as Ron Krueck, at least in selected
examples. Yet those drawing from more distant sources
should not be discounted. Time has softened what was once
sensational about their work, but in the best instances they
define strikingly original positions. Venturi and Scott Brown,
for example, have convincingly shown that historicizing
features can be reinterpreted through such techniques as

fig. 105
Ludwig Mies van der Rohe
Interior, Tugendhat House, Brno, Czech Rebublic, 1928–30

Further complicating any projection (a dangerous venture at best) is recent work by Philip Johnson, without question the dean of American architecture in much the same way that Richard Morris Hunt was a century ago.[66] Johnson seems always the very first to sniff out a new direction just at its birth, and he is able to develop that emerging fashion with such skill that it sometimes seems he invented it himself. Together with Henry-Russell Hitchcock, he had, for American observers, defined orthodox Modernism itself in 1932.[67] Similarly, he was one of the first to embrace Postmodernism, and the scale of his AT&T Building (New York City, 1978–84) made it visible to all. More recently Johnson's work has reflected expressionist trends, and more recently still he has begun to explore the common profiles of farm buildings (fig. 106).[68] This latest and surely unexpected shift might now be characterized as the latest chapter in Johnson's predictable unpredictability.

Architects may again follow Johnson's latest lead, this time by celebrating the everyday, or they might further examine potentials of a symbolic, as opposed to a literal, historicism. Yet it can be strongly argued that inventive investigations of near, or modern sources provide the broadest potential for meaningful development, a development better positioned to expand the traditions of our own time further into the twenty-first century. And as the best elements of those seemingly divergent sources are reworked and gradually joined, and the divisions themselves are revealed as ever more arbitrary, a true and workable fusion should occur. The codification of these near sources can help in our understanding of recent history, but ultimately, instead of seeking to separate today's currents into their component parts, we should no doubt welcome those creative forces that are instead drawing them closer together.[69]

fragmentation, flattening, and exaggerated scale—far different from mere imitation. Through such artfully wrought transformations, their designs evoke both history and location, but remain wholly contemporary. From Venturi and Scott Brown's viewpoint, their quotations are no more arbitrary an application to modern frame construction than abstract images drawn from early twentieth-century sources. The special benefit of their approach is one of communication, and the symbols of time and place they represent on their buildings are, to them, in greater accord with the two-dimensional imagery of our electronic age than reworkings of twentieth-century abstraction. In this way Venturi and Scott Brown define a position rooted in the expression of context and function rather than style, however much images of style may seem to dominate their work.

fig. 107 *below*
Steven Holl. Steven Holl Architects
Interior, Stretto House, Dallas, Texas, 1989–92
Photo: Paul Warchol

fig. 110 *below*
Steven Holl. Steven Holl Architects
Exterior, Stretto House, Dallas, Texas, 1989–92
Photo: Paul Warchol

figs. 108/109 *opposite, top to bottom*
Steven Holl. Steven Holl Architects
Stretto House, Dallas, Texas, 1989–92
Model, mixed media, 25 x 119 x 107 cm (10 x 47 x 42 in.)
Collection of Steven Holl Architects
Sketch, watercolor on paper, 30 x 23 cm (12 x 9 in.)
Collection of Steven Holl Architects

AMERICAN DECORATIVE AND INDUSTRIAL DESIGN: FROM CRISIS BACK TO THE VANGUARD

R. CRAIG MILLER

previous page
Ali Tayar
Plaza Screen, 1999
Aluminum and rubber, 213 x 222 x 5 cm (84 x 87 ½ x 2 in.)
Structural engineer: Attila Rona. Manufacturer: ICF Group. Collection of Denver Art Museum,
Gift of ICF Group

The last quarter of the twentieth century has proved to be a problematic—and in many respects, transitional—time for American design, much like the polyglot decades between the World Wars. For unlike architecture and graphics during the 1960s and early 1970s, design in the United States lost the commanding international leadership that it had enjoyed in the immediate postwar years.[1] Quite simply, the synergy of forces needed to maintain such a dominant position came apart. The reasons were many.

There were, first of all, a number of fundamental changes in the American design industry itself. One of the most noticeable was a shift of creative energies and investment away from domestic to contract furnishings, an enormous market soon to be dominated by office systems and ergonomic chairs. This shift toward the corporate world greatly enhanced the power of marketing departments in the decision-making process and concurrently began to undercut the role of design directors. A number of major American design companies also ceased to be family-owned businesses, metamorphosing into large-scale corporations; in the transition, the design vision of these companies and the belief in a social mission for design were often lost and replaced by a preoccupation with the bottom line. Steven Holt, the critic and industrial designer, expressed it succinctly: "As design became the trusted servant of American industry … it gave up its role as a socially innovative agent of change."[2] Likewise, support for young designers and cutting-edge work lessened, as American design companies increasingly found it easier and cheaper to license the products of foreign manufacturers, particularly in Italy. Fundamental theoretical shifts were also occurring in the design arts.

The advent of the so-called American Studio Movement of the 1960s had a major impact. Several generations of craftspeople—who worked in furniture, glass, ceramics, metalwork, and textiles—left the design field and attempted to become fine artists.[3] An equally profound shift occurred in architecture, a field that had historically "provided the thinkers for design throughout the twentieth century,"[4] as Peter Dormer has noted. By the 1960s, far fewer American architects actually thought of themselves as designers or were producing significant work. Thus the ideal of the unity of the arts, with an architect designing everything from the building to the smallest furnishing, fell out of favor; and this theoretical cornerstone of the modern movement from the mid-nineteenth century onward was greatly diminished.

Equally disruptive, the power of the press and museums—not to mention the critical milieu they foster—to champion innovative design was weakened by the cultural divisions and artistic factions of the 1960s and 1970s. Not surprisingly, then, there was no dominant style from the 1960s on, for the hegemony of Modernism and the ideal of "good design" were under increasing attack.

Thus the '60s and early '70s marked a period of crisis in American design, accentuated in no small part by the extraordinary reemergence of Italy—and Milan, in particular—as the major center for avant-garde design in the Western world. It is against this turbulent and uncertain background that design in the United States from the last quarter century must be judged. It is certainly not a simple story. But it has ultimately proved to be one of resurgence—initially of the triumph of individuals against great odds and, more recently, of the advent of a younger generation.

USDesign chronicles this remarkable story primarily through an appraisal of four design directions that were seminal in propelling the United States back into a leadership position in the design arts.

A number of other factors also merit note. This story involves three generations of designers. The oldest was born largely in the 1930s and began to produce its major designs by the mid-1970s. It was the individual work of this generation that returned American design to a position of international attention. The *Easy Edges* series by Frank Gehry, the California architect, was a harbinger (1972; fig. 111).[5] It was not only among the most original American furniture designs of the decade, but it was also prophetic of major changes occurring in American design: the shift of power from New York to the West Coast and of innovative work from large design companies to small-scale studio production. The work of the second generation—born in the immediate postwar years—has proved more ambiguous. Because many of these designers have expended their major energies on architecture, they have not produced consistent oeuvres of design, at least not to date. While they have created individual objects of real originality, many of their designs have remained, in part, isolated gestures. The third generation was born largely after 1960; presenting its work in a larger historical context is one of the goals of USDesign. With notable exceptions, such as Karim Rashid, most of these designers have not reached maturity; but they have nonetheless produced a body of remarkably original work to date.

It should also be noted that the history of design is a distinct entity, although it is often considered merely as an adjunct to the history of architecture. Design has a much more diverse theoretical basis, and it has evolved in ways often quite independent of architecture, graphics, and even the fine arts.

Lastly, this chronicle deals with at least four different kinds of designers: the architect designer, the decorative designer, the industrial designer, and the "functional" craftsperson who has designed for serial production. All have been trained differently, and they approach design in markedly different manners. It is the architect designer, however, who has played a predominant role during this quarter century in pushing American design in new directions both theoretically and aesthetically. Robert Venturi and Frank Gehry have, in particular, proved to be seminal figures; and it has often not been an easy task for younger designers to avoid the shadows of such giants. Yet they have risen to the challenges, as this exhibition and catalogue demonstrate.

fig. 111
Frank O. Gehry
Wiggle Side Chair and Stool, 1972
Designed for the *Easy Edges* Series

fig. 112
Joe D'Urso
Interior, Kramer Apartment, New York, New York, 1978

fig. 113
Charles Pfister. Skidmore, Owings & Merrill LLP
Interior, Weyerhaeuser Technical Center, Tacoma, Washington, 1978

Inventing Tradition: History, an Implausible Catalyst for Change

One of the first concerted attempts to renew American design began with a heated challenge during the late 1970s, when a generation of designers openly questioned the prevailing Modernist canon. These young Turks rebelled against the minimal Modernism that had dominated American design (and even graphics) during much of the 1960s and 1970s. This minimal design was, in many respects, an afterglow of American Modernist work of the previous two decades. Its designers were often preoccupied with technological, ergonomic, or sociological issues. They also tended to favor starkly geometric forms; palettes limited to white, gray, and black; and materials with an aura of restrained elegance, whether in domestic or contract commissions (figs. 112–13). Perhaps most disconcerting, these designers appeared aloof from the turmoil rending American society—the Vietnam conflict, the political assassinations of the 1960s, and the Watergate scandal of 1972–74. Like much contemporary minimal art, American minimal design seemed incongruously serene, if not solipsistic. As Dan Friedman observed, "the strong commitment to a reductionist process meant that no design could ever get beyond being primarily about itself."[6]

Rejecting this spare and stylish aesthetic, a number of designers began to look at history with a fresh perspective as early as the mid-1960s, with the idea of infusing a new richness and greater humanist element into design. Robert Venturi's *Complexity and Contradiction in Architecture* (1966) became a central treatise for this historicizing and decorative movement, which was ultimately christened "Postmodernism" for lack of a better term.[7] Indeed, one should note that the revival of a decorative tradition in American design initially lagged a good decade behind that in architecture, as the interiors of the Vanna Venturi residence, with their reliance on period and reproduction furnishings, make clear (1959–64; fig. 114).[8] But by the late 1970s, a body of vital historicizing work coalesced in the United States.

The enthusiasm for Postmodernism has, of course, now lessened; and many of its once sweeping aspirations have been challenged or forgotten. A quarter century later, it may be viewed in a larger historical perspective. At the time, this new fascination with a historicizing and decorative tradition seemed novel and singular, though in fact it was another cyclical revival.[9] Eclectic designers in the 1920s had largely looked to the eighteenth century for inspiration. For these new designers, however, history became something of a design smorgasbord; and their sources ranged from antiquity to the twentieth century. One should also keep in mind that the fascination with tradition was international; European and Japanese colleagues included Ettore Sottsass, Aldo Rossi, (early) Philippe Starck, Bořek Šípek, and Shiro Kuramata. As with any movement, there was a significant difference between followers and originators; the former most often deftly resorted to more literal pastiches of historical motifs, while the latter—such as Venturi or Sottsass—used historical vocabularies merely as a starting point for highly personal creations.

The American manifestation was also quite distinct from its European counterpart. It was, first of all, decidedly more formalist and overtly historicizing. In reaction to the strong influence of technology and sociology on design in previous decades, there was now a renewed search for an aesthetic

fig. 114
Robert Venturi. Venturi & Short, Architects
Living Room, Vanna Venturi House, Chestnut Hill, Pennsylvania,
1959–64

fig. 115
Robert Venturi and Denise Scott Brown
Interior, Venturi, Scott Brown House, Mount Airy, Pennsylvania,
1972–88

basis for design.[10] Designers sought to reintroduce an
iconography that the public would readily understand. As
Michael Graves noted, "It's not a matter of returning to history,
it's a matter of using the values and cultural symbols which
are shared by society."[11] Unsurprisingly, these designers were
not preoccupied with the latest technology or materials but
instead sought to reintroduce a visual complexity to design
through the revival of traditional form, color, ornament,
pattern, material, and craftsmanship. They initially favored
limited production over industrial mass production. Most
important, they revived the concept of "total design" and
reestablished the predominance of the architect-designer,
ultimately at the status of a media star. They even reasserted
the importance of drawing, not just as a means of conveying
ideas, but as an art form in itself.

Perhaps more than any American designer of his gener-
ation, Robert Venturi clearly showed that this commitment to
a historicizing, decorative tradition did not entail a style per
se but instead marked a fundamentally new conceptual and
theoretical approach to design.[12] Like that of other major
designers such as Le Corbusier and Finn Juhl earlier in the
century, Venturi's major period of productivity as a designer
was quite short, spanning little more than a decade.[13] But he
is one of the most original and protean American designers of
the late twentieth century—the one American designer who is
the equal of Sottsass. The latter had, of course, quite literally
turned Italian design topsy-turvy in the early 1980s with the
delirious design group called Memphis;[14] Venturi, on the other
hand, sought to revolutionize design as an individual through
his work and pronouncements, both written and oral.[15] Thus
their design approaches were markedly different, but these

fig. 116 *left to right*
Robert Venturi. Venturi, Rauch and Scott Brown
Louis XVI Chest of Drawers, 1984
Painted wood, 77 x 89 x 46 cm (30 ⅜ x 35 x 18 in.)
Manufacturer: Arc International. Collection of Tom and Betsy Schifanella

Sheraton 664 Side Chair, 1979–84
Wood, plastic laminate, and painted decoration, 85 x 59 x 61 cm (33 ½ x 23 ⅛ x 23 ⅞ in.)
Manufacturer: Knoll International. Collection of Denver Art Museum, Funds provided by
Suzanne Farver

fig. 117 *opposite, left*
Robert Venturi. Venturi, Rauch and Scott Brown
Drawing, *Louis XVI* Chest of Drawers, 1983–84
Marker on yellow tracing paper, 91 x 122 cm (35 ¾ x 48 in.)
Collection of Joe Duke, Off-Road America

fig. 118 *opposite, right*
Robert Venturi and Maurice E. Weintraub
Venturi, Rauch, and Scott Brown
Drawing, *Louis XVI* Chest of Drawers, 1983–84
Colored paper on print, 92 x 97 cm (36 ⅛ x 38 in.)
Collection of Venturi, Scott Brown and Associates

differences only serve to illustrate the remarkably prolific nature of this historicizing, decorative movement.

Fundamental to Venturi's work is his knowledge of the history of architecture and design, perhaps the most encompassing of any American designer of his generation. His sources range from the classical world through the Renaissance up to the modern era. He plumbs Western antecedents almost exclusively, however, unlike Sottsass who readily absorbs ideas from India to North Africa.[16] Venturi's sense of history is also more learned than that of his European contemporaries. Indeed, his work can often be overtly eclectic or even didactic, as he readily mixes *objets* or motifs from various periods, often in startling juxtapositions. Most important, there is a pronounced two-dimensionality to Venturi's work, perhaps an indication that he never quite escaped the influence of the International Style. Whereas there is a decided plasticity to Sottsass's forms, Venturi prefers distinct juxtaposed planes, which he articulates with incising or bold two-dimensional patterns, employing stenciling, silk screens, or enameling. Even on the rare occasions when he uses wood, it is most often a veneer. His favored materials tend to the vernacular and are characteristically thin and planar: plywood, plastic laminate, etc. Moreover, Venturi abjures gold leaf, marble, or fine woods, unlike Sottsass or Michael Graves. He instead relies on a bold color palette, one that often approaches the acidic Pop hues seen in the late Postmodernist work of his contemporary, the British architect James Stirling.[17]

In short, the remarkable appeal of Venturi's work is both visual and cerebral. There is none of the overt Italian sensuality or spontaneity of a Sottsass. Instead, there is a seeming Yankee candor and straightforwardness, although there is certainly nothing simple—or easy—about a Venturi design. The Venturi and Scott Brown residence in Mount Airy, Pennsylvania, itself stands as one of the most personal and important paradigms of this design aesthetic in its flamboyant and seamless blending of past and present (1972–88; fig. 115).

These general characteristics infuse three aspects of Venturi's work that illustrate his remarkable dexterity as a designer—his furniture, tableware, and textiles. Not surprisingly, they also evidence many of the same ideas seen in his architecture but at a more concentrated and refined level.

Venturi first emerged as a designer of international repute with a furniture collection of 1978–84 for Knoll.[18] A series of side chairs were perhaps the most accomplished forms (fig. 116). Fashioned of molded plywood, they refer to the planar, laminated, Modernist furniture pioneered in the late 1920s and 1930s by Alvar Aalto—one of Venturi's heroes—rather than the more three-dimensional plywood forms developed by Charles Eames and Eero Saarinen from the 1940s onward. The designs appear to be as flat and frontal as billboards on initial viewing; when viewed from the side, however, the chairs reveal a subtle complexity typical of Venturi. The structure is expressed in the exposed wood edges, and the proportions are slightly chunky.[19] Against this, Venturi introduces a refined linearity in an extraordinarily subtle play between the two-dimensional undulations of the molded wood and the curving profiles of the chair itself. Like Aalto, Venturi also plays with the number of laminations in the wood for both structural and decorative effects. The series came in a variety of finishes—plastic laminate and wood veneer—as well as a myriad of revival styles—Queen Anne,

Chippendale, Sheraton, Hepplewhite, Empire, Biedermeier, Gothic Revival, and even Art Nouveau and Art Deco.[20] Venturi's most successful chair design, the Knoll series represented a virtuoso display of form, structure, pattern, and detail—a true melding of Modernist and Postmodernist vocabularies.

Having mastered the chair, perhaps the quintessential modern furniture form, Venturi next took on the challenge of revitalizing the case piece, for in many respects, his goal was nothing less than to reinvigorate—if not reinvent—American design of the late twentieth century. From 1984 to 1989 he designed a series of chests (or, more properly, lowboys or commodes) for Arc International, which were made in very limited numbers (figs. 116–18). The eclectic choice of styles in itself reveals the ambitiousness of his undertaking; the English Queen Anne style ushered in a century of Georgian design, whereas the Louis XV and XVI styles marked the culmination of eighteenth-century French decorative arts. The chest series also clearly illustrates Venturi's design method: after making small thumbnail sketches, he explored forms in full-size rough sketches, developed color and pattern in full-size collages, and finally made full-size elevations in order to refine details before production. Again, forms are quite planar: each chest has a decorated façade, two plain side panels, and an extended top. The façades, however, are tours de force in faux pattern-making; the Neoclassical form, parquetry, and ormolu mounts of a Louis XVI commode are transformed into exuberant two-dimensional ornament. Equally clever in the design of a simple drawer handle, Venturi has deftly enlarged diminutive escutcheon forms in scale and transformed them from positive to negative.

A similar bravura and wit mark Venturi's designs for smaller decorative objects. In a ceramic coffee and tea set of 1985–86 for Swid Powell, an array of architectural forms—from the Pantheon to vernacular houses—is reduced to table scale (fig. 119); and the buildings' façades are translated into stencil applications.[21] In a pair of Georgian revival candlesticks of 1985–86, a baluster shape is cut out of two sheets of silver, which are then slotted together at right angles like cardboard packaging (fig. 120).[22] The construction is elemental (and was also used by Venturi in a table series for Knoll); the visual effect is dazzling.

A coffee and tea service for Alessi of 1980–83 is as learned and complex a design as any of Venturi's furniture (fig. 121). The plethora of preliminary sketches in the Venturi archive confirms his phenomenal grasp of history from Michelangelo to Dagobert Peche (figs. 122–24) and documents the simplification of the design as it went into production. The forms also illustrate a greater three-dimensionality, although they have likewise been fashioned from sheets of silver. A remarkable compendium of history, the design embarks with the oval tray as a stately prelude, where Venturi evokes the patterned pavement of Michelangelo's Campidoglio piazza in Rome. He then follows with a Queen Anne teapot and a Rococo coffeepot, both decorated with elaborate incised, layered, and gilded ornament that ranges from geometric to floral to typographic.[23] These vessels also show Venturi's love of formal contradictions, in his juxtaposition of the three-dimensional bodies of the pots with two-dimensional appendages, such as the feet and finials. He then moves onward with a Neoclassical sugar bowl, finally arriving at the twentieth century with the creamer

fig. 119 *opposite, above*
Robert Venturi. Venturi, Rauch and Scott Brown
Village Tea and Coffee Service, 1985–86
Ceramic, largest: 23 x 13 x 22 cm (9 ¾ x 5 x 8 ¾ in.)
Manufacturer: Swid Powell. Sugar and creamer: Collection of Elliott Kaufman, Elliot Kaufman Photography. Coffee pot: Nan Swid. Teapot: Private collection

fig. 120 *opposite, below*
Robert Venturi. Venturi, Rauch and Scott Brown
Candlesticks, 1985–86
Silver plate, 23 x 23 x 10 cm (9 x 9 x 4 in.)
Manufacturer: Cleto Munari for Swid Powell. Collection of Denver Art Museum, Lilliane and David M. Stewart Collection

which recalls the designs of Koloman Moser for the Wiener Werkstätte. Thus in one exquisite and highly eclectic ensemble, Venturi has created—with a seeming effortlessness—an icon of Postmodernist form, concept, and theory.

Like his furnishings, Venturi's textile designs broke new ground, although they were not significant for their technical innovations but rather for their revival of important traditions. For example, in reaction to the ubiquitous gray wall-to-wall carpeting and generic carpet tile of the 1960s and 1970s, Venturi, along with a number of his American and European counterparts, helped revive the decorative area rug.[24] Defying the Modernist tenet that ornament is a crime, these designers

also brought back an exuberance of color and pattern into designer textiles—the antithesis of the minimalist (though extraordinarily elegant) textiles of a Gretchen Bellinger, who focused on material and technique. Venturi's textile designs helped to define this new approach. In *Tapestry*, he enlarged and abstracted flower motifs in a rich palette of red, pink, and black (1978–84; fig. 125), while in *Gingham Floral*, he layered geometric and floral patterns, recalling Viennese textiles of the 1910s and 1920s (1989–91; fig. 126).[25]

By the early 1990s, there were the inevitable shifts in what was considered au courant in design; and Michael Graves became something of a lightning rod for the Post-

fig. 121
Robert Venturi. Venturi, Rauch and Scott Brown
Tea and Coffee Service, 1980–83
Silver with gilt decoration, largest: 42.5 x 35.5 cm dia. (16 ¾ x 14 in. dia.)
Manufacturer: Alessi S.p.A.
Collection of Denver Art Museum, Lilliane and David M. Stewart Collection

figs. 122/123/124 *from top left*
Robert Venturi. Venturi, Rauch and Scott Brown
Preliminary Sketch, Sugar Bowl for Tea and Coffee Service, 1982
Pencil and marker on yellow tracing paper, 31 x 29 cm (12 ⅛ x 11 ½ in.)

Preliminary Sketch, Coffee Pot for Tea and Coffee Service, 1981
Colored pencil and pencil on diacotype print, 36 x 29 cm (14 x 11 ¼ in.)
Collection of Venturi, Scott Brown and Associates

Preliminary Sketch, Teapot for Tea and Coffee Service, 1982
colored paper on diacotype print, 28 x 22 cm (11 x 8 ½ in.)
Collection of Venturi, Scott Brown and Associates

fig. 125
Robert Venturi and Denise Scott Brown. Venturi, Scott Brown and Associates
Tapestry Textile, 1978–84
Cotton and synthetic fibers, 416 x 144 cm (164 x 57 in.)
Manufacturer: Knoll International. Collection of The Metropolitan Museum of Art, Gift of Knoll International

fig. 126
Robert Venturi and Denise Scott Brown. Venturi, Scott Brown and Associates
Gingham Floral Textile, 1989–91
Cotton, 366 x 137 cm (144 x 54 in.)
Manufacturer: DesignTex, Inc. Collection of Denver Art Museum, Gift of Robert Venturi and Denise Scott Brown

modernist movement with certain critics. Notwithstanding this, his accomplishments as a designer have been significant. Unlike Venturi, Graves has not articulated a complex theoretical basis for his work; but he is the one American architect who has produced a consistent body of design over this quarter century—no small achievement.[26] Graves is, in many respects, an unrepentant formalist; and he has worked in two distinct manners. He began his architectural career in the late 1960s in a white, geometric style; but by the late '70s, he shifted into a historicizing eclecticism. Thus throughout his career, there are remarkable parallels to the work of Josef Hoffmann, one of the most significant (and underrated) decorative designers of the twentieth century.[27]

Janet Abrams, the British critic, has noted that perhaps "the formative experience of Graves's career was the time spent in Rome, from 1960 to 1962, as a Fellow of the American Academy. For a young man from the mid-West, who had never previously traveled to Europe, landing in Rome was an utter revelation."[28] Like the architect Louis Kahn, Graves would need almost a decade to translate what he had absorbed in Europe into his oeuvre.

Graves's historicizing work falls loosely into two phases. The first began in the late 1970s, when he defined his mature style. He revived the ideal of "total design" as did no other American architect—Modernist or Postmodernist—of his generation. In the age of the computer, he brought back drawing as an important means of conveying his ideas; and, likewise, he revived mural painting as an important part of his interior designs. In contrast to Venturi's vivid colors, Graves developed a subtle but luxurious palette of grays, terra cottas, and blues that is uniquely his. Equally important, he was among the earliest American designers to embrace luxury materials again—exotic veneers, ebony, gold leaf, and marble—and to revive the use of ornamental inlay. Consequently, this early work remained largely limited in production.

One of the earliest and most forceful statements of Graves's historicizing aesthetic are his murals for the SunarHauserman showrooms in New York (1981; fig. 128). They evoke a dream world where architecture, design, and the landscape achieve a classical harmony. Graves's early furniture sketches also illustrate his exploration of the past (fig. 127). In contrast to Venturi's far-ranging eclecticism, he looked primarily at Neoclassical sources for inspiration: the late eighteenth and early nineteenth centuries (from Robert Adam to Thomas Hope) and the late 1910s and 1920s (the work of designers such as Pierre Chareau and Jean Puiforcat).[29] Graves's residence—harking back to Sir John Soane's home and later museum—is perhaps the most cogent and personal statement of his study of Neoclassicism (1977ff.; fig. 129).

Two furniture designs demonstrate Graves's duality of approach to this Neoclassical tradition. His first important furniture commissions were for SunarHauserman, a lounge chair of 1980–81 being one of the most notable (fig. 130).[30] Unlike Venturi's chairs, this design has a decidedly three-dimensional, faceted form; and the frame is veneered in bird's-eye maple with ebony accents. The work is derived from furniture by Chareau, as well as a set of late Wiener Werkstätte Neoclassical revival chairs in Graves's private collection.[31] But this chair also exemplifies a more funda-mental shift in furniture design during this period. Modernist designers had characteristically placed their emphasis on a minimal structural frame, industrial materials, and mass

fig. 127
Michael Graves
Lounge Chair Studies, 1980
Ink on paper, 22 x 28 cm (8 ½ x 11 in.)
Collection of Michael Graves & Associates

production; Graves has instead returned to the realm of the *objet de luxe* in his design of a traditional upholstered lounge chair that revels in its luxury finishes and superb handcraftsmanship.

A design for a dining table of 1989 shows Graves's mastery of yet another Neoclassical idiom (fig. 130).[32] In its composition of simple geometric forms of exquisite proportions, the design recalls work by the late eighteenth-century French architect Claude-Nicolas Ledoux. Again Graves veneered the piece with bird's-eye maple with ebony inlay. It is in such rare furnishings that he has shown himself to be perhaps the consummate architect-craftsman in America of the 1980s. Had Graves pursued this line, he might well have become the Jacques-Emile Ruhlmann of his generation, ruling the luxury market as that French master of decorative design had in the interwar period.

As refined as the dining table is Graves's prototype for an ice bucket (1988; fig. 131). Here he returned to the 1920s for inspiration, to the elegant silver of Jean Puiforcat; and he relied on simple geometries transformed through superb proportions and detailing. But more typically, Graves's designs for smaller decorative objects—like Venturi's—tend toward the use of architectural forms at a reduced scale. Examples include a prototypal lamp of 1983 of alabaster with gold leaf; a mantel clock of 1986 of bird's-eye maple and ebonized wood; and a ceramic vase of 1989 evoking an Ionic capital (figs. 132–34). These designs also signal the beginning of a shift in Graves's work in the mid-'80s away from limited production toward mass production.

By the late 1980s, there was a virtual explosion of design work in Graves's office, in a wide range of media for a host

fig. 128 *middle left*
Michael Graves
Mural for Sunar Furniture Showroom, New York City, 1981
Paint on canvas, 274 x 328 cm (108 x 129 in.)
Courtesy of Max Protetch

fig. 129 *bottom left*
Michael Graves
Living Room, *The Warehouse*, Graves House, Princeton, New Jersey, 1977ff

fig. 130 *above, left to right*
Michael Graves
Lounge Chair, 1980–81
Produced for the Sunar Showroom, London, England, 1986
Ebonized wood, bird's-eye maple, and new leather upholstery,
75 x 77 x 71 cm (29 ½ x 30 ½ x 28 in.)
Manufacturer: SunarHauserman. Collection of Denver Art Museum, Funds from Lewis and
Joan Sapiro

Dining Table, 1989
Bird's-eye maple with ebony and mother-of-pearl inlay, 81 x 112 cm dia. (32 x 44 in. dia.)
Manufacturer: Craftwood Products. Collection of Denver Art Museum, Gift of Craftwood:
Division of Sonnenberg Industries Limited

of international manufacturers. In 1991, he announced a product design section in his firm; and three years later he opened his own store to sell his designs. For better or worse, Graves pushed the idea of the architect as design star to the ultimate. Since the late '80s, he—like Sottsass—has not developed his basic style in any substantive manner;[33] but one may argue that Graves has maintained a greater control of form, material, and detailing in his late design than in his architecture.

Two evolutions, however, should be noted in Graves's work. Since the late '80s, it has shown a greater sense of pattern. His textiles of 1988 for Disney dramatically illustrate this development (fig. 135) by comparison with his designs of 1987 for wall-to-wall carpeting for Vorwerk. Likewise, two designs of 1992 and 1994 for dinnerware show a remarkable creativity in pattern and color that rivals Hoffmann's work between the World Wars (figs. 136–37). Like his Viennese precursors (and Venturi as well), Graves has with uncommon dexterity used multiple patterns at varying scales for carpeting, upholstery, and drapery in his late interiors.

Perhaps most important, Graves has achieved his goal of making his design accessible to the average American consumer. Indeed, his work for such companies as Target has on occasion been criticized, because he often produces more than a hundred products a year (generally priced at less than $30 each). Clearly, some are inexpensive adaptations of earlier Graves designs; but the best offer smart and often witty styling, a guiding principle of much American Moderne work of the 1930s (figs. 138–40). As Rainer Krause, the German writer and entrepreneur, has remarked, "In the field of tension between past and present, between highbrow art

and everyday culture, between Europe and America, [Graves] has, since 1979, been developing a new product language. It has been somewhat over-hastily classified as 'Post-Modern' but in reality goes far beyond."[34] If nothing else, these designs provide a strong contrast to the Modernist (and considerably more costly) work of companies like Braun or Bang & Olufsen. Thus it is perhaps a bit ironic—to say the least—that in late twentieth-century America the Modernist ideal of good design for the masses was actually realized by a Postmodernist!

While both Venturi and Graves have clearly identifiable styles, Stanley Tigerman is a designer who cannot be readily

figs. 131–34 *opposite, clockwise from top left*
Michael Graves
Ice Bucket, 1988
Silver and resin, 20 x 22 x 36 cm (8 x 8 ¾ x 14 in.)
Manufacturer: Cleto Munari. Collection of Denver Art Museum,
Lilliane and David M. Stewart Collection

Prototype, *Finestra* Table Lamp, 1983
Gilded and painted wood; acrylic and alabaster, 33 x 18 x 18 cm (13 x 7 x 7 in.)
Manufacturer: Michael Graves & Associates and Baldinger Architectural Lighting.
Collection of Michael Graves & Associates

Vase, 1989
Ceramic, 18 x 20 x 18 cm (7 x 8 x 3 in.)
Manufacturer: Swid Powel.

Mantel Clock, 1986
Bird's-eye maple veneer, ebonized wood, enameled metal, and acrylic
25 x 16 x 9 cm (9 ¾ x 6 ⅜ x 3 ¹¹⁄₁₆ in.)
Manufacturer: Alessi S.p.A. Collection of Denver Art Museum, Gift of Alessi S.p.A.

fig. 135 *top to bottom*
Michael Graves
Lily Pond and *Grid with Flowers and Stripes* Textiles, 1988
Designed for the Walt Disney World Swan Hotel and the Walt Disney World Dolphin Hotel,
Lake Buena Vista, Florida
Printed cotton, each: 366 x 137 cm (144 x 54 in.)
Manufacturer: Kravet Fabrics.
Collection of Denver Art Museum, *Lily Pond*: Lilliane and David M. Stewart Collection.
Grid with Flowers: Lilliane and David M. Stewart Collection, Gift of David A. Hanks

Dialog Carpet, 1987
Nylon and polypropylene, 244 x 488 cm (96 x 192 in.)
Manufacturer: Vorwerk.
Collection of Denver Art Museum, Lilliane and David M. Stewart Collection

fig. 136 *top*
Michael Graves
Prototypes, Tableware, Disney Consumer Products, 1992
Painted ceramic and glass, largest: 2 x 27 cm dia. (⅞ x 10 ½ in. dia.)
Manufacturer: Michael Graves & Associates. Collection of Michael Graves & Associates

fig. 137
Michael Graves
Deanery Garden Dinnerware, 1994
Ceramic, largest: 19 x 32 x 21 cm (7 ½ x 12 ¾ x 8 ⅜ in.)
Manufacturer: Alessi S.p.A. Collection of Michael Graves & Associates and Collection of
Denver Art Museum, Gift of Alessi S.p.A.

figs. 139/140 above, *left to right*
Michael Graves
Garlic Press, 1999
Plastic and metal, 18 x 6 x 4 cm (7 x 2 ¼ x 1 ½ in.)
Manufacturer: Target. Collection of Michael Graves & Associates

Angel Egg Cup, 1996
Glass, 10 x 9 cm dia. (4 x 3 ⅜ in. dia.)
Manufacturer: Glaskoch/Leonardo. Collection of Denver Art Museum, Gift of Michael
Graves & Associates

fig. 138 *top*
Michael Graves
Telephone, 1999
ABS and metal, 16 x 20 x 17 cm (6 ⅛ x 7 ⅞ x 6 ⅞ in.)
Manufacturer: Target. Collection of Denver Art Museum, Gift of Michael Graves & Associates

fig. 146
Dan Friedman
A Fallen Sky in a Regal Landscape Assemblage, 1985
Painted plywood, found objects, and internal light, 91 x 130 x 28 cm (36 x 51 ⅛ x 11 in.)
Manufacturer: Dan Friedman. Collection of Ken Friedman

manifestations of postwar modern design—the ubiquitous California ranch house and the Miami Beach strip, rather than the rigorous Modernism of the Eameses. Their work can also be highly conceptual, with objects used as metaphors. At the same time, these designers readily adapt everyday imagery from American popular culture, from jellybeans to Disney characters to Sears products. They enjoy vibrant colors, ornament, and patterns, while materials tend toward the low-tech and vernacular: plywood, plastic, or ceramic tile. They often reuse found objects, such as flower pots, plumbing pipe, or second-hand dinnerware, in a Dada-like manner; and like Oldenburg, they love to play with the scale of objects. This is, in sum, a populist movement that has sought with great wit and imagination to unite design and mainstream culture once again, through the magical transformation of the ordinary into the extraordinary.

A number of American designers stand out as "cultural provocateurs" for the everyday.[44] One of the most accomplished was the late Dan Friedman, who personifies the protean nature of this mode. He began his career as a graphic designer, winning considerable acclaim, but turned to the decorative arts in the early 1980s. Building strong ties to Europe, he collaborated with designers such as Mendini in Milan, a number of Italian manufacturers, and galleries such as Neotu in Paris.[45] Friedman also attempted to dissolve the barriers between design, painting, and even fashion through his collaborations with artists such as Keith Haring and the clothing designer Willi Smith. A wall mural—which Friedman called a "metaphysical landscape"—boldly expresses this new approach (1985; fig. 146). On a raw plywood ground, he created a collage of found objects from the street

and united them with garish colors. Friedman's New York apartment, however, was perhaps the boldest expression of his design aesthetic. A continual work in progress, it was the punk equivalent of Kurt Schwitters's home, Merzbau, of 1923–36 in Hannover. Comparing it with the Venturi and Scott Brown residence perhaps best dramatizes the polarity between these coeval design approaches (figs. 145, 115).

Two husband-and-wife teams illustrate other seismic shifts that occurred in American design during this quarter century. Constantin Boym was born in Russia and trained in Milan, but he emigrated to the United States to begin his professional career, like many of the younger designers included in **USDesign**. Being an "American" designer in this period increasingly became one of global assimilation. Lyn Godley and the late Lloyd Schwan represent the breakdown of barriers between art and design: they trained in the fine arts during the 1980s and then chose to become designers. And, lastly, Laurene Boym and Godley reflect the growing influence of female designers in the profession, women who have moved decisively beyond the traditional role of "interior decorator."

One of the most powerful design forms for the expression of this everyday aesthetic has been the chair. Five examples show various conceptual and aesthetic possibilities for the chair seen not as a functional object but as a metaphor (figs. 147–48). Friedman's *Truth* side chair of 1987 is, on the one hand, a simple geometric form made of wood and plastic laminate. But it is also an intellectual game on a number of levels, in which the designer poses the question, what is the importance of truth, beauty, and function in design. Allan Wexler's design reinterprets the picket fence of middle-class

Constantin Boym
Prototype, *Husband* Armchair, 1992
Designed for the *Searstyle* Collection
Oak and upholstery, 84 × 74 × 72 cm (33 ¼ × 29 × 28 ½ in.)
Manufacturer: Boym Partners Inc. Collection of Denver Art Museum,
Funds from Joel and Carol Farkas

Lisa Krohn, Steven Skov Holt, Tucker Viemeister
Pool Armchair, 1985
Resin, metal, and ceramic tile, 92 × 61 × 66 cm (36 ¼ × 24 × 26 in.)
Collection of Denver Art Museum, Gift of the Designers

Frederic Schwartz
House Side Chair, 1987–88
Painted wood, 76 × 52 × 30 cm (30 × 20 ½ × 12 in.)
Manufacturer: Frederic Schwartz. Collection of Frederic Schwartz

Dan Friedman
Truth Side Chair, 1987
Fiberboard, plastic laminate, wood, and metal, 88 × 52 × 60 cm (34 ½ × 20 ½ × 23 ½ in.)
Manufacturer: Dan Friedman. Collection of Ken Friedman

fig. 148
Allan Wexler
Prototype, *Picket Fence* Furniture, 1985
Painted wood, 91 x 229 x 92 cm (36 x 90 ¼ x 36 ⅛ in.)
Manufacturer: Allan Wexler. Collection of Allan Wexler. Courtesy Ronald Feldman
Fine Arts

fig. 149
Lyn Godley, Lloyd Schwan
Otto Cabinet, 1990–91
Painted wood and metal, 125 x 127 x 39 cm (49 ½ x 50 x 15 ½ in.)
Manufacturer: Godley Schwan. Collection of Jenette Kahn

of Venturi's ceramic tea set for Swid Powell (fig. 119; Venturi was Schwartz's mentor and an architect with whom he often collaborated). Likewise, the *Pool* armchair of 1985 by Krohn, Viemeister, and Holt is an equally caustic and droll critique of the upwardly mobile suburban lifestyle.

As with any significant mode, the everyday aesthetic was readily translated by designers into diverse materials for a multitude of functions. Godley-Schwan's *Otto* cabinet hearkens back to the 1950s mainstream designs of Morris Lapidus and Vladimir Kagan in its over-the-top biomorphic form poised on spindly metal legs (1990–91; fig. 149).[46] Equally effervescent is Friedman's monumental *Wave Hill* centerpiece, a cross-pollination of a French bistro wire basket and a wrought-iron whatnot of postwar American suburbia (1991; fig. 150). Some of the most fanciful designs are for lighting. Friedman's shocking pink floor lamp (1989; fig. 151) recalls the comically futuristic TV show, *The Jetsons*, while Harry Allen's *Daylight* wall lamp is a faux window with the ubiquitous Levelor-style blind as its shade (2000; fig. 152).[47] With great gusto, all these designs refute the maxim that form must follow function.

Designs that incorporate and transform found objects are perhaps the quintessence of this everyday mode. The Boyms use plastic plumbing pipes for a series of serene and austere vases (1999; fig. 153). For their *Salvation* ceramics, they rescue second-hand dinnerware from thrift shops and give them a new life as *objets d'art*, the pun being fully intended (2000; fig. 154). Even industrial design firms have appropriated ready-made forms and transformed them for different purposes, engaging the user with imaginative, almost surreal imagery. Herbst Lazar Bell made a flower pot into a symbol

suburbia as a contradictory metaphor of barrier and welcoming seat (1985). The Boyms delight in using found objects to comment on our consumer culture; the *Husband* chair of 1992 for the *Searstyle Collection* is a kitsch bed backrest on a Miesian geometric base, an incongruous juxtaposition. Fred Schwartz's *House* side chair of 1987–88 is a witty work of Pop art. Its silhouette back recalls the rustic house sugar bowl

fig. 150
Dan Friedman
Wave Hill Centerpiece, 1991
Painted metal and wood, 42 x 67 x 43 cm (16 ½ x 26 ½ x 17 in.)
Manufacturer: Neotu. Collection of Susan and Marc Strausberg

fig. 151
Dan Friedman
Cosmos I Floor Lamps, 1989
Painted metal and light bulbs, 37 x 46 cm dia. (14 ½ x 18 in. dia.)
Manufacturer: Dan Friedman. Collection of Ken Friedman

fig. 152
Harry Allen
Daylight Lamp, 2000
For the Sputnik Collection, Idee Gallery, Tokyo, Japan
Painted metal, venetian blind, ceramic, and light bulb,
47 x 32 x 12 cm (18 ⁹⁄₁₆ x 12 ⅜ x 4 ¾ in.)
Manufacturer: Sputnik for Idee. Collection of Harry Allen

figs. 153/154 *below, top to bottom*
Constantin Boym, Laurene Boym
Wye and *Elbow Plumbing* Vases, 1999
PVC pipe, largest: 29 x 24 x 12 cm (11 ¼ x 5 ½ x 4 ½ in.)
Manufacturer: Benza. Collection of Boym Partners Inc.
Collection of Denver Art Museum, Lilliane and David M. Stewart Collection,
Gift of David A. Hanks

Prototypes, *Salvation* Ceramics, 2000
Ceramic, largest: 43 x 18 cm dia. (17 x 7 ⅛ in. dia.)
Manufacturer: Boym Partners Inc.
Collection of Denver Art Museum, Funds from Joel and Carol Farkas

fig. 155
Herbst Lazar Bell: HLB Vision Team
Prototype, *Zuzu's Petals* Communication Center, 1998
Injection-molded plastic, aluminum, Santoprene, LEDS, acrylic, and embedded solar cells,
15 x 28 cm dia. (6 x 15 in. dia.)
Product design and model-making: Josh Goldfarb, Jon Lindholm, and Simon Yan
Manufacturer: Herbst Lazar Bell. Collection of Herbst Lazar Bell

g. 156
homson multimedia: Ronald Lytel
Prototype, *Internet Radio* for RCA, 1998
LA resin and aluminum, 25 × 43 × 20 cm (10 × 17 × 8 in.)
Manufacturer: Thomson multimedia. Collection of Thomson multimedia

fig. 157
Dorothy Hafner
Tea Service, 1991
Porcelain, largest: 2.5 × 30 × 31 cm (1 × 12 × 12¹⁄₁₆ in.)
Manufacturer: Hafner Studio. Collection of Dorothy Hafner

fig. 158
**Smart Design: Annie Brekenfeld, Tom Dair, John Loczak,
and Davin Stowell**
Copco Dinnerware, 1988
Plastic, largest: 2 × 25 cm dia. (¾ × 10 in. dia.)
Manufacturer: Copco. Collection of Smart Design

fig. 159
Dorothy Hafner
Jitterbug Phone Call Carpet, 1988
Wool and silk, 198 x 168 cm (78 x 66 in.)
Manufacturer: V'Soske Inc. Collection of V'Soske Inc.

In defiance of the austerity of much Modernist good design, everyday designs—from tableware to textiles—are often awash in tumultuous two-dimensional pattern. In Michael Graves's prototypal dinnerware for Disney, planes of colorful geometric patterns and Mickey Mouse silhouettes collide with joyous abandon (1992; fig. 136). Equally humorous is Dorothy Hafner's tea service with its surreal juxtaposition of jelly bean shapes and cartoonish scribbling on Japanesque forms (1981; fig. 157). A variant was designed for Tiffany & Co.—of all firms. Not to be outdone, Copco commissioned Smart Design to create a line of inexpensive, mix-and-match plastic dinnerware; its parody of design by two icons of the 1980s, Memphis and Swid Powell, scores a bull's-eye (1988; fig. 158).

Textiles celebrating the everyday are equally original. Hafner's carpet pattern recalls sidewalk graffiti in chalk (and even twentieth-century automatist painting); but the rug is, in fact, a deluxe *objet* handmade by V'Soske (1988; fig. 159).[48] California Drop Cloth's textile exploits the same clever play between high art—Jackson Pollock's drip paintings—and the ordinary object—a painter's drop cloth with drips and spills (1975; fig. 160). Nostalgically vernacular, Venturi's textile (1981–84) enlarges the pattern of a child's black-and-white school notebook cover, while Tony Costanzo's fabric (1980) reuses a generic vinyl tile pattern of the 1950s (fig. 161).[49] All three of these fabrics were limited productions by small studios. In rebellion against the dominance of enormous textile mills rolling out contract goods, this innovative atelier production assumes a similar exponential importance, like the earlier work of Herbst Lazar Bell and Thomson multimedia.

of a sophisticated communications system, humanizing the product as the "mouse" serves to personalize the computer (1998; fig. 155). In a design for an Internet radio, Thomson multimedia has taken an opposite tack by alluding to Picasso's sculpture of a bull's head (1998; fig. 156). In industrial design, a field so subjugated by market forces, such experimental ideas are rare and hardly ever get beyond the prototypal stage of development. This kind of conceptual industrial design thus assumes an exponential importance.

fig. 160
California Drop Cloth Co.
Celebration Textile, 1975
Hand-painted cotton, 366 x 123 cm (144 x 48 ½ in.)
Manufacturer: California Drop Cloth Co. Collection of Philadelphia Museum of Art, Gift of California Drop Cloth Co.

fig. 161 *bottom, left to right*
Robert Venturi. Venturi, Scott Brown and Associates
Notebook Textile, 1981–84
Cotton sateen and pigment, 366 x 133 cm (144 x 52 ½ in.)
Manufacturer: The Fabric Workshop and Museum.
Collection of Denver Art Museum, Lilliane and David M. Stewart Collection, Gift of David A. Hanks

Tony Costanzo
Linoleum Banner Textile, 1980
Cotton sateen and pigment, 366 x 112 cm (144 x 44 in.)
Manufacturer: The Fabric Workshop and Museum. Collection of Denver Art Museum, Lilliane and David M. Stewart Collection

fig. 162 *opposite*
Frank O. Gehry
Interior, Frank O. Gehry Residence, Santa Monica,
California, 1977–78, addition 1991–94

In sum, whether one chooses "Inventing Tradition" or "Celebrating the Everyday," both design approaches shatter the myth of Postmodernism. Some critics since the 1990s have condemned Postmodernist innovators for the vulgarizations of their followers, but this is much like condemning Mies van der Rohe for the bland glass office buildings of postwar corporate America. Postmodernist design was not just a facile regurgitation of historical motifs but a considered attempt to define alternate design approaches to mid-century Modernism. The responses were multifarious, but they clearly produced new ideas of form, material, construction, and detailing that decisively changed design in the late twentieth century. The whiplash of action/reaction in the late twentieth century is so violent, however, that no sooner had these Postmodernist developments achieved some recognition than counter-movements arose.

Redefining Expressionism: Intuitive Form Again

There were two major counter-movements that arose in this quarter century: an expressionist and a rationalist mode. Much of the history of twentieth-century design has focused on rationalist or functional design—what one normally thinks of as the many variants of Modernism—and, in particular, on the cyclical shifts in the fascination by these designers with geometric and biomorphic forms. Expressionism has been viewed largely as an intermittent architectural mode, but it now seems clear that there might well be a continuous design parallel running through the century, much as David De Long has suggested for architecture in his essay here. With the perspective of a new century, designers who had once seemed anomalous or whose work seemed to go nowhere,

to paraphrase Henry-Russell Hitchcock on certain architects, may now be seen in a new light. At least four antecedents may be noted that can be viewed as leading, in part at least, into the new expressionist revival of the last quarter century.

The Art Nouveau style—and its various European manifestations—permeated design at the turn of the century. But there were designers such as the Spaniard Antoni Gaudí and the German Bernhard Pankok who pushed their fluid, naturalistic forms to an almost bizarre level. It was the Italian Carlo Bugatti, however, who perhaps achieved the most highly personal designs in his exotic furniture covered in vellum with copper ornament.[50]

Expressionist design between the Wars took a slightly different tack. Not much seems to have been actually realized by the German Expressionists or the Soviet Constructivists. But Holland was an important center for expressionist architecture and design. There was the rather massive and sculptural furniture of Piet Kramer and Michel de Klerk; this important design work by the Amsterdam school has often been overlooked.[51] Frank Lloyd Wright's furniture from this period has also proved equally difficult to categorize. His work from the 1910s and 1920s reflected the kind of geometric ornament that increasingly embellished his architecture; in the next two decades, the crystalline form and structure of his furniture grew out of the powerful geometric shapes of his buildings.[52]

In the postwar period, designers such as Carlo Mollino and Friedrich Kiesler returned to highly expressive forms handmade of wood. But younger designers such as Eero Saarinen and Verner Panton used new plastics to achieve expressive forms that went beyond rationalist Modernism.[53]

fig. 163 *opposite, left to right*
Gerrit Thomas Rietveld
Zig-Zag Chair, 1934

Eero Saarinen
Tulip Side Chair, 1955–57

Verner Panton
Stacking Chairs, 1960–67

Gaetano Pesce
Dahlia Side Chair, 1980

Frank O. Gehry
Wiggle Side Chair, 1972

fig. 164
Frank O. Gehry
Bubbles Chaise Longue, 1979–82
Designed for the *Experimental Edges* Series
Cardboard, 86 x 208 x 71 cm (34 x 82 x 28 in.)
Manufacturer: New City Editions. Collection of Denver Art Museum,
Gift of J. Landis and Sharon S. Martin

By the 1960s, innovative materials like polyurethane, stretch fabrics, and resins gave even greater leeway to a designer's imagination. Gaetano Pesce has been among the most creative in harnessing new technology and materials for his highly personal work, which is both handmade and mass-produced.[54]

Throughout the century, expressionist designers, starting with Bugatti, have intermittently been preoccupied with creating a continuous chair: i.e., transforming the conventional four-legged chair into a highly intuitive, sculptural form. It was Gerrit Rietveld, the Dutch designer, who took this idea (perhaps for slightly different reasons) one step further in his attempt to create a continuous chair of one material. His model has been brilliantly enlarged upon in succeeding decades by Saarinen, Panton, Pesce, right up to Gehry (fig. 163), designers who have pushed the poetic possibilities of materials in their expressive forms. Indeed, if an argument can be made for a strain of expressionist design in the twentieth century, this may well be one of its most compelling manifestations.[55]

The expressionist revival of the last quarter century has also been largely perceived as an architectural mode, ranging from Frank Gehry's soaring, sculptural forms to Peter Eisenman's explosive, deconstructed buildings. But it has permeated the design field in a number of intriguing ways since the early 1980s, much like the antecedents noted above. Some of the best designers in this vein are, in fact, architects. Their work can veer from fragmented and layered forms to a charged anthropomorphism or surrealism. It is often highly theoretical in nature, for function and comfort are generally not major concerns. Designers tend to employ industrial materials—metal, cardboard, rubber, or concrete—and to exaggerate their rawness. Indeed, in their attempt to break from a rationalist architectonic model, they often use such materials as the genesis for a design—exaggerating the inherent qualities of these substances and making highly personal statements— much as Venturi manipulates a historical vocabulary. The intrinsic textures and limited, muted hues are left undisguised: the palette remains one of gray, buff, or black. Ironically, this work is largely handmade, with the exception of certain product designs, and not readily adaptable for mass production.

fig. 165
Frank O. Gehry
Fish Lamp, 1984
ColorCore plastic laminate and wood, 198 x 109 x 81 cm (78 x 43 x 32 in.)
Manufacturer: New City Editions. Collection of Fred and Winter Hoffman. Courtesy Fred
Hoffman Fine Art, Santa Monica, California

Unquestionably the major American expressionist
designer of this quarter century is Frank Gehry. Perhaps his
most significant rival is the London-based designer Ron Arad,
who is twenty-two years his junior; the contemporaneous
parallels are remarkable between Arad's highly fluid steel
furniture of the late 1980s and early 1990s and Gehry's
equally sculptural buildings clad in titanium.[56] Gehry's
residence in Santa Monica, California (1977–78, addition
1991–94) was one of the first harbingers of his move to
define a new expressionist aesthetic (fig. 162).

Gehry's design oeuvre falls into two phases, from 1969
to 1986 and from 1989 to the present.[57] His most important
designs date from the earlier period, before his internationally
acclaimed museums made him a household name. They
consist of two furniture series executed in cardboard and a
series of objects with representational imagery, most notably
the fish.[58] Gehry's fascination with the fish form has led him
to use it at a variety of scales, from goblets to sculptures to
buildings. Although his oeuvre is somewhat small, it nonethe-
less ranks among the most visually arresting design of the late
twentieth century.

Gehry's design approach is distinctive in two ways. Like
some of the designers who celebrate the everyday, he con-
sciously blurs the conventional lines between the fine and
applied arts. In fact, he has acknowledged that his friendships
with artists such as the sculptor Claes Oldenburg and the light
artist Robert Irwin have had an influence on his designs. Like
an artist, Gehry works with a hands-on method; his designs
are fundamentally about a highly intuitive response to a
material—whether cardboard or plastic laminate—that is
transformed into a sculptural object and most often produced

in limited numbers in a studio. It is this artistic process that drives Gehry as a designer. "I prefer the sketch quality," he says, "the tentativeness, the messiness, if you will, the appearance of 'in-progress' rather than the presumption of total resolution and finality."[59] Secondly, his unwavering instinct as a seminal designer allows him to reach back into history to what Martin Filler has called the "first principles" of design—to the genesis of major design concepts—and then to bring them up to the present, though transformed in a completely original manner.[60] The parallels throughout his career to work by innovators of the first rank such as Thonet[61] and Wright[62] are uncanny.

Gehry's first furniture design, the *Easy Edges* series of 1969–73, was cited earlier (fig. 111). Although constructed of cardboard rather than wood, the collection shows a clear extension of a Modernist aesthetic running from Thonet through Aalto: it relies on meticulously crafted laminated materials; it emphasizes its light, structural frame; and it was intended to be an inexpensive product that could be produced in volume. However, the overnight success of this series overwhelmed Gehry, who was still struggling to establish his identity as an architect; and it was only some seven years later that he began to experiment with cardboard again, in the *Experimental Edges* furniture series of

fig. 166 *left to right*
Thom Mayne
Nee Side Chair, 1988
Designed for the Leon Max Showroom, Los Angeles, California
Metal, 61 x 61 x 76 cm (24 x 24 x 30 in.)
Manufacturer: Tom Bonuovo. Collection of Denver Art Museum,
Lilliane and David M. Stewart Collection

Ralph No
Big Spring Frog Stool, 1989
Concrete and metal, 57 x 37 x 38 cm (22 ½ x 14 ⅜ x 15 in.)
Manufacturer: 10 Little Indians. Collection of Rheda Brandt

Henner Kuckuck
Spine Chair KI, 1001, 1991
Koroseal, aluminum, and metal, 64 x 67 x 46 cm (25 ¼ x 26 ¼ x 18 in.)
Manufacturer: Henner Kuckuck. Collection of Henner Kuckuck

1979–82.[63] These works marked a new direction for Gehry, one that ran parallel to changes in his architecture. His designs now had a greater sense of mass and rough tactility, and both his forms and his method of construction were much more improvisational.[64] In chairs like *Grandpa Beaver*, large chunks of torn cardboard were seemingly slapped together; and in the *Bubbles* chaise, lengths of shaggy cardboard were layered and folded in improbable S-curves like ribbons (fig. 164).[65] It is not the cardboard alone, though, but the extraordinary intuitive interplay between mass, material, construction, and texture that marks *Experimental Edges* as perhaps Gehry's most accomplished and original furniture design to date. The series also reflected his new status as a rising star and a darling of the media. While the *Easy Edges* series was mass-produced, modestly priced, and retailed in department stores, *Experimental Edges* was handmade and sold through galleries as expensive, limited-edition art furniture.[66]

Gehry's other important design from this period is the *Fish lamp* series of 1983–86 (fig. 165). He conceived it at the invitation of the Formica Company, which was promoting a new product called ColorCore.[67] Gehry initially disliked the commercial properties of the plastic laminate and broke the material in frustration, which proved to be a happy accident. He discovered that the shard-like quality and rawness of the shattered ColorCore—along with its variable translucency—lent itself to lighting. He designed some three dozen variations on the fish form, with bases of wood timbers or logs, some with coiling snakes made of laminate.[68] Italian designers in the 1960s and 1970s had, of course, dramatically transformed lighting, enlarging it from table scale to that of

an architectural element. Gehry's fixtures, however, pushed this development even further: his fish lamps are free-standing sculptures, ethereal forms that serve no function other than sheer delight.

Like Graves, Gehry moved away from studio production to true mass production in the late 1980s, as the focus of his design work shifted. Joseph Giovannini has perhaps best captured the essence of Gehry's aesthetic: "The designs are highly studied and refined; the final subtlety is that the rawness remains intact, that it has been worked on but not polished."[69] This late work has thus proved somewhat problematic, for there is a finesse and elegance—Gehry almost "pasteurized"—that has replaced the roughness and vigor that impart such remarkable power and distinctiveness to his early design.[70]

A number of younger designers, primarily based in Los Angeles and New York, have shared Gehry's absorption with unconventional materials and have extended his intuitive experiments (fig. 166). Thom Mayne, who worked in Gehry's office, produced a variety of designs in metal and glass in the late 1980s.[71] Perhaps the most notable was his *Nee* side chair of cast, welded, and perforated sheet metal (1988). A tour de force of structural expression, this taut and linear chair has a strangely anthropoidal quality, as if it could slink across the room. Ralph No chose an unlikely material—concrete—but created an unexpected visual effect. In his *Big Spring Frog* stool, he mischievously denies the weight and immobility of concrete by suspending the seat on springs and putting the base on industrial wheels (1989). For his continuous chairs, Henner Kuckuck most often adapts sheets of industrial materials, such as linoleum flooring, which he folds or bends

fig. 167
Lisa Krohn
Twiggy Lamp, 1993
Tree branches and resin, 243 x 122 x 23 cm (96 x 48 x 9 in.)
Collection of Lisa Krohn

and secures with metal clips (1991). These small, gleaming details are structural and decorative. Like Gehry with cardboard, Kuckuck exploits a minimal palette of color, texture, and material with an almost Zen-like concentration. And like Gehry, each of these designers gives an unconventional industrial material a new purpose and a highly personal expression; the parallels to a number of young London-based designers such as Tom Dixon and Danny Lane are also quite remarkable.[72]

Some designers have also extended Gehry's model of lighting as sculpture. Perhaps the most poetic is Lisa Krohn's floor lamp of tree branches held together by an ersatz bird's nest of resin that houses the light bulb (1993; fig. 167). This slightly surreal fixture is a wonderful illustration of Hartmut Esslinger's admonition that "form follows emotion." Josh Owen's *Hose* lamp is more technological in form and construction (1997; fig. 168). The straightforward design consists of two elements: a metal base echoes a garden hose wheel and exposes its electrical components; the lighting fixture is a flexible fiber-optic cable that can be arranged in highly sculptural configurations. These two lamps—different in every way—suggest the gamut of expressive possibilities that designers are currently pursuing.

Product design has, up to this point, played something of a peripheral role in our survey of American design from this quarter century. The first two sections of **USDesign**, with their respective focus on tradition and the everyday, dealt with more unorthodox aspects of the product design field. The last two sections of **USDesign**, however, focusing on the expressionist and rationalist revivals, deal with product design that is much more mainstream. The developments in this area over the last quarter century have been nothing less than astounding.[73]

Some critics have questioned, nonetheless, whether there is an articulated conceptual basis for product design in this country. American product designers—and even manufacturers—have often been criticized, at least relative to their European colleagues, for having less commitment to a strong theoretical basis and social agenda in their work. To paraphrase Tucker Viemeister, the Puritan ethic remains

a driving force in our love of simple, functional, engineered, economical design. Indeed, Americans have often been accused of placing a greater emphasis not only on engineering and technology but on styling, marketing, packaging, and the sheer visual appeal of a product. But there are product designers who have gone beyond engineering and styling, for the tens of thousands of objects made each year for global markets, to create "products that form a statement about the aesthetics of our time," as the French designer Jean Nouvel so eloquently put it.[74] There are, in short, product designers who aspire to be artists—or at least to infuse a strong aesthetic component into their work. It is these rare individuals, Steven Holt has written, who "have the ability to peer into the souls of physical objects and the consumers that use them"; and it is this more "spiritual" aspect of product design that **USDesign** celebrates.[75]

The challenges facing these designers are formidable, for they are working in a field beset by tumultuous change over the last quarter century. One of the chief forces in this topsy-turvy has been globalization. Products designed in America are now increasingly manufactured in Asia or South America. Conversely, a number of renowned European product designers have emigrated to the United States, particularly to the Bay Area, clouding the issue of what "American" means. Given the growth of multinational markets, many more products are designed to have a certain visual neutrality, so they can appeal to a "universal consumer." Likewise, design firms and manufacturers have increasingly become multinational institutions. The question thus becomes, does product design have a national identity anymore?

fig. 168
Josh Owen. owenLOGIKdesign
Hose Lamp, 1997
Fiber-optic cable, metal, motor, and resin, 69 x 32 x 32 cm (27 x 12 ½ x 12 ½ in.)
Manufacturer: owenLOGIKdesign. Collection of Josh Owen

fig. 169
Donald Chadwick and William Stumpf
Aeron Armchair (Model A), 1992
Carbon fiber; *Pellicle* and leather upholstery, 99 x 64 x 64 cm (39 ¼ x 25 x 25 in.)
Manufacturer: Herman Miller Inc. Collection of Denver Art Museum, Gift of Herman Miller Inc.

Within the United States itself, there has been a profound shift of power in the field during these decades, with the emergence of the West Coast and especially of Silicon Valley. The Bay Area is now widely regarded as the principal center for American industrial design, and California designers are internationally perceived as having a decided edge that comes from working on the front line of technological innovation.

Social responsibility—particularly concerning the environment—has also been an intermittent force in American product design during this quarter century. It came to the fore during the early 1970s with the energy crisis and gained momentum with the ecological movements that created Earth Day, recycling laws, and Green political activity. The American designer and theorist Victor Papanek was one of the most articulate spokesmen for this international cause, and his books have been among the most widely read design publications of the twentieth century.[76] With the economic booms of the 1980s and 1990s, however, environmental anxieties seem to have lessened. But in reality, the Green

movement never really developed a recognizable aesthetic—at least in the United States. Its influence seems to have been more pervasive in affecting the choice of materials and manufacturing methods.

A technological revolution has also profoundly affected product design during this quarter century. Micronization has fundamentally changed the entire field. With no form of its own, the chip neutered the Modernist directive that the form of a product should reflect its function; designers have thus resorted to metaphors or emotive forms to represent function. Plastics have replaced metal for casings of products, which have allowed a far greater variety of form, detailing, and color. Such casings were initially opaque; but by the 1990s, a new generation of plastics appeared with translucent properties and frosted finishes. The impact of the computer cannot be overstated, from computer-aided design (CAD) to computer-aided manufacture (CAM). Given this greater technological complexity, many offices and manufacturers have changed their whole method of design: the emphasis has shifted from the individual product designer to more anonymous, collaborative design teams. And there have been a host of inventions that have changed the lifestyle of the average middle-class consumer, products that are now being manufactured by the hundreds of thousands each year: the personal computer, the Palm Pilot, the compact disk, and the cellular telephone, to name just a few. Moreover, the Internet and satellite television have fundamentally altered our whole notion of time and distance in recent years. Perhaps more than any other segment of the design field, product design is poised on the cutting edge of such profound technological change.

fig. 170
Stephen Peart. Vent Design
Animal Wet Suit, 1991
Neoprene and nylon 152 x 56 cm dia. (60 x 22 in. dia.)
Manufacturer: O'Neill. Collection of Stephen Peart, Vent Design

fig. 171 *top*
Comfort Products, Inc.: Roger Brown and Erik Giese
Flexon T Ski Boot, 1979
Plastic and fabric, 35 × 29 × 12 cm (13 ½ × 11 ¼ × 4 ¾ in.)
Manufacturer: Raichle. Collection of Denver Art Museum, Gift of KDR

fig. 172 *bottom*
Rollerblade
Advance In-Line Skate, 2000
Nylon, plastic, and metal, 33 × 34 × 13 cm (13 × 13 ¼ × 5 in.)
Manufacturer: Rollerblade. Collection of Denver Art Museum, Funds from DAM Uncorked, 2001

fig. 173 *top, left*
Oakley "O" Design Team
Juliet Glasses, 1996
Titanium alloy, 4 x 17 x 8 cm (1 ½ x 6 ½ x 3 in.)

Romeo Glasses, 1996
Titanium alloy, 4 x 18 x 8 cm (1 ¾ x 7 x 3 in.)
Design Director: Colin Baden. Manufacturer: Oakley. Collection of Oakley

fig. 174 *top, right*
Spy Optic
Spy Microscoop Sunglasses and Case, 1998
Plastic, rubber, and metal, 6 x 14 x 6 cm (2 ¾ x 5 ¾ x 2 ¾ in.)
Art Director: Jerome Mage. Manufacturer: Spy Optic. Collection of Spy Optic

fig. 175 *bottom*
Nike: Nike Design Team
Triax Ballistic 15 Super Watch, 2000
Plastic and stainless steel, 24 x 4 x 1 cm (9 ½ x 1 ¾ x ½ in.)
Manufacturer: Nike. Collection of Denver Art Museum,
Lilliane and David M. Stewart Collection, Gift of David A. Hanks

Triax 50 Aluminum Watch, 1998
Plastic and aluminium, 23 x 4 x 1 cm (9 x 1 ¾ x ½ in.)
Director of equipment: Raymond Riley. R&D: Gene Yanku.
Manufacturer: Nike. Collection of Denver Art Museum,
Lilliane and David M. Stewart Collection, Gift of Lynn Verchere

fig. 176
Oakley: "O" Design Team
Flesh Shoes, 2000
Rubber and fabrics, 13 x 30 x 12 cm (5 ¼ x 11 ¾ x 4 ⅝ in.)
Design Director: Colin Baden. Manufacturer: Oakley. Collection of Oakley

A number of American industrial designers have clearly understood the magnitude of the changes confronting their field and have produced work with a remarkable vigor. While their objects are largely black or gray, like so many consumer goods of this period, these designers have sought to make their technologically sophisticated products more appealing to the public by shaping them to fit the body. The resultant anthropomorphic forms can often verge on the surreal. In addition, highly exaggerated detailing and evocative, sometimes droll names, like *Animal* and *Flesh* or *Romeo* and *Juliet*, are used to forge personal and emotional bonds, on a number of levels, between products and their users—what has been called "emotional ergonomics."[77] Such works rely heavily on the computer for design and production, as well as innovative materials and technology. Yet these designers clearly approach their work from a highly subjective, not rationalist, vantage.

One of the most acclaimed icons of this expressive aesthetic is the *Aeron* office chair by Donald Chadwick and William Stumpf (1992; fig. 169).[78] Famed for their comfort, the contoured seat and back panels are made of a tough but translucent industrial material, called Pellicle. For the underside mechanisms that adjust the chair, the designers have sculpted each component into a highly complex but elegant composition. Another equally assured anthropomorphic design is Stephen Peart's *Animal* wet suit; it is a bold biomorphic composition of black on black—almost painterly in feeling (1991; fig. 170). The detailing is masterly: it expresses the muscular movement of the body and at the same time has the sculpted undulations of a pleated garment by Mariano Fortuny. Three designs for footwear reveal a similar absorption with highly charged forms and refined detailing: the *Flexon T* boot by Erik Giese and Roger Brown is almost an emblem of the speed and excitement of downhill skiing (1979; fig. 171); the *Advance* In-Line skate captures the energy and exhilaration of skating on asphalt turf (2000; fig. 172); while the *Flesh* shoe by the "O" Design Team is refreshing in showing how simple and sleekly sculpted the ubiquitous sneaker can be when freed of the gimmicky details and commercial logos seen on so much athletic footwear today (2000; fig. 176).[79]

On yet a smaller scale, design directors such as Colin Baden (of Oakley) and Jerome Mage (of Spy) have endowed eyewear design with a new spirit not only in material—through the use of new plastics and high-tech substances such as titanium—but in form. Their chic, sculptural glasses of 1996–98 are as carefully detailed and crafted as pieces of fine jewelry (figs. 173–74). Likewise, Raymond Riley and

fig. 177 *right*
Kevin Foley and James O'Halloran
Radius Toothbrushes, 1984
Plastic, each: 17 x 5 x 2 cm (6 ¾ x 2 x ¾ in.)
Manufacturer: Radius Toothbrush. Collection of Radius Toothbrush

fig. 178 *below*
Donald Booty Jr.
Double Plus Calculator, 1986
Plastic, 15 x 7 x 1 cm (5 ¾ x 2 ⅜ x ½ in.)
Manufacturer: Zelco Industries.
Collection of Denver Art Museum, Gift of Carla and Carl Hartman

fig. 179 *below*
frogdesign: frogteam
Vadem Clio Computer, 1997
Glass-filled polycarbonate and magnesium, 29 x 34 x 3 cm (ca. 11 ½ x 13 ½ x 1 in.)
Manufacturer: Vadem Ltd. Collection of frogdesign

fig. 180 *above, top to bottom*
Microsoft: Microsoft Design Team
Trackball Optical Mouse, 2000
Plastic, metal, and rubber, 18 x 11 x 5 cm (7 x 4 ¼ x 2 in.)

Trackball Explorer Mouse, 2000
Plastic, metal, and rubber, 17 x 11 x 5 cm (6 ⅞ x 4 ½ x 2 in.)
Manufacturer: Microsoft. Collection of Denver Art Museum, Funds from DAM Uncorked 2001

fig. 181
Design Logic: David Gresham
Prototype, *Book* Computer, 1985
Plastics, 29 x 32 x 32 cm (11 ½ x 12 ½ x 12 ½ in.)
Collection of Cranbrook Art Museum,
Gift of David Gresham and Martin Thaler through Design Logic

Gene Yanku (of Nike) have transmuted the sports watch into an expressive running instrument (1998; fig. 175). Even the humble toothbrush has not escaped the designer's impulse to express the act of brushing. One of the earliest and still most successful ergonomic examples is Kevin Foley and James O'Halloran's *Radius* of 1984: its design came in left- and right-hand models (fig. 177). It is certainly no coincidence that many of these highly expressive products were envisioned for an idealized athletic consumer. They reflect the California dream—an American preoccupation since the 1970s—about youth, fitness, and an on-the-go lifestyle.

Instant information is a more recent craze in American culture and one that powers the immense sales of electronic products, which now permeate almost every aspect of our existence. The vast majority of such products represent "good engineering": they are simple, functional, economical, and black—like the classic Model T Ford. Three designs illustrate an alternate approach. Though the objects too are still black, the designers have instead chosen expressive forms to humanize the machine. Donald Booty's *Double Plus* calculator of 1986 was early in giving an ergonomic shape to a hand-held product, which was available in left- and right-hand versions (fig. 178). The *Vadem Clio* computer by frogdesign breaks out of the ubiquitous bland "computer box": on the one hand, it is a sleek, sensuous mini-sculpture; but it is also a highly functional product with its adjustable armature and screen (1997; fig. 179). Transplanted from Germany to California some two decades ago, frogdesign has consistently been a pacesetter in its organization and its vision for American product design.

fig. 182
Lisa Krohn and Tucker Viemeister
Prototype, *Phonebook* Answering Machine, 1987–88
Plastic, 6 x 33 x 24 cm (2 ⅜ x 13 x 9 ⅜ in.)
Collection of Cranbrook Art Museum, Gift of Lisa Krohn

In recent years, a number of American computer companies have become so enormous that they have developed their own in-house design teams. The behemoth Microsoft has been a leader, and some of their newest products take expressive form to a new level. In the *Trackball Explorer* and the *Optical* of 2000, the lowly mouse has been transformed, with a windswept form and glowing red eye, into a hand-sized *Stealth* bomber (fig. 180). Whether such military associations are tongue-in-cheek or a subtle warning to the competition, these are exceptional designs that set a benchmark for product design.

Other product designs have overtly employed "product semantics"—shapes and mechanical features intended to make the complex functioning of the item understandable to the average consumer through associative meanings. Because of their linguistic aspects, works marked by product semantics have theoretically been associated with

Postmodernism, which shares sources in such theory.[80] But the formal qualities of these objects are more expressive than decorative or historicizing. Two such designs play on book forms. With the *Phonebook* answering machine by Lisa Krohn and Tucker Viemeister, one flips "pages" to activate various functions (1987–88; fig. 182); with the *Book* computer by David Gresham of Design Logic, variable modular components are stacked vertically together (1985; fig. 181). Other designs employ more expressive forms. Martin Thaler and David Gresham of Design Logic use a mask form for a *Videodisc* camera to symbolize "the senses of sight, sound, and memory" (1985; fig. 183).[81] The android-like form of Peter Stathis's *Satori* television is highly suggestive of its function (1988; fig. 184). The TV "wakes up" when touched, turning its screen up to look at the user. The design presents the idea of technology as a companion or pet."[82] Clearly, product design is one of the most dynamic aspects of American design from this quarter century, but it is not quite ready to be shoehorned into neat historical boxes.

Paradoxically, it is in this examination of expressive design that we have first come to grips with many of the major forces that have buffeted late twentieth-century design: accelerating technological change, the pervasive impact of the computer, and spiraling globalization. Perhaps most telling is how these designers have chosen to confront such overwhelming issues. To use an industrial material as the genesis for personal form. To humanize the machine. To create an emotional bond between viewer and object. All proved to be highly intuitive responses. There is, however, another group—the new Modernists—who have sought to confront reality head on, by reverting to a new kind of rationalist, architectonic design approach.

fig. 184
Peter Stathis
Prototype, *Satori* Television, 1988
Mixed media, 17 x 17 x 24 cm (6 ½ x 6 ½ x 9 ⅜ in.)
Collection of Cranbrook Art Museum, Gift of Peter Stathis

fig. 185
Richard Meier
Interior, Jerome Meier House, Essex Falls, New Jersey, 1963–65

Expanding Modernism: Poetic Rationalism

The fascination with a rationalist direction has been one of the most influential design currents throughout the twentieth century. Modernism has had a number of manifestations, however, from the early work of Josef Hoffmann, Marcel Breuer, and the Eameses, up to the current revivalists. In its purest form, rationalist design is decidedly different from expressionist work. It is characterized by its use of elemental abstract forms, industrial materials, and mass production; its denial of any overt historical reference or applied ornament; its clear expression of function and structure; its concern for a social morality; and its belief in the *Gesamtkunstwerk*, a total work of art, in which all of the design arts are coordinated to express the same vision.

There have been three American generations involved in the Modernist revival of this quarter century. One of the most prolific designers from the older generation is Richard Meier. An interior of 1963–65 for his parents' residence in Essex Falls, New Jersey, clearly shows the direction that his architecture would take (fig. 185), but there is a certain irony in that Meier's design work is as overtly historicizing as that of Graves. He has looked, in particular, at the oeuvre of a number of early twentieth-century designers: Josef Hoffmann in his furniture for Knoll (1978–82); Charles Rennie

Mackintosh in his tableware for Swid Powell (1983ff); and even Frank Lloyd Wright in his office system for Stow Davis (1992). The question is whether such designs are original extensions of their sources or clever intellectual take-offs.

Perhaps the most innovative work in this new Modernist revival has come from the second and, in particular, the third generation. The most significant designers in this movement are largely based in New York or San Francisco. A number are emigrants who have decided to pursue their professional careers in the United States. Many of the younger designers who are expanding Modernism trained as architects, but they have chosen not to apprentice in large architectural offices. Instead, following the Italian and Japanese example, they have begun their careers as designers and opened small studios to develop their individual aesthetics and reputations. Many end up producing and even distributing their own work. This approach marks a new model for American design and reflects the scarce opportunities not only for building commissions but for employment by major American design manufacturers.

A fundamental goal of many of these designers is to make inexpensive, good design for the average consumer—a cherished Modernist ideal. Yet unlike early Modernists, they do not believe that design can revolutionize society, but

fig. 186
Karim Rashid
Interior, Karim Rashid Apartment, New York, New York, 2000

perhaps more realistically, that it can simply enrich it immeasurably. Given their youth, many of them are also acutely aware of the seismic changes occurring in American culture, particularly as the United States has become a global super power. "Our object culture," Karim Rashid has noted, "can captivate the energy … of this contemporary universal culture of the digital age. The birth of industrial processes, new materials, global markets are my great interests in design [and they] … lend hope to reshaping our lives. I feel new culture demands new forms."[83] More recently, he has even proclaimed: "I want to change the world."[84]

Thus these designers have developed a distinctive aesthetic to express a new culture. They have, unquestionably, been influenced by post-World War II design; but they are looking at high-style Modernist designers such as the Eameses, Jean Prouvé, and Isamu Noguchi, not at the vernacular or ordinary. The formal vocabulary of this group includes both the geometric and the biomorphic, as in the postwar period. These designers prefer light, planar forms and rational, highly articulated construction methods. Yet their bent is not technological but poetic, especially in the relationship they reveal between material and construction. They share a real concern with how their objects are made, but it is tempered with strong aesthetic considerations—

including pushing the inherent qualities of materials as a means to expand their vocabularies of mass, color, and texture. These materials—plywood, resin, plastics, stock metal components, or painted metal—tend to be inexpensive and vernacular through necessity. But their sense of color can be acute: they favor bright, clear hues. Manufacturing is low-tech, and production is most often limited (with notable exceptions such as the work of Karim Rashid). Because so few American manufacturers have supported them, these designers often rely on small galleries for the distribution of their work. Perhaps because they lack the advanced technology that only large-scale manufacturers can provide, few of them have tackled the chair, the quintessential Modernist furniture form. Instead, they have chosen to design a variety of case pieces, utilizing studio production methods.

Indeed, few major American manufacturers have stepped forward to promote these young Modernist designers, unlike European design companies, which are always on the lookout for new talent.[85] Artists like Rashid, who have chosen to work as true industrial designers, are unusual. And even he initially had to seek out smaller firms that needed to take creative risks to stay in the market. Until his recent fame, Rashid has had little support from major American companies. He has, nonetheless, defined many of the characteristics of this gener-

ation in his own work, as epitomized in his New York loft (2000; fig. 186). He is also unquestionably one of the most talented and prolific American designers of his age, an artist of the stature of Jasper Morrison or Marc Newsom, two of his multinational contemporaries based in Europe.[86]

Designers such as the late David Gulassa are more representative of the new Modernists. He started out as a craftsman in a studio executing accessories for architects such as Steven Holl, but he went on to become an important designer in his own right. Like that of many of his generation, Gulassa's work is primarily about material; his choices ranged from industrial substances like raw steel and the resins used in the aircraft industry to large blocks of wood from Northwest Coast forests. Thus there is a wonderful dichotomy between the handmade and the industrial in his work—a

refined vigor that gives it tension and power. His forms tend to the elementary. Like the furnishings of the French designer Jean-Michel Frank, his have a superb sense of proportion and detail that is often lacking in contemporary American work with a similarly spare aesthetic. Gulassa's death at the age of forty in January 2001 was a tremendous loss for American design, for he was one of the most gifted designers of this third generation.

As noted earlier, the new Modernists alternate between two stylistic modes. Rashid has perhaps most fully developed the biomorphic aesthetic in a variety of media. The *parti* of a bent tubular metal frame and taut upholstery employed in his *Space* chaise of 1999 recalls that of the famous Modernist chaise longue of 1927 designed jointly by Le Corbusier, Charlotte Perriand, and Pierre Jeanneret. Rashid has made it

fig. 187
Karim Rashid
Space Chaise, 1999
Designed for the Decola Vita Collection for Idee Gallery, Tokyo, Japan
Glass, steel chrome, and neoprene, 83 x 217 x 58 cm (32 ½ x 85 ½ x 22 ¾ in.)
Manufacturer: Idee, Co. Collection of Karim Rashid, Inc.

figs. 188/189 *top, left to right*
Karim Rashid
Soft Lighting, 1999
Glass and chrome-plated metal, largest: 44 x 41 cm dia. (17 ¼ x 16 ¼ in. dia.)
Manufacturer: George Kovacs. Collection of George Kovacs Lighting, Inc.

Soft Carpet, 2000
Wool, 183 x 267 x 1 cm (72 x 105 x ½ in.)
Manufacturer: Directional. Collection of Totem Design Group LLC

fig. 190
Ali Tayar
Plaza Screen, 1999
Aluminum and rubber, 213 x 222 x 5 cm (84 x 87 ½ x 2 in.)
Structural engineer: Attila Rona. Manufacturer: ICF Group. Collection of Denver Art Museum,
Gift of ICF Group

fig. 191
Ross Menuez
Vanilla Fudge Chaise Longue, 1998
Plastic and metal, 245 x 33 x 244 cm (96 ½ x 13 x 96 ⅛ in.)
Manufacturer: Ross Menuez. Collection of Totem Design Group LLC

his own, however, by simplifying the overall form and by adding playful curved ends and intensely hued upholstery and glass shelves (fig. 187). His series of *Soft* lighting fixtures of 1999 employ double globes of Murano glass in sensuous colors (fig. 188), rivaling the earlier, organically shaped lamps of Aalto and Poul Henningsen. Rashid has also recently taken on textiles, conceiving a series of carpet designs to complete his interiors. One of the most successful is also called *Soft*, with its overlapping amoeboid shapes rendered in brilliant colors (2000; fig. 189).

Other designers have also extended this biomorphic aesthetic in remarkably original ways. Ron Krueck, a Chicago designer, belongs to the second generation, born after World War II.[87] His custom coffee table of 1983 for the Celia Marriott apartment in Chicago recalls the organic shapes of Noguchi's classic table of 1948, although Kreuck's design juxtaposes plates of glass with painted steel, not wood (see fig. 104). Similarly, the young designer Ali Tayar

looks back to the serpentine wooden screens of Aalto and the Eameses, but he fabricated his tactile design in aluminum (1999; fig. 190). Tayar has written that he is primarily interested in the "structural behavior in form";[88] he constructed his *Plaza* screen with three different kinds of perforated ribs held together with meticulously crafted hinges. Ross Menuez's designs are a homage to commonplace industrial materials. In his monumental, voluptuous *Vanilla Fudge* chaise of 1998, he exploits the pliancy and translucence of plastic sheeting, which he bends and laces together on a metal armature (fig. 191). Likewise in lighting, Gisela Stromeyer examines the lyrical possibilities of a single material—stretch fabric (suspended on a metal armature). Her monumental, sculptural fixtures have a haunting presence (1987; fig. 192). All of these designs illustrate how the materiality of metal, glass, plastic, and fiber can be transformed or transcended in a biomorphic aesthetic.

Other new Modernist designers are equally adept in handling geometric forms. Two diminutive designs by David Gulassa show that less can be much more (fig. 193). A table/stool of 1999–2000 carved from a solid chunk of

fig. 192
Gisela Stromeyer
Hula Hoop and *Oval* Lighting, 1987
Lycra and fiberglass, each 284 x 97 cm dia. (112 x 38 in. dia.)
Manufacturer: Gisela Stromeyer Design. Collection of Denver Art Museum,
Funds from Joel and Carol Farkas

fig. 193 *top, left to right*
David Gulassa
Complex End Table, 1999
Steel, 51 x 46 x 46 cm (20 x 18 x 18 in.)

Wood Block Stool, 1999
Douglas fir, 46 x 30 x 38 cm (18 x 12 x 15 in.)
Manufacturer: Gulassa & Co. Collection of Gulassa & Co.

fig. 194 *bottom*
Christopher Deam
Galley Blonde and *Gallery Black* Storage Cabinets, 1994
Maple and black anilyne dyed plywood; aluminum, each: 71 x 122 x 46 cm (28 x 48 x 18 in.)
Original manufacturer: CCD
Collection of Denver Art Museum, Funds from Joel and Carol Farkas

fig. 195 *top, left*
Daven Joy
430 Dresser Chest, 1993
Stainless steel, mahogany, and neoprene, 76 x 108 x 43 cm (30 x 42 ½ x 17 in.)
Manufacturer: Park Furniture. Collection of Denver Art Museum, Funds from Joel and
Carol Farkas

fig. 196 *top, right*
Michael Solis
Grid Six Screen Cabinet, 1996
Formica, metal, glass, and rubber, ca. 137 x 163 x 20 cm (ca. 54 x 64 x 8 in.)
Manufacturer: Worx. Collection of Worx

fig. 197 *bottom*
Nick Dine
Prototypes, Shelf System, 2000
Powder-coated steel, largest: 46 x 91 x 23 cm (18 ¼ x 36 x 9 in.)
Manufacturer: Dinersan, Inc. Collection of Dinersan, Inc.

fig. 198
Steven Holl
Rug No. 2, 1987
Wool, 152 x 366 cm (60 x 144 in.)
Manufacturer: V'Soske Inc. Collection of V'Soske Inc.

wood offers an almost subliminal subtlety, in the contrast between the primary geometric form and the "linear ornament" of the vertical and cut wood grain. His raw steel table of 1999, on the other hand, is De Stijl-like in its elemental composition of perpendicular planes.

Other designers have developed this geometric aesthetic in case pieces of metal and wood. Christopher Deam's *Gallery Blonde* and *Gallery Black* cabinets of 1994 feature adroitly proportioned planar panels of aluminum and natural and painted wood (fig. 194). In a chest with a similar palette of industrial materials, Daven Joy accentuates the relationship between frame and modular unit, recalling George Nelson's *Steelframe* case group (1954) and the Eameses' *ESU* series (1950). It is the highly articulated method of construction and the fine, handcrafted detailing that make Joy's chests of

1993 so remarkable (fig. 195). Similarly, Mike Solis has a somewhat idiosyncratic sense of proportion. His *Grid Six Screen* cabinet of 1996 juxtaposes a large and translucent storage unit with a low, *takonoma*-like display shelf (fig. 196). In contrast to the enveloping masses of Stromeyer, Solis reduces his floor lamp of metal rods to the gaunt attenuation of lighting by Serge Mouille or Achille Castiglioni; his design consists of a simple tripod with a cylindrical bulb (1999; fig. 199). Nick Dine exploits sheet metal with equal agility in his straightforward but elegant, modular, metal display shelves of 2000; Dine is unusual among his contemporaries, however, in his application of bright, glossy painted finishes to deny his material and to lessen the seeming anonymity of his forms (fig. 197). Lastly, Steven Holl's carpet of 1987 provides a powerful contrast

fig. 199
Michael Solis
Hammerhead Floor Lamps, 1999
Steel and glass, ca. 153 x 50 cm dia. (ca. 60 x 20 in. dia.)
Manufacturer: Worx. Collection of Worx

figs. 200/201 *top, left to right*
Apple Computers, Inc.: Apple Design Team
Apple *iBook* Personal Computer, 1999
Plastic, 4 x 30 x 24 cm (1 ½ x 12 x 9 ½ in.)
Manufacturer: Apple. Collection of Apple

Power Mac G4 Cube Desktop Computer, 2000
Plastic, largest: 26 x 20 x 20 cm (10 ⅛ x 7 ¹¹⁄₁₆ x 7 ¹¹⁄₁₆ in.)
Manufacturer: Apple. Collection of Apple

to Rashid's *Soft* rug; his design is a melodic composition of lines and rectangles in intense color (fig. 198).

The product designs conceived by these new Modernist designers also show a polarity between biomorphic and geometric forms, yet they share a number of traits. First, there is a youthful quality that is direct and vital. Reacting against the clichéd "black box" of many commercial products, they have a sense of color that is deliciously sensual. Many have also discovered that technology does not have to be hidden—thus their fascination with translucent and transparent materials.

Rashid is a leader in the use of such materials, elevating utilitarian housewares into works of good design. His colorful *Garbo* trash cans of 1996 are now emblematic of the 1990s: the play of light through the polished and frosted surfaces of the alluring form is magical (fig. 203). His vibrant,

translucent packaging of 1997 for Issey Miyake proved to be a clever teaser in exposing the consumer's latest purchase (fig. 202). This taste for naked display has even affected companies like Apple. Long regarded as among the most innovative forces in American computer design, Apple broke away from the customary beige or black box for PCs in the late 1990s with a series of trim, curvacious designs in bright colors as well as translucent and transparent plastic casings: the *iBook* (1999; fig. 200) and the *Power Mac G4* (2000; fig. 201).

Products utilizing geometric forms can also be handmade, versus mass-produced. David Gulassa conceived a series of exquisitely proportioned vases fabricated out of either steel or an industrial resin used in the aircraft industry (1999; fig. 204). Their play of surface materiality varies from a

figs. 202/203 *opposite and right*
Karim Rashid
Bow and *Tummy* Holiday Gift Bags, 1997
Cleartint polypropylene, each: 29 x 10 x 44 cm (11 ¼ x 4 x 17 ¼ in.)
Manufacturer: Issey Miyake. Collection of Karim Rashid, Inc

Garbo and *Garbino* Trash Cans, 1996
Polypropylene, largest: 43 x 34 x 33 cm (17 x 13 ½ x 13 in.)
Manufacturer: Umbra. Collection of Denver Art Museum, Gift of Karim Rashid, Inc.

fig. 204 *left to right*
David Gulassa
Japanese Vase, 1999
Blackened steel and stainless steel, 41 x 20 x 18 cm (16 x 8 x 7 in.)

Vase, 1999
Cast resin, 37 x 13 x 25 cm (14 ¾ x 5 ¼ x 10 in.)
Manufacturer: Gulassa & Co. Collection of Gulassa & Co.

fig. 205
Harry Allen
Stratta Bowls, 1997
Plastic and plywood, largest: 18 x 29 cm dia. (7 x 11 ¹¹⁄₂ in. dia.)
Manufacturer: Harry Allen. Collection of Harry Allen

fig. 206
Harry Allen
Flip Lighting, 2000
Fluorescent plexiglass, largest: 58 x 37 x 13 cm (23 x 14 ½ x 5 in.)
Manufacturer: Harry Allen. Collection of Harry Allen

fig. 207
Ziba Design: Tom Froning and Sohrab Vossoughi
Prototype, *Encore* Portable Heating System, 1988
Plastic and metal, 15 x 46 x 51 cm (6 x 18 x 20 in.)
Manufacturer: Ziba Design. Collection of Ziba Design

fig. 208
Eric Chan
EC II Telephone, 1991
Ultrasuede, polyurethane, and rubberized coating on ABS housing, 8 x 16 x 22 cm (3 x 6 ⅛ x 8 ½ in.)
Manufacturer: ECCO Design, Inc. Collection of Denver Art Museum, Gift of Eric P. Chan, ECCO Design, Inc.

fig. 209
Design Central: Gregg Davis
Prototype, Calculator, 1987
Plastic and metal, 1 x 16 x 8 cm (½ x 6 ⁵⁄₁₆ x 3 ⅛ in.)
Manufacturer: Design Central. Collection of Design Central

velvety opacity to an alabaster-like translucency. Harry Allen simultaneously achieves both effects in his hand-turned *Stratta* bowls of plywood laminated with sheets of candy-colored plastic (1997; fig. 205). In his *Flip* lighting series of 2000, Allen fabricates swiveling geometric forms out of sheets of fluorescent plastic; the iridescence of their edges and the resultant layering of color impart a remarkable verve to these elemental designs (fig. 206).

One of the most enticing Modernist ideas about product design was that the reduction of utilitarian objects to simple geometric forms would bring order to our daily lives. A number of contemporary Modernist designers have revived this ideal. Newly refined materials such as plastics and rubber have also allowed a greater leeway with the form of opaque casings. Three planar compositions show a subtle softening of conventional hard-edged geometry: Ziba's prototype for the *Encore* heater by Tom Froning and Sohrab Vossoughi (1988; fig. 207), Ecco Design's sinuous *EC II* telephone of rubber by Eric Chan (1991; fig. 208), and Design Central's sleek calculator by Gregg Davis (1987; fig. 209).

Along with "emotional ergonomics," the term "universal design" entered the parlance of industrial designers in the 1990s.[89] It was an offshoot of the ergonomics of the 1980s, which recognized the aging of the baby-boomers and addressed the issue of designing products not only for the physically impaired but also for young children. Among the most noted exemplars of this design approach are the *Good Grips* products by Davin Stowell and Steven Allendorf at Smart Design (1992ff; fig. 210). They have become another emblem of the 1990s with their straightforward, no-nonsense forms and oversized black rubber handles.

Textiles form a field as vast and complicated as that of product design.[90] The new Modernists have been among the most active designers in this arena, particularly in the commercial market for contract goods.[91] Like designers for the office furnishings market, these textile designers must meet stringent economic and functional requirements—code regulations, marketing, technological competition, etc.—which often outweigh aesthetic concerns. Thus like mainstream product design, this contract market is dominated by a multitude of "well-engineered" textiles.

Within this vast field, one may cite at least two design approaches inherited from mid-century. Innovative postwar designers, such as Jack Lenor Larsen, established their own companies to design, manufacture, and retail their work. Other individuals worked as the chief designers for progressive companies, such as Alexander Girard at Herman Miller. But the future seems increasingly to belong to a new hybrid, the team player, because the recent explosion of new technology has shifted the emphasis to the factory, where the more anonymous textile designer must collaborate with teams of chemists and engineers. This phenomenon is increasingly global, with textile factories in Asia and Europe; and all of them are relentlessly searching for ever-cheaper and more innovative production methods.

With their predisposition toward technological innovation, the new Modernist designers have perhaps been the most receptive among textile artists to the myriad changes that have buffeted the field.[92] The computer has altered both the method of design and the manufacture of textiles; but its biggest impact to date seems to have been on production, particularly of woven fabrics. Several new generations of synthetic fibers have been invented, while natural fibers have undergone

fig. 210
Smart Design: Davin Stowell and Steven Allendorf
OXO Mixing Bowls, 1992
Santoprene and rubber, largest: 15 x 29 x 23 cm dia. (5 ¾ x 11 ⅜ x 8 ⅞ in. dia.)
Manufacturer: OXO. Collection of Denver Art Museum, Gift courtesy of OXO

chemical alteration. Chemically altered finishes have been embraced by the industry, and designers have also used vacuum heat-set machines to alter the surfaces of textiles or to bond textiles to other materials. The Japanese, in particular, have become internationally recognized leaders in fusing high technology and handcraftsmanship, outdistancing their American counterparts. Indeed, this quarter century appears, in many respects, to have been a period when Americans have not played a decisive leadership role internationally in pushing the parameters of contract textiles.

Nonetheless, a number of new Modernist American designers have explored these innovations with real imagination; and if nothing else, the marvelous names that designers such as Mark Pollack have assigned to their fabrics hint at their energy. The fascination with the layering of textiles (fig. 211) has led to designs such as Suzanne Tick's *Imago* panels and Pollack's *City Slickers*, both of 2000, where the textiles are fused between layers of plastic. Textiles may also be altered during manufacture to produce new finishes or relief-like surfaces. Examples range from such metallic fabrics (fig. 213) as Pollack's *Stardust* of 1996 and Tick's *Pucker Up* fabric of 1997 to colorful and textured fabrics (fig. 212) like

Susan Lyons's *Minor Miracle* of 2000, Katrin Hagge's *Crystal Pleat* of 2001, and Pollack's *Scheherazade* of 2000. New surfaces may also be applied, creating glistening metallic finishes and iridescent colors (fig. 214): instances include Fred Schecter's *Presto-Change-O!* of 1999, Pollack's *Lust* of 2000, and Tick's *En Route* of 1999. With their conspicuous concern for surface, structure, and technology, these textile designers provide an apt complement to the furnishings and product designs of their Modernist contemporaries.

With a movement so close to the present, definitive statements cannot be made about the new Modernists; but they do not seem to be in the least daunted by the challenges of a new millennium. On the contrary. Many of them grew up in this quarter century; and with the boundless wisdom of youth, they are not intimidated by the complexities of globalization, technology, and the like. New materials, colors, construction methods; limited production, mass production; geometric forms, biomorphic forms: the new Modernists are tackling all of it with a remarkable clarity and extraordinary energy. And in the process, they seem destined to ensure that the United States will remain in the vanguard of contemporary design in this new century.

fig. 211 *above, left to right*
Suzanne Tick
Imago Textile, 2000
Resin and fabric, 122 x 245 x ½ cm (48 x 96 x ⅛ in.)
Manufacture: KnollTextiles. Collection of KnollTextiles

The Pollack Studio: Mark Pollack
City Slickers Textile, 2000
Viscose, Lurex polyester, and polyester, 392 x 149 cm (154 ¼ x 58 ½ in.)
Manufacturer: POLLACK. Collection of Denver Art Museum, Gift of POLLACK

Suzanne Tick
Imago Textile, 2000
Resin and fabric, 122 x 245 x ½ cm (48 x 96 x ⅛ in.)
Manufacture: KnollTextiles. Collection of KnollTextiles

fig. 212 *above, left to right*
Susan Lyons
Minor Miracle Textile, 2000
Polyester, rayon, and acrylic, 366 x 122 cm (144 x 48 in.)
Manufacturer: DesignTex, Inc. Collection of DesignTex, Inc.

Katrin Hagge
Crystal Pleat Textile, 2001
Polyester, rayon, and acrylic, 124 x 375 cm (49 x 147 ½ in.)
Manufacturer: KnollTextiles. Collection of KnollTextiles

The Pollack Studio: Mark Pollack
Scheherazade Textile, 2000
Silk and polyamide, 384 x 142 cm (151 x 56 in.)
Manufacturer: POLLACK. Collection of Denver Art Museum, Gift of POLLACK

fig. 213 *top to bottom*
The Pollack Studio: Mark Pollack
Stardust Textile, 1996
Viscose and polyester, 480 x 144 cm (189 x 56 ¾ in.)
Manufacturer: POLLACK. Collection of Denver Art Museum, Gift of POLLACK

Suzanne Tick
Pucker Up Textile, 1997
Viscose, acetate, polyester, and Lycra, 466 x 134 cm (183 ½ x 52 ¾ in.)
Manufacturer: Groundworks, a division of LeeJofa. Collection of KnollTextiles

fig. 214 *top to bottom*
Fred Schecter
Presto Change-O! Textile, 1999
Polyurethane and polyester, 404 x 144 cm (159 x 56 ¾ in.)
Manufacturer: DesignTex, Inc. Collection of DesignTex, Inc.

The Pollack Studio: Mark Pollack
Lust Textile, 2000
PVC, polyurethane, cotton, and polyester, 385 x 142 cm (151 ¾ x 56 in.)
Manufacturer: POLLACK. Collection of Denver Art Museum, Gift of POLLACK

Suzanne Tick
En Route Textile, 1999
Vinyl and cotton, 372 x 140 cm (146 ½ x 55 in.)
Manufacturer: KnollTextiles. Collection of KnollTextiles

objects in space

Man is a ladder placed

on earth touching heaven

with its head, that all his gestures and

above nature and

above time

october25—november24, 1999

April Greiman @
Selby Gallery

AN ERA OF INNOVATION AND DIVERSITY IN GRAPHIC DESIGN 1975–2000

PHILIP B. MEGGS

figs. 222/223
Ned Drew
Cover and May, *The Design Consortium Millennium* Calendar, 1999
Letterpress and offset lithography, 40 x 28 x 1 cm (15 ¾ x 11 x ⅜ in.)
Client: Rutgers University-Newark
Collection of Ned Drew

fig. 224
Dan Friedman
Page from *Cultural Geometry* Catalogue, 1988
Offset lithography, 27 x 27 x 1 cm (10 ½ x 10 ½ x ¼ in.)
Collection of Ken Friedman

and private presses continue the traditions of handset type and letterpress printing in limited-edition books and graphic ephemera. One master of this genre is the West Virginia educator and designer, Clifford A. Harvey, proprietor of the Permutation Press. His 1998 hand-printed book, *Before Rosebud was a Sled* [15] (fig. 221), is about nineteenth-century American commercial wood engraving. *Rosebud* is profusely illustrated using hand-cut woodblocks and metal engravings from the S. George Company of Wellsburg, West Virginia. This firm manufactured paper, fabricated it into flour sacks, then printed them.

When the S. George Company closed its doors in 1977 after more than a century of manufacturing and printing, its inventory included 2,000 wood blocks, 120 drawers of wood type, and hundreds of metal engravings. Many of the blocks are three- and four-color sets consisting of a key block carefully registered over colors printed beneath it. Harvey hand-printed *Rosebud* on a Vandercook SP20 flat-bed proof press using fifty-five separately mixed inks in 255 separate press impressions. The fifty copies of the book required a total of 12,750 individual press impressions. Each copy has an original 1930s, one-of-a-kind printed proof of an original flour sack label archivally mounted to the cover. This masterwork of the private press is eloquent proof of the commitment by designers and private-press printers who are preserving time-honored traditions.

The hand letterpress technique dates back to Johan Gutenberg 550 years ago, but results in addition to Harvey's can be strikingly contemporary. A year 2000 calendar (figs. 222,223) conceived by the designer and educator Ned Drew was designed and printed for The Design Consortium

at Rutgers University–Newark. The design of each page was built through an additive process: large-scale letters and numbers were printed with overlapping and juxtaposed forms to create a dynamic spatial design for each month. The calendar portion was printed in a horizontal band across the bottom of each page by offset lithography; then wood types spelling out each month were printed over and around this information on a hand-operated letterpress using an array of translucent colors.

Drew's calendar typifies the motives of designers who draw upon their rich cultural heritage. They freely recycle images, typefaces, and ideas to convey nostalgic and historical content, to broaden their range of solutions, and to transform their fascination with earlier design genres into new and compelling designs. The past in not merely imitated, but reinvented from a contemporary vantage point.

Celebrating the Everyday: Vernacular Graphics and Low-Tech Methods

The line between graphics that rediscover and "invent" traditions, and graphics that celebrate the everyday, can be indistinct. For example, Dan Friedman's photographic collage created for the *Cultural Geometry* exhibition catalogue (fig. 224) fits into both categories. The century-spanning permanence of the Parthenon is celebrated by the repetitive pattern of a photograph. But by superimposing a

Literacy First

fig. 225 *opposite*
Haley Johnson Design Co.: Haley Johnson
Literacy First Poster, 1997
Offset lithography, 92 × 64 cm (36 ¹⁄₁₀ × 24 ⅛ in.)
Photo illustrator: Richard Boynton
Collection of Haley Johnson Design Co.

fig. 226 *below*
Yee-Haw Industries: Kevin Bradley
Bill Monroe: Father of the Bluegrass Music Poster, 1998
Linoleum block cuts and hand-pulled letterpress, 46 × 64 cm (18 × 25 in.)
Collection of Denver Art Museum, Funds from DAM Uncorked, 2001

vernacular illustration of this iconic ancient building on a disposable paper cup, Friedman sabotages the integrity of the timeless monument. The viewer is forced to contemplate the way we value our cultural traditions.

Works in both "Inventing Tradition" and "Celebrating the Everyday" reject the notion of championing one ideal typography or set of graphic conventions, but the traditions they embrace originate from different artistic perceptions and attitudes about socio-economic issues. While the traditions described earlier range vastly in time from Classical to Modernist, they all quote distinguishing characteristics from venerable traditions, whether with irony or affirmation. "Everyday" celebrations, however, sometimes border on the tawdry and often reflect graphic forms associated with the lower middle class, spanning retro fashions and flea market finds from the 1920s–1960s and cheap artifacts from baseball cards to the cookie jars that Warhol collected. He and other Pop artists had discovered the brash appeal of older consumer graphics, like Brillo boxes and Campbell soup cans; the Museum of Modern Art documented the same interest among a vast diversity of artists in its "High and Low" exhibition of 1990. Underlying all the phenomena is the artists' effort to create a sense of warmth, familiarity, and accessibility in their work. They reject the aura of elitism and try to see the ordinary through fresh eyes.

"Vernacular" means "commonplace" or "of the people." Unpretentious and apparently untrained, with the air of spontaneous and direct expression, "vernacular design" covers the workaday prose of graphics—the handbills, playing cards, matchbook covers, commercial illustrations, and novelty lettering from past decades. These earlier

graphics—often produced by persons with limited artistic training who apprenticed in printing shops or attended trade schools, or fine artists stooping to accept graphic assignments for remuneration—provide rich visual possibilities for contemporary designers. For example, the prosaic graphic of an obsolete television set on the *Literacy First* poster (fig. 225) by Haley Johnson and Richard Boynton, evokes 1950s product design and advertising imagery while capturing our attention, creating a striking context for the message. By combining the photograph of a television with a photograph of a book, Johnson and Boynton create a symbolic tension between the processes of reading and viewing. The differences between information acquired from printed and video media are conveyed, supporting the elemental two-part headline: "Read" and "Literacy First."

At a time when computer techniques have dramatically expanded the possibilities of graphic design, many designers have embraced low-technology methods to create words and pictures. The *Bill Monroe: Father of the Bluegrass* Music poster (fig. 226), designed and illustrated by Kevin Bradley of Yee-Haw Industries, uses a rough, hand-printed technique to create a portrait and lettering. Bradley's expressive energy conveys the ambiance of bluegrass music while evoking the unpolished directness of folk art by such masters as Howard Finster.

LEGS AGAINST ARMS, SANE AND UNIVERSITY SANE PRESENT

GIVE PEACE A DANCE

a 2 4 - h o u r d a n c e m a r a t h o n

JUNE 20, 21 1987 SATURDAY 2 PM TO SUNDAY 2 PM U. OF W. HUB BALLROOM

Many graphic designers are deeply concerned about social issues and deploy their design vocabulary to capture viewers' attention and engage them in a purposely troubling way. The crude graphics of Art Chantry's[16] *Give Peace a Dance* poster (fig. 227) involve grainy photocopied pictures of President Ronald Reagan and Soviet leader Mikhail Gorbachev collaged onto a vernacular illustration of dancers to convey a serious message in an attention-getting manner. The slogan and image join to ask the public to support a twenty-four-hour dance marathon to raise money for a peace event. James Victore's[17] *Racism and the Death Penalty* poster (fig. 228) announces a video distributed by the American Civil Liberties Union and the legal defense fund of the National Association for the Advancement of Colored People. A large-scale, graffiti-like rendition of the children's hangman game, with three letters of a racial slur filled in, boldly proclaims the relationship between race and execution. Similarly, Victore's *Disney Go Home* poster (fig. 229) demonstrates how simple black ink on white paper can create an arresting message: here America's beloved mouse has been decapitated. Victore was concerned about the forced sanitizing of Times Square in New York City; he felt that corporate titans like Disney and Time Warner were changing the area, with its small shops and vernacular vitality, into a tourist destination akin to an airport mall. This poster was hand silk-screened in an edition of 300–400 copies, then posted around Times Square as a personal protest against the changes occurring.

fig. 228 *above, left*
James Victore
Racism and the Death Penalty Poster, 1993
Offset lithography, 83 x 58 cm (32 ½ x 23 in.)
Collection of James Victore Inc.

fig. 227 *opposite*
Art Chantry
Give Peace A Dance Poster, 1987
Offset lithography, 52 x 42 cm (20 ½ x 16 ½ in.)
Collection of Art Chantry

fig. 229 *above, right*
James Victore
Disney Go Home Poster, 1999
Offset lithography, 97 x 64 cm (38 x 25 in.)
Collection of James Victore Inc.

fig. 230 *below*
Art Chantry and Jamie Sheehan
Jobe *Culture Shock Wakeboard*, 1995
Printed aluminum and resin, 142 x 39 x 6 cm (56 x 15 ½ x 2 ⅜ in.)
Collection of Art Chantry

fig. 231 *bottom*
**Charles S. Anderson Design Co.: Charles S. Anderson,
Randal Dahlk, Haley Johnson, and Daniel Olsen**
Tins for *Fossil* Watches, 1991
Painted metal, each: 14 x 7 x 1 cm (5 ⅜ x 2 ⅜ x ⅜ in.)
Manufacturer: Fossil
Collection of Charles S. Anderson Design Co.

Graphics can change everyday objects into compelling artifacts. The Jobe *Culture Shock Wakeboard* (fig. 230), designed by Art Chantry and Jamie Sheehan, is but one example of how sports equipment can gain its look of spirited vitality from graphic design. Layers of clip art images are overlapped and collaged on the wakeboarder and transform it into a veritable feast of dense popular iconography. Wearing the 3D Chroma-depth glasses provided with the product, the wakeboarder can see the imagery as layers in dimensional space. Fossil Watch packages (fig. 231), designed by the Charles S. Anderson[18] Design Co., also draw upon the vocabulary of vernacular commercial illustration; they mimic the imagery, typefaces, and color palette of 1930s and 1940s graphics. The watches are housed in metal boxes that have become collectible objects in their own right. Not surprisingly, Anderson considers minimalist design sterile, and advocates work rich in pictorial expression, typographic vitality, and a sense of popular tradition.

Seth Jaben's graphics for E. G. Smith packages and catalogues for socks (fig. 232) are in a similar vein, but draw from a different realm of imagery. Surrealism, Tarot cards, and the occult are referenced by his colorful and expressive designs. A comparable embrace of the vernacular is seen in the Poster Cover Edition set of playing cards (fig. 233) by Modern Dog of Seattle.

On occasion, old typefaces—considered kitsch by Modernists—have sparked visual puns. The visual identity, packaging, and shopping bags designed by Paula Scher (fig. 234) for the Öola chain of Swedish candy stores in American shopping malls began with inspiration from the

fig. 232 *below, top to bottom*
Seth Jaben
Color Crisis Sales Catalogue, 1985
Offset lithography, 11 × 16 × 3 cm (4 ³⁄₁₀ × 6 ¼ × 1 ⅛ in.)

Friend Sales Catalogue, 1986
Offset lithography, 10 × 18 × 2 cm (3 ⅞ × 7 ⅛ × ¾ in.)
Client: E. G. Smith
Collection of Seth Jaben Studio

fig. 233 *above, left*
Modern Dog Design Co.
Modern Dog Commercial Art Playing Cards, 1995
Offset lithography, 14 × 7 × 2 cm (5 ⅜ × 2 ⅞ × ¾ in.)
Manufacturer: Modern Dog Design Co.
Collection of Modern Dog Design Co.

fig. 234 *above, right*
Paula Scher
Öola Identity Packaging, 1988
Offset lithography on paper and plastic, largest: 22 × 12 cm (8 ¾ × 4 ⅞ in.)
Collection of Pentagram Inc.

fig. 235 *opposite*
Kit Hinrichs, Belle How, and Amy Chan
Simpson Sundance Lingo Poster, 1993
Offset lithography, 89 x 46 cm (35 x 18 in.)
Collection of Pentagram Inc.

fig. 236 *below*
Tibor Kalman and Scott Stowell
Alphabet Blocks, 1991
Wood and ink, 35 x 29 x 6 cm (13 ¾ x 11 ⅜ x 2 ½ in.)
Collection of M&Co.

1935 German typeface, Gillies Gothic. Scher noticed that the serif stroke on the *o* looked like an eyelash; this led to the face composed of the letters of the *Öola* name.

As the United States becomes an increasingly multicultural society, and transportation and communications technology have made Marshall McLuhan's "global village" a more concrete reality, graphic designers have seized upon this diversity to convey our pluralistic culture. The alphabet blocks (fig. 236) designed by Tibor Kalman and Scott Stowell of M&Co. present signs from six alphabetical language systems on the six facets of each block. Pluralism is both the medium and the message.

While these alphabet blocks embody linguistic diversity, the *Simpson Sundance Lingo* promotional poster by Kit Hinrichs,[19] Belle How, and Amy Chan presents a remarkable visual range of vernacular and illustrated letter forms. It offers twenty-six alphabet characters (fig. 235); each is executed in a pictorial or symbolic font made of a material whose name begins with that letter, such as a barbed wire B and a rope R. As with Vanderbyl's Modern /Postmodern architecture

posters, these designs incorporate whimsy into their statements. In general, graphic designs celebrating the everyday demonstrate that the humor entering graphic design in the 1960s has flowered in a rich graphic medley that engages the viewer's intellect and imagination.

Redefining Expressionism:
Digital Tools Expand Design Possibilities

Traditionally, the high costs involved in typesetting and printing were powerful constraints upon the development of self-initiated projects. But the digital revolution that occurred over the past two decades changed this situation dramatically. Powerful digital tools allow graphic designers to gain greater control over their work. Software for page layout, typeface design, typesetting, and image manipulation enables them to experiment in ways that would have been prohibitively expensive, or simply impossible, before the computer era.[20]

The digital revolution in graphic design was a direct result of innovation by three companies: Apple, Adobe, and Aldus. Apple Computer released its Macintosh computer in 1984.

The Macintosh has an intuitive, user-friendly interface whose cursor is controlled by a desktop "mouse." A user who wanted to draw a line on the screen, for example, could click the mouse on the line-drawing icon, then click the start and stop points on the screen, instead of typing long computer codes using mathematical coding to instruct the computer to draw the line. Suddenly, an affordable computer within the means of artists, designers, and writers permitted computer-aided creative work without the intermediary of complex computer programming. With the Adobe System's PostScript page-description language, graphic elements—text, lines, shapes, and images—could be placed on a page electronically and output by three hundred dot-per-inch laser printers. Page-layout software using PostScript and the Macintosh's intuitive interface to combine type and image seamlessly into a graphic design became a reality in 1985 when Aldus released its first version of Pagemaker.

Many designers decried digital technology during its infancy and called designers who explored it "the new primitives."[21] Others embraced it as an innovative new tool capable of expanding the scope of design possibilities and the very nature of the design process. The computer lets one make and easily correct mistakes. Color, texture, images, and typography can be stretched, bent, made transparent, layered, and combined in unprecedented ways. In the 1980s a number of graphic designers created works that might be considered harbingers of the revolution about to explode, as each successive generation of computers and software became more powerful.

Just as the Macintosh was entering the marketplace, a graphic designer, author, and book artist named Warren Lehrer[22] was completing work on a self-published novel, *French Fries* (fig. 237). With a play-script format in which each of eight characters has a distinctive voice set in a different typeface, *French Fries* takes place in a Dream Queen fast-food restaurant. This book, produced in a limited edition of 750 copies, seems in hindsight to anticipate many of the design techniques later made possible by computer technology. Here, and in Lehrer's design for *I mean/You know* (fig. 238), type, images, and graphic elements are layered in the way Pagemaker later permitted, as if each image or type element had been printed on a transparent sheet of glass, capable of being freely moved to the top or bottom of the stack. *French Fries* is all the more remarkable because the pages were composed in a pre-computer fashion, with phototype and photostats of images pasted onto multiple sheets of acetate—one sheet for each color. But this high watermark in the preparation of art for offset printing pales in comparison to its design—to its imaginative uses of typefaces, scale, signs, symbols, and images to convey a nonlinear drama of everyday life. The spatial syntax of this remarkable tour de force is complex, uninhibited, and unconstrained by the norms of page design.

Another forecast of the collage aesthetic soon to be fostered by new software is seen in the *Metropolis* magazine covers (fig. 239) designed by the art director Helene Silverman from 1986 to 1988. Silverman's approach encompassed the layering of elements in space with abrupt scale changes, transparency, and lively color juxtapositions.

Early pioneers who embraced the new technology's creative potential included the Los Angeles designer April Greiman,[23] the *Emigre* magazine designer/editor Rudy

fig. 237
Warren Lehrer
Spread, *French Fries* Book Design, 1983–84
Offset lithography, 28 x 22 cm (11 x 17 in.)
Authors: Warren Lehrer and Dennis Bernstein
Collection of Warren Lehrer

fig. 238
Warren Lehrer
Spread, I mean/You know Book Design, 1983–84
Offset lithography, 32 x 46 cm (12 ½ x 18 in.)
Author: Warren Lehrer
Collection of Warren Lehrer

fig. 239 *opposite*
Helene Silverman
Cover, *Metropolis* Magazine, April, 1986
Offset lithography, 42 × 28 cm (16 ½ × 11 in.)
Collection of Helene Silverman

fig. 240 *below*
April Greiman
The Spiritual Double Poster, *Design Quarterly* 133, 1987
Offset lithography, 192 × 65 cm (75 ¾ × 25 ½ in.)
Collection of Denver Art Museum, Lilliane and David M. Stewart Collection,
Gift of R. Craig Miller

VanderLans, and the typeface designer Zuzana Licko. Rather than use the new tools to imitate designs produced by conventional methods, Greiman sought to expand the communications landscape by finding new ways to express ideas. She explored the layering and overlapping of computer-screen information, synthesizing video and print, the tactile patterns and shapes made possible by the new technology, and the visual properties of bit-mapped fonts. When asked to design an issue of *Design Quarterly* magazine for the Walker Art Center in Minneapolis, Greiman created a single-sheet magazine with a two-by-six-foot (61 by 183 cm) digital collage (fig. 240) executed entirely on the Macintosh computer. Making video image captures and then digitizing them, she overlapped images in space, and integrated words and pictures as part of a single computer file. The juxtapositions and combinations gained new symbolic meaning and a graphic dynamism. Uniting the whole was her life-size, bit-mapped self-portrait. The entire design was tiled and output on an 8½-by-11-inch laser printer. As computers and their software became more powerful, a new spatial elasticity became possible in typography and imagery. Greiman's more recent work, represented in **USDesign** by her 1999 exhibition poster for the Selby Gallery (fig. 241), demonstrates the innovative manipulations of space and color made possible by these powerful advances.

In 1984, Rudy VanderLans[24] began to edit, design, and publish *Emigre*, with two fellow Dutchmen in San Francisco, as a vehicle to present their own and others' unpublished creative works. The magazine's title was selected because they believed exposure to various cultures, and living in

fig. 241
April Greiman
Selby Gallery Poster 1999
Offset lithography, 165 × 112 cm (65 × 44 in.)
Collection of April Greiman

capabilities of computer graphic design, in both its editorial page layouts and its presentation of designers from around the world, whose work was still too experimental for mainstream design publications.

In 1987 VanderLans formed Emigre Graphics, a partnership with the designer Zuzana Licko, whose education included computer-programming courses. Licko was dissatisfied with the limited fonts available for the early Macintosh and turned to public-domain character generation software to create digital typefaces. Her first fonts were designed for low-resolution technology, then converted to companion high-resolution versions after font-design software and printer resolution improved. VanderLans's 1989 *Emigre 11* cover, also illustrated in figure 242, shows some of Licko's early geometric fonts. Although this cover is printed in only two colors, it appears to have three layers in space. The cool gray type looks suspended in front of the images of an orange tape recorder, a globe, and the skewed type arching back toward a blurred background. These types evoke the feelings of many designers toward the technological forces remolding their profession: ambition and fear.

Experimentation entered the magazines when editorial designers applied innovations resulting from experimentation with computer software to their pages. As art director/designer of *Beach Culture* from 1989 until 1991 and *Ray Gun* [25] from 1992 until 1996, David Carson[26] rejected grid formats, typographic traditions, and consistent layouts; instead, he explored the expressive possibilities of each subject and each page or spread. Some page numbers were set in large display type; on occasion, normally diminutive picture captions became prominent design

different cultural environments, had a significant impact upon creative work. *Emigre*'s first issue was designed with typewriter type and copier images. After the partners left and the Macintosh became available, *Emigre* quickly became a laboratory for design experimentation with the new technology. Although its press run was only seven thousand copies, *Emigre* became a lightning rod for experimentation, outraging many design professionals while captivating those who embraced computer technology as a means to redefine design. The names on the 1989 *Emigre 9* cover (fig. 242) are computer inventions: the randomly redesigned letter forms result from the computer's incapacity to figure out how to redraw low-resolution screen fonts at a large size. *Emigre*'s experimental approach helped define and demonstrate the

fig. 242 *opposite, left to right*
Rudy Vanderlans and Zuzana Licko
Emigre Magazines, no. 9 and no. 11, 1989
Offset lithography, each: 43 × 29 × .5 cm (16 ¾ × 11 ¼ × ⅛ in.)
Typeface: *Oblong* by Rudy VanderLans and Zuzana Licko
Collection of *Emigre* Magazine

elements. Article titles were letter-spaced erratically across images or arranged in expressive rather than narrative sequences. Parts of letters were sliced away, skewed, or scattered across the page, requiring readers to participate by deciphering the meaning. Carson's choices for text typesetting, such as line length and type size, sometimes challenged the fundamental criteria for legibility. He also eliminated the space between lines of type, used extreme forced justification, set text columns the width of the page (and in at least one layout, the width of a double-page spread) or in curved or irregular shapes, and jammed columns together with no gutter. Yet Carson's designs, no matter how radical, often emerged from the meaning of words, or made a comment about the subject, as he sought to bring the expression of the layout into harmony with the expression of the writing.

While designing *Ray Gun,* Carson turned over a half-dozen pages in each issue to readers to display their illustrations for song lyrics. The participatory vernacular spirit this encouraged coincided with the popularity of *zines,* which are self-published magazines using desktop publishing software and cheap printing or copier reproduction. Carson

was controversial during the early 1990s. Young designers drew energy and direction from his work, while many communications professionals believed he crossed the line between order and chaos.

Carson applies his approach to the design of books, book-jackets, television commercials, music videos, Web sites, and visual identity. Pages from his book, *2nd Sight* (figs. 243–44), [27] which include a quotation from Albert Einstein, exemplify his intuitive and dynamic approach to typography. As he, Licko, VanderLans, and others explored the edges of illegibility in typeface designs and page layouts, designers found readers more adaptable to unique graphics than most professionals had assumed. Carson believes one should not confuse legibility with communication, because many highly legible traditional printed messages offer little visual appeal to readers, while more expressionist designs can attract and engage them.

Perhaps designers who flout traditions and explore new directions are not graphic *designers,* but graphic *artists.* Their experimentation captures the imagination of young people whose primary information comes from video and electronic means of communication. In these media the ordered structure

"THE ïmtelleectt HAS L has little to do E to do om therroad prossoovery

■ there comes a LEAP in consciousnes CALL IT LEAP INTUITION or what you will, in consciousness CALL IT INTUITION, COME TO what you will AND THE SOLUTION COME TO YOU and you don't know and you don't know WHY. how or WHY." albert einstein

" the fundamental SKILL of a designer is talent. TALENT is a RARE com- modity.

IT'S ALL intuition.

AND you can't "
-paul rand, 1996
TEACH intuition

figs. 243/244 *opposite*
David Carson
Spreads, *2nd Sight: Grafik Design After the End of Print* Book, 1997
Offset lithography, each: 29 x 48 cm (11 ½ x 19 in.)
Text: Lewis Blackwell
Collection of Denver Art Museum, Funds from DAM Uncorked, 2001

of page design yields to a shifting, kinetic spatial environment where type and image are allowed to overlap, fade, and blur. Disparate visual and verbal information jostles and collides in space the way sound and image bump and shove in film and video.

The influence of computer graphics upon magazines, among other media, can be seen as a part of the effort to compete more effectively with television and the Internet. In the 1990s, *Wired* magazine, with the art direction of John Plunkett, moved to the forefront of innovative page design reflective of a computer graphics culture. One stunning innovation is a four-page visual introduction, just before the contents page, presenting the essence of a major article in each issue. The introduction to the July 1994 issue (figs. 245, 246), by Erik Adigard and John Plunkett, redefines money as a type of information speeding around the planet. The opening spread presents a densely textured image of the word *money*, integrating traditional engraved forms with patterns and numbers evoking data transmission. Turning the page takes the reader from hot to cool—with a diffused bluish percent sign opposite a black die. In tandem, they signify reward and risk. Design has transformed this printed page into a more contemporary expression of content.

New technologies in the past decade have also included new materials and manufacturing processes. The Graffito design firm in Baltimore and WYD Design of Westport, Connecticut, bring an experimental edge to work for corporate clients. The plastic-forming capabilities of Apogee Designs, Ltd., are demonstrated in a booklet designed by Graffito (fig. 247). The cover is a molded transparent plastic sheet three-dimensionally reflecting the images printed on the

figs. 245/246 *above*
Plunkett + Kuhr: Erik Adigard and John Plunkett
Introductory spreads, *Wired* Magazine, July 1994
Offset lithography, each: 27 x 46 cm (10 ¾ x 18 in.)
Art director: John Plunkett
Collection of Erik Adigard

fig. 247 *below*
Gr8, Inc. (founded as Graffito): Joe Parisi, Tim Thompson, and Ed Whitman
Capabilities Brochure, ca. 1991
Offset lithography, 28 x 22 cm (11 x 8 ¾ in.)
Client: Apogee Designs, Ltd.
Collection of Gr8, Inc.

fig. 248 *opposite*
Frank J. Oswald and Randall Smith
The Changing Face of Reinsurance, Annual Report, 1991
Offset lithography, 36 x 26 cm (14 ¼ x 10 ¼ in.)
Art Directors: David Dunkelberger and Randall Smith
Writer: Frank J. Oswald
Illustrators: Seth Jaben and John Martinez
Client: Centre Reinsurance
Collection of Frank J. Oswald

paper beneath it. Synthetic paper and a clear plastic spiral binding continue the theme of new materials. While they were at WYD Design, Frank Oswald and Randall Smith created annual reports for Centre Reinsurance (fig. 248) that combined a diverse range of exploratory images with unexpectedly placed die-cut pages and paper stocks. Bold colorful shapes dominate their designs, in contrast to the restrained conservatism of most corporate communications.

American graphic design education was strongly influenced by European postwar modern design (discussed below) in the 1970s, but it has tilted toward Postmodernism and expressionism during the last two decades. Under the direction of Katherine and Michael McCoy from 1971 until 1995, the small graduate design department at Cranbrook Academy of Art epitomized an evolution from Modernism to Postmodernism to a new expressionism. The design of a book about the program presents the work of this influential school (figs. 249–50).

Around 1990 Adobe Systems released a new software program called Photoshop. Initially intended as a tool for retouching photographs and preparing them for printing, Photoshop was recognized by artists and designers as a powerful new tool to manipulate, combine, transform, and create images. Ensuing upgrades ended photography's claim to represent documentary truth in every picture, for photographs can now be altered invisibly and infinitely. The *New Media Invision Awards* poster (fig. 251), with art direction by Michael Cronan and design by Anthony Yell, is just one example of how photography can be transformed by image-manipulation software. In this seamless montage of about eighty images, color and texture have been heightened and altered.

figs. 249/250
McCOY & McCOY: Katherine McCoy, Alan Hori, Mary Lou Kroh, and P. Scott Makela
Spread, *Cranbrook Design: The New Discourse*, 1990
Offset lithography, 28 x 43 cm (11 x 17 in.)

Cranbrook Design: The New Discourse Book Jacket, 1990
Offset lithography, 28 x 22 cm (11 x 8 ½ in.)
Collection of Katherine McCoy

fig. 251
Cronan Design: Michael Cronan and Anthony Yell
New Media Invision Awards Program Poster, 1996
Offset lithography, 69 x 99 cm (27 x 39 in.)
Creative Director: Michael Cronan
Client: *New Media* Magazine
Collection of Cronan Design

The line between photography and design blurs in the work of the Boston-area design firm of Skolos/Wedell.[28] Many of their design solutions begin with their photographs of their still-life compositions. A stunning integration of type and image results from their ability to make a three-dimensional setup, then apply typography in a way that completes a dynamic composition. Their poster for the Lyceum Fellowship in Architecture (fig. 252), for example, contains a photograph of a rolled site map in front of two architectural models. One is linear, the other one consists of planes. Shadows, translucency, and overlapping are important spatial devices. Type and three drawn ovals were added to the photograph in a manner that extends and completes the photographic composition.

The long-running series of posters and other graphics by Paula Scher for New York's Public Theater uses type to generate an energy consistent with the expression of the music and performances publicized. The 1996 *Bring in 'da*

fig. 252
Nancy Skolos and Thomas Wedell
Lyceum Fellowship Competition Poster, 1996
Designed for the Annual Student Architecture Competition
Duotone on vellum paper, 66 x 66 cm (26 x 26 in.)
Collection of Skolos/Wedell

fig. 253
Paula Scher and Lisa Mazur
Bring in 'da Noise, Bring in 'da Funk Poster, 1996
Offset lithography, 117 x 76 cm (46 x 30 in.)
Photo: Richard Avedon
Collection of Pentagram Design Inc.

the menacing nature of this film and bring a kinetic vitality to the unfolding title information. In addition, Web site design[31] is moving closer to motion graphics, as increasingly faster hardware and powerful software for sound, video streaming, and graphic interactivity are used to create communications unimaginable a few years ago. Many Web sites operate on the threshold of design expression, existing not just as a vehicle for e-commerce or information sharing, but as explorations of new art experiences. The Web site for Lux Pictures (fig. 261), designed by April Greiman, turns the letters of the corporate logo into light and motion, engaging the viewer with a sound and light show as lively as a music video.

Perhaps most typical of the fluid visual environment of the last twenty years is the ever-changing face of the Music Television network (MTV). The company ignored the concept of consistent and unchanging visual identity—closely related to the modern design movement discussed below—and chose to identify itself with innumerable expressionist variations of "MTV."[32] When Pat Gorman and Frank Olinsky of Manhattan Design designed the first mark in 1981, they realized that the slab-like *M* and gestural *tv* could retain their identity in the face of infinite metamorphosis. Over two decades, a parade of designers has explored graphic, three-dimensional, and kinetic variations of what has become one of the most widely recognized trademarks in the world.

The graphic expressionism of the past quarter century proves once again the synergy between technology and design creativity. After scientists and engineers create new machines, often with efficiency and economy in mind, risk-taking designers immediately explore the potential of the technology, pushing the design possibilities into uncharted territories.

Noise, Bring in 'da Funk poster (fig. 253), designed by Scher with Lisa Mazur, has a central dancing figure who creates dynamic spaces around his body and limbs. These are filled with type moving in multiple directions. Together, type and image create a visual cacophony of vibrant expression.

Technology has also enabled graphic designers to move rapidly into the arena of video and motion-picture graphics. A music video by Tibor Kalman,[29] then head of M&Co (fig. 254), for the Talking Heads music group projects song lyrics onto the musicians as they sing them. Words and live action are coupled into a unified communication using time-based media.[30] Film titles by R/Greenberg Associates, such as the title sequence for the movie *Seven* (figs. 255–60), forecast

fig. 254 *right*
Tibor Kalman
Clip from *Talking Heads* Video, 1988
Producer: Warner Brothers
Collection of M&Co.

figs. 255–60 *overleaf*
R/GA (founded as R/Greenberg Associates)
Seven Film Titles, 1995
Director: David Fincher
Collection of R/GA

Expanding Modernism:
New Solutions within a Proven Morphology

The European modern design movement of the first half of the twentieth century left an indelible imprint on American graphic design. After World War II, the legacy of Cubism, Constructivism, and de Stijl, along with the influence of the Bauhaus, coalesced into a movement called "Swiss Design" or "The International Typographic Style." A set of postulates governing this work were combined into a morphology.[33] Sans-serif typefaces were considered the only appropriate expression of our technological and scientific age. Elemental geometric forms and bright flat colors were seen as timeless and universal. Grid structures of horizontal and vertical lines were used to organize and place type and images on the page. "Objective, neutral" photography was favored; such machine-made images were thought to avoid the subjective bias of traditional illustration and painting. Ornament of any kind was banished. During the 1950s and 1960s, this movement had a broad impact upon American graphic design and especially design education. Its clarity of form and system was widely embraced as an antidote to the cluttered information environment. In lesser hands, it hardened into a formulaic style, but innovative designers since the 1970s have produced original and effective designs while working with the concepts and formal vocabulary underlying Modernism.

Beginning in the late 1970s, Modernist design was challenged by new directions frequently lumped under the label "Postmodernism" (presented in other sections of this exhibition and catalogue). Modernism did not entirely fade

fig. 261 *opposite*
April Greiman
Lux Pictures Web Animation, 1997
Interactive media
Collection of April Greiman

from the scene, for the vitality of elemental form and geometric order, along with abstract shapes and pure color derived from modern painting, continues to attract innovators. Much of the finest design continuing Modernist traditions draws upon the formal language of Modernism, while conveying new messages or exploring new materials. Designers working within the traditions of the International Typographic Style have produced invigorating original statements. This is seen in the late Tomás Gonda's[34] Tanagraphics calendar of 1986 (figs. 262,263). Using die-cuts and colored paper, Gonda created a series of shallow relief compositions that changed with the turn of each month's page.

In visual communications, messages must be absorbed quickly from distant posters or billboards, or conveyed to viewers from small surfaces such as paperback book covers or even postage stamps. The architect Ludwig Mies van der Rohe's famous design dictum, "less is more," stands as sage advice. Minimalism is not a mere passing fashion, but remains a sound strategy in graphic design. In Alexander Gelman's 1996 *Poetry Readings* poster (fig. 264), the economy of two flat colors printed on a modest sheet of white paper produces a powerful focal point, an iconic image of a table lamp, which catches the eye of the passerby and directs it to typography announcing a poetry reading.

figs. 262/263 *above, left to right*
Tomás Gonda
March and July, *Tanagraphics* Calendar, 1986
Offset lithography and die cuts, each: 34 x 32 cm (13 ¼ x 12 ¾ in.)
Printer: Tanagraphics Printing
Collection of the Estate of Tomás Gonda

fig. 264
Alexander Gelman
Poetry Readings Poster, 1996
Offset lithography 77 x 55 cm (30 ½ x 21 ½ in.)
Collection of Design Machine

poetry
readings

every
thursday
at biblio's

starting
at 8:30

317 church st
new york

Willi Kunz's long series of posters (fig. 265) for the
Columbia University Graduate School of Architecture, Plan-
ning, and Preservation are designed, not by applying ele-
ments to a predetermined grid, but by positioning display
type, text type blocks, rules, and photographs in taut relations
on the white page, using these two-dimensional elements in
an organic design process. In the *Light Years* poster by
Michael Bierut and Nicole Trice (fig. 267), modern design's
clear and distinct presentation of sans-serif type gains a
superimposed layer of complexity. The five letters forming the
word *light* overlap the five letters of the word *years*. Each
designer brings an inventive attitude to the conventions of
modern graphics.

No area of design has been more pervasively shaped
by Modernism than graphic standards and corporate identity.
The rise of multinational corporations after World War II
made the importance of establishing a unified graphic identi-
fication critical. Many far-flung companies realized the
importance of a single image expressing the nature of their
activities. American corporations from Alcoa to Xerox
commissioned visual identity systems[35] based on a program-
med Modernist methodology. They retained design firms to
develop graphic standards—a unified visual identity through
the consistent use of trademarks, color, typefaces, and visual
formats—which they presented in manuals followed all over
the world, ensuring that an American Express or Exxon facility
in Denver, Doha, or Dijon was instantly recognized by
potential customers. The International Typographic Style, with
its program of standardized grids, sans serif typefaces, and
primary colors, dominated visual identity during most of the
postwar era. Corporations presented a clean, sanitized

fig. 265
Willi Kunz
Columbia University Graduate School of Architecture, Planning and Preservation Poster, 1992
Offset lithography, 61 x 46 cm (24 x 18 in.)
Collection of Willi Kunz Associates Inc.

Columbia University
Graduate School of Architecture
Planning and Preservation

Introduction to Architecture

A Summer Studio in New York

A summer program giving university credit which introduces the student to aspects of the design, history, theory, and practice of architecture. The program is intended both for those without previous academic experience in design who are interested in architecture as a potential career, and for those with previous experience in architectural design who would like to develop additional studio design skills, perhaps in preparation for application to graduate school.

Courses are given in the studios of Avery Hall, home of Columbia University's world-renowned Graduate School of Architecture, Planning, and Preservation, on the Morningside Heights campus in New York City. Studios and seminar courses are taught by experienced architects and designers, coordinated and supervised by members of the faculty of the Graduate School. For those who may require it, housing is available on the University campus, with direct access to Avery Hall.

Students attend classes four days a week for five weeks, both morning and afternoon sessions. In the morning session, students are introduced to the fundamentals of architectural history and theory, structures, technology, and professional practice. Also, this course will introduce the student to the extraordinary city of New York, with its world famous collection of museums, cultural institutions, and architectural monuments. Lectures, seminar presentations, tours of architect's offices, and field-trips to active building sites, museums, and famous works of architecture in New York City are led by the instructors.

In addition, students will attend a series of special lectures to be given by distinguished and renowned architects, including the following:

Kenneth Frampton
Architect; professor; author of "Modern Architecture: A Critical History"

Steven Holl
Architect; professor; winner of numerous Progressive Architecture Awards

James Stewart Polshek
Architect; professor; designer for the renovation of Carnegie Hall

Robert A. M. Stern
Architect; professor; author of "Pride of Place"

Bernard Tschumi
Architect; Dean, Columbia University; designer of the park "La Villette", Paris

In the afternoon, the students attend the design studio – an educational method unique to architecture – a place where students are given an intensive training in the skills and critical thinking involved in architectural design. Students, in small groups, work directly with studio instructors to develop their individual designs, which the students then present in periodic reviews or "juries", where they hear the comments and criticism of the invited architects and professors. The design projects given in studio are frequently situated in New York City, so that the student is able to apply the knowledge he or she has gained from the morning sessions. The development of supporting skills such as drawing and model-building is also included in the studio curriculum.

Together the studio and lectures present a comprehensive introduction to every aspect of architecture as it is practiced today. In addition, through the various field-trips and tours, the student learns from the extraordinary examples of architectural and urban design in New York City, the world's preeminent center for architectural culture.

Program Director:
Thomas Hanrahan,
Architect; professor

Introduction to Architecture:
July 6 to August 6
Monday, Tuesday, Wednesday, Thursday
10:00am-5:00pm
3 credits, studio and seminar
Tuition for 1992: $1590
Housing on the Columbia University campus (if required): approximately $600

Applications should include a transcript of the applicant's academic record; a resume summarizing education, employment, and other types of experience; and, where appropriate, examples of the applicant's design work. Also please include a $35 application fee (checks made out to: Columbia University).

Applications are due by June 30

For information and applications write or call:

Office of Admissions –
Introduction to
Architecture Program
Columbia University
Graduate School
of Architecture, Planning, and Preservation
400 Avery Hall
New York, NY 10027
(212) 854-3414

Light Years The Architectural League of New York's 1999 Beaux Arts Ball at the Starrett-Lehigh Building, Saturday March 13, 1999. For tickets please call (212) 753 1722. Corporate Sponsor *Artemide*

fig. 266 *above*
Reverb: Christian Daniels, Beth Elliot, Aaron King, James Moore, and Marie Reese
Avalon Hotel Identity Graphics, 1998–2001
Offset lithography, largest: 28 x 22 cm (11 x 8 ½ in.)
Photo: Grey Crawford
Collection of Reverb

fig. 267 *opposite*
Michael Bierut and Nicole Trice
Light Years Poster, 1999
Offset lithography, 60 x 98 cm (23 ½ x 38 ½ in.)
Client: The Architectural League of New York
Collection of Pentagram Design Inc.

image to the world. In recent years, more expressive visual identity programs within this idiom have emerged.

Extensions of Modernism are often found in 1980s and 1990s visual identity programs. The Avalon Hotel identity system (fig. 266), created by the Reverb studio in Los Angeles, draws on the Modernist vocabulary of geometric shapes and flat colors, but contrasts angular sans serif letter forms with a 1950s script, breaking with the strictures of classic Modernism. Graphics for the Esprit clothing company (fig. 268),[36] designed by Tamotsu Yagi, transform cash register receipt tapes, product labels, invitations, and other ephemera with bright color and simple pattern to make them into aesthetic experiences for the customer. Advertisements,

publications, and signage were unified by the same vocabulary of color and shape as well. In contrast to the exuberant chromatic richness of Yagi's work, the Celcius Films visual identity (fig. 270) by the designer Carlos Segura[37] is a unique image achieved by understated subtlety: it is a pattern of glowing white dots against a black ground punctuated with thin red lines. This unspecific but haunting image defies conventional ideas about immediate visual identification.

In Woody Pirtle's[38] graphics for the InfoWorks technology exposition (fig. 269), a slashing vertical black mark moves through the middle of a saturated yellow field. At one end, the black mark tapers into bit-mapped geometric shapes signifying technology; at the other, it morphs into a gestural

fig. 268
Tamotsu Yagi
Esprit Identity Graphics, 1984–87
Offset lithography, largest: 61 x 10 cm (24 x 4 in.)
Collection of Tamotsu Yagi Design.

fig. 269 *above*
Woody Pirtle
InfoWorks Identity Poster, 1984
Offset lithography, 94 x 51 cm (37 ⅛ x 20 in.)
Client: Trammel Crow Companies
Collection of Pentagram Design Inc.

fig. 270 *top, right*
Carlos Segura
Celcius Films Identity Graphics, 1997
Offset lithography, largest: 28 x 22 cm (11 x 8 ½ in.)
Collection of Segura Inc.

fig. 271 *bottom, right*
**Sussman/Prejza & Co. Inc.: Deborah Sussman
and Debra Valencia**
1984 Olympics Graphics Program, 1984
Offset lithography, 56 x 89 cm (22 x 35 in.)
Collection of Sussman/Prejza & Co. Inc.

figs. 272/273/274 *top to bottom*
Fabien Baron
Spreads, *Harper's Bazaar* Magazine, March, May, August, 1999
Offset lithography, each: 28 x 43 cm (11 x 17 in.)
Collection of Baron and Baron

brushstroke. These symbols for technology and art are linked by a complex repetition of squares growing smaller arithmetically —an apt signifier of the digital revolution across our culture.

At its best, visual identity programs can establish a sense of place and actually change perceptions of identity. This occurred with the graphics for the 1984 Los Angeles Olympics.[39] Sites throughout a sprawling city were unified by a well-defined, but flexible, design system. Designers and architects working for over sixty design firms were involved in this vast project. Two design offices—The Jerde Partnership, an architectural firm directed by Jon Jerde and David Meckel; and the Sussman/Prejza & Co. environmental and graphic design firm, headed by Deborah Sussman and Paul Prejza— collaborated on establishing the system of structures, colors, graphics, and signage. A "parts kit" (fig. 271) was invented for use in designing components and environments. It included a bright palette (magenta, aqua, yellow, vermilion, and other colors), Univers typography, and a set of shapes and patterns based on stripes, stars, and confetti. Many designers used this system to design numerous arenas, entryways, food packaging, signage, street banners, and uniforms. Each design was unique, yet all were unified by the consistent elements.

Simple off-the-shelf materials, such as Sonotubes (standard molds for casting concrete columns, but used here for colonnades of columns), hollow-core doors, Styrene panels, rented scaffolding, canvas roofing, and banners, were adorned with graphics prescribed in the design guide. Gateways, information huts, and towers were built from scaffolding painted in aqua or magenta and embellished with banners and ornaments. The Los Angeles Olympics took

RAT CITY!

They live in our walls. They wait for our trains. They eat our food. They furnish their nests with our detritus. They chew through our sheet metal, our lead pipes and our concrete. They survive nuclear war. They are our enemy, our next-door neighbor, our shadow, our They were here before we were. They'll be here when we're gone. They'll

"*There are no weird stories about rats,*" George Laws said. And then he told some. We sat at the edge of the teeming ratopolis in a basement where the city's rathunters unwind after a day going into holes with rats. The air was choked with smoke, music and the legend of that four-legged shadow of man. If rat stories did not seem weird to Laws, a foreman of exterminators for the city of New York, it was because nothing rats do surprises him. If the stories seemed weird to me, it was because I had just started collecting them. Not the commonplace assertions: that for every one of us there is one, or two, or four of them (perhaps 30 million rats in the city of New York?), or that they can squeeze through holes the size of a quarter, or that they pop up in toilets. Old news. The idea was to view the range of human experience involving rats, to dip a bucket into that polluted river! "Plastic means to a rat like a rattle to a baby," said Laws. "Any hole a rat can put his head through, he can put his body through." "They don't have no bone, just **BY PHILIP WEISS** gristle," said someone else. This was a rat myth. "The head's the only bone. She'll cut a hole for her head and cut it no wider and pull the rest of her body through." "Like a liquid?" "Not liquid. I wouldn't use that word." "You can put down bait from now till doomsday, you'll never kill them all." How's that stuff work? "His own blood drowns him. See him moving slowly, trembling just like a person having a heart attack." "Eat chicken like we eat chicken, eat bacon just like we eat bacon." "Man has been living wrong as far as sanitation is con-

MAY 1988 **SPY** 59

place within a setting of varied cheerful designs, giving a special joie de vivre to the international games.

The modern aesthetic continues to provide inspiration for editorial designers. An exquisite minimalism infused the page designs of *Harper's Bazaar* (figs. 272–74) when Fabien Baron was art director in the late 1990s. Baron delighted in juxtaposing elemental type against handsome photographs, with large-scale letters and numbers as shapes echoing the shapes or lines within the photograph, or in using small type to create quietude. In the "Rat City" editorial layout (fig. 275) for *Spy* Magazine, the art director Alexander Isley and the designer Catherine Gilmore-Barnes combined condensed geometric display type and a zigzagging line of text type to evoke a rat's journey through the city. Thus they perverted Modernist formalism to convey a satirical message. The forms

in Barbara Kruger's[40] work operate on a more complex level. Primarily known for her artworks, posters, and installations addressing women's and other social issues, Kruger combines black-and-white photography with blocky geometric sans serif typefaces on bold red rectangles. Her aggressive graphic statements evoke both Russian Constructivism and the screaming covers of tabloid periodicals. Adapting her approach for an *Esquire* cover (fig. 276), her depiction of the radio star Howard Stern assaults the viewer with a blaring headline partly hiding his face.

Package designers also plumb the modern design vocabulary to achieve arresting solutions for their projects. Turner Duckworth's Steel Reserve beer can design (fig. 278) has complex information organized into geometric zones. Alexander Isley's A/X Armani Exchange packaging program

fig. 275 *above*
Alexander Isley Inc.: Catherine Gilmore-Barnes and Alexander Isley
"Rat City" Editorial Layout, *Spy* Magazine, May 1988
Offset lithography, 28 x 46 cm (11 x 18 ¼ in.)
Collection of Alexander Isley Inc.

fig. 276 *opposite*
Barbara Kruger
Cover, *Esquire* Magazine, May 1992
Offset lithography, 28 x 23 cm (10 ¾ x 9 ¼ in.)
Photograph: David Pokress
Collection of *Esquire* Magazine

Esquire

THE MAGAZINE FOR MEN

MAY 1992 $2.50

Shocking but True!

HOWARD STERN

BLITZES AMERICA

By Barbara Kruger

I

hate

myself

and you love me for it

08276

0 748515 2

05

fig. 277

**Alexander Isley Inc.: Tim Convery, Alexander Isley,
and Bruno Nesci**

Giorgio Armani's A/X Exchange In-store Graphics and Packaging,
1990

Created in association with Weiss, Whitten, Carroll, Stagliano Advertising
Offset lithography on custom-milled recycled paper and board, largest:
55 x 34 x 10 cm (21 ½ x 14 ⅛ x 4 in.)
Manufacturer: Corporate Designs Inc.
Collection of Alexander Isley Inc.

fig. 278 *below*
Turner Duckworth: Bruce Duckworth and David Turner
Steel Reserve Beer Cans, 1998
Aluminum, each: 16 x 7 dia. cm (6 ¼ x 2 ⅜ dia. in.)
Manufacturer: Steel Brewing Company
Collection of Turner Duckworth Design

(fig. 277) combines a pattern of dots and geometrically drawn initials with hairline serifs on a yellow field: these elements create a unified image for the brand.

The stunning range of book jacket designs by Chip Kidd[41] includes work that could comfortably fit any of the four categories of this exhibition. The ones presented here (fig. 279) include a cover for *Geek Love* with a quirky variation of sans serif type; an optical pattern in fluorescent colors for *Intensity*; and a stately geometric composition for *City of Boys*. Each evokes earlier Modernist work while providing an apt visual equivalent for the contents of its book. The clarity of modern design is especially useful in the design of information graphics, where imparting knowledge to the audience in a clear and factual manner is essential. The *Do It!* how-to-book series (fig. 280) by the art director Michael Bierut and the designer Agnethe Glatved employs the same format and typography with readily understandable diagrammatic illustrations in each volume to explain tasks to the reader.

During the late 1920s, a host of geometric sans serif typefaces were designed and released in a range of sizes and weights, providing designers with an appropriate vehicle to express modernity. While the major thrust in typeface design in recent years has focused on expressing new possibilities, the geometric impulses of Modernism continue to be explored. Jonathan Hoefler's *Gestalt* typeface (fig. 282) departs from the near-fanatical emphasis upon legibility by designers of Modernist sans serif fonts. The crossbar of the *A* and *H* are deleted; the vertical stroke of the *E* and *P* are removed; and the *T* is a plus sign. Its playful range of simplified and abstracted letters has a refreshing originality.

The clarity and functionality associated with modern design are found in the Web site for OXO International (fig. 281), whose Good Grips kitchen tools are designed to make everyday life easier, especially for impaired users. The opening page has nine concise white icons, representing the site's nine major sections. These turn green, and their descriptive type pops onto the screen when the cursor passes over them. The straightforward design and accessible interface make this site a paradigm of user-friendly Web site design. This is a most appropriate design approach for OXO's easy-to-use tools.

Twentieth-century modern art might be due for a centennial celebration in the near future, if only historians and critics could agree when it began. The birth of Modernism was not a sudden event, but a process spread over many years. As evidenced by the works in this section of the exhibition, even after a hundred-year run Modernism's formal vocabulary has

fig. 279 *left to right*
Chip Kidd
Intensity Book Jacket, 1996
Offset lithography, 24 x 17 x 3 cm (9 ½ x 6 ½ x 1 ⅜ in.)

City of Boys Book Jacket, 1992
Offset lithography, 22 x 15 x 3 cm (8 ¾ x 5 ¾ x 1 ⅜ in.)

Geek Love Book Jacket, 1989
Offset lithography, 24 x 17 x 4 cm (9 ½ x 6 ½ x 1 ½ in.)
Collection of Denver Art Museum, Gift of Chip Kidd

fig. 280
Michael Bierut and Agnethe Glatved
Do It! Guides, 1993
Offset lithography, each: 18 x 6 x 3 cm (7 ⅛ x 2 ⅜ x 1 in.)
Client: Redefinition Books
Collection of Pentagram Design Inc.

continued to provide designers with tools and attitudes that allow an ongoing extension of its forms and ideas.

I return to my point of departure: one wonders why workaday graphics for pizza boxes, drugstore packages, product advertisements, and billboards are, at best, pedestrian, and, at worst, obscenely ugly. Does the public taste drive the cult of graphic mediocrity, or is the general public a hapless victim of design decisions controlled by an MBA mentality, where marketing experts cite opinion surveys and focus-group responses to perpetrate an abysmally low level of public visual communication? The graphic designs in

this exhibition are, however, an oasis in the artistic wasteland of the urban visual communications environment. This alternative is shaped by design aesthetics: life-enhancing, and a balm for the human spirit rather than a drain upon our existence. As computer technology puts graphic design capabilities in the hands of many people, will this create a greater appreciation of design, or further erode the quality of our communications environment? One hopes that projects such as this book and exhibition will prompt greater public awareness of the potential of design as an invigorating force in the twenty-first century.

fig. 281 *left*
Peter Comitini
OXO International Web Site, launched March 15, 1999
Interactive media
Client: OXO International
Collection of Peter Comitini

fig. 282 *opposite*
Jonathan Hoefler
Gestalt Typeface Poster, 1991
Offset lithography, 74 x 51 cm (29 x 20 in.)
Collection of Hoefler Type Foundry

THIS SPECIMEN SHEET WAS PRINTED ON FRENCH CONSTRUCTION STEEL BLUE IN A LIMITED EDITION OF 750, SEPTEMBER 1995, BY JULIE HOLCOMB PRINTERS, 665 THIRD STREET SUITE 425, SAN FRANCISCO, CALIFORNIA 94107 TEL 415 243 0530 FAX 243 3520. THIS POSTER IS COMPOSED IN THE GESTALT, A SET OF EXPERIMENTAL TYPES DESIGNED BY JONATHAN HOEFLER AND NOW AVAILABLE FROM THE HOEFLER TYPE FOUNDRY, INC. THE HOEFLER TYPE FOUNDRY SPECIALIZES IN THE DESIGN OF ORIGINAL TYPEFACES. FOR MORE INFORMATION CONTACT 611 BROADWAY, ROOM 815 · NEW YORK, NY 10012-2608 · TEL 212 777 6640 FAX 777 6684 · E-MAIL US AT HOEFLER@AOL.COM

ENDNOTES

INTRODUCTION
R. CRAIG MILLER

1 For the role of the Metropolitan, see R. Craig Miller, *Modern Design at The Metropolitan Museum of Art, 1890–1990* (New York: The Metropolitan Museum of Art and Harry N. Abrams, 1990), 1–45. For the MoMA shows, see Mary Anne Staniszewski, *The Power of Display: A History of Exhibition Installations at the Museum of Modern Art* (Cambridge, Mass., and London: MIT Press, 1998), 141–204. In more recent years, other American institutions have also attempted to do annual reviews or triennials of the latest in design, including the Cooper-Hewitt Museum in New York and the Chicago Athenaeum; but they have not offered assessments of American design in any larger historical context. The Philadelphia Museum of Art has perhaps come closest to the DAM's *Masterworks* exhibits in a number of shows organized by Kathryn Hiesinger, such as *Design Since 1945* and *Japanese Design: A Survey Since 1950*; but these important exhibits were not envisioned as a concerted series. For the Cooper-Hewitt, see Steven Skov Holt, Ellen Lupton, and Donald Albrecht, *Design Culture Now: National Design Triennial*, exh. cat. (New York: Princeton Architectural Press, 2000). For the Philadelphia Museum, see Kathryn B. Hiesinger and George H. Marcus, eds., *Design Since 1945*, exh. cat. (Philadelphia: Philadelphia Museum of Art, 1983); and Kathryn B. Hiesinger and Felice Fischer, *Japanese Design: A Survey Since 1950*, exh. cat. (Philadelphia: Philadelphia Museum of Art, 1994).

2 For the Denver exhibition, see R. Craig Miller, *Masterworks: Italian Design, 1960–1994* (New York: American Federation of Arts, 1996). Emilio Ambasz organized a landmark exhibition of contemporary Italian design at the Museum of Modern Art, New York, in 1972; but the split between Modernism and Postmodernism would not become so discernable until the late 1970s. See Emilio Ambasz, *Italy: The New Domestic Landscape: Achievements and Problems of Italian Design*, exh. cat. (New York: The Museum of Modern Art, 1972).

3 From the initial stages of the project, financial considerations, the logistics of moving design exhibitions, and the ability of the public to absorb large-scale, multimedia shows led us to limit the exhibit to approximately 200 objects. Similarly, it was determined that the catalogue would be approximately 250 pages so that it could be affordable to a large, international audience.

4 The American Studio Movement was specifically not included because it has in many respects left the design arts for the fine arts. Its theoretical and conceptual basis—not the media involved—was the determining factor here.

5 One of the most articulate arguments for this new approach has been made by Nicolas Serota, director of the Tate Gallery in London. See Nicholas Serota, *Experience or Interpretation: The Dilemma of Museums of Modern Art* (London: Thames & Hudson, 1996).

6 Peter Brook, quoted in Mel Gussow, "Sir John Gielgud, 96, Dies; Beacon of Classical Stage," *The New York Times*, May 23, 2000, B10.

7 Eduard F. Sekler, *Josef Hoffmann: The Architectural Work* (Princeton, N.J.: Princeton University Press, 1985), 8.

THINGS AND CHANGE: **HOW LIFE SHAPED DESIGN** (AND DESIGN SHAPED LIFE) IN THE FINAL QUARTER OF THE TWENTIETH CENTURY **THOMAS HINE**

1 See Richard Neutra, *Survival through Design* (New York: Oxford University Press, 1954).

2 For a good summary of the economic ills of the period, see Don L. Boroughs, David Hage, Sara Collins, and Warren Cohen, "What's Wrong with the American Economy," *U.S. News & World Report* (November 2, 1992): 36–51. Also Gene Koretz, "Economic Report: Not Enough Is Trickling Down," *Business Week* 3666 (January 31, 2000): 34.

3 Robert Venturi, Denise Scott Brown, and Steven Izenour, *Learning from Las Vegas* (1972; rev. ed., Cambridge, Mass.: MIT Press, 1977).

4 Sussman/Prejza & Company, *Beyond Graphic Design* (Tokyo: Process Architecture, 1974).

5 James Wines, *De-Architecture* (New York: Rizzoli International Publications, 1987).

6 On energy-efficient architecture, see Bruce Anderson, *Solar Energy in Building Design* (Harrisville, N.H.: Total Environmental Action, 1975); Ken Butti and John Perlin, *A Golden Thread: 2500 Years of Solar Architecture and Technology* (New York: Van Nostrand Reinhold, 1980); Michael J. Crosbie, *Green Architecture: A Guide to Sustainable Design* (Rockport, Mass.: Rockport Publishers, 1994). For planning implications, see Sim van der Ryn and Peter Calthorpe, *Sustainable Communities: A New Design Synthesis for Cities, Suburbs and Towns* (San Francisco: Sierra Club Books, 1986). For industrial design, see Victor J. Papanek, *The Green Imperative: Natural Design for the Real World* (New York: Thames & Hudson, 1995).

7 Leon Jaroff, "Profile: He Gives Wings to Dreams," *Time* (June 11, 1990): 54.

8 For an overview of advances in materials, see Tom Forrester, ed., *The Materials Revolution: Superconductors, New Materials and the Japanese Challenge* (Cambridge, Mass.: MIT Press, 1988). For the aesthetic consequences, see Paola Antonelli, *Mutant Materials in Contemporary Design* (New York: Museum of Modern Art, 1995).

9 Beth Dunlop, *Building a Dream: The Art of Disney Architecture* (New York: Harry N. Abrams, 1996).

10 For a history of the Japanese challenge to the American automobile industry, especially during the 1970s and 1980s, see David Halberstam, *The Reckoning* (New York: William Morrow, 1986). For a novel that expresses anxiety over the perceived Japanese threat, see Michael Crichton, *Rising Sun* (New York: Alfred A. Knopf, 1992).

11 Paul DuGay, *Doing Cultural Studies: The Story of the Sony Walkman* (Thousand Oaks, Calif.: Sage, 1997); Akio Morita with Edward Reingold and Mitsuko Shimomura, *Made in Japan: Akio Morita and Sony* (New York: Dutton, 1986); John Nathan, *Sony: The Private Life* (Boston: Houghton Mifflin, 1999).

12 John Lardner, *Fast Forward: Hollywood, the Japanese and the Onslaught of the VCR* (New York: W. W. Norton, 1987); Mark R. Levy, *The VCR Age: Home Video and Mass Communication* (Newbury Park, Calif.: Sage, 1989).

13 Steven Levy, *Hackers: Heroes of the Computer Revolution* (Garden City, N.Y.: Doubleday, 1984); Paul Frieberger and Michael Swaine, *Fire in the Valley: The Making of the Personal Computer* (Berkeley, Calif.: Osborne/McGraw-Hill, 1984).

14 James Chposki and Ted Leonsis, *Blue Magic: The People, the Power and the Politics Behind the IBM Personal Computer* (New York: Facts on File, 1988).

15 Steven Levy, *Insanely Great: The Life and Times of Macintosh, the Computer that Changed Everything* (New York: Viking, 1994).

16 The best documentation of this short-lived trend is Hugh Aldersey-Williams, Katharine McCoy, Michael McCoy, *Cranbrook: The New Discourse* (New York: Rizzoli International Publications, 1990); also Seppo Vakeva, ed., *Product Semantics '89* (Helsinki, Finland: University of Industrial Arts, 1990).

17 Robert J. Thompson, *Television's Second Golden Age: From Hill Street Blues to ER* (New York: Continuum, 1996).

18 Carol Rust, "America's Attachment with Post-it Notes Will Never Be Unstuck," *Minneapolis Star-Tribune* (December 17, 1995): 4-E.

19 Tim Berners-Lee with Mark Fischetti, *Weaving the Web: The Original Design and Ultimate Destiny of the World Wide Web* (San Francisco: HarperSanFrancisco, 1999).

20 VALS was defined in Arnold Mitchell, *Consumer Values, a Typology* (Menlo Park, Calif.: SRI International, 1978); and expanded, popularized, and refined in Arnold Mitchell, *The Nine American Lifestyles: Who We Are and Where We're Going* (New York: Macmillan, 1983).

21 Michael J. Weiss, *The Clustered World: How We Live, What We Buy, and What It All Means about Who We Are* (Boston: Little, Brown, 2000).

22 Philip J. Longman, "The World Turns Gray," *U.S. News and World Report* (March 1, 1999): 30.

23 See, among many others, William L. Wilkoff, *Practicing Universal Design* (New York: Van Nostrand Reinhold, 1994); Steven Winter Associates, *Accessible Housing by Design: Universal Design Principles in Practice* (New York: McGraw-Hill, 1997); Cynthia A. Liebrock and James Evan Terry, *Beautiful Universal Design: A Visual Guide* (New York: John Wiley, 1999).

24 Laura Herbst, "Nobody's Perfect: Today's Products Are Being Designed for People Who Are Far from Average," *Popular Science* 250, 3 (January 1, 1997): 64.

25 Charles Jencks, *Postmodernism: The New Classicism in Art and Architecture* (New York: Rizzoli International Publications, 1987), 231–34.

26 See Nory Miller, *Johnson/Burgee Architecture* (New York: Random House, 1979); *Philip Johnson/John Burgee Architecture 1979–1985* (New York: Rizzoli International Publications, 1985); Nory Miller, *Helmut Jahn* (New York: Rizzoli International Publications, 1986); Sonia Chao and Trevor Abramson, eds., *Kohn Pedersen Fox Buildings and Projects 1976–1986* (New York: Rizzoli International Publications, 1987); A. Eugene Kohn, William Pedersen, and Sheldon Fox, *Kohn Pedersen Fox Architecture and Urbanism 1986–1992* (New York: Rizzoli International Publications, 1993). For a skeptical view of this work, see Ada Louise Huxtable, *The Tall Building Artistically Reconsidered: The Search for a Skyscraper Style* (New York: Pantheon, 1984).

MODERNISM IN CRISIS? **ARCHITECTURAL THEORY** OF THE
LAST THREE DECADES **ROSEMARIE HAAG BLETTER**

1 Eric Mumford, *The CIAM Discourse on Urbanism, 1928–60* (Cambridge, Mass.: MIT Press, 2000) The international membership of CIAM was quite large from the beginning, but it increased and varied over the organization's existence. For a review of this book, see Claire Zimmerman in the *Journal of the Society of Architectural Historians* 60, no. 1 (March 2001): 98–100. The best introduction to the ideas of Team Ten is the book edited by one of its members: Alison Smithson, ed., *Team 10 Primer* (Cambridge, Mass.: MIT Press, 1974).

2 Lewis Mumford, *The Brown Decades: A Study of the Arts in America 1865–1895* (New York: Harcourt Brace, 1931).

3 Le Corbusier's *Modulor* was first published in 1948 and his *Modulor II* in 1957. For an explanation of this modular system and its relation to the Golden Section, see Stanislaus von Moos, *Le Corbusier: Elements of a Synthesis* (Cambridge, Mass.: MIT Press, 1979), 309–13. Strong folkloristic tendencies were already evident in several of Le Corbusier's country houses of the 1930s.

4 Reyner Banham, *The New Brutalism: Ethic or Aesthetic?* (London: Architectural Press, 1966).

5 For a fuller discussion of this point, see Rosemarie Haag Bletter, "Kahn and His Defenses," *Design Quarterly* 159 (Spring 1993): 7–13. For a thorough overview of Kahn's career, see David Brownlee and David G. De Long, *Louis Kahn: In the Realm of Architecture* (Los Angeles: Museum of Contemporary Art/New York: Rizzoli International Publications, 1991).

6 Louis Kahn, quoted in Vincent Scully, Jr., *Louis I. Kahn* (New York: Braziller, 1962), 36.

7 Ann Eden Gibson, *Abstract Expressionism: Other Politics* (New Haven: Yale University Press, 1997), xxvii .

8 Christian Norberg-Schulz, *Existence, Space and Architecture* (New York: Praeger, 1971), 16.

9 Charles Jencks and George Baird, *Meaning in Architecture* (London: Barrie & Rockliff, 1969). For a more extensive review of this book, see Rosemarie Haag Bletter in the *Journal of the Society of Architectural Historians* 60, no. 2 (May 1971): 178–80.

10 Joseph Hudnut, "The Post-Modern House," *Architectural Record* 97 (May 1945): 70–75; repr. with a useful commentary in *Architecture Culture 1943–1968*, ed. Joan Ockman (New York: Rizzoli International Publications, 1993), 70–76. The important place of Hudnut in architectural education is discussed in Rosemarie Haag Bletter, "Modernism Rears Its Head—the Twenties and Thirties," in *The Making of an Architect—1881–1981*, ed. Richard Oliver (New York: Rizzoli International Publications, 1981), 103–18.

11 Lewis Mumford, *Technics and Civilization* (New York: Harcourt, Brace, 1934; republished 1963 with a new introduction), passim. Le Corbusier, despite the common perception of his primary concern for engineering, had from the 1920s on called for technology's transformation through the poetic and artful.

12 Alberto Arbasino, letter to the editor, *Times Literary Supplement* 4686 (January 22, 1993): 15. Arbasino pointed to his series of critical discussions with new directors such as Pier Paolo Pasolini, under the general title "Il cinema dei post-moderne," in the newspaper *Il Giorno* in the fall of 1966. For further precedents for the term, see also Charles Jencks, *The Language of Post-Modern Architecture*, 5th rev. ed. (New York: Rizzoli International Publications, 1987), 8.

13 Robert Venturi, *Complexity and Contradiction in Architecture*, intro. Vincent Scully (New York: Museum of Modern Art, 1966), 22. An excerpt from this book was first published in *Perspecta* 9 (1965): 17–56, the Yale architectural journal.

14 Venturi, *Complexity and Contradiction*, 22.

15 For a fuller discussion of Venturi and Scott Brown, see Rosemarie Haag Bletter, "Transformations of the American Vernacular: The Work of Venturi, Rauch, & Scott Brown," in *Venturi, Rauch and Scott Brown: A Generation of Architecture*, foreword by Stephen Prokopoff (Urbana-Champaign: University of Illinois, Krannert Art Museum, 1986). For more recent work and a full chronology, see David B. Brownlee, David G. De Long, and Kathryn B. Hiesinger, *Out of the Ordinary: Robert Venturi, Denise Scott Brown, and Associates* (Philadelphia: Philadelphia Museum of Art/New Haven: Yale University Press, 2001).

16 Robert Venturi, Denise Scott Brown, and Steven Izenour, *Learning from Las Vegas* (Cambridge, Mass.: MIT Press, 1972). Venturi married Scott Brown in 1967 and she became a partner in 1969, but she had advised and collaborated with Venturi for several years before 1967. It was Scott Brown who introduced Venturi to Las Vegas in 1966.

17 Venturi et al., *Learning from Las Vegas*, 74 and 76.

18 Interview with Scott Brown in *Beyond Utopia*, documentary film, concept and script by Rosemarie Haag Bletter and Martin Filler (New York: Michael Blackwood Productions, 1983).

19 Ibid.

20 Arthur Drexler, ed., *The Architecture of the Ecole des Beaux-Arts* (New York: Museum of Modern Art, 1977).

21 Colin Rowe, "Neo-'Classicism' and Modern Architecture I and II," *The Mathematics of the Ideal Villa and Other Essays* (Cambridge, Mass.: MIT Press, 1976), 119–58. Both essays had first been published in *Oppositions* 1 (1973).

22 Peter Blake, *Form Follows Fiasco: Why Modern Architecture Hasn't Worked* (Boston: Little, Brown, 1974).

23 Charles A. Jencks, *The Language of Post-Modern Architecture* (New York: Rizzoli International Publications, 1977).

24 Oscar Newman, *Defensible Space: Crime Prevention through Urban Design* (New York: Macmillan, 1972).

25 Herbert J. Gans, "The High-Rise Fallacy," *Design Quarterly* 157 (Fall 1992): 24–28.

26 Brent C. Brolin, *The Failure of Modern Architecture* (New York: Van Nostrand Reinhold, 1976).

27 Tom Wolfe, *From Bauhaus to Our House* (New York: Farrar Straus Giroux, 1981). For a critical review, see Rosemarie Haag Bletter, "Pop-Shots at the Bauhaus," *Art in America* 10 (December 1981): 21–23.

28 Charles Jencks, ed., *Post-Modern Classicism* (London: Academy Editions, 1980).

29 Ibid., 5.

30 Jean-François Lyotard, *The Postmodern Condition* (Minneapolis: University of Minnesota Press, 1984). This is a translation from the original French publication of 1979, *Condition postmoderne*. Charles Newman, *The Post-Modern Aura: The Act of Fiction in an Age of Inflation* (Evanston, Ill.: Northwestern University Press, 1985).

31 Andreas Huyssen, *After the Great Divide: Modernism, Mass Culture, Postmodernism* (Bloomington, Ill., and Indianapolis, Ind.: Indiana University Press, 1986).

32 Both the Plocek house and the Portland Public Service Building were dealt with critically in the film *Beyond Utopia*. For a more thorough discussion of these buildings and the difficulties of applying linguistics to architecture, see Mary McLeod, "Architecture," in *The Postmodern Moment*, ed. Stanley Trachtenberg (Westport, Conn.: Greenwood Press, 1985), 19–52.

33 Bernard Rudofsky, *Architecture without Architects: An Introduction to Non-Pedigreed Architecture* (New York: Museum of Modern Art, 1964). For a current critique, see also Felicity Scott, "Bernard Rudofsky: Allegories of Nomadism and Dwelling," in *Anxious Modernisms: Experimentation in Postwar Architectural Culture*, ed. Sarah Williams Goldhagen and Réjean Legault (Montreal: Canadian Centre for Architecture/ Cambridge, Mass.: MIT Press, 2000), 215–37.

34 This is in part the argument of New Urbanism; see, for example, *Save Our Land—Save Our Towns*, documentary film produced by Thomas Hylton (Oley, Pa.: Bullfrog Films, 2000). Fuller discussions can be found in William Fulton, *The New Urbanism: Hope or Hype for American Communities* (Cambridge, Mass.: Institute for Land Policy, 1996); David Harvey, "The New Urbanism and the Communitarian Trap," *Harvard Design Magazine* (Winter/Spring 1997): 68; and Alex Krieger, "Whose Urbanism," *Architecture* (November 1998): 73–77.

35 Charles Moore, *The Place of Houses* (New York: Holt, Rinehart and Winston, 1974).

36 Though initially conceived for several condominiums, a large number of private houses by several architects associated with the Moore circle were later built on the five thousand acres of the Sea Ranch.

37 David Mohney and Keller Easterling, eds., *Seaside: Making a Town in America* (New York: Princeton Architectural Press, 1991).

38 Charles Moore, "You Have to Pay for the Public Life," *Perspecta* 9/10 (1965): 57–87.

39 *Beyond Utopia* film.

40 *The Architecture of Frank Gehry*, ed. Mildred Friedman (Minneapolis, Minn.: Walker Art Center/ New York: Rizzoli International Publications, 1986), was published in conjunction with the first major exhibition of Gehry's work, which was also shown at the Whitney Museum of American Art, New York, and the Museum of Contemporary Art, Los Angeles. For a recent, well-illustrated publication, see *Frank Gehry, Architect*, ed. J. Fiona Ragheb (New York: Solomon R. Guggenheim Museum, 2001). For a fuller presentation of the buildings, see Francesco Dal Co and Kurt W. Forster, *Frank O. Gehry: The Complete Works* (New York: Monacelli Press, 1998).

41 Kenneth Frampton, "Towards a Critical Regionalism: Six Points for an Architecture of Resistance," in *The Anti-Aesthetic: Essays on Postmodern Culture*, ed. Hal Foster (Port Townsend, Wash.: Bay Press, 1983), 16–30.

42 Magdalene Droste, *Bauhaus 1919–1933* (Cologne: Benedikt Taschen, 1998), 72ff, and conversation with the author.

43 Susana Torre, ed., *Women in American Architecture: A Historic and Contemporary Perspective* (New York: Whitney Library of Design, 1977).

44 Pat Kirkham, ed., *Women Designers in the USA, 1900–2000: Diversity and Difference* (New Haven, Conn.: Yale University Press, 2000).

45 Beatriz Colomina, ed., *Sexuality and Space* (New York: Princeton Architectural Press, 1992); Daphne Spain, *Gendered Spaces* (Chapel Hill: University of North Carolina Press, 1992); *Architecture in Fashion*, ed. Deborah Fausch et al. (New York: Princeton Architectural Press, 1994); and Mary McLeod, "Everyday and 'Other' Spaces," in *Architecture and Feminism*, ed. Debra Coleman, Elizabeth Danze, and Carol Henderson (New York: Princeton Architectural Press, 1996), 1–37.

46 McLeod, "Everyday and 'Other' Spaces," 11.

47 Jane Jacobs, *The Death and Life of Great American Cities* (New York: Vintage Books, 1961).

48 McLeod, "Everyday and 'Other' Spaces," 23.

49 Lewis Mumford, reprinted as "Home Remedies for Urban Cancer," in Lewis Mumford, *The Urban Prospect* (New York: Harcourt Brace & World, 1968), 182–207.

50 Craig E. Barton, *Sites of Memory: Perspectives on Architecture and Race* (New York: Princeton Architectural Press, 2001).

51 Richard K. Dozier, "The Black Architectural Experience in America," in *African American Architects in Current Practice*, ed. Jack Travis (New York: Princeton Architectural Press, 1991), 8–9.

52 John Michael Vlach, *Afro-American Tradition in Decorative Arts* (Cleveland: Cleveland Museum of Art, 1978); and Pat Kirkham and Shauna Stallworth, "African American Women Designers," in *Women Designers in the USA*, 123–43. The Kirkham publication also has a chapter on Native American women designers, "The Sacred Hoop: Native American Women Designers," by Pamela Kladyk, 101–21. After its Cleveland opening, Vlach's exhibition traveled for two years to such venues as the Boston Museum of Fine Arts, the St. Louis Art Museum, and the Milwaukee Art Center. Although it deals primarily with decorative arts, Vlach's catalogue also contains a chapter on vernacular, premodern African-American architecture. See also the 1990 reprint of the Cleveland publication (Athens, Ga.: University of Georgia Press, 1990).

53 Jencks had kept his options open from the beginning. The same year that he edited his *Post-Modern Classicism*, he also wrote *Late-Modern Architecture and Other Essays* (New York: Rizzoli International Publications, 1980).

54 A general overview can be found in Jean-François Bédard, ed., *Cities of Artificial Excavation: The Work of Peter Eisenman, 1978–1988* (Montreal: Canadian Centre for Architecture/ New York: Rizzoli International Publications, 1994). For his belief in a value-free architecture, see Peter Eisenman, "The End of the Classical, the End of the Beginning, the End of the End," *Perspecta* 21 (1984) 166. His discussions with me about Chomsky and fractals took place after his lectures at the Institute of Fine Arts, New York University, New York, February 12, 1985, and at the College Art Association of America annual meeting, New York, February 16, 1990.

55 Michael Sorkin, "Decon Job," originally published in the *Village Voice* (July 5, 1988), and reprinted in Michael Sorkin, *Exquisite Corpse: Writings on Buildings* (London: Verso, 1991), 301.

56 Though he excludes enjoyment as an ingredient in his work in his theoretical writings, Eisenman himself cited his friend, the novelist and philosopher William Gass, on the aesthetic pleasures of his architecture in an interview in the *Beyond Utopia* film.

57 For a discussion of the meaning of this kind of Expressionism, see Rosemarie Haag Bletter, "The Interpretation of the Glass Dream—Expressionist Architecture and the History of the Crystal Metaphor," *Journal of the Society of Architectural Historians* 40, no. 1 (March 1981): 20–43.

58 Philip Johnson and Mark Wigley, *Deconstructivist Architecture* (New York: Museum of Modern Art, 1988).

59 Ibid., 10–11. Since Wigley disclaimed a link between Deconstructivist architecture and the theory of deconstruction, it is noteworthy that he also dissociated theory and practice five years later in *The Architecture of Deconstruction: Derrida's Haunt* (Cambridge, Mass.: MIT Press, 1993). In the MoMA catalogue, he dealt almost entirely with architecture; in his *Architecture of Deconstruction*, he dealt almost entirely with theory. In both publications, philosophy and practice barely touched hands.

60 Johnson and Wigley, *Deconstructivist Architecture*, 11.

61 Ibid., 19. For a discussion of the many different approaches to functionalism in Modernism, see Rosemarie Haag Bletter, introduction, *The Modern Functional Building: Adolf Behne* (Santa Monica, Calif.: Getty Research Institute for the History of Art and the Humanities, 1996), 9–15, 35–47.

62 Johnson and Wigley, *Deconstructivist Architecture*, 17–18.

63 On the Situationists, see, for example, Simon Sadler, *The Situationist City* (Cambridge, Mass.: MIT Press, 1998), and the critical discussion in McLeod, "Everyday and 'Other' Spaces,"

15ff. Although Wigley did not acknowledge his Situationist approach in 1988, ten years later he published a monograph on Constant, *Constant's New Babylon: The Hyper-Architecture of Desire* (Rotterdam: Center for Contemporary Art, 1998). That Constant articulated the idea of "deconstructivist architecture" was pointed out to me by Janna Eggebeen.

64 Jürgen Habermas, "Modernity— An Incomplete Project," in *The Anti-Aesthetic*, ed. Foster, 11–13. See also Richard Bernstein, *Habermas and Modernity* (Cambridge, Mass.: MIT Press, 1985).

65 Terence Riley, *Light Construction* (New York: Museum of Modern Art, 1995).

66 Conversation by author with Frank Gehry, opening reception, Vitra Design Museum (November 28, 1989).

67 For a more detailed discussion of this kind of approach in Gehry's work, see Rosemarie Haag Bletter, "Frank Gehry's Spatial Reconstructions," in *The Architecture of Frank Gehry*, ed. Friedman, 25–47.

POINTS OF VIEW IN **AMERICAN ARCHITECTURE**
DAVID G. DE LONG

1 Its most celebrated definition in the United States was made by Henry-Russell Hitchcock and Philip Johnson, in *The International Style* (Los Angeles: Museum of Contemporary Art/New York: W.W. Norton, 1932; several later editions).

2 David B. Brownlee and David G. De Long, *Louis I. Kahn: In the Realm of Architecture* (New York: Rizzoli International Publications, 1991), esp. 55–114.

3 David B. Brownlee, David G. De Long, and Kathryn Hiesinger, *Out of the Ordinary: Robert Venturi, Denise Scott Brown, and Associates; Architecture, Urbanism, Design* (Philadelphia: Philadelphia Museum of Art/New Haven: Yale University Press, 2001), esp. 178–81.

4 Robert Venturi, *Complexity and Contradiction in Architecture* (New York: Museum of Modern Art, 1966); Robert Venturi, Denise Scott Brown, and Steven Izenour, *Learning from Las Vegas* (Cambridge, Mass.: MIT Press, 1972).

5 Ellen Perry [Berkeley], "Complexities and Contradictions," *Progressive Architecture* 46 (May 1965): 168.

6 For examples of his work: Vincent Ligtelijn, *Aldo van Eyck: Works*, trans. Gregory Ball (Basel: Birkhauser, 1999).

7 Meyer Schapiro, "Style," in *Anthropology Today*, ed. A. L. Kroeber (Chicago: University of Chicago Press, 1953), 287–312; reprinted in Meyer Schapiro, *Theory and Philosophy of Art: Style, Artist and Society* (New York: George Braziller, 1994), 51–101.

8 Witold Rybczynski, *The Look of Architecture* (New York: Oxford University Press, 2001), xi–xii.

9 Reyner Banham, *Theory and Design in the First Machine Age* (New York: Praeger, 1960).

10 Among the first to reincorporate these movements into architectural history was Banham in *Theory and Design in the First Machine Age*.

11 Herbert Muschamp, "Beneath the Lawns, Seeds of Discontent," *New York Times*, November 7, 1999, Arts sec., 54.

12 Steven Brooke, *Seaside* (Gretna, La.: Pelican Publishing Co., 1995), 59. For additional information: Richard Sexton, *Parallel Utopias: Sea Ranch and Seaside: The Quest for Utopia* (San Francisco: Chronicle Books, 1995).

13 Among books that have examined Celebration are Douglas Frantz and Catherine Collins, *Celebration, USA: Living in Disney's Brave New Town* (New York: Henry Holt, 1999); and Andrew Ross, *The Celebration Chronicles: Life, Liberty, and the Pursuit of Property Values in Disney's New Town* (New York: Ballantine, 1999).

14 Reed Kroloff, "Disney Builds a Town," *Architecture* 86 (August 1997): 114–18.

15 Alex Krieger, "Whose Urbanism?" *Architecture* 87 (November 1998): 73–76; David L. Kirp, "Pleasantville," *New York Times Book Review*, September 19, 1999, 22–23.

16 Colin Rowe and Fred Koetter, *Collage City* (Cambridge, Mass.: MIT Press, 1978), cited by Herbert Muschamp in his obituary of Colin Rowe, *New York Times*, November 8, 1999, sec. B, 10; Jane Jacobs, *The Death and Life of Great American Cities* (New York: Random House, 1961), cited by Mitchell Duneier, interview with Jane Jacobs, "Joys in the Hood," *New York Times Magazine*, April 9, 2000, 33.

17 Denise Scott Brown, "Talking about the Context," *Lotus International* 74 (1992): 128.

18 *Architecture* 90 (May 2001), cover. Also in that same issue: Robert Venturi, "A Bas Postmodernism, Of Course," 154–57.

19 Since 1989, the firm has been known as Venturi, Scott Brown and Associates. For a summary of this commission: Brownlee and De Long, *Out of the Ordinary*, 122–31.

20 The firm of Michael Graves, Architect, together with the artist Edward Schmidt, had won a competition for its design, as explained in *Art + Architecture + Landscape: The Clos Pegase Design Competition* (San Francisco: San Francisco Museum of Modern Art, 1985), which includes an essay by Martin Filler. Among other publications of this design is Martin Filler, "A Shrine to Wine," *House and Garden* 159 (September 1987): 154–56, 204–07.

21 This thesis, since widely accepted in the history of modern architecture, was an underlying theme in Emil Kaufman, "Three Revolutionary Architects, Boullée, Ledoux, and Lequeu," *Transactions of the American Philosophical Society* 42 (October 1952). It had been published earlier in Emil Kaufman, *Von Ledoux bis Le Corbusier: Ursprung und Entwicklung der Autonomen Architektur* (Vienna: Passer, 1933). With further revisions, it was later published in Emil Kaufman *Architecture in the Age of Reason* (Hamden, Conn.: Archon Books, 1955).

22 Venturi, Scott Brown and Associates with Marunouchi Architects & Engineers, Tokyo. For an account of the commission: Brownlee and De Long, *Out of the Ordinary*, 160–75.

23 As explained in Robert Venturi and Denise Scott Brown, "Two Naifs in Japan," an essay of 1990 reprinted in Venturi, Scott Brown and Associates, *Architecture and Decorative Arts: Two Naifs in Japan* (Tokyo: Knoll International, 1991), 8–44.

24 For additional background and illustrations of this design by the firm of Tigerman McCurry Architects: Blair Kamin, "Temple of Energy," *Architecture* 82 (May 1993): 47–50.

25 Philip Johnson and Mark Wigley, *Deconstructivist Architecture* (New York: Museum of Modern Art, 1988).

26 An account of the commission to Frank O. Gehry and Associates, Inc., with IDOM, Bilbao, is in Francesco Dal Co and Kurt W. Forster, *Frank O. Gehry: The Complete Works* (New York: Monacelli Press, 1998), esp. 480–97.

27 Victoria Newhouse, *Toward a New Museum* (New York: Monacelli Press, 1998), 245–60.

28 Illustrated and described in Herbert Muschamp, "From the Guggenheim, a Bold Vision for a Lower Manhattan Museum," *New York Times*, April 17, 2000, sec. B, 4.

29 The CATIA software is described in Andrew Cocke, "The Business of Complex Curves," *Architecture* 89 (December 2000): 54–55, 124.

30 Henry-Russell Hitchcock, one of my professors at New York University's Institute of Fine Arts, in conversations beginning in 1971. His book, *Modern Architecture: Romanticism and Reintegration* (New York: Payson and Clark, 1929), was one of the first to examine the history of modern architecture. Later, more widely read histories of similar inclination include Nikolaus Pevsner, *Pioneers of the Modern Movement from William Morris to Walter Gropius* (London: Faber and Faber, 1936), and Sigfried Giedion, *Space, Time, and Architecture* (Cambridge, Mass.: Harvard University Press, 1941).

31 David G. De Long, *Frank Lloyd Wright: Designs for an American Landscape, 1922–1932* (New York: Harry N. Abrams in association with the Canadian Centre for Architecture and the Frank Lloyd Wright Foundation, 1996), 80–100.

32 Daniel Libeskind, Architect, in a joint venture with Gordon H. Chong & Partners, San Francisco.

33 Beginning with Ben Allan Park, "The Architecture of Bruce Goff," *Architectural Design* 27 (May 1957): 151–174; also within the special issue of *Bauwelt* devoted to his work: *Bauwelt* 49 (January 27, 1958). Also, Takenobu Mohri, *Bruce Goff in Architecture* (Tokyo: Kenchiku Planning Center Co., 1970), 96–97.

34 David G. De Long, *Bruce Goff: Toward Absolute Architecture* (New York and Cambridge, Mass.: The Architectural History Foundation and MIT Press, 1988), 27, 88. When in 1972 I consulted Nikolaus Pevsner regarding my initial investigations of the work of Goff, he unhesitatingly replied that Goff was an expressionist, as Henry-Russell Hitchcock had similarly concluded. Also echoing Hitchcock, Pevsner told me on that occasion that expressionism seemed to have no ongoing story to tell.

35 Frank Gehry, foreword to *Bruce Goff: Toward Absolute Architecture*, ix–x.

36 Herbert Muschamp, "In the City and Suburb, Models for the New Modern Age," *New York Times*, December 31, 2000, Arts sec., 36. Mayne's office, Morphosis, realized the design in association with Thomas Blurock Architects.

37 As quoted in Aaron Betsky, "Diamond Ranch High School," *Architecture* 89 (November 2000): 132–45.

38 Illustrated and described in Aaron Betsky, "The Glass Fantastic," *Architecture* 89 (March 2000): 104–11; also, Joseph Giovannini, "Eric in Wonderland," *Architecture* 90 (March 2001): 104–13. Moss practices as Eric Owen Moss Architects.

39 The close ties between architecture and sculpture are discussed in Mark Robbins, "Notes on Space," *Architecture* 87 (August 1998), 48–51. Also, Michael Kimmelman, "The Last Great Art of the 20th Century," *New York Times*, February 4, 2001, Arts sec. 2, 1, 39.

40 The competition, announced in 1998, was sponsored by the Canadian Centre for Architecture under the leadership of its founding director, Phyllis Lambert. Eisenman collaborated with David Childs and Marilyn Jordan Taylor of Skidmore, Owings & Merrill in his winning proposal. It is discussed in Karrie Jacobs, "To Hell's Kitchen and Back," *Architecture* 88 (October 1999): 63–69.

41 Joseph Giovannini, "Campus Complexity," *Architecture* 85 (August 1996): 114–28. Associated on the project with Eisenman Architects was Lorenz + Williams.

42 As quoted in Giovannini, "Campus Complexity," 119.

43 Herbert Muschamp, "A Queens Factory is Born Again, as a Church," *New York Times*, September 5, 1999, Arts sec., 30.

44 Aaron Betsky, "Machine Dreams," *Architecture* 86 (June 1997): 86–91.

45 Herbert Muschamp, "Designs for the Next Millenium," *New York Times Magazine*, December 5, 1999, 122–36.

46 Greg Lynn, FORM; Garofalo Architects, and Michael McInturf Architects.

47 For a comprehensive discussion of Prince's work, Christopher Mead, *The Architecture of Bart Prince* (New York: W. W. Norton, 1999).

48 Examples are discussed in Bradford McKee, "The Green Machine," *Architecture* 90 (February 2001): 46–50, 124–25.

49 Interview with James Wines, July 29, 1999.

50 Graham Vickers, "Where are the Ears?" *World Architecture* 21 (1993): 70–73.

51 These and related examples are discussed in Herbert Muschamp, "A Rare Opportunity for Real Architecture Where It's Needed," *New York Times*, October 22, 2000, Arts sec. 2, 38–39.

52 *Architecture* 86 (December 1997). For additional illustrations and a descriptive text in that same article, Aaron Betsky, "Faulty Towers," 78–87. A review of books relating to the Getty, together with perceptive criticism, can be found in Martin Filler, "The Big Rock Candy Mountain," *New York Review of Books* 44 (December 18, 1997): 29–30, 32–34.

53 Herbert Muschamp, "In the City and Suburb, Models for the New Modern Age," *New York Times*, December 31, 2000, Arts sec., 36.

54 The design is published in "Sculpture Studio," *Progressive Architecture* 72 (January 1991): 116–117; the completed building is published in Abby Bussel, "Barclay Simpson Sculpture Studio," *Progressive Architecture* 74 (August 1993): 86–87; also, Frank F. Drewes, "Glasstudio in Oakland," *Deutsches Bauzeitschrift* 42 (February 1994): 53–58. Jennings's office is known as Jim Jennings Architecture.

55 For example, the Oliver house in San Francisco, published in Pilar Viladas, "San Francisco Skyline; Crisp Geometries on Telegraph Hill," *Architectural Digest* 54 (August 1997): 78–87.

56 Published in Aaron Betsky, "Vegas, Seriously," *Architecture* 88 (August 1999): 84–89. Mack's office goes by the name Mack Architects.

57 Michael J. O'Connor, "Square Roots," *Architecture* 88 (September 1999): 58–59.

58 For a personal account of its design, Maya Lin, "Making the Memorial," *New York Review of Books* 47 (November 2, 2000): 33–35.

59 As quoted in Fred Bernstein, "The Mild West: Davy Crockett Meets Armani," *New York Times*, April 1, 1999, sec. F, 5. The library is more extensively published in "Langston Hughes Library," *Architecture* 89 (July 2000): 104–11. Lin's office goes by the name Maya Lin Studio.

60 The K-Loft is published in Joseph Giovannini, "Redefining the Loft," *Architectural Digest* 53 (August 1996): 80–85.

61 Ranalli designed the installation for the Scarpa exhibition at the Canadian Centre for Architecture; Nicholas Olsberg and others, *Carlo Scarpa, Architect: Intervening with History* (New York: Monacelli Press, 1999).

62 Krueck is the founding partner of Krueck and [Mark] Sexton, established in 1991. He had earlier been a partner in Krueck and Olsen. The Brick and Glass house is published in Cheryl Kent, "Set among Historicist Neighbors, a House in Chicago by Krueck & Sexton Provides a Welcome Break with the Past," *Architectural Record* 185 (April 1997): 99–103. Other work is published in *Krueck & Sexton: Work in Progress*, intro. Franz Schulze (New York: Monacelli Press, 1997).

63 An exhibition dealing with similar translucencies, "Light Construction," was held at the Museum of Modern Art in New York in 1995. It was reviewed by Herbert Muschamp, "Buildings that Hide and Reveal," *New York Times*, September 22, 1995, sec. C, 1, 28.

64 Steven Holl, "From Concept to Realization," *Stretto House* (New York: Monacelli Press, 1996), unpaginated.

65 Thomas S. Byrne Construction, builders of the Stretto House, were also the builders of Kahn's museum; *Stretto House*, unpaginated.

66 For an account of Hunt's career: Susan Stein, ed., *The Architecture of Richard Morris Hunt* (Chicago: University of Chicago Press, 1986).

67 Hitchcock and Johnson, *The International Style*.

68 Paul Goldberger, "Philip Johnson: The Architect's Daring New Residential Projects," *Architectural Digest* 58 (March 2001): 88, 92, 94, 96.

69 In formulating the ideas condensed in this essay, I gained by discussions with the students in my Spring 2001 seminar on American architecture at the University of Pennsylvania Graduate School of Fine Arts: Joyce Cheng, Julie Dunn, Mandy Hall, Carol Henkels, Seth Hinshaw, Diane Jackier, Kenneth Jacobs, Kristopher King, Kristin Miley, Fernando Moreira, Greg Saldaña, Jason Singer, and Pushkar Sohoni.

AMERICAN DECORATIVE AND INDUSTRIAL DESIGN: FROM CRISIS BACK TO THE VANGUARD
R. CRAIG MILLER

1 In the immediate postwar years, the United States and Scandinavia were the leaders in Western design. For a discussion of this important period in American design, see R. Craig Miller, "Interior Design and Furniture," in *Design in America, The Cranbrook Vision: 1925–1950,* R. Craig Miller et al., exh. cat. (New York: Harry N. Abrams in association with The Detroit Institute of Arts and the Metropolitan Museum of Art, 1983), 91–143. For a discussion of American design in the 1960s and 1970s, see Martin Filler, "1960–1975: The Interior Landscape and the Politics of Change," in *High Styles: Twentieth-Century American Design,* by Lisa Phillips, exh. cat. (New York: Whitney Museum of American Art, 1985), 161–91.

2 Steven Holt, "Model Revolutionary," in *Dan Friedman: Radical Modernism* (New Haven: Yale University Press, 1994), by Dan Friedman et al., 164. Holt was, in fact, referring to Friedman's beliefs. One of the most articulate critics of Modernism in the 1960s and 1970s, Friedman believed that American designers had often sold themselves to the corporate world and that it was a fallacy that the service provided "to corporations had the same integrity as service to the public good." Friedman further noted that "the concepts behind modernism are not what has made it internationally acceptable. Instead, it is the capacity of the modernist style to be assimilated by the corporation because of its restraint, neutrality, and potentially cost-efficient replication. . . . Modernism became a truly 'international' style only when it was introduced to the corporate agenda. . . . Modernism sacrificed its claim to moral authority when designers began to sell it as a corporate style." *Ibid.,* 114–15.

3 The idea arose in the 1960s among craftspeople that if they simply left the applied arts and became fine artists, they would be treated as the equals of painters and sculptors. But this has not happened in any significant way. There are few major American museums that show Studio Movement work with contemporary fine arts, and it is still generally acquired by decorative arts departments.

4 Peter Dormer, *Design Since 1945* (New York: Thames and Hudson, 1993), 84.

5 Gehry apparently began his designs in cardboard as early as 1969. The series went into production in 1972, but only for three months. It was later reissued by Gehry in 1982. For an analysis of this series and Gehry's work as a designer, see Joseph Giovannini, "Edges, Easy and Experimental," in *The Architecture of Frank Gehry,* ed. Mildred Friedman (New York: Rizzoli International Publications, 1986), 63–85; Martin Filler, "Frank Gehry and the Modern Tradition of Bentwood Furniture," in *Frank Gehry: New Bentwood Furniture Designs,* by Martin Filler et al., exh. cat. (Montreal: The Montreal Museum of Decorative Arts, 1992), 89–108; and Evi Ahrendt, Milena Lamarová, and Rostislav Švácha, *Frank O. Gehry: Design & Architecture,* exh. cat. (Weil am Rhein: The Vitra Design Museum, 1996).

6 Friedman et al., *Dan Friedman,* 115.

7 For a discussion of the evolution of this term, see Rosemarie Bletter's essay in **USDesign**.

8 It would, in fact, be almost a decade later before Venturi began to design decorative objects.

9 Throughout the twentieth century, architects and designers have returned to history for inspiration. In the first half, one can point to architects such as Sir Edwin Lutyens, Josef Hoffmann, Bruno Paul, (early) Gio Ponti, and Eliel Saarinen and designers such as Jacques-Emile Ruhlmann, T. H. Robsjohn-Gibbings, and Piero Fornasetti. Even at mid-century, there was a neoclassical revival with architects such as Philip Johnson and Edward Durrell Stone. In the same years, designers such as Robsjohn-Gibbings and Ed Wormley also continued to explore traditional forms in their work.

10 The concern for a strong social and political agenda that marked Italian Postmodernist design does not appear in this historicizing aspect of American design; but it does surface with designers concerned with the everyday (dealt with in section two of **USDesign**).

11 Shery Wittstock, "Michael Graves," in *Soane and After: The Architecture of Dulwich Picture Gallery* (London: The Dulwich Picture Gallery, 1987), 93.

12 The most scholarly analysis of Venturi's decorative arts is by Kathryn Hiesinger. See her essay, "Decorative Art and Interiors," in *Out of the Ordinary: Robert Venturi, Denise Scott Brown and Associates,* by Kathryn Hiesinger et al., exh. cat. (Philadelphia: Philadelphia Museum of Art, 2001), 182–243.

13 By the early 1990s, Venturi's primary energies shifted back to his architectural commissions.

14 For Memphis, see Barbara Radice, *Memphis: Research, Experiences, Results, Failures and Successes of New Design* (New York: Rizzoli International Publications, 1984). For Sottsass, see Penny Sparke, *Ettore Sottsass, jr.* (London: The Design Council, 1982); and Hans Hoger, *Ettore Sottsass, jun.: Designer, Artist, Architect* (Berlin: Ernst Wasmuth Verlag, 1993).

15 Venturi has, of course, worked within a firm for much of his career, most recently Venturi, Scott Brown and Associates.

16 Venturi and Scott Brown first traveled to Asia—Japan and Korea—in 1990, and there was an immediate influence on their later work, the textiles for DesignTex and carpets for V'Soske. See Hiesinger, *Out of the Ordinary,* 197, 237–43.

17 Indeed, Venturi (of Venturi, Scott Brown and Associates) and Stirling (of James Stirling, Michael Wilford and Associates) were responsible for two of the most acclaimed Postmodernist museums of the late twentieth century: the Sainsbury Wing at the National Gallery in London (1991) and the Staatsgalerie in Stuttgart (1983). See Victoria Newhouse, *Towards a New Museum* (New York: Monacelli Press, 1998), 179–85.

18 The collection consisted of a sofa, coffee table, and side chairs, and dining tables with two types of bases.

19 Aalto's work in molded plywood also has a decided chunkiness to it, compared to the paper-thin quality of Marcel Breuer's work for Isokon in the 1930s.

20 The Hepplewhite, Gothic Revival, and Art Nouveau chairs were made only as prototypes. One of the most important finishes was in a custom spray paint (used only on a few prototypes), emulating a pattern developed by Paola Navone from images of television static. See Hiesinger, "Decorative Art and Interiors," 209, 211, 213.

21 Venturi had initially proposed this design to Alessi in 1980 to be made of metal. But the complex forms and decoration proved to be more appropriate for ceramic. See Hiesinger, "Decorative Art and Interiors," 223, 227.

22 Likewise, the candlesticks were first proposed to Alessi but ultimately made by Swid Powell. See Hiesinger, "Decorative Art and Interiors," 227.

23 Venturi had originally envisioned rather elaborate polychromed patterning on the pots, as sketches in the Venturi and Scott Brown Archive make clear; but the decoration was ultimately reduced to an incised pattern with simple gilding.

24 V'Soske was among the earliest American manufacturers to hire architects to design such custom carpets, beginning with Michael Graves's *Rug No. 1* and *Rug No. 2* (1979–80). See Phil Patton, "Design on the Level," *Connoisseur* 217, no. 900 (January 1987): 43–47. Venturi and Scott Brown's work for V'Soske was actually later, in 1989–93. See Hiesinger, "Decorative Art and Interiors," 237–40.

25 *Gingham Floral* is perhaps the most Western pattern in the DesignTex series, which the company called in large part inspired by "Oriental woodcuts and kimonos." Quoted in Hiesinger, "Decorative Art and Interiors," 240–41.

26 One of the most comprehensive treatments of Graves's design work is Alex Buck and Matthias Vogt, eds., *Michael Graves: Designer Monographs 3* (Berlin: Ernst & Sohn, 1994).

27 For further parallels between Graves and Hoffmann, see Rainer Krause, "The 'Graves Family'—Designs for the Set Table," in *Michael Graves,* 92, 103.

28 Janet Abrams, " 'Gesamtkunstwerk'—Coming Home to Rome," in *Michael Graves,* 120.

29 Graves has, on occasion, also looked at classical sources. His vases for Steuben recall Etruscan forms, and his jewelry for Cleto Munari and Belvedere Studio draws on Greek and Roman precursors. See *Michael Graves,* 104–5, 120–23.

30 The series included an armchair, side chair, and table, as well as a series of textiles. The series was "re-issued" in 1984 by Sawaya & Moroni in Milan. SunarHauserman was one of the most important American manufacturers to make a commitment to this historical revival. Indeed, they commissioned Graves to design a number of showrooms across the country, which were remarkably controversial at the time. See Michael Collins, "Furniture and Interiors—The Designer of Archetypes in the Era of Post-Modernism," in *Michael Graves,* 17–21.

31 For an illustration of these chairs, see Karen Vogel Wheeler, Peter Arnell, and Ted Bickford, eds., *Michael Graves: Buildings and Projects 1966–1981* (New York: Rizzoli International Publications, 1982), 103. Like James Stirling, Graves also compiled a remarkable collection of classical and Neoclassical furniture and *objets* for his own residence. See Kenneth Powell, *Graves Residence: Michael Graves* (London: Phaidon Press, 1995).

32 The table was originally designed for the Arne Glimcher apartment in New York. Craftwood Products in Toronto, Canada, now makes the table by custom order. A variant is also made by Meccani in Italy.

33 Indeed, Graves's career offers almost exact parallels to that of Sottsass, who, since the late 1980s, has largely worked in a mode that comes out of his Memphis period, 1981–88.

34 Krause, "The 'Graves Family,'" 112.

35 Like Venturi and Scott Brown who are both spouses and partners, Tigerman and McCurry are married partners in their firm, Tigerman McCurry Architects. They have worked together and independently.

36 "Designers' Statement" of 1997 issued by the Boym Design Studio.

37 See Thomas Hine, *Populuxe* (New York: Knopf, 1986).

38 As early as the 1950s, British theoretical groups such as the Independent Group and critics such as Reyner Banham had attacked the concept of "good design." In their championing of Moderne design over Modernism, they set up, in many respects, a polarity of "low" versus "high" design. See David Robbins, ed., *The Independent Group: Postwar Britain and the Aesthetics of Plenty* (Cambridge, Mass.: MIT Press, 1990).

39 Some of Graves's late work belongs in this second section, such as his dinnerware for Disney (fig. 136). His work for Target, with its emphasis on styling, may also be seen as transitional between the two sections (figs. 138, 139).

40 The associated architects of The Sea Ranch were Donlyn Lyndon, William Turnbull, and Richard Whitaker. The supergraphics were designed by Barbara Stauffacher Solomon. See Filler, "1960–1975," in *High Styles*, 164–65.

41 By the 1980s, this vague line between the fine and applied arts was blurred further when a number of major artists such as Donald Judd began to design furniture.

42 For Alchimia, see Guia Sambonet, *Alchimia, 1977–1987* (Turin, Italy: Umberto Allemandi, 1986). There was, of course, another aspect of Italian Pop design, represented by the early work of designers such as Gaetano Pesce and Paolo Lomazzi, Donato D'Urbino, and Jonathan De Pas; but it was quite different from its American parallel. Designs by these Italians were industrially made and placed a strong emphasis on new materials and technology. See Emilio Ambasz, ed., *Italy: The New Domestic Landscape: Achievements and Problems of Italian Design*, exh. cat. (New York: The Museum of Modern Art, 1972).

43 For illustrations of these precedents, see Charlotte and Peter Fiell, *1000 Chairs* (Cologne: Taschen, 1997), 55, 64, 237, 238, 271, 349.

44 This was a term used by Friedman. Friedman et al., *Dan Friedman*, 27.

45 Neotu, which also had a branch gallery in New York, was an important center for showing this work. It also exhibited the work of other designers of the everyday such as Schwan & Godley.

46 In an interview with the author in November 2000, Schwan spoke of the importance of groups like Memphis to young American designers in the 1980s. "Memphis opened everything up … [it] broke barriers between art and design. It created a spirit of 'anything goes.'" Schwan also spoke of the "painterly" quality of the *Otto* cabinet. The finish of the doors was meant "to be like a painting": it has a white ground with paint streaked on it to simulate a grained surface.

47 The nomenclature of Allen's design is tongue-in-cheek: it is from the *Sputnik* series commissioned by the Idee Gallery in Tokyo. Like Neotu, Idee has been quite influential in sponsoring emerging designers from Shiro Kuramata to Karim Rashid.

48 Hafner has written: "I am grounded by my love for primitive art and dance, and so child-like marks and scribbles dance their way across the plane. . . . Synchronous with my desire to design a carpet was the beginning and continuing love affair with the study of ballroom dance. Many of the designs began as tracings of the foot paths two partners would make traversing the floor. . . . This one, from the Lindy and Jitterbug, is much more staccato and free-form." "Dorothy Hafner—Thoughts on My Rug," press release from V'Soske, undated.

49 Kathryn Hiesinger has noted that it was Denise Scott Brown who proposed the pattern adapted from children's composition notebooks. Hiesinger, "Decorative Art and Interiors," 213.

50 For illustrations, see Fiell, *1000 Chairs*, 77, 86, 78–79.

51 For illustrations of their work, see Petra Timmer, "The Amsterdam School and Interior Design: Architects and Craftsmen against the Rationalists," in *The Amsterdam School: Dutch Expressionist Architecture, 1915–1930*, ed. Wim de Wit, exh. cat. (Cambridge, Mass., and New York: MIT Press and Cooper-Hewitt Museum, 1983), 121–44. The early work of the De Stijl designer Gerrit Rietveld, which is better known, presents visual similarities to the highly planar and fragmented forms of Peter Eisenman. Though often thought of as rationalist, Rietveld's chairs and sideboards are, of course, not strictly functional objects. They are highly personal compositions, in which color—black, white, red, and gray—is used to negate the material, as in the art of the Russian Constructivists. Rietveld also employed nontraditional construction methods to achieve his magical planar effects. See Daniele Baroni, *The Furniture of Gerrit Thomas Rietveld* (Woodbury, N.Y.: Barron's Educational Series, 1978).

52 See David A. Hanks, *The Decorative Designs of Frank Lloyd Wright* (New York: E.P. Dutton, 1979), 111–44.

53 For respective illustrations, see Fiell, *1000 Chairs*, 282–83, 358–59, 363, 318–19, 425, 454–55.

54 For illustrations of Pesce's work, see France Vanlaethem, *Gaetano Pesce: Architecture Design Art* (New York: Rizzoli International Publications, 1989). An expressionist bent may even be detected in work by Postmodernist designers such as Bořek Šípek. In many of his designs—especially for furniture—the Amsterdam-based designer gives traditional materials and forms an almost baroque intensity. See Milena Lamarová, *Bořek Šípek: The Nearness of Far—Architecture and Design* (The Hague: Steltman Editions, 1993).

55 One may, of course, argue that the fascination with the continuous chair was an expression of a designer's interest in technology or efficiency of production, as noted in a letter to the author from Kathryn Hiesinger, July 6, 2001. Nevertheless, these designers are often decisively pushing the limits of materials and manufacturing methods to achieve their highly personal forms; and there is certainly nothing cost-efficient about the molds and demanding craftsmanship that they require.

56 See Alexander von Vegesack, *Ron Arad* (Weil am Rhein: Vitra Design Museum, 1990) and Deyan Sudjic, *Ron Arad* (London: Lawrence King, 1999). Gehry's American contemporaries who are fascinated with a similar aesthetic are Peter Eisenman and John Hedjuk, but they have produced virtually no design work. Gehry's European contemporary, Gaetano Pesce, is another matter; he has been enormously prolific as a designer. One may, in fact, argue that these two artists are the most important expressionist designers of their generation, much like Venturi and Sottsass in our "Tradition" section. Pesce's work is highly intuitive in its use of form, material, and technology, like Gehry's; but it has a decidedly different expressionist aesthetic. See Vanlaethem, *Gaetano Pesce*.

57 It should also be noted that it has been impossible to do primary research in the Gehry archives as they were closed for the organization of the major retrospective at the Guggenheim Museum, New York, in 2001.

58 Gehry was, of course, not the first artist to design furniture made of cardboard. Peter Murdock had designed the *Spotty* child's chair in 1963 and Peter Raacke the *Papp* chair in 1967, but both designers tended to use the sheet material in a planar manner. See Charlotte and Peter Fiell, *Modern Chairs* (Cologne: Benedikt Taschen, 1993), 91, 103.

59 Ahrendt et al., *Frank O. Gehry: Design and Architecture*, 22–24.

60 Filler, "Frank Gehry and the Modern Tradition of Bentwood Furniture," 89–107.

61 Thonet is often portrayed as a seminal precursor to Modernist furniture design. Gehry, seeking to reinvigorate American furniture design in the 1970s, perhaps found it only natural to go back to this touchstone and use such nineteenth-century work as a starting point for his new furniture. The parallels are striking between designs by Gehry and Thonet: (1) the *Easy Edges* series and a series of early Biedermeier chairs of 1836–40; (2) the *Bubbles* chaise longue and the No. 7500 rocking chaise of ca. 1880 (which also came with a loose cushion); and even (3) the *Bentwood Collection* and an experimental chair of 1867. For respective illustrations, see Derek Ostergaard, ed., *Bent Wood and Metal Furniture: 1850–1946* (New York: The American Federation of Arts, 1987), 24, 35, 232–33, 49.

62 As a designer, Wright reached back into history—whether to Japanese prints or Mayan architecture—but so completely assimilated the lessons that there are almost no discernable traces in his work. But the parallels go much further. Gehry's early work in California clearly shows the influence of Wright and his followers, such as Harwell Hamilton Harris. Both designers set out to be the greatest architects of their generation. And both architects in their late careers developed highly subjective styles that in many respects cannot be extended by followers—i.e., only Gehry can do "late Gehry." It is certainly no coincidence that Gehry's masterpiece was the commission for yet another Guggenheim Museum.

63 Unlike many Italian architects of his generation, such as Ettore Sottsass or Mario Bellini, who initially achieved fame as designers (versus architects), Gehry was uneasy about being known primarily as a designer. See Giovannini, "Edges, Easy and Experimental," 73. Gehry has noted about the *Easy Edges* series, however, that " [t]he two or three years I spent doing that [series] were some of the most rewarding times of my life." Filler, "Frank Gehry and the Modern Tradition of Bentwood Furniture," 102.

64 The greater emphasis on mass—rather than the structural frame—had begun with Italian designers in the 1960s and 1970s when they began to experiment with Pop forms made of blocks of polyurethane. See R. Craig Miller, *Masterworks: Italian Design, 1960–1994* (New York: American Federation of Arts, 1996).

65 For illustrations of this series, see Juli Capella and Quim Larrea, *Designed by Architects in the 1980s* (New York: Rizzoli International Publications, 1987), 74; Ahrendt, *Frank O. Gehry*, 21, 25, 27, 31, 33, 35; and Giovannini, "Edges, Easy and Experimental," 62, 70–71.

66 The series was made by New City Editions in Los Angeles. Certain pieces in the series were also issued by Vitra in Europe. Gehry's partner in this undertaking was Richard Saul Wurman.

67 ColorCore was an innovative material at the time: the color extended throughout the sheet of laminate, eliminating the "black line" in conventional Formica between the laminate and its base. The promotional campaign was organized by Susan Lewin and included many of the most original architects of the period. See Susan Grant Lewin, ed., *Formica & Design: From the Counter Top to High Art* (New York: Rizzoli International Publications, 1991), 143–63.

68 Like the *Experimental Edges* series, the lamps were made by Joel Sterns at New City Editions and distributed through fine arts galleries in Los Angeles and New York. Sterns has noted that the *Fish* lamps were made both in glass and ColorCore. In addition, Gehry designed a series of *Snake* lamps that were made of ColorCore or paper. Interview with Joel Sterns by R. Craig Miller, June 1999.

69 Giovannini, "Edges, Easy and Experimental," 64.

70 During this period Gehry worked primarily for two companies. For Knoll, he designed two furniture series. The initial concept for the *Bentwood Collection*—a series made of bent wooden slats, much like woven baskets—was begun for Vitra in 1984 and subsequently put into production by Knoll (1989–92). In 1992, Gehry introduced his *Fog* chairs with aluminum seats and back panels and stainless-steel legs. See *Frank Gehry: New Bentwood Furniture Designs*, and Joseph Giovannini, "Seat of Authority," *ID Magazine* (May 1999): 44–47. Gehry's work as a product designer for Alessi is more limited. One of his most notable designs is the *Pito* kettle (1988–92) with his ubiquitous fish form. See Alberto Alessi, *The Dream Factory: Alessi Since 1921* (Milan: Electa, 1998), 69.

71 See Peter Cook and George Rand, *Morphosis: Buildings and Projects* (New York: Rizzoli International Publications, 1989), 190–91, 198–201, 208–9.

72 For Dixon, see Fiell, *Modern Chairs*, 127, and Fiell, *1000 Chairs*, 594–95, 650–51. For Lane, see Fiell, *Modern Chairs*, 121, and Fiell, *1000 Chairs*, 593.

73 I would particularly like to thank Eric Chan, the industrial designer, for sharing his knowledge about American product design over the last quarter century.

74 Jean Nouvel, ed., *The International Design Yearbook 1995* (New York: Abbeville Press, 1995), 171.

75 Steven Skov Holt, "Beauty and the Blob," in *Design Culture Now: National Design Triennial*, by Steven Skov Holt et al. (New York: Princeton Architectural Press, 2000), 24.

76 Papanek's publications include *Design for the Real World: Human Ecology and Social Change* (New York: Pantheon Books, 1971); *Design for Human Scale* (New York: Van Nostrand Reinhold, 1983); and *The Green Imperative: Natural Design for the Real World* (New York: Thames & Hudson, 1995).

77 See Holt, "Beauty and the Blob," 79. Emotional ergonomics was not, however, just a development of the 1990s. Even in the 1980s, designers were beginning to shape products to fit the human body, perhaps in reaction to the crisp geometric forms so characteristic of the previous decade. The *Radius* toothbrush (1984; fig. 177) is an early example.

78 Don Chadwick worked in Gehry's office on the latter's earliest experiments with cardboard furniture. See Giovannini, "Edges, Easy and Experimental," 65.

79 Both Tom Hine and Eric Chan have remarked, in separate conversations with the author, that in the last decade or so the sneaker has replaced the Detroit car as the product with which many younger consumers connect most emotionally. Companies such as Nike, in particular, have excelled at combining fashion and function, but in reality in selling this kind of emotional bond: thus the endless stream of new merchandise flooding the market.

80 For insights on this movement, see Tom Hine's essay in this catalogue. Much of the work was exceptional in terms of design; but very little of it ever went beyond the prototype stage, since American manufacturers could not be sold on this new theoretical approach for product design. But product semantics enjoyed a great vogue for a period in the 1980s, particularly at design schools such as Cranbrook. Katherine and Michael McCoy were the heads of design departments there, and many of their students became advocates of product semantics. See *Design Issues* 5, no. 2 (Spring 1989).

81 Katherine and Michael McCoy, *Cranbrook Design: The New Discourse*, exh. cat. (New York: Rizzoli International Publications, 1990), 99.

82 Ibid., 106.

83 "Designer's Statement" (undated) received from Totem Gallery, New York City, December 17, 1998.

84 This statement is, in fact, the subtitle of a new monograph. See Gilda Bojardi, introduction, *Karim Rashid: I Want to Change the World* (New York: Universe Publishing, 2001).

85 A number of visionary entrepreneurs—unlike American corporate manufacturers—have fostered and promoted the work of some of these young designers though their galleries. Teruo Kurosaki of the Idee Gallery in Tokyo was an early admirer of Rashid—and more recently Harry Allen—developing entire collections of their work for exhibitions. Rashid's *Space* chaise (fig. 187) was one of twenty-eight prototypes developed for his *Decola Vita* collection in 1999. In New York, David Shearer of the Totem Design gallery has promoted more than a dozen young American designers in a long series of exhibits through the 1990s. Shearer has also been an advocate of young European designers, introducing their work to American audiences.

86 For further information on Rashid's contemporaries, see Peter Dormer, introduction, *Jasper Morrison: Designs, Projects and Drawings 1981–1989* (London: Architecture Design and Technology Press, 1990); and Alice Rawsthorn, *Marc Newson* (London: Booth-Clibborn Editions, 1999).

87 Kreuck & Sexton's furniture designs have primarily been custom commissions for their interiors. They have, in particular, sought to extend Chicago's remarkable design history by alluding in their work to those—from Wright to Mies—who have exerted an influence on design and architecture there. At the same time, a number of their designs in glass and metal clearly show the influence of Pierre Chareau as well as Noguchi.

88 Interview with Ali Tayar by the author, May 1999.

89 A precursor for it was the concept of "global design" developed by the Japanese in the 1970s. This "anonymous design" was intended to appeal to the largest audience of consumers, in multinational markets. See Hugh Aldersey-Williams, *World Design: Nationalism and Globalism in Design* (New York: Rizzoli International Publications, 1992).

90 For what follows in the text, I would particularly like to thank the textile designers Sheila Hicks and Jack Lenor Larsen, who have so generously shared their knowledge of innovations and changes in the textile field over the last half century.

91 In addition to contract goods, one can point to at least four other distinct approaches in textile design over this quarter century. There is the enormous market for "reproduction textiles," aimed primarily at a conservative residential clientele. Immensely affluent, the apparel industry is now a huge consumer of and innovator in "fashion textiles." The pervasive influence of the industry has led to increasingly blurred lines between the worlds of fashion and design. The American Studio Movement's pursuit of "fiber art" has had a tremendous effect over the last quarter century. Many of America's most talented textile designers have devoted their energies to "fiber art." And with the continual technological revolution in the laboratory, there is a new category of "industrial textiles" that are used as construction materials in buildings, dams, cars, and even tires. *USDesign* has chosen to focus on the innovations in the field of contract textiles.

92 One hastens to add that few of the designers cited earlier in this Modernist section have attempted to work in the textile field, with notable exceptions such as Rashid. In fact, the new Modernists have evidenced little interest in textiles or, for that matter, even upholstery in their furniture designs, their primary emphasis being on the structural material. Textiles were an important aspect of post-World War II Modernist design—a rich aspect of the history of design that the new Modernists might give further study.

AN ERA OF INNOVATION AND DIVERSITY IN
GRAPHIC DESIGN, 1975–2000 **PHILIP B. MEGGS**

1 Herbert Spencer, *Pioneers of Modern Typography*, rev. ed. (Cambridge, Mass.: MIT Press, 1983), 8.

2 In 1986, the national Graphic Design Education Association was formed to address the problems of program proliferation, standards for curriculum and faculty, and inadequate resource allocations as design methods transitioned from drafting tables to computers. In the late 1990s, the American Institute of Graphic Arts formed a task force to develop accrediting processes for graphic design education programs.

3 Steven Heller et al., *Graphic Design USA: 20* (New York: American Institute of Graphic Arts, 2000), 311.

4 Books discussing late twentieth-century graphic design in greater detail include Ronald Labuz, *Contemporary Graphic Design* (New York: Van Nostrand Reinhold, 1991); Philip B. Meggs, *A History of Graphic Design*, 3d ed. (New York: John Wiley & Sons, 1998); and Steven Heller and Seymour Chwast, *Graphic Style from Victorian to Digital*, rev. ed. (New York: Harry N. Abrams, 2000).

5 Glaser's works are presented in Milton Glaser, *Milton Glaser: Graphic Design* (Woodstock, N.Y.: Overlook Press, 1973); and Milton Glaser, *Art is Work* (Woodstock, N.Y.: Overlook Press, 2000).

6 Rand's works are presented in Paul Rand, *Paul Rand: A Designer's Art* (New Haven: Yale University Press, 1985).

7 Vignelli's works are presented in Germano Celant et al., *Design—Vignelli* (New York: Rizzoli International Publications, 1990).

8 Both surveys and books on specific genres began to appear in the early 1980s. In addition to the books listed in note 4 above, surveys include James Craig and Bruce Barton, *Thirty Centuries of Graphic Design* (New York: Watson-Guptill, 1987); and Richard Hollis, *Graphic Design: A Concise History* (New York: Thames and Hudson, 1994).

9 English editions of books by Swiss graphic designers and educators were widely used in American graphic design education during the 1960s and 1970s. These include Armin Hofmann, *Graphic Design Manual: Principles and Practice* (New York: Van Nostrand Reinhold, 1965); and Emil Ruder, *Typography* (Teufen AR, Switzerland: Niggli, 1967).

10 Bierut's work is discussed in Paula Scher and Sarah Haun, "Pentagram in the 90s: The Next Generation," *Idea* 232 (May 1992): 36–41.

11 Vanderbyl's work is discussed in Colin Wood and Anna Griffiths, "Michael Vanderbyl," *Design World* 29 (November 1991): 2–13; and Beverly Russell, "Twentieth Year Celebration," *Interiors* 152, no. 2 (February 1993): 36–37.

12 Fili's work is discussed in Susan E. Davis, "Classic Innovation," *Step-by-Step Graphics* 14, no. 1 (January–February 1998): 42–53.

13 Scher's work is discussed in Paula Scher and Susan E. Davis, "No Repeat Performances," *Step-by-Step Graphics* 14, no. 3 (May–June 1998): 84–93.

14 The Duffy Design Group is discussed in "Chair Leader's Delight," *Novum* (March 1999): 16–21.

15 *Before Rosebud was a Sled* is discussed in depth by *Print* magazine 53, no. 3 (June 1999): 41–49.

16 See Julie Lasky, *Some People Can't Surf: The Graphic Design of Art Chantry* (San Francisco: Chronicle Books, 2001).

17 Victore's work is discussed in Leslie H. Sherr, "James Victor," *Idea* 46, no. 266 (January 1998): 35–38.

18 Anderson's work is discussed in Kira Obolensky, "Charles S. Anderson: Designs Created by Vernacular," *Graphis* 53, no. 312 (November-December 1997): 28–37.

19 See Kit Hinrichs, *Typewise* (Cincinnati: North Light Books, 1990).

20 *Emigre* magazine chronicled the early computer revolution as it happened, providing an outlet for designers and writers covering this major revolution. The book by Rudy VanderLans and Zuzana Licko et al., *Emigre: Graphic Design into the Digital Realm* (New York: Van Nostrand Reinhold, 1993), provides an overview.

21 The term "new primitives" was coined because low-resolution output and the use of obviously bit-mapped images characterized much early graphic design executed on personal computers and laser printers.

22 For a discussion of *French Fries* and other book art projects by Lehrer, see Philip B. Meggs, "Performing Art." *Print* 47, no. 3 (May–June, 1993): 80–87.

23 See April Greiman, *Hybrid Imagery: The Fusion of Technology and Graphic Design* (New York: Watson-Guptill, 1990); and April Greiman and Ric Poyner, *April Greiman: it'snotwhatyouthinkitis* (Bordeaux: Arc en Rève Centre d'Architecture; and Zurich: Artemis, 1994).

24 See VanderLans and Licko et al., *Emigre: Graphic Design*.

25 Covers and pages from *Ray Gun* are reproduced in Lewis Blackwell and David Carson, *The End of Print: The Graphic Design of David Carson* (San Francisco: Chronicle Books, 1995), 76–111.

26 Blackwell and Carson, *The End of Print*, is the most comprehensive publication on Carson.

27 See Lewis Blackwell and David Carson, *David Carson: Second Sight* (New York: Rizzoli International Publications, 1997).

28 See Marty Neumeier, "Page Craft," *Critique* 8 (Spring 1998): 18–29.

29 See Tibor Kalman et al., *Tibor Kalman: The Perverse Optimist* (New York: Princeton University Press, 1988).

30 A survey of contemporary motion graphics is provided by Jeff Bellantoni and Matt Woolman, *Type in Motion: Innovations in Digital Graphics* (New York: Rizzoli International Publications, 1999).

31 An outstanding book on Web site design is Roy McKelvey, *Hypergraphics* (New York: Watson-Guptill, 1998).

32 One can view the latest kinetic versions of the MTV animated logo through one's local cable television provider.

33 This design system is detailed in Josef Müller-Brockmann, *The Graphic Artist and His Design Problems* (Teufen AR, Switzerland: Verlag Arthur Niggli, 1968); and Josef Müller-Brockmann, *Grid Systems* (Niederteufen, Switzerland: Verlag Arthur Niggli, 1981).

34 See Philip B. Meggs, *Tomás Gonda: A Life in Design* (Richmond: Virginia Commonwealth University, Anderson Gallery, 1993).

35 For businesses wishing to know more about visual identity, an excellent book, with English and Danish texts, is Per Mollerup, *The Corporate Design Programme* (Copenhagen: Danish Design Centre, 1987).

36 A full presentation of Esprit graphics can be seen in the book by Douglas Tompkins et al., *Esprit's Graphic Work 1984–1986* (San Francisco: Esprit de Corp, 1987).

37 See Lewis Blackwell, "A Man of Many Faces," *Creative Review* 17, no. 5 (May 1997): 87; and Poppy Evans, "Fonts by Hand." *How* 13, no. 1 (January–February 1998): 68–75.

38 See "Woody Pirtle," *Idea* 412, no. 240 (September 1993): 154–55.

39 For a more detailed presentation of the 1984 Olympics graphics, along with graphics for all the modern Olympic games, see Wei Yew, *The Olympic Image: The First 100 Years* (Edmonton, Canada: Quon, 1996).

40 See Barbara Kruger et al., *Barbara Kruger* (Cambridge, Mass.: MIT Press, 1999); and Barbara Kruger and Kate Linker, *Love for Sale: The Words and Pictures of Barbara Kruger* (New York: Harry N. Abrams, 1990).

41 See Emma O. Kelly, "Kidd's Stuff," *Design Week* 12, no. 27 (July 11, 1997): 12–13.

BIOGRAPHIES
COMPILED BY
MELISSA MARTIN MARSH

RIK ADIGARD
1953, Brazzaville, Congo.
Graphic designer
F.A., California College of Arts and Crafts, Oakland, Calif., 1987.

Designer, Cronan Design, 1985–86; free-lance graphic designer, 1986–89; co-founder and principal, M.A.D., 1989 to present; design director, Wired Digital, 1996–98.

Awards include Chrysler Award for Innovation in Design, 1998; numerous *Communication Arts* and *Graphis* awards. Work has been exhibited at San Francisco Museum of Modern Art, San Francisco, Calif.; Cooper-Hewitt, New York City; International Design Conference, Aspen, Colo., and many others.

HARRY ALLEN
b. 1964, Plainfield, N.J.
Designer
M.A., industrial design, Pratt Institute, New York City, 1993.

Opens Harry Allen & Associates, New York, 1993.

Interior, furniture, product, and lighting designer. Clients have included Donna Karan, Ikea, MAC Cosmetics, Magis, George Kovacs, and Dom Perignon. Internationally acclaimed design of MOSS gallery, SoHo, New York, 1994.

Brooklyn Museum of Art, Young Designer Award, 2000; foam lamps shown in Museum of Modern Art's "Mutant Materials in Contemporary Design" (1994) and recently joined MoMA's design collection.

Currently has office in New York City.

CHARLES S. ANDERSON
b. 1958, Minneapolis, Minn.
Graphic designer
B.F.A., Minneapolis College of Art and Design, 1981.

Designer, Design Center Minneapolis, 1983; designer, Duffy Design Group, Minneapolis, 1985; becomes partner at Duffy Design Group (part of Fallon McElligott Advertising), 1987; opens Charles S. Anderson Design Company, Minneapolis, 1989; founds affiliate company CSA Images, Minneapolis, 1995.

Clients include Nike, Warner Brothers, Coca-Cola, Levi's, Sony, and Paramount Pictures.

Work has been exhibited at Museum of Modern Art, New York City; Cooper-Hewitt, New York; The Institute of Contemporary Arts, London, England; Ginza Graphic Gallery, Tokyo, Japan.

Currently lives and works in Minneapolis.

APPLE COMPUTERS
Founded by **Steve Jobs** and **Steve Wozniak**, 1976.
Computer and product design firm
First to introduce the personal computer, with *Apple I*, 1976, *Apple II*, 1977; beige color design by Jerry Manock, Terry Ozana, and Steve Jobs set industry standard for personal computers, 1984; 500-series PowerBook laptop computer, 1994; minimalist *eMate 300* desktop computer, 1996; *iBook* laptop, 1999; and *Power Mac G4 Cube* desktop, 2000.

Awards include DaimlerChrysler Design Award, 1993; named as one of the most design-driven companies, *ID Magazine*, 1999. Apple's computer designs are in collections of Museum of Modern Art, New York City; Whitney Museum of American Art, New York, and others.

Company headquarters in Cupertino, Calif., with offices in Canada, Europe, Mexico, South America, and Japan.

MICHAEL BIERUT
b. 1957, Cleveland, Ohio.
Graphic designer
B.S., University of Cincinnati, Ohio, 1980.

Joins Vignelli Associates, New York City, 1980; joins Pentagram Design, New York, as partner, 1990.

Clients have included United Airlines, Walt Disney Imagineering, Brooklyn Academy of Music, Rock 'n' Roll Hall of Fame and Museum, Motorola, Alfred A. Knopf, and Council of Fashion Designers of America.

Work is in permanent collections of Museum of Modern Art, New York; Metropolitan Museum of Art, New York; Cooper-Hewitt, New York; Library of Congress, Washington, D.C.; and Museum für Kunst und Gewerbe, Hamburg, Germany. Senior Visiting Critic, Yale University School of Art, 1996 to present; National President, American Institute of Graphic Arts, 1998–2001.

Currently lives in Sleepy Hollow, N.Y., and works in New York.

DONALD BOOTY JR.
b. 1956.
Designer
Studied at Illinois Institute of Technology, Chicago, Ill.

Founded Booty Design Associates, Scottsdale, Ariz., 1988.

Designs electronics, housewares, lighting, and industrial products including Zelco *Double Plus* calculator, 1986.

Work is included in collection of Denver Art Museum, Denver, Colo.

Currently has office in Scottsdale, Ariz.

CONSTANTIN BOYM
b. 1955, Moscow, Russia.
Architect and designer
B. Arch., Moscow Architectural Institute, Moscow, Russia, 1978; M. Design, Domus Academy, Milan, Italy, 1985; U.S. registered architect, 1988.

Establishes Boym Design Studio, New York City, 1986.

Product, furniture, and exhibition designer. Clients include Alessi, Geiger/Brickel, Authentics, Swatch, Cooper-Hewitt Museum, and Wichita Art Museum.

Annual Design Review Award, *ID Magazine*, 1988, 1990, 1991, 1993, 1994, 1997, 2000; first prize in IDSA Design competition for writing instruments, 1989; Federal Design Achievement Award, 1995. Boym Design Studio's objects are in collections of Museum of Modern Art, New York City, Cooper-Hewitt, and many others. Has taught design at Parsons School of Design, New York, 1986–2000. Guest lecturer at such institutions as University of the Arts, Philadelphia, Pa.; Cranbrook Academy of Arts, Bloomfield Hills, Mich.; University de Nuevo Leon, Monterrey, Mexico; and Kanazawa International Design Institute, Kanazawa, Japan.

Boym Partners Inc. has office in New York City.

LAURENE LEON BOYM
b. 1964, New York City.
Designer
B.F.A., School of Visual Arts, New York City, 1986; M.I.D., Pratt Institute, New York, 1993. Joins Boym Design Studio in 1993 as design partner.

Product, furniture, and exhibition designer. Clients include Alessi, Geiger/Brickel, Authentics, Swatch, and Cooper-Hewitt Museum.

Founding member of Association of Women Industrial Designers (AWID).

Designs have been exhibited at Gallery 91, New York; at Alessi Studio, Milan, Italy; and in "Mechanical Brides" exhibition, Cooper-Hewitt Museum, New York. Teaches at Parsons School of Design.

Editor and designer of AWID Web site.

Boym Partners Inc. has office in New York City.

KEVIN BRADLEY
b. 1963, Greenville, Tenn.
Graphic designer
Attended the University of Tennessee, 1987–94.

Designer, Hatch Show Print, Nashville, Tenn., 1994.

Currently works at Yee-Haw Industrial Letterpress, Knoxville, Tenn.

ROGER BROWN
b. 1949, Colorado Springs, Colo.
Designer
B.A., Colorado University.

Currently has office in Colorado.

CALIFORNIA DROP CLOTH
Founded 1975 by **Leonard Polikoff**, Los Angeles, Calif.
Textile design firm and manufacturer
Polikoff is a graduate of University of California, Los Angeles.

Company is known for fabrics with patterns that appear accidental, splattered-on. Fabrics are hand-painted and manufactured in over seventy patterns.

DAVID CARSON
b. 1956, Corpus Christi, Tex.
Graphic designer
B.A., San Diego State University, San Diego, Calif., 1977.

Begins work at *Transworld Skateboarding*, 1983; art director, *Beach Culture*, 1990; art director, *Ray Gun*, 1992; opens David Carson Design, ca. 1993.

Firm produces print graphics, television commercials, and Web designs. Clients include American Airlines, American Express, Budweiser, Citibank, Nike, Pepsi, and Sony.

Awards include Designer of the Year, International Center of Photography, 1995; Best Book Design, *Cyclops*, by Albert Watson, 1995; "Master of Typography," *Graphis* magazine; one of "America's Most Innovative Designers," *ID Magazine*.

Books include *The End of Print: The Graphic Design of David Carson*, New York, 1995; *2nd Sight: Grafik Design After the End of Print*, New York, 1997; *Fotographiks*, New York, 1999.

Currently has offices in New York and San Diego.

DONALD CHADWICK
b. 1936, Los Angeles, Calif.
Designer
B.A., University of California, Los Angeles, 1959.

Opens practice in Los Angeles, 1964; forms partnership Chadwick, Stumpf & Associates with Bill Stumpf, Winona, Minn., 1977.

Design work for Herman Miller includes modular seating system, 1974; *C-forms* office desk systems, 1979; *Equa* chair with Stumpf, 1984; and *Aeron* chair with Stumpf, 1994.

International Product Design Award, ASID, 1986; First Place Award for Seating, Institute for Business Designers, 1992; and Design Innovations 95 Award, Design Zentrum, Germany, 1995. Work included in collections of Museum of Modern Art, New York City, and Denver Art Museum, Denver, Colo.

Currently Donald Chadwick & Associates has office in Santa Monica, Calif.

AMY CHAN
b. 1961, Seattle, Wash.
Graphic designer
B.F.A., Columbus College of Art and Design, Columbus, Ohio, 1984.

Typesetter, Bellevue Printing and Graphics, Bellevue, Wash., 1984; production artist, William Allen & Associates, Seattle, Wash., 1986; joins Pentagram Design, San Francisco, Calif., 1989.

Currently senior designer at Pentagram Design, San Francisco.

ERIC CHAN
b. 1952, Canton, China.
Designer
B.A., Hong Kong Polytechnic, Hong Kong, 1976; M.F.A., Cranbrook Academy of Art, Bloomfield Hills, Mich., 1980.

Founds Ecco Design, New York City, 1989.

Furniture and product designer. Clients include Herman Miller, Apple Computer, Motorola, LG, Corning, Siemens, OXO, and Sharp.

Annual Design Review Award, *ID Magazine*, 1988–92, 1994, 1997–99, 2001; Forma Finlandia 2, International Design Competition, Finland, 1990; Best Product of 1990, *Design News*; Design Plus Award, Frankfurt Fair, Germany, 1990; IDEA award, IDSA, 1994, 1995, 1997, 2000, 2001. Designs are in collections of Design Museum, London, England; Cranbrook Museum of Art, Bloomfield Hills, Mich., Museum of Modern Art, New York City; Cooper-Hewitt, New York; and Denver Art Museum, Denver, Colo.

Currently has office in New York City.

ARTHUR S. W. CHANTRY II
b. 1954, Seattle, Wash.
Graphic designer
B.A., Western Washington University, Bellingham, Wash., 1978.

Free-lance designer.

Currently lives and works in St. Louis, Mo.

COMFORT PRODUCTS INC.
Founded by **Eric Giese**, 1973.
Sports equipment design firm
Eric Giese
b. 1939, Seattle, Wa.

B.S., J.D.L., University of Washington.

PETER COMITINI
b. 1957, New York City.
Graphic designer
B.F.A., School of Visual Arts, New York, 1982.

Design director, NBC, New York, 1986–89; cover art director, *Newsweek* magazine, New York, 1999–94; opens Peter Comitini Design, now known as LiveArea, 1995; director, customer experience architect, Scient, New York, 2000; independent design consulting, New York, 2001.

Clients have included OXO International, Nickelodeon Online, Discovery Channel, NY1 News, Global Strategy Group, RevMart, DPA, and Ferguson 2000.

Numerous awards from Art Directors Club, AIGA, Society of Publication Designers, *Graphis* and *Print* magazines, *Communication Arts*, and *American Journalism Review*. Work has been exhibited at Cooper-Hewitt, New York. Has taught at School of Visual Arts, New York.

Currently lives and works in New York.

TONY COSTANZA
b. 1949, Schenectady, New York.
Designer
B.F.A., Art Institute of California, Berkeley, Calif.,1971; M.F.A., Mills College, Oakland, Calif., 1973.

Textile and product designer. Works with Fabric Workshop, 1980.

Currently is founder of and designer at Theatrum Botanicum in Cooperstown, New York.

MICHAEL CRONAN
b. 1951, San Francisco, Calif.
Graphic designer
B.A., California State University, Sacramento, Calif., 1973.

Opens Cronan Artefact, product development, manufacturing, and marketing company, Emeryville, Calif., 1991; opens Cronangroup, identity and design company, Emeryville, 1999.

Clients have included Adobe Systems, Apple Computer, Estée Lauder, Nintendo, Radius, Silicon Graphics, Williams-Sonoma, and the U.S. Postal Service.

Work is in permanent collections of Library of Congress, Washington, D.C.; Museum of Modern Art, San Francisco, Calif.; Victoria & Albert Museum, London, England.

Currently lives and works in Emeryville.

CHRISTOPHER DEAM
b. 1965, Ann Arbor, Mich.
Architect and designer
B. Arch., California Polytechnic State University, San Luis Obispo, Calif., 1986; M. Arch., University of Notre Dame, Notre Dame, Ind., 1991.

Works with Matteo Thun, Milan, Italy, 1986; works with Frank Gehry, Venice Beach, Calif., 1987; works for Antonio Citterio, Milan, Italy, 1990; founds CCD, architecture and furniture design studio, 1991.

ICFF Editor's Award for furniture design, 1997; ICFF Editor's Award for Body of Work, 1998; George Nelson Award for furniture design, *Interiors*, 1999; AIA Honor Award, 1999; Good Design Award, Chicago Athenaeum, 2000. Teaches at California College of Arts and Crafts, San Francisco, Calif.

Currently has office in San Francisco, Calif.

DESIGN CENTRAL
Industrial design firm
Firm opens 1985.
Principals are **Rainer Teufel**, **Gregg Davis**, and **Deb Davis-Livaich**
Clients include Artromick International, Caterpillar, Daewoo, GE Europe, Mead, Nike, Rubbermaid, Siemens, Sunbeam, and Whirlpool Corporation.

Awards include *Business Week* & IDSA, IDEA Gold, 2000, 1999, 1995, 1994, 1989; *Appliance Manufacturer Magazine* Award 2001, 2000, 1996; American Society for the Aging, Gold, 2000; Industrie Design Forum Hannover, IF design award, 1996.

Currently has headquarters in Columbus, Ohio; member of Designet with offices in San Francisco, Calif., and Hollis, N.H.

DESIGN LOGIC
Founded in 1985 by **David Gresham** and **Martin Thaler**.
Product design firm
Gresham graduated from Cranbrook Academy of Art, Bloomfield Hills, Mich. Thaler graduated from Royal Academy of Art, London. Both partners previously worked in industrial design department of communications company ITT.

Firm has designed products for such clients as View-Master, Dictaphone, RCA, and Bang & Olufsen.

Designs included in collection of Cranbrook Museum of Art, Bloomfield Hills, Mich.

NICK DINE
b. 1966, New York City.
Designer
B.A., Rhode Island School of Design, Providence, R.I., 1987; advanced degree, Royal College of Art, London, England, 1991.

Sets up practice in London, 1991; founded Dinersan, Inc., New York City, 1993.

Firm projects include interiors of Embassy Bar, 1995; Take Restaurant, 1995; Totem Showrooms, 1997, all in New York City, as well as numerous private residences. Launches line of furniture at NY International Contemporary Furniture Fair, 1997.

Currently has office in New York City.

NED DREW
b. 1963, Alexandria, Va.
Graphic designer
B.F.A., 1987; M.F.A., 1994, Virginia Commonwealth University, Richmond, Va.

Senior designer, Grafik Communications Ltd., Alexandria, Va., 1987–91; design consultant, Rev Group, Philadelphia, Pa., 1995 to present; director, The Design Consortium, Rutgers University, Newark, N.J., 1995 to present.

Awards include Certificate of Design Excellence, *Print Magazine*, 2000; Certificate of Typographic Excellence, New York Type Directors Club, 2000; Award of Merit, HOW International Design Competition, 2000; Award of Excellence, Graphis Poster Annual, 1998; Certificate of Design Excellence, *Print Magazine*, 1997; Award of Excellence for Book Cover Design, AIGA, 1995. Associate Professor, Rutgers University, Newark, N.J.

Currently lives in New York City and works in Newark.

JOE DUFFY
b. 1949, Minneapolis, Minn.
Graphic and Web-site designer
Attended Minneapolis School of Art, 1968–69; University of Minnesota, 1970–71.

Partner and creative director, DBK & O Advertising, Minneapolis, 1980; founds Duffy Design, Minneapolis, 1984; opens office in New York City, 1995; London, England, 2000.

Clients include BMW, EDS, Nordstrom, FAO Schwartz, and International Truck and Engine Corporation.

Work has been exhibited at Gallery van Oertzen, Frankfurt, Germany; Victoria & Albert Museum, London, England.

Currently is Chairman of Duffy Design.

PETER EISENMAN
b. 1932, Newark, N.J.
Architect
B. Arch., Cornell University, Ithaca, N.Y., 1955; M. Arch., Columbia University, New York City, 1960; Ph.D., theory of design, Cambridge University, England, 1963.

Founds Institute for Architecture and Urban Studies, New York, 1967; director of the Institute and editor of its magazine *Oppositions*, to 1982; opens architectural firm, New York, 1980.

Works include Aronoff Center for Design and Art, University of Cincinnati, Ohio, 1988–96; Wexner Center for the Arts and Fine Arts Library, Ohio State University, Columbus, Ohio, 1983–89; Koizumi Sanyo Corporation Headquarters, Tokyo, Japan, 1988–90; Office Development Project, Madrid, Spain, 1990; Virtual House Competition, Berlin, Germany, 1997; Hell's Kitchen South, New York, project, 1999.

Guggenheim Fellow, 1976; Brunner Prize, American Academy and Institute of Arts and Letters, 1984. Has taught at such institutions as Princeton, Cooper Union, Harvard, Yale, and Ohio State universities.

Books by Eisenman: *House X*, New York, 1985, *Houses of Cards*, New York, 1987; *Moving Arrows and Other Errors*, London, 1989; *Guardiola House*, Berlin, 1989.

Currently has office in New York.

_OUISE FILI
.1951, Orange, N.J.
raphic designer
.S., Skidmore College, 1973.

_enior designer, Herb Lubalin Associates, New York City,
_976–78; art director, Pantheon Books, New York, 1978–89;
_stablishes Louise Fili Ltd., New York, 1989.

_rm specializes in logo, package, type, and book jacket design.
_lients include Chronicle Books, Williams-Sonoma, Bella Cucina,
_an-Georges Vongerichten, El Paso Chile Co., and Steerforth Press.

_wards include Gold and Silver Medals, New York Art Directors
_lub and Society of Illustrators; Premio Grafica, Bologna Book Fair;
_NEA Grant. Work is in permanent collections of Library of Congress,
_Washington, D.C.; Cooper-Hewitt Museum, New York; Musée des
_rts Décoratifs, Lausanne, Switzerland.

_urrently has office in New York.

_AN FRIEDMAN
_. 1945, Cleveland, Ohio; d. 1995.
Designer and graphic designer
_.F.A., Carnegie Institute of Technology, 1967; postgraduate study
_n Ulm, Germany, and School of Design, Basel, Switzerland.

_Worked as graphic designer for such firms as Anspach, Grossman,
_Portugal, and Pentagram Design.

_Work in graphic design while at Yale University includes introducing
_new design for typography which influenced the "New Wave" in
_U.S. graphic design. Experimental furniture designs have been
_produced by Neotu, Paris, France; Arredaesse, Driade, and
_Alchimia, Milan, Italy.

_Work is in collections of Museum of Modern Art, New York City;
_Museum of Modern Art, San Francisco, Calif.; Art Institute of
_Chicago, Chicago, Ill.; Virginia Museum of Fine Arts, Richmond,
_Va.; Gewerbemuseum, Basel, Switzerland; and Cooper-Hewitt,
_New York. Taught at Yale University, New Haven, Conn., and
_Cooper Union, New York.

_Books include _Dan Friedman: Radical Modernism_, Yale University
_Press, 1994.

FROGDESIGN
Founded by **Hartmut Esslinger**, Altensteig, Germany, 1969.
Industrial design firm
Hartmut Esslinger
b. 1944, Beuren, Germany.
University of Stuttgart, Stuttgart, Germany, 1966–67;
Fachhochschule für Design, Schwäbisch Gmünd, 1968–70.

Industrial, digital, and brand design. First Client, Wega Radio,
becomes Sony, 1975; opens offices in California, 1982. Clients
include Apple Computer, Olympus, AT&T, and AEG. Notable
designs include Apple IIc computer, Sony Triniton flatscreen TV,
Micron PC products, and Wurther t'Blade hockey skate.

Awards include Lucky Strike Designer Award for Outstanding
Industrial Design, Raymond Loewy International Foundation, 1992;
Industrial Design Excellence Award, IDSA, 2000; and Design
Distinction Award, _ID Magazine_, 2000.

Headquarters in Sunnyvale, Calif.; other offices in Germany, Japan,
Taiwan, Israel, as well as New York, Michigan, and Texas.

DOUG GAROFALO
b. 1958, Schenectady, N.Y.
Architect
B. Arch., University of Notre Dame, Notre Dame, Ind., 1981;
M. Arch., Yale University, New Haven, Conn., 1987.

Yale University Graduate School of Architecture winner of Feldman
Prize, Winchester Traveling Fellowship, 1985; Skidmore, Owings &
Merrill Foundation Traveling Fellowship, 1987.

Buildings include Dermon house, Skokie, Ill., 1992; Oneiric house,
Burr Ridge, Ill., 1993; Thornton-Tomasetti Engineers Offices,

Chicago, Ill., 1999; New York Presbyterian Complex, New York
City (with Greg Lynn FORM and Michael McInturf Architects), 1999;
Time Museum, Chicago, 2001.

Young Architect Award, AIA Chicago, 1996; New Vanguard,
Architectural Record, 2000; Design Award, AIA Chicago, 2001;
Emerging Voices, Architectural League of New York, 2001. Teaches
at Archeworks design laboratory; Associate Professor, University of
Illinois, School of Architecture, Chicago; is visiting lecturer at
numerous architectural schools.

Currently has office in Chicago.

FRANK O. GEHRY
b. 1929, Toronto, Canada
Architect and designer
B Arch., University of Southern California, Los Angeles, Calif.,
1954; Graduate School of Design, Harvard University, Cambridge,
Mass., 1956–57.

Opens Frank O. Gehry and Associates in Los Angeles, 1967.

Architect. Furniture, lighting, and tableware designer. Architectural
work includes Gehry house, Santa Monica, 1977–78; California
Aerospace Museum, Los Angeles, 1984; Yale Psychiatric Institute,
New Haven, Conn., 1989; Frederick Weisman Museum,
Minneapolis, Minn., 1994; Guggenheim Museum, Bilbao, Spain,
1991–97; Experience Music Project, Seattle, Wash., 2000.
Design work includes _Easy Edges_ cardboard furniture, 1969–72;
and _Experimental Edges_ cardboard furniture, 1979–82.

Awards include Brunner Prize, American Academy and Institute of
Arts and Letters, 1983; Pritzker Prize, 1989; Imperiale Award in
Architecture, Japan Art Association, 1992; National Medal of Arts
Award, 1998; Gold Medal, AIA, 2000.

Has taught architecture at University of California, Los Angeles,
1977–79; and Yale University, 1982, 1985, 1987–89.

Currently has office in Santa Monica, Calif.

ALEXANDER GELMAN
b. 1967.
Graphic designer
B.F.A., Moscow Art Institute, 1988.

Joins Access Factory, New York City, 1993; becomes partner at
Access Factory, 1995; joins Swatch Design Lab, New York, 1997;
establishes Design Machine, New York, 1998; creative director,
NOVO, New York, 2000.

Clients have included Absolut Vodka, Apple Computers, Chanel,
Dell Computers, HBO, IBM, Sony, and United Airlines.

Work is in permanent collections of Museum of Modern Art, New
York; Cooper-Hewitt, New York. Teaches at Cooper Union School of
Art and School of Visual Arts, New York.

Currently lives and works in New York.

LYN GODLEY
b. 1956, Oberlin, Ohio.
Designer
B.F.A., Ohio State University, Columbus, Ohio, 1978; M.F.A.,
University of Wisconsin, Madison, Wis., 1980.

Founds Godley & Schwan with Lloyd Schwan, 1984; becomes sole
owner of firm, Lyn Godley & Co., 1997.

Designs jewelry, accessories, lighting, and furniture. Clients include
Barney's New York, Geoffrey Beene, Walt Disney, and Warner
Bros.

Excellence in Product Design, New York Gift Fair, 1989, 1995;
Crinkle Lamp in permanent collection of Museum of Modern Art,
New York City, 1998.

Currently has office in Hamburg, Pa.

TOMÁS GONDA
b. 1926, Budapest, Hungary; d. 1988, New York City.
Graphic designer
Studied at Budapest Academy of Fine Arts, 1944–46.

Taught at Ulm Hochschule, Ulm, Germany, 1962–65; opened
Gonda Design, Inc., New York, 1978.

Worked as designer in Argentina, Germany, Italy, and the U.S.
Taught at Ohio State University, Columbus, Ohio; SUNY, Purchase,
N.Y.; and Cooper Union, New York.

Work included publications, corporate identity, fine art, and
photography.

MICHAEL GRAVES
b. 1934, Indianapolis, Ind.
Architect and designer
B. Arch., University of Cincinnati, Cincinnati, Ohio, 1958,
M. Arch., Harvard University, Cambridge, Mass., 1959. Opens
architecture firm, Princeton, N.J., 1964.

Architect. Furniture, lighting, textile, jewelry, product, and tableware
designer. Architectural projects include Public Services Building,
Portland, Or., 1980; Swan and Dolphin hotels, Orlando, Fla.,
1987; Humana Building, Louisville, Ky., 1982; Museum of Art,
Emory University, Atlanta, Ga., 1982; Denver Central Library,
1995; Domaine di Pegase winery and houses, Napa Valley, Calif.,
1984–87. Product designs include tableware for Swid Powell and
Alessi, carpeting for Vorwerk, furniture for SunarHauserman, product
designs for Target, bath fixtures for Duravit, Dornbracht, and Hoesch,
metal door handles for Valli & Valli.

Eleven honorary degrees; Fellow at the American Academy in
Rome, 1960–62; ten AIA National Honor Awards; National Medal
of Arts, 1999; Gold Medal, AIA, 2001. Professor of Architecture,
Princeton University, Princeton, since 1962; Fellow, AIA; and trustee,
American Academy in Rome. Work is in permanent collections of
Museum of Modern Art, New York City; Metropolitan Museum,
New York; Cooper-Hewitt, New York; Brooklyn Museum, Brooklyn,
N.Y.; Denver Art Museum, Denver, Colo.; Berlin Museum, Berlin,
Germany; and the Virginia Museum of Fine Arts, Richmond, Va.

Books include _Five Architects_, Oxford University Press, 1972;
Michael Graves: Building and Projects, 1966–1981, Rizzoli,
1983; _The Master Architect Series III: Michael Graves: Selected
and Current Works_, Images Publishing, 1999.

Has offices in Princeton, N.J., and New York, for architecture,
interior, product, graphic design.

APRIL GREIMAN
b. 1948, New York City.
Graphic designer
Attended Kansas City Art Institute, Kansas City, Mo.; Allgemeine
Kunstgewerbeschule, Basel, Switzerland. Opens practice in Los
Angeles, Calif., 1976; joins Pentagram Design, Los Angeles, as
partner, 2000.

Awards include Medal of the American Institute of Graphics, 1998;
Chrysler Award for Innovation, 1998.

Currently is partner at Pentagram Design, Los Angeles.

DAVID GULASSA
b. 1961, Walnut Creek, Calif; d. 2001, Seattle, Wash.
Designer and sculptor
Studied at Renaissance Art School, Oakland, Calif.

Founds David Gulassa & Co., specializing in furniture, lighting,
vases, and interior design, Seattle, Wash., 1990.

Designs and constructs interior metalwork for Steven Holl's St.
Ignatius Chapel, Seattle University, Seattle, Wash., 1997; constructs
Washington State's World War II Memorial, Olympia, Wash.,
1998. Gulassa was known for his metalwork, but company also
worked with wood, glass, and concrete for comprehensive interior
designs.

David Gulassa & Company currently has office in Seattle, Wash.

DOROTHY HAFNER
b. 1952, Woodbridge, Conn.
Designer
B.A., Skidmore College, N.Y., 1974.

Designer of ceramics, glass, and textiles.

Produced signature ceramic collection for Tiffany & Co., 1979–90; throughout 1980s was principal designer at Rosenthal in Germany; produced a line of handblown and fused glass first exhibited at Heller Gallery, New York City, 1995, now in galleries worldwide.

Certificate of Honor, Women in Design International, 1983; Fellowship, New York Foundation for the Arts, 1986; Design Excellence, Stuttgart Design Center Award, 1987, 1988. Work is in collections of Cooper-Hewitt, New York City; Los Angeles County Museum, Los Angeles, Calif.; Victoria & Albert Museum, London, England; American Craft Museum, New York City; Corning Museum of Glass, Corning, N.Y., and others.

Currently has studio in New York City.

KATRIN HAGGE
b. 1963, Bonn, Germany.
Designer
B.A., Fashion Institute of Technology, New York City, 1990.

Has worked in Italy and U.S.; designs for Knoll Textiles since 1996.

Awards include Good Design Award, Chicago Athenaeum, 1999, 2000.

Currently works in New York City.

CLIFFORD A. HARVEY
Graphic designer
B.F.A., Minneapolis College of Art and Design, Minneapolis, Minn., 1960.

Special book designer, Meredith Publishing Company, Des Moines, Iowa, 1960–61; Design director, Control Data Corporation, 1961–66; Assistant Professor, University of Utah, 1966–73; opens Permutation Press, 1977; Associate Professor and Coordinator, Graphic Design Program, West Virginia University, 1973; Professor, West Virginia University, 1979 to present.

Awards include Design Grants, NEA, 1986, 1993; Jurors Choice Award, Pyramid Atlantic Book Fair and Invitational, Corcoran Gallery, Washington, D.C., 1998; Distinguished Service Award, West Virginia University, Division of Art, 1999.

Work has been exhibited at numerous colleges, galleries, and museums including Cincinnati Academy of Fine Arts, Cincinnati, Ohio; Corcoran Gallery, Washington, D.C.; and New York Center for the Book, New York City. Work is in permanent collections of Baker Library and Historical Collection, Harvard Business School; Arts of the Book Collection, Yale University Library; Hamilton Wood Type Museum, Two Rivers, Wis., and many others.

Currently lives and works in Morgantown, W.Va.

HERBST LAZAR BELL
Founded 1963, Chicago, Ill.
Product design firm

Provides research, planning, industrial design, engineering, and prototype resources to clients such as Motorola, Kodak, Hewlitt-Packard, Compaq, Sunbeam, Craftsman, and Gillette. Company creates brand identities, refurbishes old product lines, and develops products for specific marketplaces.

Headquarters in Chicago with additional offices in Fla., Mass., and Calif.

KIT HINRICHS
Graphic designer
Studied at Art Center College of Design, Los Angeles, Calif.

Forms Jonson, Pedersen, Hinrichs & Shakery, design partnership, San Francisco, Calif., 1976; merges with Pentagram Design, San Francisco, 1986.

Specializes in corporate communication and promotion, packaging, editorial, and exhibition design.

Work is in collection of San Francisco Museum of Modern Art. Fellow, AIGA; member, Alliance Graphique Internationale; currently trustee, Art Center College of Design, Los Angeles; serves on Accessions, Design, and Architecture Committee, San Francisco Museum of Modern Art. Has taught at School of Visual Arts, New York City; California College of Arts and Crafts, San Francisco; and Academy of Art, San Francisco.

Currently lives and works in San Francisco.

JONATHAN HOEFLER
b. 1970, New York City.
Graphic designer
Opens Hoefler Type Foundry, New York, 1999.

Clients include *Rolling Stone, Harper's Bazaar, Sports Illustrated,* and *Esquire.*

Awards include three Certificates of Excellence in Typography, New York Type Directors Club, 1991; four Certificates of Excellence, AIGA, 1992; Bronze Medal for Typeface, Morisawa Awards, 1996; Certificate of Excellence in Type Design, New York Type Directors Club, 1998. Work is in permanent collection of Cooper-Hewitt, New York.

Currently lives and works in New York.

STEVEN HOLL
b. 1947, Bremerton, Wash.
Architect and designer
B. Arch., University of Washington, 1970; studied at Architectural Association, London, England, 1976.

Opens firm in New York City, 1976.

Architect. Furniture, textile, and tableware designer. Architectural work includes Hybrid Building, Seaside, Fla., 1988; D. E. Shaw & Co. Office, New York, 1991–92; Storefront for Art and Architecture, New York, 1994; Stretto House, Dallas, Tex., 1989–92; Makuhari Housing, Chiba, Japan, 1992–97; Museum of Contemporary Art, Helsinki, Finland, 1993–97; Chapel of St. Ignatius, Seattle University, Wash., 1994–97; Cranbrook Institute of Science, Bloomfield Hills, Mich., 1998. Design work includes tableware for Swid Powell and rug design for V'Soske, Inc.

Progressive Architecture Citations, 1982, 1984, 1986, 1987; Brunner Prize, American Academy and Institute of Arts and Letters, 1990; Progressive Architecture Award for Void Space/Hinged Space Housing, Fukuoka, Japan, 1991; and National Honor Award, AIA, 1991–92. Teaches at Columbia University, New York.

Currently has office in New York.

STEVEN SKOV HOLT
b. 1957, Santa Barbara, Calif.
Designer
Has worked at Zebra Design, Cologne, Germany; Smart Design, New York City. Became Director of Strategy, frogdesign, New York, 1992.

Chair of Industrial Design programs, California College of Arts and Crafts, San Francisco, Calif., 1995; editor, *ID Magazine.*

Currently works at frogdesign, San Francisco.

BELLE HOW
b. 1953, San Francisco, Calif.
Graphic designer
B.A., University of California, Berkeley, 1975.

Designer, Jonson, Pederson, Hinrichs & Shakery, San Francisco, 1983; designer, Pentagram Design, San Francisco, 1986; elected Associate, Pentagram Design, 1995.

Currently works at Pentagram Design, San Francisco.

ALEXANDER ISLEY
b. 1961, Durham, N.C.
Graphic designer
B.E.D., North Carolina State University, Raleigh, N.C., 1983.

B.F.A., Cooper Union for the Advancement of Science and Art, New York City, 1984.

Senior designer, M&Co., New York, 1984; art director, *Spy Magazine,* New York, 1987; principal, Alexander Isley Inc., New York, and Redding, Conn., 1988 to present.

Work has been exhibited at Museum of Modern Art, New York; Pompidou Center, Paris, France; Library of Congress, Washington, D.C., and Cooper-Hewitt, New York.

Currently lives in Ridgefield, Conn.

SETH JABEN
b. 1956, Kansas City, Mo.
Graphic designer
B.F.A., Rhode Island School of Design, Providence, R.I., 1979.

Principal, Seth Jaben Studios, New York City, 1979 to present; designs award-winning packaging, posters, and catalogues as creative director of E. G. Smith Hosiery, 1983; launches Seth Jaben Watch Collection, 1987.

Clients include SwatchWatch, CBS Records, Disney, Seagrams, American Express, and AT&T.

Currently has office in New York.

JIM JENNINGS
b. 1940, Santa Barbara, Calif.
Architect and designer
B. Arch., University of California, Berkeley, 1966.

Opens Jennings & Stout with William Stout, 1978; opens own firm, Jim Jennings Architecture, 1986.

Works include office of Jim Jennings Architecture, San Francisco, Calif., 1988; Italian Cemetery, Colma, Calif., 1990–93; Barclay Simpson Sculpture Studio, California College of Arts and Crafts, Oakland, Calif., 1990–93; Becker house, Oakland Hills, Calif., 1994; Grandia Stephenson house, Calistoga, Calif., 1995; Oliver house, San Francisco, 1997; Rimerman house, Napa, Calif., 2001; Wong house, Hillsborough, Calif., 2002.

Teaches at California College of Arts and Crafts, San Francisco, Calif.

Currently has office in San Francisco.

HALEY JOHNSON
b. 1964, Olivia, Minn.
Graphic designer
B.F.A., Moorhead State University, Moorhead, Minn., 1986.

Joins Duffy Design Group, 1986; becomes senior designer at Charles Anderson Design, 1990; opens Haley Johnson Design, Minneapolis, Minn., 1992.

Clients include Blue Q, Turner Classic Movies, and Jane Jenni, Inc.

Currently has office in Minneapolis.

DAVEN JOY
b. 1961, Los Angeles, Calif.
Designer
B.A., University of California, San Diego, Calif., 1988.

Works at North American Still Life on architectural projects, 1989; does studio work under Michael Boyd, 1991; opens Park Furniture, 1992.

Furniture designer. Clients include Sony Corporation, Gap, Banana Republic, Manhattan Hotel Tokyo, and Warner Brothers.

Best Body of Work, ICFF, USDA, 1998; bookcase and side table selected for collection of Museum of Modern Art, San Francisco, Calif., 1998.

Currently has office in Pacifica, Calif.

TIBOR KALMAN
b. 1949, Budapest, Hungary. d. 1999, Puerto Rico.
Graphic designer and designer
Studied at New York University, New York City.

Design and publicity director, Barnes and Noble Bookstores, 1970–79; opens design firm, M&Co., New York, 1979; editor, *Colors* magazine, New York, 1991; reopens M&Co., New York, 1995.

Clients included Talking Heads, 42nd Street Redevelopment, and Jonathan Demme.

Winner of numerous design awards.

CHIP KIDD
b. 1964, Reading, Pa.
Graphic designer
B.A., Penn State University, 1986.

Art director, Alfred A. Knopf, Inc., 1986 to present; founds Chipkidddesign, New York City, 1986.

His work has been published in *Time* magazine, *New York Magazine*, *Metropolis*, *Graphis*, *Print*, and *ID* magazines.

Has won numerous awards including *ID Magazine* annual design review, best of show, 1993, 1998; "Best Use of Photography in Graphic Design," International Center of Photography, 1997.

Currently lives and works in New York.

LISA KROHN
b. 1963, New York City.
Designer
B.A., Brown University, Providence, R.I., 1985; M.F.A., Cranbrook Academy of Art, Bloomfield Hills, Mich., 1988. Works at Smart Design, New York City, 1986; founds Krohn Design, New York City, 1987; designs at Johnson & Johnson, New York City; works with Mario Bellini, Milan, Italy, 1988; Krohn Design moves to Los Angeles, Calif., 1992.

Work as product designer includes lighting, furniture, and textiles. Clients include Herman Miller, Knoll International, Estée Lauder, Alessi, Disney, Columbia Pictures, and Steuben.

Awards include Forma Finlandia, 1987; Fulbright Fellowship, 1988; National Endowment for the Arts Grant, 1994; Young Designer Award, Brooklyn Museum, 1996; one of "40 Top Innovators," *ID Magazine*, 1997; Chrysler Design Award, 1997. Work is in the collection of Cooper-Hewitt, New York City, and many others. Teaches at Art Center College of Design, Los Angeles, Calif., Southern California Institute of Architecture, and California Institute of the Arts, 1992 to present.

Currently has office in Los Angeles, Calif.

KRUECK & SEXTON ARCHITECTS
Ronald Krueck
b. 1949, Cincinnati, Ohio.
Architect and designer
B. Arch., Illinois Institute of Technology, Chicago, Ill., 1970.
Mark Sexton
b. 1956, Chicago, Ill.
Architect
B. Arch., Illinois Institute of Technology, Chicago, 1980.

Sexton is partner, Krueck & Olsen Architects, Chicago, 1980–91; firm becomes Krueck & Sexton Architects, 1991.

Works include Painted Apartment, Chicago, 1983; Herman Miller showrooms, Chicago, 1993, 1998–2001; many U.S houses, including the Brick and Steel House, Chicago, 1981; and the Brick and Glass House, Chicago, 1994–96. Design work consists of custom furniture for residences.

AIA Award of Excellence, Chicago Chapter, 1980; AIA National Honor Award, 1986; 1st Place Award for a Bank

for Northern Trust of California, Architecture and Design Society of the Art Institute of Chicago, 1995; Honor Award, Chicago Chapter, AIA, 1996; Interior Architecture Honor Award and Architecture Honor Award Chicago Chapter, AIA, 2000. Krueck is Professor of Architecture, Illinois Institute of Technology, Chicago, 1992 to present.

Firm currently has office in Chicago.

HENNER KUCKUCK
b. 1940, Berlin, Germany.
Designer and sculptor
Technical University of Braunschweig, School of Architecture, Germany, 1960–62; Sculpture Hochschule für Bildende Kunste, Berlin, Germany, 1962–68; master student with Professor Hans Uhlman, 1968.

After a long career in public sculptor, begins industrial design in 1990, primarily furniture.

Awards include Gold Medal, Spine Chair design, *ID Magazine*, 1992; Design Distinction Award, *ID Magazine*, 1994, Felissimo Art and Design Award, 1994. Numerous exhibitions and one-man shows in New York City including Gallery 91, Pen & Brush Galleries, and The Gold Bar. Designs in the collection of Design Museum, London, England; and Denver Art Museum, Denver, Colo.

Currently has studio in New York.

WARREN LEHRER
b. 1955, Queens, N.Y.
Graphic designer, artist, and author
B.A., Queens College, Queens, N.Y., 1977; M.F.A., Yale University, New Haven, Conn., 1980.

Artistic Director, Ear/Say, writing, design, publishing, book, radio, and theatre works company, Mass., Conn., N.Y., 1980 to present; Associate Professor, School of Art and Design, SUNY, Purchase, N.Y., 1982 to present; graduate faculty, School of Visual Arts, New York City, designer as author, M.F.A. program, 1998 to present.

Has received numerous fellowships and grants for his projects.

Currently lives and works in Sunnyside, N.Y.

MAYA LIN
b. 1959, Athens, Ohio.
Architect, designer, and sculptor
B. Arch., Yale University, New Haven, Conn., 1981; M. Arch., 1986.

Works include Vietnam Veterans' Memorial, Washington, D.C., 1981; Civil Rights Memorial, Birmingham, Ala., 1989; *Eclipsed Time*, Pennsylvania Station, New York City, 1989–95; Rosa Esman Gallery (with William Bialosky), New York, 1990; Museum for African Art (with David Hotson), New York, 1992–93; *Women's Table*, Yale University, New Haven, Conn., 1993; Asia/Pacific/American Studies Institute, New York University (with David Hotson), 1997; Norton apartment, New York, 1998; Langston Hughes Library, near Clinton, Tenn., 1996–99.

Currently has studio in New York.

GREG LYNN
b. 1964, North Olmsted, Ohio.
Architect
B. Phil., Miami University of Ohio, 1986; B. Environmental Design, Miami University of Ohio, 1986; M. Arch., Princeton University, Princeton, N.J., 1988.

Works for Eisenman Architects, New York City, 1987–91; opens Greg Lynn FORM office, Hoboken, N.J., 1992; moves to Los Angeles, Calif., 1998.

Works include Artists' Space exhibition design, New York,

1995; H2 House for the OMV Austrian Mineral Oil Company, Vienna, Austria, 1996; Electra 96, Oslo, Norway, 1996; New York Presbyterian Complex, New York, designed in collaboration with Michael McInturf Architects of Cincinnati and Douglas Garofalo Architects of Chicago, 1999. Design collaborations with other firms include Uniserve Corporate Headquarters in Los Angeles, 2001; international showrooms for PGLIFE.com, 2000; Bijlmermeer Housing, Amsterdam, 2003 completion; Imaginary Forces offices, New York, 2001.

Progressive Architecture Citation, 1997; AIA Ohio Citation Award, 1999.

Teaches at institutions including ETH Zurich, UCLA, and Yale University.

Currently has office in Venice, Calif.

SUSAN LYONS
b. 1954, New York City.
Designer
B.A., Williams College, Williamstown, Mass., 1976.

Lyons and two fellow students establish Alliance Editions, textile printing studio, 1976; works as designer for Clarence House and Boris Kroll Fabrics, New York, 1979–1984; joins DesignTex, New York, as director of design, 1989.

Textile designer. Designs award-winning, environmentally safe upholstery with William McDonough, 1992.

Awards include Design Sense 2000 award (with Rohner Textile and William McDonough), Design Museum, London, England.

Currently executive vice president of design at DesignTex.

MARGARET McCURRY
b. 1942, Lake Forest, Ill.
Architect and designer
B.A., Vassar College, Poughkeepsie, N.Y., 1964; Loeb Fellow, Harvard University, Cambridge, Mass., 1986–87.

Designer, Skidmore, Owings & Merrill, 1964–77; opens Margaret McCurry Ltd., 1977; joins Stanley Tigerman and Robert Fugman to form Tigerman, Fugman and McCurry, 1982; becomes Tigerman McCurry Architects, 1988.

Architect and furniture designer. Works include Juvenile Protective Association, Chicago, Ill., 1984; Chicago Bar Association Building, 1990; Prairie Crossing Conservation Community, 1995–99; HBF Furniture & Fabrics, 1998.

Vice President, Chicago chapter, AIA, 1987–89; Chair, National AIA Committee on Design, 1993; IIDA IFMA Gold Award for Best Furniture System, NeoCon, 1998; since 1995 on appointment to Public Buildings Service National Register of Peer Professionals of the U.S. General Services Administration. Has taught design studios at Art Institute of Chicago and University of Illinois, Chicago. Currently a board member of Textile Society.

Author, *Margaret McCurry: Constructing Twenty-Five Short Stories*, 1999.

Tigerman McCurry Architects currently has an office in Chicago.

KATHERINE McCOY
b. 1945, Decatur, Ill.
Graphic designer
Joins Unimark International as designer, 1967; opens design firm McCoy & McCoy with husband, Michael McCoy, 1971.

Recent clients include Arthur Anderson Worldwide, Chronicle Books, Chicago Bears.

Co-chair of Department of Design, Cranbrook Academy of Art, Bloomfield Hills, Mich., 1971–95; Senior Lecturer,

Institute of Design, Illinois Institute of Technology, Chicago, Ill., 1995 to present.

Currently lives and works in Buena Vista, Colo. and Chicago.

MICHAEL McINTURF
b. 1962, New Philadelphia, Ohio.
Architect and designer
B. E. D., Miami University of Ohio, 1985; M. Arch., University of Illinois, Chicago, Ill., 1988.

Principal designer for Peter Eisenman, 1988; becomes associate partner at Eisenman Architects, 1991; opens Michael McInturf Architects, Cincinnati, Ohio, 1996.

Works include numerous private residences; campus plan for Cincinnati Country Day School, 1997; interior design of ProScan International, Cincinnati, 1998; Korean Presbyterian Church, Sunnyside, Queens, N.Y., 1999, designed in collaboration with Greg Lynn FORM of California and Douglas Garofalo Architects of Chicago.

Awards include Architectural Design Citation, Progressive Architecture, 1997; Citation Award for new building, AIA Ohio, 1999; Honor award, AIA, 1999. Is Assistant Professor of Architecture, School of Architecture and Design, University of Cincinnati.

Currently has office in Cincinnati.

MARK MACK
b. 1949, Judenburg, Austria.
Architect and designer
Magister of Architecture, Academy of Fine Arts, Vienna, Austria, 1972.

Begins work as free-lance architect, San Francisco, Calif., 1975; forms Batey & Mack with Andrew Batey, 1978; opens MACK Architects, San Francisco, Calif., 1985; opens office in Los Angeles, Calif., 1990.

Work includes Kirlin house, Napa, Calif., 1980; Holt house, Corpus Christi, Tex., 1983; Baum house, Berkeley, Calif., 1988; Conegliano Housing, Italy, 1995; Suter Rowhouses, Buus, Switzerland, 1996; Thomas house, Las Vegas, Nev., 1997–98.

Taught at University of California, Berkeley, 1986–93; professor of architecture at University of California, Los Angeles, since 1994.

Currently has office in Los Angeles.

THOM MAYNE
Morphosis
b. 1944, Waterbury, Conn.
Architect and designer
B. Arch., University of Southern California, Los Angeles, Calif., 1968; M. Arch., Harvard University, Cambridge, Mass., 1978.

Opens Morphosis, 1972.

Architect. Furniture and lighting designer. Works include Kate Mantilini Restaurant, Beverly Hills, Calif., 1986; Cedar's Sinai Comprehensive Cancer Care Center, Beverly Hills, 1987; Crawford house, Montecito, Calif., 1987–92; Blades house, Santa Barbara, Calif., 1992–96; Sun Tower, Seoul, Korea, 1995–97; Diamond Ranch High School, Diamond Bar, Calif., 1994–2000. Design work includes *Nee* side chair, 1988.

Has taught at University of Southern California, Harvard, Yale, Columbia, and Miami universities among others; founding board member of SCI-Arc.

Firm currently has office in Santa Monica, Calif.

RICHARD MEIER
b. 1934, Newark, N.J.
Architect and designer
B. Arch., Cornell University, Ithaca, N.Y., 1957.

Opens Richard Meier & Partners, New York City, 1963.

Architectural works include Smith house, Darien, Conn., 1967; Westbeth Artists' Housing, New York, 1970; Museum of Modern Art, Villa Strozzi, Florence, Italy, project, 1973; Hartford Seminary, Hartford, Conn., 1981; High Museum of Art, Atlanta, Ga., 1980–83; Canal + Television Headquarters, Paris, France, 1991; Getty Center, Los Angeles, Calif., 1984–97. Designs include furniture, Knoll International, 1978; housewares, Alessi, 1980; housewares, Swid Powell, 1984–96; glass bowl and vase, Steuben, 1992; grand piano, Ibach & Sohn, 1996.

Brunner Prize, American Academy and Institute of Arts and Letters, 1972; Pritzker Prize, 1984; Gold Medal, Royal Institute of British Architects, 1989; Commander of Arts and Letters, France, 1992; Gold Medal, AIA, 1997. Has taught at institutions including Cornell, Yale, and Harvard universities.

Books by Meier: *Richard Meier, Architect: Buildings and Projects 1966–1976*, New York, 1976; *Building the Getty*, New York, 1997; *Richard Meier, Architect 2: 1992–1999*, New York, 1999.

Richard Meier & Partners has offices in New York and Los Angeles.

ROSS MENUEZ
b. 1965, New York City.
Designer
Studied sculpture at Hunter College, New York.

Furniture, lighting, and accessories designer. Recent work in New York includes ceiling for David Barton Gym; reception desk, Halston couture; display, Polo; and chairs, Coup Restaurant.

Awards include Best New Designer, design magazine editors, ICFF, 1996.

Currently works in London, England.

MICROSOFT
Founded by **Paul Allen** and **Bill Gates** in Albuquerque, N.M., 1975.
Bill Gates, Chairman and Chief Software Architect.
Product design firm
Specializes in software, services, and Internet technology for personal and business computing. Offices located in over 60 countries employing nearly 44,000 people.

Firm moves to Bellevue, Wash., 1979; incorporated, 1981; IBM introduces personal computer with Microsoft's 16-bit operating system, MS-DOS 1.0, 1981; stock goes public, 1986; firm moves to Redmond, Wash., 1986; introduces Windows 3.0, 1990; Windows 95, 1995; Windows 98, 1998; Windows 2000, 2000; Windows XP, 2001.

Corporate headquarters in Redmond.

MODERN DOG
Founded by **Robynne Raye** and **Michael Strassburger**, Seattle, Wash., 1987.
Graphic and Web-site design firm
Clients include Simon & Schuster, Nike, Converse, Swatchwatches, RCA Records, and Warner Brothers Records.

Designs are in permanent collections of Denver Art Museum, Denver, Colo.; Cooper-Hewitt, New York City; Library of Congress, Washington, D.C.

Currently has office in Seattle.

JENNIFER MORLA
b. 1955, New York City.
Graphic designer
B.F.A., Massachusetts College of Art, Boston, Mass., 1978.

Opens Morla Design, 1984.

Morla Design, Inc. clients include Apple Computer, Chronicle Books, Levi Strauss, and MTV Networks.

Work is in permanent collections of Library of Congress, Washington, D.C., Grand Palais, Paris, France; Museum of Modern Art, New York; and numerous others.

Currently has office in San Francisco, Calif.

ERIC OWEN MOSS
b. 1943, Los Angeles, Calif.
Architect and designer
B.A., University of California, Los Angeles, 1965; M. Arch., 1968; M. Arch., Harvard University, Cambridge, Mass., 1972.

Works include Central Housing Office, University of California, Irvine, 1989; Lindblade Tower, Culver City, Calif., 1989; Gary Group, Culver City, 1990; The Box, Culver City, 1994; and the IRS Building, Culver City, 1994; Stealth Building, Culver City, 1999–2000. Is Professor of Design at Southern California Institute of Architecture.

Currently has office in Culver City.

NIKE, INC.
Founded by Bill Bowerman and Phil Knight, 1962.
Sportswear company
Began as company producing running shoes called Blue Ribbon Sports, renamed in 1972 when Nike brand was launched at U.S. Olympic Trials. Nike designs include shoes, sportswear, watches, and sportsgear.

Corporate headquarters in Portland, Ore.

RALPH NO
Architect and designer
B. Arch., Virginia Polytechnic and State University, Blacksburg, Va., 1990.

Furniture designer.

Awards include First Place and Honor Award, Ghent Arts Festival, 1989; First Place, Concrete & Masonry Competition, 1989; Honorable Mention, Concrete & Masonry Competition, 1990.

OAKLEY
Founded by **Jim Jannard**, 1975.
Product design company and manufacturer
Firm uses new materials and production techniques for sunglasses and high-performance eyewear for athletes. Its product line has expanded to include apparel, watches, and other sport products.

Currently based in Foothills Ranch, Calif.

FRANK J. OSWALD
b. 1957, St. Francis, Wis.
Graphic designer
B.A., journalism, University of Wisconsin, Madison, Wis.

Clients have included leading graphic design firms and companies ranging from Accenture to Yahoo!

More than twenty-five national and international awards from *Graphis, Communication Arts, Print*, AR 100 (including Best of Show), and the Mead Annual Report Show, among others.

Currently free-lance writer and communications consultant in Monroe, Conn.

JOSH OWEN
b. 1970, Philadelphia, Pa.
Designer
B.F.A., sculpture, Cornell University, Ithaca, N.Y., 1993; B.A., visual studies, Cornell, 1994; M.F.A., furniture design, Rhode Island School of Design, Providence, R.I., 1997.

Founds industrial and graphic design studio owenLOGIKdesign, Philadelphia, Pa., 1997.

Furniture, lighting, and corporate identity designer. Clients include DMD/Droog Design, IBM, MAP/Aldo Rossi Studio de Architettura, Material Connexion, Minima, and Umbra.

Awards include Michael Rapuano Design Distinction Award, 1993; Samuel Gragg Award for Achievement, 1997; nominee for Chrysler Award for Innovation in Design, 1998. Is professor of industrial design at Philadelphia University.

Currently has office in Philadelphia, Pa.

STEPHEN PEART
b. 1958, Durham, England.
Designer
B.A., Sheffield City Polytechnic, Sheffield, England; M.A., Royal College of Art, London, England.

Formerly design director of frogdesign; opens design firm Vent, Campbell, Calif., 1987.

Clients include Apple Computers, Nike, Herman Miller, Knoll Group, Compaq, and Plantronics.

Awards include Distinction Award, Annual Design Review, *ID Magazine*, 1994; Best of Category, Annual Design Review, *ID Magazine*, 1996; Industrial Design Excellence Award, 1997. Product designs are in permanent collections of Museum of Modern Art and Cooper-Hewitt, New York City.

Currently has office in Campbell, Calif.

WOODY PIRTLE
b. 1944, Corsicana, Tex.
Graphic designer
B.A., University of Arkansas, Fayetteville, Ark., 1967.

Opens Pirtle Design, Dallas, Tex., 1978; joins Pentagram Design, New York City, as partner, 1988.

Clients have included Nine West, Northern Telecom, Rizzoli Publishing, Simpson Paper Company, and Rockefeller Foundation. Work is in permanent collections of Museum of Modern Art, New York; Cooper-Hewitt Museum, New York; Library of Congress, Washington, D.C.; Victoria & Albert Museum, London, England; and Zurich Poster Museum, Zurich, Switzerland.

Currently lives and works in New York.

JOHN PLUNKETT
b. 1957, Chicago, Ill.
Graphic designer
B.F.A., Cal Arts, 1976.

Designer, Pentagram Design, 1979–82; designer, Designframe, Inc., 1982–84, 1987–90; opens Plunkett & Kuhr, 1991; opens *Wired* with Louis Rossetto, 1992; sells company, 1999.

Clients have included Sundance Film Festival, Carnegie Hall Museum, *Wired*, *Hot Wired*, and Wired Books.

Has received numerous awards including AIGA Communication Graphics Awards and National Magazine Awards for general excellence and design.

Currently has office in Park City, Utah.

MARK POLLACK
b. 1954, Baltimore, Md.
Designer
B.F.A., Rhode Island School of Design, Providence, R.I., 1976.

Opens textile company, Pollack & Associates, with Rich Sullivan and Susan Doty Sullivan, 1988; introduces first collection, 1988; first residential collection, 1995; changes company name to Pollack, 1998. Firm's fabrics are distributed internationally.

Currently has office, design studio, and showroom in New York City.

BART PRINCE
b. 1947, Albuquerque, N.M.
Architect
B. Arch., Arizona State University, Tempe, Ariz., 1970.

Works with Bruce Goff, 1968–72; opens his own studio, 1973.

Work includes his own house and studio, Albuquerque, N.M., 1983; Joe Price house, Corona del Mar, Calif., 1986; Spence house, Taos, N.M., 1993; Mead/Penhall house, Albuquerque, 1994; Hight house, Mendocino County, Calif., 1992–96; Skilken house, Columbus, Ohio, 2000.

Currently has office in Albuquerque.

R/GA (FOUNDED AS R/GREENBERG ASSOCIATES) DIGITAL STUDIOS
Digital imaging firm.
Founded in 1977.

Designs include feature films, broadcast, print, and interactive media.

Television commercials include Dodge, Diet Coke, and Reebok. Movie titles include *Seven*, *Braveheart*, *Predator*, *The Shadow*, and *In the Line of Fire*. Web sites include Rhode Island School of Design, Ericsson, Purina Cat Chow, and BBC America.

Currently has offices in Los Angeles and Stockholm.

RADIUS TOOTHBRUSH
Founded by **James O'Halloran** and **Kevin Foley**, 1982.
Toothbrush design firm

Produces original toothbrush design, 1982; establishes company in New York City, 1983; company moves to Kutztown, Pa., 1988.

Awards include Most Original Design, Accent on Design Show, New York, 1984; Accepted Status, American Dental Association, 1990. Designs are in permanent collection of Cooper-Hewitt, New York.

Currently firm is located in Kutztown, Pa.

GEORGE RANALLI
b. 1946, New York City.
Architect and designer
B. Arch., Pratt Institute, New York, 1972; M. Arch., Harvard University, Cambridge, Mass., 1974.

Works include offices for Formica, New York, 1994; K-Loft, New York, 1993–95; addition to 96th St. penthouse, New York, 2000.

Artist Fellowship in Architecture, New York Foundation for the Arts, 1988; Architecture Award, New York Chapter, AIA, 1994; Design Award, New York Chapter, AIA, 1996; Projects Award, New York Chapter, AIA, 1997. Work is in permanent collections of Metropolitan Museum of Art, New York; Denver Art Museum, Denver, Colo. Has taught at Yale and Columbia universities, and the University of Chicago. Dean at City College of New York.

Currently has office in New York.

KARIM RASHID
b. 1960, Cairo, Egypt; Canadian citizen; resides New York City.
Designer
B.A., industrial design, Carleton University, Ottawa, Canada, 1982.

Works for KAN Industrial Design, Toronto, Canada, 1985; founds Karim Rashid Industrial Design, Toronto, 1991; moves firm to New York, 1993.

Furniture, textile, lighting, and tableware designer. Notable designs include furniture for Gallery Idee, packaging for Issey Miyake, lighting for George Kovacs, and product design for Umbra. Clients include Nambe, Pure Design, Umbra, Fasem, Guzzini, Magis, and Edra.

Awards include DaimlerChrysler Award, 1999. Work has been exhibited at Museum of Modern Art, New York; Chicago Athenaeum, Chicago, Ill.; and Design Museum, London, England.

Has taught at University of the Arts, Philadelphia, Pa.; Pratt Institute, New York; Rhode Island School of Design, Providence, R.I.

Currently has office in New York.

REVERB
Graphic design firm
Founded by **Lisa Nugent**, **Sami Kim**, **Susan Parr**, **Whitney Lowe**, and **Lorraine Wild**, 1993.
Firm specializes in branding.

Clients include Nike, Warner Brothers, IBM, Beverly Hills Avalon Hotel, and Hewlitt-Packard.

Currently has office in Los Angeles, Calif.

ROLLERBLADE
Founded in 1980.
In-line skate manufacturer

Developed by two hockey players in Minnesota for off-season training. Company was sold in 1984; in-line skating was marketed as a new sport.

Currently located in Bordertown, N.J.

STANLEY SAITOWITZ
b. 1949, Johannesburg, South Africa.
Architect
B. Arch., University of Witwatersrand, Johannesburg, South Africa, 1974; M. Arch., University of California, Berkeley, Calif., 1977.

Works include Transvaal house, South Africa, 1978; Berlin Library, Germany, 1988; California Museum of Photography, Riverside, Calif., 1990; Sinai Memorial Chapel, Berkeley, 1993; New England Holocaust Memorial, Boston, 1996; Yerba Buena Lofts, San Francisco, 1999–2001

Transvaal house declared National Monument, National Monuments Council of South Africa, 1997; Harleston Parker Award, Boston Society of Architects, 1997; Henry Bacon Medal for Memorial Architecture, AIA, 1998. Has taught at Harvard, University of Oklahoma, UCLA, University of Texas at Austin, and University of Witwatersrand, South Africa; is Professor of Architecture, University of California, Berkeley, Calif.

Currently has office in San Francisco.

FRED SCHECTER
Designer
B.A., Hofstra University, New York City, 1972.

Begins work at Sommers Plastics, father's company, 1977; Nike begins using company's innovative materials for shoes; Norma Kamali uses them for apparel, 1997; firm introduces fabrics to companies such as Donna Karan, Nike, Fill, DesignTex, 1998.

PAULA SCHER
b. 1948, Washington, D.C.
Graphic designer
Studied at Tyler School of Art, Philadelphia, Pa., 1970.

Opens Koppel & Scher, New York City, 1984; joins Pentagram Design, New York, as partner, 1991.

Clients have included *New York Times Magazine*, Asia Society, Anne Klein, Public Theatre, Citigroup, Herman Miller, and American Museum of Natural History.

American Institute of Graphic Arts Medal, 2001; Chrysler Award for Innovation in Design 2000; Art Directors Club Hall of Fame, 1998; Beacon Award for identity for the Public Theater, 1996. Work is in permanent collections of Museum of Modern Art, New York; Cooper-Hewitt, New York; Denver Art Museum, Denver, Colo.; Library of Congress, Washington, D.C.; Pompidou Centre, Paris, France; and Israel Museum, Jerusalem. Teaches at School of Visual Arts, New York.

Currently lives and works in New York.

LLOYD SCHWAN
b. 1956, Chicago, Ill.; d. 2001, Kutztown, Pa.
Designer
Studied at Chicago Art Institute

Forms Godley Schwan with wife, Lyn Godley, Chicago, 1984; firm moves to New York City, 1985; opens Lloyd Schwan Design, New York, 1998.

Furniture, lighting, tableware, and interior designer. Designs exhibited at Neotu Gallery and Totem Gallery, New York. Furniture exhibited at Salone di Mobile, Milan, Italy, 1998. Early designs for Godley Schwan were largely handmade. Later work mass-produced by Cappellini, Box Mobler, Magis, and Asplund.

Work included in collection of Museum of Modern Art, New York.

FREDERIC SCHWARTZ
b. 1951, New York City.
Architect and Designer
B. Arch., University of California, Berkeley, Calif., 1973; M. Arch., Harvard University, Cambridge, Mass., 1978.

Works at Venturi & Rauch, Philadelphia, Pa., 1978; director, Venturi, Scott Brown & Associates, New York, 1980; forms Anderson/Schwartz Architects, New York and San Francisco, 1984; establishes Schwartz Architects, New York, 1996.

Architect. Tableware, furniture, textile, and lighting designer. Architectural projects include Princeton Club of New York; Joe's Restaurant, New York; Bumble & Bumble hair salon, New York; and numerous Manhattan apartments and lofts. Product design includes tableware, Swid Powell; bedding, Cannon Fieldcrest; as well as hardware, stained glass, mosaics, andirons, and weathervanes.

Winner of International Competition for Staten Island Ferry Terminal, 1992; Southwest regional capital of France, Toulouse, 1992. Work has been shown in Venice Biennale exhibition and Paris Biennale exhibition, as well as many others. Has taught at Princeton University, Princeton, N.J.; Harvard University, Cambridge, Mass.; Yale University, New Haven, Conn.; and Columbia University, New York.

Currently has office in New York.

DENISE SCOTT BROWN
b. 1931, Nkana, Zambia.
Architect and planner
B. Arch., University of Witwatersrand, Johannesburg, South Africa, 1952; M.C.P., University of Pennsylvania, Philadelphia, Pa., 1960; M. Arch., 1965.

Begins teaching architecture, 1960; joins Venturi and Rauch as architect and planner, 1967; becomes partner, 1969; firm becomes Venturi, Rauch and Scott Brown, 1980; Venturi, Scott Brown and Associates established, 1989.

Recently completed projects of Venturi, Scott Brown and Associates include University of Pennsylvania, Perelman Quadrangle, 2000; Hôtel du Département de la Haute-Garonne, Toulouse, France, 1992–99; Mielmonte Nikko Kirifuri Resort, Japan, 1992–97.

Awards include Commendatore of the Order of Merit, Republic of Italy, 1987; National Medal of Arts, U.S. Presidential Award, 1992; ACSA-AIA Joint Award for Excellence in Architecture Education, Topaz Medallion, 1996; Chevalier de l'Ordre des Arts et Lettres, Republic of France, 2001. Honorary doctorates include Oberlin College, Ohio, 1977; Parsons School of Design, New York City, 1985; Pratt Institute, New York, 1992; University of Pennsylvania, Philadelphia, Pa., 1994; University of Nevada, Las Vegas, 1998. Has taught at such institutions as Yale, Harvard, Rice universities, and the University of California, Los Angeles. Has served on board of directors for Central Philadelphia Development Corporation since 1985, as advisor for the National Trust for Historic Preservation, 1981–85.

Books include *Learning from Las Vegas*, with Robert Venturi and Steven Izenour, Cambridge, Mass., 1972; *A View from the Campidoglio, Selected Essays, 1953–84*, with Robert Venturi, New York, 1985; *Urban Concepts*, London, 1990.

Venturi, Scott Brown and Associates currently has office in Philadelphia.

CARLOS SEGURA
b. 1957, Santiago, Cuba.
Graphic designer
Opens Segura, Inc., Chicago, Ill., 1991.

Has received awards from New York Type Directors Club, American Center for Design, Tokyo Type Directors Club, Tokyo Art Directors Club, and many others.

Currently lives and works in Chicago.

JAMIE SHEEHAN
b. 1968, Detroit, Mich.
Graphic designer
Works as free-lance art director/designer.

Currently lives and works in St. Louis, Mo.

HELENE SILVERMAN
b. 1953, Brooklyn, N.Y.
Graphic designer
Senior designer, *Mademoiselle* magazine, New York City, 1984; design director, *Metropolis* magazine, New York, 1985–89; founding member, Hello Studio, design co-op, New York, 1989; design director, The Red Hot Organization, 1990 to present.

Clients include Random House, Harry N. Abrams, *Rolling Stone*, Time, Inc., Warner Communications, MTV, and Japan Airlines.

Currently lives and works in Brooklyn, N.Y.

NANCY SKOLOS
b. 1955, Cincinnati, Ohio.
Graphic designer
B.F.A., Cranbrook Academy of Art, Bloomfield Hills, Mich., 1977; M.F.A., Yale University, New Haven, Conn., 1979.

Partner, Skolos, Wedell & Raynor, Inc., Boston, Mass., 1980; partner, Skolos/Wedell, Boston, an interdisciplinary graphic design and photography studio, 1990.

Clients include Boston Acoustics, Digital Equipment Corporation, EMI Music Publishing, Hasbro, and the U.S. Postal Service.

Studio has received numerous awards including silver prize, Lahti Poster Biennale, and bronze prize, International Triennial of Posters, Toyama, Japan. Is Associate Professor of Graphic Design, Rhode Island School of Design, Providence, R.I.

Currently lives and works in Boston.

SMART DESIGN
Established in 1981 as David Stowell Associates. Becomes Smart Design in 1985 with partners David Stowell, Tom Dair, Tamara Thomsen, and Tucker Viemeister.
Product design firm

Specializes in product strategy, industrial design, graphics, and interaction design, as well as engineering and design research.

Clients include Hewlitt-Packard, OXO International, Issey Miyake, Timex, Corning Ware, LG Electronics, Johnson & Johnson, and Kellogg's.

Designs are included in collections of Cooper-Hewitt, New York; Design Center, Stuttgart, Germany; Museum of Modern Art, New York; Chicago Athenaeum, Chicago, Ill., and the Design Museum, London, England.

Currently has office in New York.

RANDALL SMITH
b. 1957, Cumberland, Md.
Graphic designer
B.S. Design, University of Cincinnati, Cincinnati, Ohio.

Clients have included Fortune Brands, Cabot Corporation, and Praxair.

Has received more than twenty-five national and international awards from *Graphis*, *Communication Arts*, *Print*, AR 100, New York Type Directors Club, and Mead Annual Report Show, among others.

Currently partner at SVP Partners in Wilton, Conn.

MIKE SOLIS
b. 1969, Dallas, Tex.
Designer
B.A., Parsons School of Design, New York City, 1991.

Opens own studio, Worx, in Brooklyn, New York, 1991; works at Dinesan Inc., New York.

Furniture and lighting designer. Launches line of furniture and home accessories, ICFF, New York, 1995.

ICFF Editor's Award, Best New Designer, 1996. Has exhibited at K&T Lionhart Gallery, Boston, Mass.; Rotunda Gallery, Brooklyn, N.Y.; ICFF, New York, 1996, 1998.

Currently works in Dallas, Tex.

SPY OPTIC
Founded 1994.
Product design firm and manufacturer

Spy uses new technologies for eyewear, including camera-quality Spyglass, Trident polarized lenses, ARC prismatic lenses, and patented Scoop venting systems.

Headquarters currently located in Vista, Calif.

PETER STATHIS
Designer
B.I.D., Pratt Institute, Brooklyn, N.Y., 1982; M.F.A., Cranbrook Academy of Art, Bloomfield Hills, Mich., 1989.

Senior designer, Richard Penney Group, New York City, 1986–87; works in Applied Research division, NYNEX, Inc., White Plains, N.Y., 1989; senior designer, Smart Design, New York, 1989–92; principal, Virtual Studio, San Francisco, Calif., 1992 to present.

Furniture, lighting and houseware designer. Clients include Apple Computer, Black and Decker, Johnson & Johnson, Kovacs Lighting, Knoll, Museum of Modern Art, Nambe, OXO Good Grips, Pure Design, and Swatch.

Awards include Best of Show, ICFF, New York, 2000; IDEA award, Industrial Designers of America; *ID* Annual Design Review. Work is included in permanent collections of Cranbrook Art Museum, Bloomfield Hills; Cooper-Hewitt, New York; Museum of Modern Art,

New York. Designer-in-residence and Head, 3-D Design Department, Cranbrook Academy of Art, Bloomfield Hills, 1995–2001.

Currently has office in San Francisco.

GISELA STROMEYER
b. 1961, Konstanz, Germany.
Designer
Studies at Technical University, Munich, Germany; B. Arch., Pratt Institute, New York City, 1989. Studies at Frei Otto's atelier, Stuttgart, Germany, 1981; joins FTL Happold, New York, 1985; opens Gisela Stromeyer Design, New York, 1989.

Interior and lighting designer. Residential and commercial projects, offices, homes, showrooms, restaurants, spas, and stage sets. Clients include Sony, MTV, TWA, Disney, Elizabeth Arden, Click Model Agency, Ralph Lauren, and Emanuel Ungaro.

Awards include best of furniture award, *ID Magazine*.

Currently has office in New York.

WILLIAM STUMPF
b. 1936.
Designer
B.A., University of Illinois, Chicago, Ill.

Appointed research director of design for Herman Miller, 1970; opens design partnership Chadwick, Stumpf & Associates with Donald Chadwick, 1977; opens Stumpf & Weber, Minneapolis, Minn.

Industrial designer. Design work for Herman Miller includes *Ergon* chair, 1976; *Equa* chair with Chadwick, 1984; and *Aeron* chair with Chadwick, 1994.

Named "Designer of the 70s," *ID Magazine*.

Currently has office in Minneapolis, Minn.

DEBORAH SUSSMAN
b. Brooklyn, N.Y.
Graphic designer
B.A., Bard College, Annandale-on-Hudson, N.Y.; studied at Black Mountain College, Black Mountain, N.C; and Institute of Design, Chicago, Ill.

Opens Sussman/Prejza & Co. with husband, Paul Prejza, Los Angeles, Calif., 1968.

Multi-disciplinary firm works in corporate identity, signing, print programs, architectural and sculptural amenities, urban planning, streetscaping, exhibit and interior design. Clients include Apple Computer, Champion Papers, Denver Center for the Performing Arts, Esprit International, EuroDisney, Hallmark, Hasbro, Herman Miller, City of Long Beach, Calif., Los Angeles World Airports, Rand Corporation, Rolling Stones, Times Square Associates, and numerous others.

Member, Alliance Graphique Internationale; Fellow, Society for Environmental Graphic Design; National Board Member, American Institute of Graphic Arts; honorary member, American Center for Design; honorary member, American Institute of Architects. Has taught at University of Southern California, Art Center College of Design, Rhode Island School of Design, and Santa Monica College of Design.

Currently has office in Culver City, Calif.

ALI TAYAR
b. 1959, Istanbul, Turkey.
Designer and architect
B.S., University of Stuttgart, Stuttgart, Germany, 1986; M.S., Massachusetts Institute of Technology, Cambridge, Mass., 1988.

Works at FTL Associates, New York City, as project architect, 1988; becomes principal at Parallel Design Partnership, New York City, 1991.

Interior, furniture, product, and lighting designer. Recent projects include Gansevoort Gallery and Waterloo Brasserie, both New York.

Annual Design Distinction Award, *ID Magazine*, 1994–98. Has lectured and taught at Illinois Institute of Technology, Chicago, Ill.; MIT, Cambridge, Mass.; City University of New York, New York; University of Pennsylvania, and Columbia University, New York. Currently teaches at Parsons School of Design, New York.

Currently has office in New York.

THOMSON MULTIMEDIA
Originally founded in late nineteenth century by Elihu Thomson.
Product design firm

Firm provides wide range of technologies, systems, finished products, and services to the media industry, including digital media solutions, displays and components, consumer products, new media services, and patents and licenses. Its products are distributed under Thomson, RCA, and Technicolor brand names.

Currently has offices in over thirty countries.

SUZANNE TICK
b. 1959, Bloomington, Ill.
Designer
B.F.A., University of Iowa.

Forms Tuva Looms, woven carpet company with partner Terry Mowers, 1996; has been design director for Boris Kroll, Brickel Associates, and Unika Vaev; is currently creative director for KnollTextiles and consultant for Interface Inc.'s Prince Street and Bentley brands.

Design Distinction Award, Annual Design Review, *ID Magazine*, 1999; Best of Neocon 2000, Gold Award; Good Design Award, Chicago Athenaeum, 2000.

Currently lives and works in New York City.

STANLEY TIGERMAN
b. 1930, Chicago, Ill.
Architect and designer
B. Arch., Yale University, New Haven, Conn., 1960; M. Arch., 1961.

Establishes Tigerman and Koglin, 1962; Stanley Tigerman and Associates, 1964; Tigerman, Fugman and McCurry, 1982; Tigerman McCurry Architects, 1988.

Architect. Furniture, tableware, and product designer. Projects include The Five Polytechnic Institutes, Bangladesh, 1966–75; Urban Villa, Berlin, Germany, 1982; apartment building, Fukuoka, Japan, 1990; Power House Energy Education Center, Zion, Ill., 1993–99; and The Educare Center, Chicago, Ill., 2000. Design projects include chair designs, Knoll International, 1980; screen prototype, Rizzoli International, 1982; tableware for Swid Powell, 1983; and product designs, American Standard, 1990.

Alumni Arts Award, Yale University, 1985; American Jewish Committee Cultural Achievement Award, 1996; and Louis Sullivan Award, 2000. Tigerman's designs are in the permanent collections of the Art Institute of Chicago, Chicago; Metropolitan Museum of Art, New York City; and the Denver Art Museum, Denver, Colo. Has taught at such institutions as Northwestern, Cornell, Columbia, Harvard universities, and Cooper Union.

Books by Tigerman: *Versus: An American Architect's Alternatives*, with Ross Miller and Dorothy Metzger Habel, New York, 1982; *The Postwar American Dream*, Chicago, 1985; and *The Architecture of Exile*, New York, 1988.

Tigerman McCurry Architects currently has an office in Chicago.

TURNER DUCKWORTH
Founded by **David Turner** and **Bruce Duckworth**, 1992.
Graphic design firm
David Turner
b. 1962, Solihull, England.
B.A., St. Martin's School of Art, 1984.
Bruce Duckworth
b. 1963, Harrow, England.
B.A., Kingston University, 1985.
Firm specializes in brand identity and packaging design.

Clients include Palm Inc., Amazon.com, Levi Strauss, Virgin Atlantic, Procter & Gamble, Royal Mail, and The SETI Institute.

The firm currently has offices in London, England, and San Francisco, Calif.

MICHAEL VANDERBYL
b. 1947, Oakland, Calif.
Graphic designer and designer
B.F.A., California College of Arts and Crafts, San Francisco, Calif., 1968.

Opens Vanderbyl Design, San Francisco, 1973.

Multidisciplinary firm specializing in graphics, packaging, interiors, showrooms, retail spaces, furniture, and textiles. Clients include Walt Disney Company, Esprit, IBM, Luna Textiles, Mead Paper Company, and Polaroid.

Awards include AIGA Medal, American Institute of Graphic Arts, 2000. Work is in permanent collections of Cooper-Hewitt, New York City; Library of Congress, Washington, D.C.; San Francisco Museum of Modern Art; Museum die Neue Sammlung, Munich, Germany. Has taught at Cranbrook Academy of Art, Kent State University, and the Universities of Cincinnati, Kansas, and Washington. Currently Dean, School of Design, California College of Arts and Crafts, San Francisco.

Currently lives and works in San Francisco.

RUDY VANDERLANS and ZUZANA LICKO
Graphic designers
Zuzana Licko
b. 1961, Bratislava, Czechoslovakia.
B.A., University of California, Berkeley, 1985.
Rudy VanderLans
b. 1955, The Hague, Netherlands.
B.A., Royal Academy of Art, The Hague, Netherlands, 1979.
M.A., University of California, Berkeley, 1983.

VanderLans and Licko establish *Emigre* magazine, Sacramento, Calif., 1984; this leads to creation and distribution of Emigre Fonts software.

Awards include Chrysler Award for Innovation in Design, 1994; AIGA Gold Medal Award, 1997; nominated for Cooper-Hewitt National Design Lifetime Achievement Award, 2000.

Currently have office in Sacramento.

ROBERT VENTURI
b. 1925, Philadelphia, Pa.
Architect and designer
B.A., summa cum laude, Princeton University, Princeton, N.J., 1947; M.F.A., 1950. Works as a designer in firms of Oscar Stonorov, 1950; Eero Saarinen and Associates, 1951–53; designer in firm of Louis Kahn, Philadelphia, Pa., 1958; partnership with Paul Cope and H. Mather Lippincott, 1958–61; partner with William Short, 1961–64; partner with John Rauch, 1964–89; partner with Denise Scott Brown, 1968 to present.

Venturi's architectural works include Vanna Venturi House, Chestnut Hill, Philadelphia, Pa., 1959–64; Welcome Park, Philadelphia, 1983; Sainsbury Wing, National Gallery, London, 1985–91; Mielmonte Nikko Kirifuri Resort, Japan, 1992–97. Recently completed projects include Hôtel du Département de la Haute-Garonne, Toulouse, France, 1992–99; Historical Society of Pennsylvania, Philadelphia, 1996; diverse work for Harvard, Yale,

Princeton, Pennsylvania, Michigan, UCLA, and other colleges and universities. Venturi's designs include furniture for Knoll and Arc International, tableware for Alessi and Swid Powell, and textiles for Fabric Workshop, Knoll, and DesignTex Inc.

Fellow, American Academy in Rome, 1954–56; Resident, American Academy in Rome, 1964; Commendatore of the Order of Merit, Republic of Italy, 1986; Pritzker Prize, 1991; National Medal of Arts, U.S. Presidential Award, 1992; Commandeur de l'Ordre des Arts et Lettres, Republic of France, 2001. Honorary doctorates include Oberlin College, Ohio, 1977; Yale University, 1979; University of Pennsylvania, 1980; Princeton University, 1983; University of Rome, 1994; University of Nevada, 1998. Designs represented in collections of Metropolitan Museum of Art, New York City, and Denver Art Museum, Denver, Colo.

Books by Venturi: *Complexity and Contradiction in Architecture*, New York, 1966; *Learning from Las Vegas*, with Denise Scott Brown and Steven Izenour, Cambridge, Mass., 1972; *A View from the Campidoglio: Selected Essays, 1953–84*, with Denise Scott Brown, New York, 1985; *Iconography and Electronics upon a Generic Architecture. A View from the Drafting Room*, Cambridge, Mass., 1996.

Venturi, Scott Brown and Associates currently has an office in Philadelphia.

JAMES VICTORE

b. 1962, New York City.
Graphic designer
Opens James Victore, Inc., New York, 1999; moves company to Beacon, N.Y.

Company has received numerous awards including gold and bronze medals, Broadcast Designers Association; gold and silver medals, New York Art Directors Club; gold and silver medals, Mexico Poster Biennale. Work is in permanent collections of Library of Congress, Washington, D.C.; Palais du Louvre, Paris, France; Museum für Gestaltung, Zurich, Switzerland. Victore teaches at School of Visual Arts, New York.

Author, *James Victore: A Design Life*, China, China Youth Press, 1998.

Currently lives and works in Beacon, N.Y.

TUCKER VIEMEISTER

b. 1948, Yellow Springs, Ohio.
Designer
Studied at Pratt Institute, New York City.

Becomes partner at Davin Stowell Associates, New York, 1979; from 1985, known as Smart Design; creative director, frogdesign, 1996; joins Razorfish, New York, 1999.

Product and tableware designer. Clients include Serengeti, Sanyei, Oxo, and Corning Ware.

Awards include Presidential Design Achievement Award, IDEA Award. Designs included in the collections of Cooper-Hewitt, New York, the Cranbrook Academy of Art Museum, Bloomfield Hills, Mich., and Denver Art Museum, Denver, Colo.

Currently independent designer in New York.

THOMAS WEDELL

b. 1949, Kalamazoo, Mich.
Graphic designer and photographer
B.A., University of Michigan, Ann Arbor, Mich., 1973; M.F.A., Cranbrook Academy of Art, Bloomfield Hills, Mich., 1976.

Partner, Skolos, Wedell & Raynor, Inc., Boston, Mass., 1980; partner, Skolos/Wedell, Boston, an interdisciplinary graphic design and photography studio, 1990.

Clients include Boston Acoustics, Digital Equipment Corporation, EMI Music Publishing, Hasbro, and the U.S. Postal Service.

Studio has received numerous awards including silver prize, Lahti Poster Biennale and bronze prize, International Triennial of Posters,

Toyama, Japan.

Since 1993 has been Adjunct Faculty in Graphic Design at Rhode Island School of Design, Providence, R.I.

Currently lives and works in Boston.

ALLAN WEXLER

b. 1949, Bridgeport, Conn.
Architect and designer
B.F.A., Rhode Island School of Design, Providence, R.I., 1971; B. Arch., Rhode Island School of Design, 1972; M.A., Pratt Institute, New York City, 1976.

Architect and furniture designer. Commissions include Schneider Winery, Riverhead, N.Y.; Utopian Café, Karl Ernst Osthaus Museum, Hagen, Germany; Levy House, Accord, New York, 1985; Henry Luce Nature Observatory at Belvedere Castle, Central Park, New York, (with Ellen Wexler), 1996; High Museum, "Learning to Look," permanent environment, Atlanta, Ga. (with Ellen Wexler), 1999; and "Tables of Content," Douglas Park, Santa Monica, Calif. (with Ellen Wexler), 2000.

Fellowship Award, New York Foundation for the Arts, 1990; Chrysler Award for Design Innovation, 1997; George Nelson Design Award, 1999. Designs have been exhibited at San Diego Museum of Contemporary Art, San Diego, Calif.; The Jewish Museum, New York; Gallery Joe, Philadelphia, Pa., San Francisco Museum of Modern Art, San Francisco, Calif.; and Ronald Feldman Gallery, New York, since 1984. Teaches at Pratt Institute, Department of Architecture, New York.

Currently works in New York.

JAMES WINES

b. 1932, Oak Park, Ill.
Architect, designer, and sculptor
B.A., Syracuse University, Syracuse, N.Y., 1955.

Founded SITE (Sculpture in the Environment) Incorporated, 1969.

Work includes the SITE studio and offices in New York City, 1984; Here and Now Pavilion, Vancouver, B.C., 1985; West Hollywood Civic Center, Los Angeles, Calif., 1988; Ross's Landing Park and Aquatorium, Chattanooga, Tenn., 1989–93ff.

Fellow, American Academy in Rome, 1956; Ford Foundation Grant, 1964; Graham Foundation Grant, 1974; Chrysler Award for Design Innovation, 1995; Chair of Department of Architecture, Penn State University.

Books by Wines: *De-Architecture*, New York, 1987; *SITE*, with Herbert Muschamp, New York, 1989.

Currently has office in New York.

TAMOTSU YAGI

b. 1949, Kobe, Japan.
Graphic designer
Worked for Hamano Institute, Tokyo, Japan, 1967–84; art director, Esprit, San Francisco, Calif., 1984–91; opens Tamotsu Yagi Design, San Francisco, 1991.

Multi-disciplinary design studio specializes in package and logo design, and corporate identity. Clients include Apple Computer, Benetton, Tribu, Intel, Fila, Danskin, and numerous international companies.

Member, Alliance Graphique Internationale.

Currently lives and works in San Francisco.

ZIBA DESIGN

Founded by Sohrab Voussoughi, 1984.
Product design firm

Clients include Black and Decker, Microsoft, Coleman, Intel, Fujitsu, Nike, Estée Lauder, Federal Express, Kenwood, Sprint, Sunbeam, Whirlpool, and Sanyo.

Multiple national and international design awards; more awards from IDSA than any other U.S. design firm.

Firm is based in Portland, Ore., with offices in San Jose, Calif.; Tokyo, Japan; and Taipei, Taiwan.

Erik Adigard

Harry Allen

Steven Allendorf

Charles S. Anderson

Apple Design Team

Colin Baden

Fabien Baron

Michael Bierut

Donald Booty Jr.

Constantin Boym

Laurene Boym

Kevin Bradley

Annie Brekenfeld

Roger Brown

California Drop Cloth Co.

David Carson

Donald Chadwick

Amy Chan

Eric Chan

Art Chantry

Peter Comitini

Tim Convery

Tony Costanzo

Michael Cronan

Gregg Davis

Christopher Deam

Randal Dahlk

Tom Dair

Christian Daniels

Nick Dine

Ned Drew

Andres Duany

Bruce Duckworth

Joe Duffy

Peter Eisenman

Beth Elliot

Louise Fili

Kevin Foley

Dan Friedman

frogdesign

Tom Froning

Douglas Garofalo

Frank O. Gehry

Alexander Gelman

Erik Giese

Catherine Gilmore-Barnes

Agnethe Glatved

Lyn Godley

Tomás Gonda

Michael Graves

April Greiman

David Gresham

David Gulassa

Dorothy Hafner

Katrin Hagge

Clifford A. Harvey

Herbst Lazar Bell Vision Team

Kit Hinrichs

Jonathan Hoefler

Steven Holl

Steven Skov Holt

Alan Hori

Belle How

Alexander Isley

Seth Jaben

Jim Jennings

Haley Johnson

Daven Joy

Tibor Kalman

Chip Kidd

Aaron King

Mary Lou Kroh

Lisa Krohn

Ronald Krueck

Barbara Kruger

Henner Kuckuck

Willi Kunz

Warren Lehrer

Zuzana Licko

Maya Lin

John Loczak

Greg Lynn

Susan Lyons

Ronald Lytel

Mark Mack

Jerome Mage

P. Scott Makela

Thom Mayne

Lisa Mazur

Katherine McCoy

Margaret McCurry

Michael McInturf

Richard Meier

Ross Menuez

Scott Merrill

Microsoft Design Team

Modern Dog Design Co.

James Moore

Jennifer Morla

Eric Owen Moss

Bruno Nesci

Nike Design Team

Ralph No

James O'Halloran

Daniel Olsen

Keith Olsen

Frank J. Oswald

Josh Owen

Joe Parisi

Stephen Peart

Woody Pirtle

Elizabeth Plater-Zyberk

John Plunkett

Mark Pollack

Bart Prince

George Ranalli

Karim Rashid

R/GA (founded as R/Greenberg Associates)

Marie Reese

Rollerblade Design Team

Stanley Saitowitz

Fred Schecter

Paula Scher

Lloyd Schwan

Frederic Schwartz

Denise Scott Brown

Carlos Segura

Mark Sexton

Jamie Sheehan

Helene Silverman

Nancy Skolos

Randall Smith

Michael Solis

Peter Stathis

Davin Stowell

Scott Stowell

Gisela Stromeyer

William Stumpf

Deborah Sussman

Ali Tayar

Martin Thaler

Tim Thompson

Suzanne Tick

Stanley Tigerman

Nicole Trice

David Turner

Debra Valencia

Michael Vanderbyl

Rudy VanderLans

Robert Venturi

James Victore

Tucker Viemeister

Sohrab Vossoughi

Thomas Wedell

Maurice E. Weintraub

Allan Wexler

Ed Whitman

James Wines

Tamotsu Yagi

Anthony Yell

INDEX

Page numbers in bold type refer to illustrations.

PHOTO CREDITS

Fig 1 Beth Keiser; AP/Wide World Photos
Fig 2 J.R. Hernandez; AP/Wide World Photos
Fig 3 Lucasfilm Ltd.; © 1977 Lucasfilm Ltd. & TM
Fig 4 SITE Environmental Design, Inc.; © SITE Environmental Design,
 Inc. 1975
Fig 5 NASA
Fig 6 Charles S. Anderson Design Co.
Fig 7 DaimlerChrysler Corporation
Fig 8 IBM Corporation
Fig 9 Volkswagen of America, Inc.
Fig 10 Apple Computer, Inc.
Fig 11 by permission Office for Metropolitan Architecture/
 Rem Koolhaas
Fig 12 Paul Sakuma; AP/Wide World Photos
Fig 13 Apple Computer, Inc.
Fig 14 OXO International
Fig 15 TimePix
Fig 16 The Cryptic Corporation; © 1980, The Cryptic Corporation
Fig 17 Rosemarie Bletter
Fig 18 The Museum of Modern Art, New York
Fig 19 Rosemarie Bletter
Fig 20 Rosemarie Bletter
Fig 21 Ezra Stoller © ESTO
Fig 22 Staatliche Museen zu Berlin – Preussischer Kulturbesitz
 Kunstbibliothek
Fig 23 Venturi, Scott Brown and Associates
Fig 24 Venturi, Scott Brown and Associates
Fig 25 Rosemarie Bletter
Fig 26 St. Louis Post-Dispatch
Fig 27 Michael Graves & Associates, Inc.
Fig 28 Michael Graves & Associates, Inc.
Fig 29 Rosemarie Bletter
Fig 30 Alvar Aalto Foundation
Fig 31 Rosemarie Bletter
Fig 32 Rosemarie Bletter
Fig 33 Eisenman Architects
Fig 34 Estate of Gordon Matta-Clark and David Zwirner, New York;
 by permission of the Artists Rights Society, New York/ADAGP
 Paris
Fig 35 Rosemarie Bletter
Fig 36 Rosemarie Bletter
Fig 37 © Richard Bryant/Esto
Fig 38 Eisenman Architects
Fig 39 Rosemarie Bletter
Fig 40 Rollin R. LaFrance; courtesy of Venturi, Scott Brown and
 Associates
Fig 46 Paschall/Taylor
Fig 47 Michael Graves & Associates
Fig 48 Michael Graves & Associates
Fig 51 Venturi, Scott Brown and Associates
Fig 52 Venturi, Scott Brown and Associates
Fig 56 Tigerman McCurry Architects
Fig 57 Jeff Wells, Denver Art Museum
Fig 60 David DeLong
Fig 61 © Michael Moran
Fig 62 The Art Institute of Chicago
Fig 63 Daniel Libeskind Architecture
Fig 64 Morphosis
Fig 65 Morphosis
Fig 69 Eric Owen Moss Architects
Fig 75 Lynn, Garofalo, McInturf
Fig 76 Lynn, Garofalo, McInturf
Fig 78 William O'Connor; Denver Art Museum
Fig 79 Jeff Wells; Denver Art Museum
Fig 81 © SITE Environmental Design, Inc. 1992
Fig 82 © SITE Environmental Design, Inc. 1992
Fig 85 by permission Architecture Magazine
Fig 87 Jeff Wells; Denver Art Museum
Fig 88 Jeff Wells; Denver Art Museum
Fig 91 Jeff Wells; Denver Art Museum
Fig 92 Jeff Wells; Denver Art Museum
Fig 94 Jeff Wells; Denver Art Museum
Fig 95 The National Park Service
Fig 99 © Michael Moran
Fig 100 Paul Warchol
Fig 101 Hedrich Blessing
Fig 102 Greg Williams, photo © The Art Institute of Chicago
Fig 103 Greg Williams, photo © The Art Institute of Chicago
Fig 105 Mies van der Rohe Archive, The Museum of Modern Art,
 New York
Fig 106 Philip Johnson/Alan Ritchie Architects
Fig 108 Steven Holl Architects
Fig 109 Steven Holl Architects
Fig 111 William O'Connor; Denver Art Museum
Fig 112 © Peter Aaron/Esto
Fig 113 Jamie Ardiles-Acre; Skidmore, Owings & Merrill LLP

Fig 114 George Pohl; Venturi, Scott Brown and Associates
Fig 115 Matt Wargo; Venturi, Scott Brown and Associates
Fig 116 William O'Connor; Denver Art Museum
Fig 117 Jeff Wells; Denver Art Museum
Fig 118 Venturi, Scott Brown and Associates
Fig 119 William O'Connor; Denver Art Museum
Fig 120 William O'Connor; Denver Art Museum
Fig 121 Alessi S.p.A.
Fig 122 Jeff Wells; Denver Art Museum
Fig 123 Jeff Wells; Denver Art Museum
Fig 124 Jeff Wells; Denver Art Museum
Fig 125 © 1989 The Metropolitan Museum of Art
Fig 126 William O'Connor; Denver Art Museum
Fig 127 Michael Graves & Associates
Fig 128 Jeff Wells; Denver Art Museum
Fig 129 Oberto Gili © House & Garden; courtesy of The Condé Nast
 Publications Inc.
Fig 130 William O'Connor; Denver Art Museum
Fig 131 Michael Graves & Associates
Fig 132 Paschall/Taylor
Fig 133 William O'Connor; Denver Art Museum
Fig 134 William Taylor
Fig 135 Michael Graves & Associates
Fig 136 William O'Connor; Denver Art Museum
Fig 137 William O'Connor; Denver Art Museum
Fig 138 George Kopp Photography
Fig 139 William O'Connor; Denver Art Museum
Fig 140 Michael Graves & Associates
Fig 141 Deutsches Architekturmuseum
Fig 142 Deutsches Architekturmuseum
Fig 143 William O'Connor; Denver Art Museum
Fig 144 Morley Baer; Morley Baer Publishing Rights Trust
Fig 145 by permission Ken Friedman
Fig 146 Joe Coscia Jr.
Fig 147 William O'Connor; Denver Art Museum
Fig 148 William O'Connor; Denver Art Museum
Fig 149 William O'Connor; Denver Art Museum
Fig 150 William O'Connor; Denver Art Museum
Fig 151 Antoine Boots
Fig 152 William O'Connor; Denver Art Museum
Fig 153 William O'Connor; Denver Art Museum
Fig 154 William O'Connor; Denver Art Museum
Fig 155 Herbst Lazar Bell, Inc.
Fig 156 Thomson multimedia
Fig 157 William O'Connor; Denver Art Museum
Fig 158 William O'Connor; Denver Art Museum
Fig 159 V'Soske Inc.
Fig 160 Lynn Rosenthal; Philadelphia Museum of Art
Fig 161 William O'Connor; Denver Art Museum
Fig 162 © Tim Street-Porter/Esto
Fig 163 William O'Connor; Denver Art Museum
Fig 164 William O'Connor; Denver Art Museum
Fig 165 William O'Connor; Denver Art Museum
Fig 166 William O'Connor; Denver Art Museum
Fig 167 Lisa Krohn
Fig 168 Mark Johnston
Fig 169 Herman Miller, Inc.
Fig 170 Vent Design
Fig 171 William O'Connor; Denver Art Museum
Fig 172 William O'Connor; Denver Art Museum
Fig 173 William O'Connor; Denver Art Museum
Fig 174 William O'Connor; Denver Art Museum
Fig 175 William O'Connor; Denver Art Museum
Fig 176 William O'Connor; Denver Art Museum
Fig 177 Mark Malabrigo
Fig 178 William O'Connor; Denver Art Museum
Fig 179 frogdesign
Fig 180 William O'Connor; Denver Art Museum
Fig 181 Martin Thaler
Fig 182 by permission Tucker Viemeister
Fig 183 Martin Thaler
Fig 184 Peter Stathis
Fig 185 Bill Maris © Esto
Fig 186 Carlos Emilio; courtesy of Tom Booth Inc.
Fig 187 William O'Connor; Denver Art Museum
Fig 188 William O'Connor; Denver Art Museum
Fig 189 William O'Connor; Denver Art Museum
Fig 190 William O'Connor; Denver Art Museum
Fig 191 William O'Connor; Denver Art Museum
Fig 192 Michael Moran
Fig 193 William O'Connor; Denver Art Museum
Fig 194 Christopher Deam
Fig 195 Daven Joy
Fig 196 Worx
Fig 197 William O'Connor; Denver Art Museum
Fig 198 V'Soske, Inc.

Fig 199 Worx
Fig 200 Apple, Inc.
Fig 201 Apple, Inc.
Fig 202 Doug Hall
Fig 203 Doug Hall
Fig 204 William O'Connor; Denver Art Museum
Fig 205 Liz Deschenes
Fig 206 William O'Connor; Denver Art Museum
Fig 207 William O'Connor; Denver Art Museum
Fig 208 Eric Chan
Fig 209 Design Central
Fig 210 William O'Connor; Denver Art Museum
Fig 211 William O'Connor; Denver Art Museum
Fig 212 William O'Connor; Denver Art Museum
Fig 213 William O'Connor; Denver Art Museum
Fig 214 William O'Connor; Denver Art Museum
Fig 215 Jeff Wells; Denver Art Museum
Fig 216 Jeff Wells; Denver Art Museum
Fig 217 William O'Connor; Denver Art Museum
Fig 218 Pentagram Design Inc.
Fig 219 Joe Duffy
Fig 220 Jennifer Morla
Fig 221 Jeff Wells; Denver Art Museum
Fig 222 Ned Drew
Fig 223 Ned Drew
Fig 224 Jeff Wells; Denver Art Museum
Fig 225 Graham Brown, Graham Brown Photography
Fig 226 Yee-Haw Industries
Fig 227 Jeff Wells; Denver Art Museum
Fig 228 James Victore
Fig 229 James Victore
Fig 230 Art Chantry
Fig 231 William O'Connor; Denver Art Museum
Fig 232 William O'Connor; Denver Art Museum
Fig 233 Greg Montijo
Fig 234 Pentagram Design Inc.
Fig 235 Kit Hinrichs
Fig 236 M & Co.
Fig 237 Warren Lehrer
Fig 238 Warren Lehrer
Fig 239 Helene Silverman
Fig 240 Jeff Wells; Denver Art Museum
Fig 241 April Greiman
Fig 242 Jeff Wells; Denver Art Museum
Fig 243 Jeff Wells; Denver Art Museum
Fig 244 Jeff Wells; Denver Art Museum
Fig 245 Erik Adigard
Fig 246 Erik Adigard
Fig 247 Jeff Wells; Denver Art Museum
Fig 248 Frank J. Oswald
Fig 249 Jeff Wells; Denver Art Museum
Fig 250 Jeff Wells; Denver Art Museum
Fig 251 Michael Cronan
Fig 252 Skolos/Wedell
Fig 253 Pentagram Design Inc.
Fig 254 M & Co.
Fig 255 R/GA Digital Studios, LA
Fig 256 R/GA Digital Studios, LA
Fig 257 R/GA Digital Studios, LA
Fig 258 R/GA Digital Studios, LA
Fig 259 R/GA Digital Studios, LA
Fig 260 R/GA Digital Studios, LA
Fig 261 April Greiman
Fig 262 Jellybean
Fig 263 Jellybean
Fig 264 Jeff Wells; Denver Art Museum
Fig 265 Bill Rivelli
Fig 266 William O'Connor; Denver Art Museum
Fig 267 Pentagram Design Inc.
Fig 268 William O'Connor; Denver Art Museum
Fig 269 Pentagram Design Inc.
Fig 270 William O'Connor; Denver Art Museum
Fig 271 Annette Del Zoppo Productions
Fig 272 Jeff Wells; Denver Art Museum
Fig 273 Jeff Wells; Denver Art Museum
Fig 274 Jeff Wells; Denver Art Museum
Fig 275 Alexander Isley, Inc.
Fig 276 Jeff Wells; Denver Art Museum
Fig 277 Monica Stevenson
Fig 278 Turner Duckworth Design
Fig 279 William O'Connor; Denver Art Museum
Fig 280 William O'Connor; Denver Art Museum
Fig 281 Peter Comitini
Fig 282 Jonathan Hoefler